Susan
Meiselas

In History

Susan Meiselas

In History

Meiselas

Edited by **Kristen Lubben**

International Center of Photography, New York

Steidl

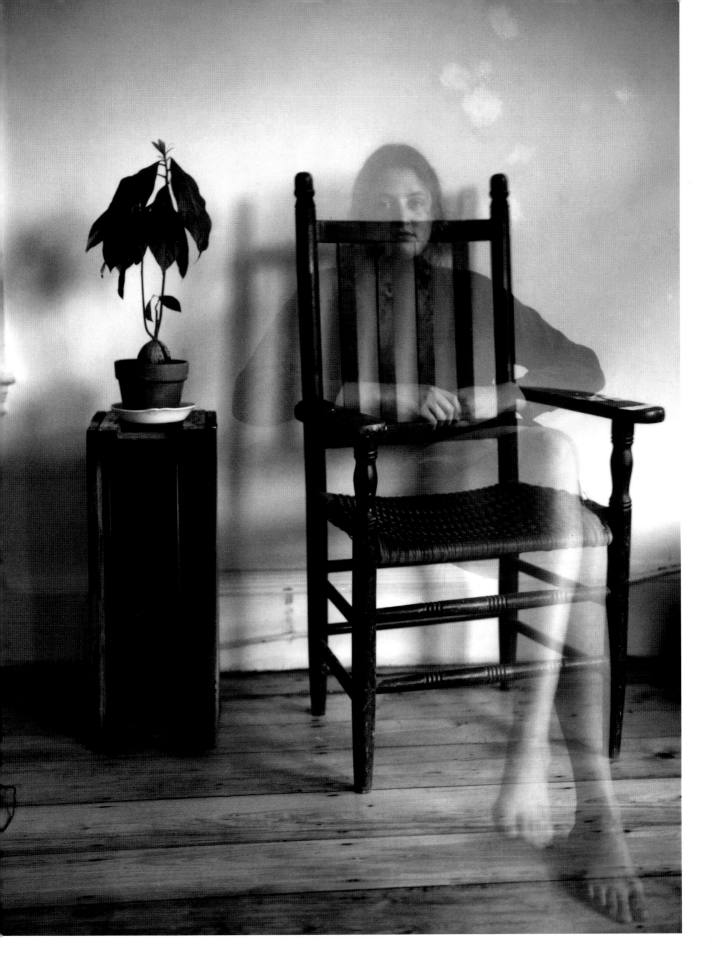

Contents

Director's Foreword

It would be hard to think of a photographer who better represents the link between the past and future of the International Center of Photography than Susan Meiselas. One of the leading American photographers of her generation, Susan emerged out of the tradition of socially engaged photography on which ICP was founded. But in over three decades of work she has gone on to challenge, question, and reinvent that tradition. After seeing her photographs of the insurrection in Nicaragua published throughout the international media, she created installations critically examining the use of photographs in magazines. She reanimated her photographs and provided a platform for photographic subjects to speak for themselves in films like *Pictures from a Revolution* (1991). More recently, she has employed new media, as in her web project *akaKURDISTAN*, to exponentially expand both audience and possibilities for participation and collective storytelling.

Susan has a long and close history with ICP. In 1983, we presented *El Salvador: Work of Thirty Photographers*, an exhibition Susan organized with Harry Mattison and twenty-eight other photographers who were covering the brutal civil war in El Salvador. ICP's founder Cornell Capa had himself photographed in El Salvador in the early 1970s, recording the poverty and injustice in that country that ultimately contributed to the outbreak of war. When Susan brought the El Salvador project to Cornell's attention, he saw in her work the reinvigoration of issues central to his own concerns. Then and now, Susan represented the possibilities for incisive, expansive, and conscientious documentary practice.

Through this publication and its accompanying exhibition, ICP is pleased and honored to present the first major in-depth look at Susan Meiselas's work. A project of this scope and ambition could not have been possible without the dedicated work of many people. First, our thanks go to Susan herself, who has willingly joined with us in this important collaborative undertaking. She has been a wonderful partner at every point in this process, and we thank her for this opportunity. Associate curator Kristen Lubben conceived this exhibition and guided it through to completion. I am grateful for her expertise, and for her dedication to this important project.

The extraordinary and early support of Shell International B.V. allowed ICP to realize its vision for this exhibition and the accompanying public programs. I extend very special thanks to our partners at Shell, especially Bjorn Edlund, Serge Giacomo, and Nathalie Graafland. This project would not have been possible without their support and involvement.

Several staff members at ICP were crucial to the success of this exhibition. Brian Wallis, director of exhibitions and chief curator, has been a champion and supporter throughout. The energetic commitment of Martine Neider, exhibitions assistant, was exemplary. Production manager Todd McDaniel and preparator Maanik Singh oversaw a complicated exhibition installation with characteristic skill, and registrar Barbara Woytowicz coordinated the movement of many works. We were honored to have the opportunity to work with designer Jeroen de Vries, whose contributions added greatly to the exhibition. Alicia Cheng and her colleagues at mgmt design managed exhibition graphics with care. The dedication of curatorial interns Claartje van Dijk, Jacob Garvelink, Miriam Grotte, and Darcie La Farge was essential, as was the support of studio assistant Elizabeth Moy. Public programming is a central component of this exhibition, which would not have been possible without the hard work of Phil Block, deputy director for programs, and Suzanne Nicholas, associate director of education. The efforts of former deputy director for external affairs Evan Kingsley were important in garnering the support necessary to realize this project, the completion of which was skillfully handled by Barbara Perlov and Marie Spiller.

This publication was expertly guided by director of publications Philomena Mariani. She has handled all aspects of this project, including editing of the texts, with deep commitment and intelligence. She was aided by the capable managing editor Eli Spindel. We deeply appreciate the generous engagement of Bethany Johns with this project, and thank her for the beautiful design of the book. Authors Caroline Brothers, Elizabeth Edwards, David Levi Strauss, Lucy Lippard, Abigail Solomon-Godeau, and Diana Taylor made major contributions through their original essays, and we thank them. For permission to reprint their texts, we are grateful to Edmundo Desnoes, Allan Sekula, and Hermione Harris, widow of Marc Karlin. Imaging technician Christopher George scanned many of the photographs and magazines that appear in this book. As always, we thank our publishing partner Gerhard Steidl and his dedicated team.

ICP was pleased to have this opportunity, one of many over the years, to cooperate with our colleagues at Magnum Photos to show work that represents our common purpose.

Willis E. Hartshorn
Ehrenkranz Director

Preface

Susan Meiselas is best known for her committed coverage of political conflicts in Nicaragua and El Salvador during the 1970s and '80s. Subsequently, she has explored issues of nationalism and identity through the revisiting of her own earlier subjects and through the collection and interpretation of historical photographs and texts. As a result, the complicated trajectory of Meiselas's career has sometimes been reduced to a simplified narrative: a war photographer who rejects traditional photojournalism and puts down her camera in favor of mining found imagery and promoting the work of other photographers. However, a closer examination of her work shows that, from her earliest projects to her most recent, Meiselas has consistently interrogated and expanded the documentary tradition, and has fueled cross-disciplinary dialogue between anthropologists, human rights workers, and critical theorists working toward a new understanding of the role of photographs in constructing histories and communities.

The contested function of documentary practice has been central to debates in photography since the 1970s. Critics from Susan Sontag to Martha Rosler have challenged photography's depictions of violence and victimization, claims of objectivity, and reliance on text or other mediating information. Perhaps no other photographer has so closely and consistently mirrored and participated in these debates than Susan Meiselas. She has grappled with pivotal questions about her relationship to her subjects, the use and circulation of her images in the media, and the relationship of images to history and memory. Her insistent engagement with these concerns has positioned her as a leading voice in the debate on documentary practice, one of the most critical topics in contemporary photography.

It is important to see Meiselas's photographs not in art, but in history. The Cuban writer Edmundo Desnoes called attention to this primary aim of Meiselas's photographs in 1985. But his observation takes on further layers of meaning in light of Meiselas's work as it has evolved over three decades. Her sustained engagement with her subjects and her exploration of projects that rely as much on found images as her own output often mean that Meiselas embeds her own photographs within larger histories. Her photographs are, therefore, not static but active: their meanings and uses change over time, and they are reanimated by reuse and expanded by the inclusion of other voices and images. Rather than individual photographic images fixed in time, Meiselas's works are sprawling and stimulating projects that set in motion ideas and concerns relating to a mutable collection of pictures and texts.

Susan Meiselas: In History accompanies an exhibition of the same title, which focuses on three of Meiselas's central bodies of work. The book, however, expands outward from those projects into three thematic chapters that explore the changes in Meiselas's approach. Chapter 1, covering the years 1971–78, looks at Meiselas's early black-and-white portraiture and documentary projects, which demonstrate an emphasis on finding ways to include subjects in their own representation. The second chapter, spanning the years 1978–2004, tracks Meiselas's entry into the world of the international media and her attempts to navigate the opportunities and challenges it presented as she committed herself fully to a decade of work on Latin American politics. The third and final grouping focuses on Meiselas's archival projects, from 1991 to the present, in which her own photographs are set into a larger examination of the relationships between power and representation.

Most often, it is writers and critics who define the terms of the debate around visual representation. In order to invert that paradigm, and foreground the ideas of an exceptionally thoughtful practioner, the central text in this volume is an extended interview with Meiselas. In addition to that interview, this reader collects new and reprinted writings by some of the many thinkers who have engaged with Meiselas's work over the past three decades. I extend my

deep thanks to these writers, who have contributed significant essays on a range of critical issues raised by her practice; this volume owes much to the richness and variety of their work. In the first chapter, Abigail Solomon-Godeau positions the *Carnival Strippers* photographs within the political and cultural context of representations of labor and women in the 1970s in contrast to the present, and proposes a nuanced reading of photographic voyeurism. Caroline Brothers's essay ranges over three decades of work to draw out the continuity of Meiselas's concern with return and repatriation. The intimate and essential (but often suspect) act of storytelling is at the core of documentary practice, as David Levi Strauss reveals in both the subject and form of his contemplative text. In chapter 2, Lucy Lippard draws on her three decades at the center of art and progressive politics in an essay about Meiselas's work in Nicaragua and El Salvador and the possibilities for political action within arts communities. In his film *Voyages* (1985), Marc Karlin beautifully captured Meiselas's process of questioning the role and utility of her images from Nicaragua; we have included a transcript of the film. "The Death System," by Edmundo Desnoes, offers a powerful reading of how Meiselas's photographs of dead bodies signify differently in North and South America. From the field of performance studies, Diana Taylor focuses on Meiselas's recent project *Reframing History* (2004) to examine how the Nicaragua photographs become actors within a collective project of historical memory. In chapter 3, Elizabeth Edwards explores the interrelationships of visual and textual documents—and the material lives of photographs—in Meiselas's books *Kurdistan: In the Shadow of History* and *Encounters with the Dani*. The final text in the book is Allan Sekula's study of Meiselas's archival work on the Kurds, which relates that project to the larger topic of the intersections of representation and national identity. His essay concludes with a fitting coda for the book: "Thus she begins . . . with the sense that where bodies are buried in secret there must also be a buried archive. . . . An archive, but not an atlas: the point here is not to take the world upon one's shoulders, but to crouch down to the earth, and dig."

Like much of Meiselas's work, this book was a deeply collaborative effort, a product of the dedication and commitment of many people. First among these is Susan herself. I could not have hoped for a partner who was more open and engaged at every stage of the process, or for a subject whose work was so consistently rewarding. Supporting our efforts was our skillful and committed editor and publications director Philomena Mariani. The range of disparate texts, images, and documents were transformed into a beautiful and characteristically intelligent design by Bethany Johns. The dedication of exhibitions assistant Martine Neider, initiative of curatorial intern Claartje van Dijk, and steady hand of studio assistant Elizabeth Moy were all invaluable. Brian Wallis, chief curator and director of exhibitions, was an early supporter of this project and provided essential guidance and encouragement throughout.

I am grateful for the support and friendship of several colleagues during the making of this book and its accompanying exhibition: Christopher Phillips, Edward Earle, Carol Squiers, Erin Barnett, Okwui Enwezor, Cynthia Young, Todd McDaniel, Maanik Singh, Eli Spindel, Christopher George, Barbara Woytowicz, Evan Kingsley, Barbara Perlov, Phil Block, and Suzanne Nicholas. Outside of ICP, I extend my sincere thanks to Jeroen de Vries, Jacob Garvelink, Sylvia Wolf, Sally Stein, Aichen Lin, Miriam Grotte, Darcie La Farge, Joanna Lehan, and Kathryn Trotter.

Kristen Lubben
Associate Curator

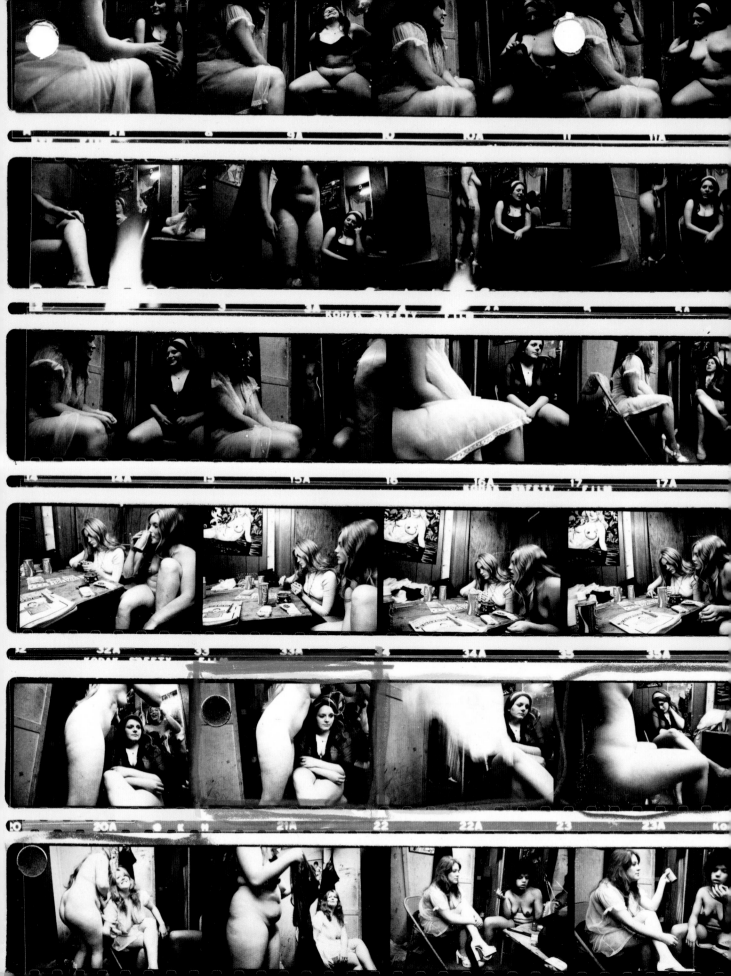

Chapter 1:

Community:
Portraits and Voices

1971–1978

i'm glad to have this picture as a record of the time i'm here...
for my life now, i don't want any othere distractions. i just want
to finish the thing i've come here to do...

barbara

as t my photograph, it looks too much like me...i must say that the
eye of a camera is remoreeless--the detail of my clutter does not
<u>appear</u> as cozy as it <u>feels</u> to live with

gil

i look overrelaxed in that picture, but it depicts me in a natural,
authentic posture. i'm not a sad person.

ellen

this person obviously cannot order herelf into a paragraph...
my room sometimes frightens me, there is ~~nothing~~ potential but
nothing actual...

michael

if i don't have anything interesting to say, i won't say anything
at all, and i don't...can you read the files;draws?...oh they're
just labeled 'truth' and 'knowledge'...

eddie

An interview with Susan Meiselas

by Kristen Lubben

(The interview continues on pages 115 and 239)

becky

— edda
— darrell
— seymour
— jean

nothing
john
eddie

Beginnings

KL: What were your first experiences of taking pictures?

SM: I don't have a specific memory related to my beginning interest in photography. My father was a doctor who took some pictures on family trips, but relatively few. I do remember processing black-and-white film in his little examining room in the back of our house. And I borrowed his Argus for some of my first photographs. My cousin Elsa was more serious in her own photography. I remember visiting as a teenager and watching her develop film in the laundry room while doing her family's wash. She was commissioned to do children's portraits and would produce beautiful little books for her clients. I did art throughout my early life. There was a sculpture teacher in our town with whom I did afterschool classes, and my sister and I traveled often to New York to museums—especially MoMA—and galleries with my parents. My uncle Alan was the manager of the Stable Gallery throughout that time, and so we often went to openings (shows of Robert Indiana, Andy Warhol, Marisol, etc.). My father's collecting brought me into artists' studios and brought art into our home—both were important to me when I was growing up.

KL: Were you an avid reader of *Life* or other photo magazines?

SM: I certainly saw *Life* and *Look* magazines regularly, and I remember looking at the catalogue of the *Family of Man* exhibition at MoMA, but I don't have any strong memories of the impact those publications had on me.

During my third year at Sarah Lawrence, I had an extraordinary experience through a travel and study abroad program called the IHP [International Honors Program]. We started in Japan and traveled to eight countries, staying with host families. This was very important in terms of exposing me to "there is a world out there." And yes, I had a camera, and I did make images, and I was told by the professor who accompanied us that photographs don't stand in for words. But every time we had to write a paper, my inclination was to complement it with photographs. To make photo-essays, in fact, believing that "a picture is worth a thousand words." He would simply respond, "No, it isn't."

44 Irving Street (1971)

KL: After Sarah Lawrence, you went to Harvard, where you studied education, rather than photography.

SM: Yes, I was in the Graduate School of Education. They had a program in "visual education" which meant that I could take a photography course at the Carpenter Center. I took a class with Barbara [Bobbi] Norfleet and Len Gittleman. Len came out of the Institute of Design in Chicago. Bobbi had worked with the sociologist David Riesman [author of *The Lonely Crowd*] and had become interested in photography through that connection. Peter Galassi was in that class. Sally Stein came to Harvard that summer, to study with Arthur Siegel [director of the Institute of Design in Chicago]. I took another class with Siegel that summer.

KL: So it was a real community of people thinking about photographs.

SM: *Beginning* to think about photographs. And that class was certainly influenced by Bobbi's sociological perspective. Len was a formalist with very strong training in the technique of photography. So, we started off with 4 x 5, which is what led me to the *44 Irving Street* project, in which I made portraits of fellow residents in my Cambridge boarding house.

I was interested in the idea of a place, that boarding house, where people didn't know each other because their doors were always closed. They shared a kitchen, they shared bathrooms, and that was it. People came and went. I didn't know what else anybody did in that boarding house. I didn't have a real relationship with any of them. So it was extremely difficult in the beginning to knock on someone's door and justify making an image. I felt awkward, as if I were trespassing.

KL: Even though this was in your own house, essentially.

SM: Still, the anxiety was tremendous. Right from the beginning, I was questioning the process. Why am I making a picture? Who is it for? What purpose does it serve? It's an entirely different process from commercial photography, where people come into a studio and want a picture made. I remember wanting to work with the 4 x 5 because they could walk over to the viewfinder and see what I was

Left: Texts to accompany portraits from the series *44 Irving Street*, 1971.
Previous page: Contact sheet from the series *Carnival Strippers*, 1975.

framing. One girl, Joan, put a guitar in the picture because she wanted to make sure the photograph included something that was important to her. It was a collaborative portrait in a way.

KL: You asked each subject to write a text to accompany their portrait. Did you decide to do this at the outset of the project, before starting to photograph?

SM: No, I made a contact print, brought it back to them, and that's what opened up the discussion. "That's interesting. That doesn't really look like me." "Oh, it doesn't? Well, tell me more, tell me how you're different from how the camera sees you." When I showed the project at the end of that term, I presented it with their text and the image. And I presented myself also in this ghostlike image, because I felt I belonged there, but I wasn't sure how. That's how I chose to represent myself.

KL: Did this project lead you to want to explore those ideas further?

SM: I liked the structure of it; both the 4 x 5 format and the limits of this one building. You know, these were the glory days of Friedlander and Winogrand, and it seemed everyone else was out on the street taking pictures.

KL: And that approach never appealed to you?

SM: No. This was also right at the time that Larry Clark's *Tulsa* and Danny Lyon's *Bikeriders* came out. And I was much more drawn to that approach. You know, there's something about even the physical space that links people, and draws a circle, or a community, which has a kind of narrative potential. And, of course, there was Diane Arbus. When looking at her work, I remember thinking that each image was the beginning of a story. It was one moment of an encounter, of a relationship. I always wanted to know more—Who is that giant? What is it like to be a giant?

KL: Had it been you, you would have followed him to work and then home? Turned it into a photo-story rather than a single, iconic image?

SM: Yes. Arbus was able to capture his world in that one moment with his family. It's a powerful photograph, but I wanted to see more of the life behind it.

Carnival Strippers (1972–75)

KL: In 1972, you started photographing women who worked as strippers in itinerant carnivals, published in the 1976 book *Carnival Strippers*.

SM: For the most part, my photography in the early 1970s was very localized documentary work. Photographing in my neighborhood, or venturing to the South Bronx (where I was already teaching) or the U.S. South—these projects were all about finding a way to make photography that made sense for me. *Carnival Strippers* was the turning point. The smaller projects preceding *Strippers* were about exploring ways of making photographs, and they were mostly portraits.

KL: What was your particular interest in these women?

SM: In 1972, Dick [filmmaker Richard P. Rogers, Meiselas's partner] and I spent our first summer together and wanted to take a road trip. We decided to follow small circuses in the Midwest and ended up at state fairs and then carnivals in New England. I wasn't looking for the girl shows, until I found them. It was the context of the times, for one thing. One of the debates of the early women's movement was whether or not to make oneself into an object to attract men—and here I saw women displaying their sexuality so publicly. So how could I not be curious about them?

KL: The photographs backstage are so intimate, showing the women with their guard down. It is clear that they came to feel very comfortable around you. How did you gain their trust?

SM: The work was done over three summers, each one building off the last. The first year I photographed on the fairgrounds, like everyone else walking by and watching. When I decided to return the second summer and follow the full route of the show, starting in Maine, I began to forge relationships and eventually it was through the women's invitations that the managers allowed me into the dressing rooms. Each weekend some girls rotated out, but enough of them—or at least one—would feel comfortable enough to invite me inside. The classic fly-on-the-wall approach. Not intervening. I'm sure the girls were very aware of my presence, but I felt invisible. Unlike in *44 Irving Street*, where I was using a tripod, I shot these photographs with a handheld Leica, no flash. Much of the conversations I collected were overheard, not direct interviews—whether between the managers and the girls,

or the clients and the girls, or the girls among themselves. The weeks of being with them, changing locations each week, setting up the show, enduring long rainy nights, hoping there would be an audience, standing by them in difficult moments—all were factors in gaining their trust. In fact, the managers posed the greatest obstacle. They were suspicious that I was trying to close them down.

KL: Were the women interested in your work?

SM: They were sort of intrigued. Those who were around saw the contact sheets and that was a big thing. I did the straight portraits at their request because the work of the show itself was less interesting to them. Only a few of the women didn't want to be photographed.

KL: How did the men in the audience respond to you while you were photographing them and the women onstage?

SM: Their minds were elsewhere. I doubt they even noticed me.

KL: What was your initial perception of the carnival strippers? That they were exploited women, abused women, without alternatives . . .?

SM: I don't think I started with the assumption that they were victims, I started with a much more open frame, one of fascination. When I saw a woman standing on a ticket box, which looked like an auction block, I said: How can this woman do that? How does she feel about what she is doing?

I learned that these women were poor, from small towns with few options. Hearing about their lives and their choices from the women themselves, I came to understand my own kind of privilege, something I hadn't even considered before. I was struck also by the comfort level they had with themselves and their bodies that I didn't yet have. I was a tomboy and had a physical sense of myself as an athlete, but their physical assuredness and sexual expressiveness was very striking.

Through the women I was also able to explore the men. You can hear it in some of the tapes. I'm talking to a man, with Shortie sitting there, and he's saying that he thinks the women do it for money. And she responds, "No, I enjoy my job."

At the time I was taking those pictures, "women's lib" was at the forefront of contemporary consciousness. And what was women's lib? Women being able to do what they wanted to do. Even if it was in a kind of crude way,

these women were doing what they wanted to do. It wasn't like women who were trafficked, which represents complete disempowerment. The carnival strippers were making tradeoffs, doing what they had to do in order to be able to do something else, or so they described it. It was surprising, their willingness to acknowledge that they were being exploited, but had some other purpose in mind. Like Ginger, who was saving up for college. This is what she was doing to be able to go to college. There really wasn't room for that kind of subtlety in the feminist discussion at the time. That was what I wanted to give texture to. I wanted the women to speak for themselves. There was also the class dimension. I was never confronted with having to do anything I didn't want to do, and I felt that class difference—between my own middle-class background and these lower-working-class women— very acutely.

KL: Were the women involved in the making of the book?

SM: I processed the film weekly so that they could see the contact sheets if they returned to the show or if I could find the show when it traveled to the next spot. So they saw essentially what I was shooting, but they didn't really participate in the making of the book. They knew I was recording them, but the selection and editing process was done elsewhere. It began with transcribing a hundred and fifty hours of tape, then creating a textual narrative and weaving that together with the visual narrative.

I remember Coffee saying, "Gee, if you had told me that you were going to do a book, maybe I would have told you more." Well, I didn't know quite what the book was going to be or how it was going to look. The work had been seen in a few exhibits, and I had a box of prints, which I used to get other small jobs. In 1975, when I was no longer teaching in just one classroom, I tried to get work as a photographer, which I didn't quite know how to do. And *Strippers* was all I had.

South Carolina: Porch Portraits and Lando (1974–75)

KL: Almost all of your early work is portraiture. Did you see it as a way around the prevalence of street photography at the time, a way to have a greater connection with your subject than random encounters on the street would allow?

SM: But portraits aren't necessarily an expression of a sustained relationship, either. Portraits are encounters, often awkward and limited in time. This accurately characterizes many of my photographs of the 1970s, whether taken in the South (the *Porch* series) or wandering around New York or shooting at the state fairs.

One of the books I most remember from that period is Bruce Davidson's *East 100th Street* (1970). I was very moved by it, partly because he was making portraits in people's homes! I loved the idea, the concept of it. I was astounded by the intimacy of the photographs. Women naked on the bed, but comfortable with themselves. I was impressed by that. But I was startled by the fact that when the Museum of Modern Art did a show of *East 100th Street*, they didn't invite people from the neighborhood. Now, Bruce may well have brought photographs back to people, I have no idea. But I was shocked that the opening didn't include the subjects because by that time I was so sensitized to the issue of, not just gifting the work back to people, but also who the work was for. This is still a potent question for me.

KL: Another criticism of *East 100th Street* was also leveled at *Carnival Strippers*, namely that taking such intimate pictures constituted a further exploitation and victimization of people who were already on the fringe. Is that something you were wary of?

SM: I don't remember feeling that Davidson's subjects were exploited. I remember feeling that work to be largely participatory. I felt the subjects' invitation to him, their openness to him.

KL: But the relationship between subject and photographer isn't a completely equal one.

SM: Of course not. But a white man comes into this neighborhood and people are accepting enough to bring him into their homes. There's a kind of sincerity in that exchange. Of course, the inherent two-sidedness of the behind-the-camera and in-front-of-the-camera relationship is something I think those images do reflect, in various coded ways. But what leads to the photograph, to a woman sitting naked on a bed with her child? Who asks that question? Who's gone back to that woman and asked her? You know, it's very simple to suggest that there is a victim without knowing how she in fact felt then. I don't think she would have done that as a performance for the camera if she weren't fully comfortable. I don't think it works that way. Unless subjects are paid to pose.

KL: You had already begun the carnival strippers project when you became an artist-in-residence with the South Carolina and Mississippi arts commissions in 1973, which led to the *Porch Portraits* series and the Lando project. Photographing the girl shows was an incredibly intimate experience of portraiture, getting to know your subjects, taking these intimate pictures . . .

SM: . . . and feeling *confident* about it. The *Porch* series was, among other things, another exercise in gaining confidence with photographing strangers. Again I was starting from scratch. And when you start from scratch, you experience this inhibition about invading people's territory. I was constantly asking myself, "What am I doing here?" and answering in the negative—"I don't belong here."

I could justify to myself that as a teacher in the local school, I had a reason for going down these back roads trying to find out where the kids lived. On the other hand, I could have just asked the kids directly in the classroom to visit their homes, but I wasn't confident enough to do so.

KL: Who were these kids? What was the demographic of the school population?

SM: Kingstree was principally black and very poor. I remember saying to somebody, "I'm teaching kids photography and they don't have running water at home."

I would drive down a road, see a house, stop my car, and hope that someone would open the door and come outside. I had no idea what I'd say to them. Or I would see someone cooking with a big pot in the middle of their yard, or carrying sticks along the road, or I would see kids sitting on a porch. And a conversation would begin with the fact that I was teaching in the local school and that I came from the North. Then I would begin an exchange that involved taking their picture and later sending them the photograph. That was important.

KL: For you or for them?

SM: I've always felt uncomfortable about taking something away without reciprocating. In allowing one's picture to be taken, someone is consenting to be a subject. And what am I giving in return? It's a form of exchange as well as a feeling of photography being a wonderful gift.

KL: Most of those portraits were isolated encounters, but some led into a larger community event that you organized.

SM: I don't remember exactly when I came upon Lando, but I was intrigued by this small town around a cotton mill which had already been closed down. At some point I met the local preacher and proposed to do a project with teenagers who were linked to the local church with the idea of gathering an oral and visual history with them.

KL: So the Lando project evolved from an educational or community organizing initiative engaging kids in local history?

SM: It was a celebration of their community organized as part of the Bicentennial. I taught the kids how to make pictures of their families and neighbors using Polaroids. They would photograph and then collect stories of how families had originally come to Lando, who in the family had left Lando, and what had happened to them. Then we started collecting family photographs. Somewhere along the way I had this idea of a visual genealogy that would track the people who had stayed in Lando over multiple generations.

The show was held in a small community center. The photographs were hung around the pool tables and on the walls, and we brought the oral histories together into listening stations.

KL: Did you include your own work in the show? Portraits you had taken when driving around?

SM: I don't think so. It was really a collecting and teaching project.

KL: You've never published the Lando project, but it clearly contains the seeds of elements that later became integral to your work.

SM: I wasn't consciously thinking about Lando when I went to Kurdistan thirty years later and began collecting family photographs and oral histories. That was such a different time in my life. But I see the relationship now and I'm astonished by it.

Learn to See (1974)

SM: After graduating from Harvard in 1971, I went to New York to work with a former teacher of mine from Sarah Lawrence who created the Community Resources Institute. She had hired me to explore ways in which visual media could be integrated into the classroom. I taught photography and cut-out animation to kids in the South Bronx and began to explore the use of photography as a pedagogical tool. I taught students in an experimental "open classroom"—which included fourth, fifth, and sixth graders. I began with how to make pinhole cameras out of shoeboxes. We would go out into the neighborhood to take photographs, then bring the pictures back to the classroom, where the students would tell me the stories around the photographs they'd taken and I would write them down. They would then learn to read their own stories. It was a very intuitive method for stimulating basic reading, while developing ideas of visual literacy.

I recently heard from someone who had been a student in that classroom. I had often wondered what had happened to those kids and what the experience had given them. I certainly didn't think any of them had become photographers. This young boy (now a man), Richie, talked about how photography had strengthened his connection to community. He remembered leaving the Bronx on the Third Avenue El and entering Manhattan—with the camera—as a very vivid experience. I think I made a similar kind of connection myself in that classroom—linking to the world through photography. Or finding a reason to be in the world. A reason to be curious about the world. That experience taught me a way to engage.

Prince Street Girls (1976–78)

SM: *Prince Street Girls* began in an incidental way. I'd moved to Mott Street in Little Italy. One day I was riding my bicycle down Prince Street in the same neighborhood and the sun was glaring in my eyes, and I realized that a group of girls who lived on the block were using a little mirror to focus the sun onto me as I rode by.

KL: Was it that you were the big girl and they wanted your attention?

SM: I was the big girl, I didn't belong in their neighborhood, I wasn't Italian. And I lived in this building of artists, a former vocational training school gifted to the Italian community by John Jacob Astor's wife.

I called these kids the "Prince Street Girls" because they were told by their parents that they had to stay on Prince Street. I'm a half block away from Prince, so I'm within the radius of where they're allowed to be. These were kids who were pretty well watched because everyone in the community knew each other. Their curiosity about me is what brought me to notice them in a sense. But that led to

an extended relationship. I'd see them when I went to the supermarket, I'd see them hanging out, I'd meet their mothers. They were just very present.

Perhaps I was drawn to the expressiveness of girls beginning to understand their bodies. The pictures I love the most are the ones in which the girls are . . . what's the word . . .

KL: Beginning to own their bodies . . .

SM: Yes, they're beginning to own their bodies. I love the ones where the girls are posturing and posing. Not so much for the camera, but for themselves and each other.

KL: The pictures also convey a combination of toughness and vulnerability in all of the girls. There's that sense of danger—think of the mean streets of New York in the 1970s—but also of possibility. The girls are tough, but they're still just tiny little girls in tube tops.

SM: Interestingly, I didn't photograph in the homes of the Prince Street Girls. They didn't invite me inside. I was their secret friend who had a kind of treehouse on the street that they could visit like a clubhouse. And that's how they saw me.

KL: They didn't want their mothers . . .

SM: . . . to know that they were hanging out with me, right. Their relationship with me was definitely sneaky. They would introduce me to their parents if I saw them together. But their parents didn't quite know what to make of me.

KL: Did the parents know that you were photographing the girls?

SM: Yes, because the girls had taken the photographs home. But no one ever said to me, "My mother doesn't want you to photograph me." I don't recall any girls *not* wanting to be photographed.

KL: It's a different moment. Can you imagine the response now to a person, stranger or otherwise, in the neighborhood taking pictures of the kids?

SM: Or parents knowing that their kids were hanging out in somebody's apartment. So the project characterizes something about that time.

Joining Magnum (1976)

KL: Were you still teaching at this time, or trying to establish yourself as a professional photographer? *Carnival Strippers* was published in 1976 accompanied by a few small exhibitions; that must have opened up some opportunities for you.

SM: I had stopped teaching but didn't really know how to get a job as a photographer. I had the photographs of the strippers, but no magazine wanted to publish them. The best thing that happened was that *Harper's* picture editor Sheila Wolf offered me my first job, after seeing the stripper pictures. She sent me to the Democratic Convention in 1976 to photograph the women delegates. That was where I met Gilles Peress, who was a member of Magnum Photos. Somewhere in conversation I mentioned *Strippers*, and he was curious to see my work. A week later, he and Burk Uzzle presented the *Strippers* pictures at the annual Magnum meeting in Paris. Shortly after that, I was invited to join the collective. The whole process happened very quickly and, frankly, my initial response was "Now what?"

KL: You had shopped your work around?

SM: Oh yes. *Ms.* wasn't interested in *Strippers*. Neither was *Esquire*, which was surprising because they had published so many of Arbus's photographs. Sheila Wolf was very important to me in that she was willing to give me a chance, to see what I might do. No one else did. And then through Magnum I began to meet other editors. Magnum had set up an appointment for me to meet John Loengard at *Life* magazine. I had no idea what *Life* would be interested in—I was shooting for myself, and my interests didn't always correspond to what publications considered "newsworthy." Loengard wasn't interested in the work that I showed him of the *Prince Street Girls*, but he suggested that I photograph a story on coeducation at Yale.

KL: So this was your first assignment for a major publication?

SM: It was one of them. Another was about women in the Army, which I proposed—published in *Newsday*. I was fascinated by the subject of women in basic training. Women were being trained by the Army and for the first time demanding active duty, though of course we've seen the results of that only recently, in the war with Iraq.

KL: As a member of Magnum, was there pressure for you to take newsworthy pictures? If you had decided that you wanted to continue photographing the Prince Street Girls for the rest of your life, would that have been okay?

SM: Yes. Certain kinds of documentary projects were very much a part of the Magnum landscape. Those initial days were not so news driven, or tied to writer-photographer partnerships. I worked the way I was used to working in documentary. There was Bruce Davidson doing personal projects and street photographers like Richard Kalvar. In America, some of us were working with a wonderful editor named Gary Hoenig, who had a very different idea about newspaper photography at the time. Gary worked at the *Week in Review* of the *New York Times*. He knew what the principle issues were and assumed that at some point he would need pictures for a story. So, for example, I was sent to photograph public city hospitals, without a writer, no "story," just the directive to look and capture the working conditions I saw.

Volunteers of America (1976–78)

KL: An early, little-known body of work is your series on transient men who dressed up as Santa Claus for charity fundraising. Like *Prince Street Girls*, it grew out of seren-dipitous encounters in your neighborhood.

SM: Early one morning, near my home and on my way to someplace else, I crossed paths with a Santa Claus.

Now, I don't usually make surrealistic images. Another photographer might have done that. And if I were a street photographer, I might have made a humorous photograph of the Santa Claus surrounded by other people in their work clothes, on the subway or in the street, and left it at that. But I wanted to know who this guy was. Where did he come from? Why was he in my neighborhood?

Then I discovered the Volunteers of America, just around the block from me. It was the organization behind the homeless men on Fifth Avenue who dressed as Santa Clauses to collect money for the shelter in my neighbor-hood. That linkage drew me in and kept me involved for a three-week period following these men daily between Thanksgiving and Christmas day, taking pictures and capturing their reflections. I wanted to deconstruct the man in a costume back to who he really was. I was behind the scenes as he was dressed to perform as "Santa" and then watched the reactions of people on the sidewalks. Most just walked past them, some made contributions,

but others had their children balance on Santa's knees, never of course imagining where these men had come from. I myself was devastated by the rawness of those men's lives, post-Christmas, again flat out on the street, homeless alcoholics. After the holiday season was over, I discovered that the men were shipped from the Bowery to detox upstate in an old women's prison facility.

Concerned Photography

KL: How does your early work—your roots in education and your exploratory documentary projects—carry through to where you are now?

SM: A week or so ago, I shot a series of photographs of migrants caught in Calais, on the northern coast of France, trying to sneak into the UK. I do work now almost exactly as I did then. I go to a region having read some background material but not knowing what I will find, or much about who the people really are, or what stories they will tell. That sense of the unknown roots me in the process, and the result is always beyond whatever I can imagine. The stories always take me somewhere, and I return feeling as if one more dot has been colored in. I have seen and understand the world more fully.

KL: "Colored in" for yourself, or is the important thing that you are able to bring that information back to others?

SM: For myself first. Whatever I convey to the rest of the world is, in a way, what I've learned later, after the fact. The point I'm trying to make here is that the camera creates a path for me to follow my instinct and curiosity.

KL: So you would say that your process is less about "concerned photography," reporting back to the rest of the world what you've discovered, and more about following your own curiosity?

SM: I think my own curiosity precedes the urge to inform or educate people. I don't start from the premise that a ter-rible thing is happening and I should photograph it so that people will become aware. Of course, I *have* discovered terrible things and wanted to tell people about them, but I set out from a different place. I didn't imagine a body on a hillside before I went to Nicaragua. I had no idea what I would encounter on that hillside.

KL: Why go, then?

SM: In the case of Nicaragua, because I was hearing about people beginning to organize against a dictator. I was interested in a people challenging the authority that had held them in place for many years. What sparked my interest in Nicaragua relates more to that than to a preconceived image of what I would find once I got there. I didn't envision guys running around with handkerchiefs over their faces in a full insurrection. But I could relate to the demonstrations and the protests and the students rising up against a dictatorship. Because that corresponded to my own experience in '68, marching on Washington and the Pentagon.

KL: Do you consider yourself a "concerned photographer"?

SM: There's a very subtle difference between going to a place because one is "concerned," and becoming "concerned" through the process of engagement.

KL: But you clearly have, perhaps not a plan *per se*, but predilections for certain types of investigations. You're not just blowing along with the breeze.

SM: No, but still, I don't go someplace with a goal in mind. Again, the goal arises and takes shape through active engagement.

KL: Let's set aside your own work for a moment and think about concerned photography as such. I doubt that any of the great concerned photographers woke up one morning and decided, "I think rural poverty is a problem and I'm going to find it and take pictures and show people." It's more likely that a photographer goes where an opportunity presents itself. In the process, she is educated about a particular issue and realizes that her pictures may raise awareness. Is this different from your process?

SM: Well, we have to be careful how we define "concerned photography." On one level, yes, I'm a concerned photographer—I'm interested in real people, their stories, representing them as best I can. That's the storyteller in me. And that storytelling aspect embodies a certain broad sense of concern—versus: I'm an artist who just wants to make my own photographs and put my name under them. So within that construct, yes, I work in the world of what one could broadly define as documentary and concerned photography.

KL: What is essential, though, to the idea of concerned photography is the notion that photographs can actually *do* something.

SM: But "do" is a small word that means many different things. Do. Telling the story of—is that doing enough?

KL: No, I think the promise it holds out is that photography can do more than "just" tell stories. That photography has a role to play in social change, social justice; it can lead to action or material change in people's lives.

SM: Was I thinking that if I photographed strippers I might be able to change the girl shows, get them closed down, for instance? No. I believed it was important for people to hear who these women were, how they saw their own lives. That was most interesting to me. Not whether or not the shows should be closed down. I was willing to be part of that debate, but *Strippers* was not intentionally produced in service of that debate.

KL: And people needed to hear these women's voices because they were presenting a different version of female independence?

SM: Not just female independence. It was just as important to me to hear what the men had to say about their need for sexuality in their lives. To hear about what their relationships didn't give them, what they felt these women, the strippers, somehow strangely did.

The key issue here is whether or not the work is produced in service to some agenda. Now, it's true that my later human rights work is very different. Perhaps it is more "concerned" than my documentary work from the early 1970s. What are my concerns with the Prince Street Girls? I'm just observing the transformation of these young women. The Santa Clauses presented a different but no less fascinating transformation. In these works, I am in the role of the storyteller of people's lives, but the work is also in service of a community—as opposed to an artist whose chief goal is to put her imprint on an image.

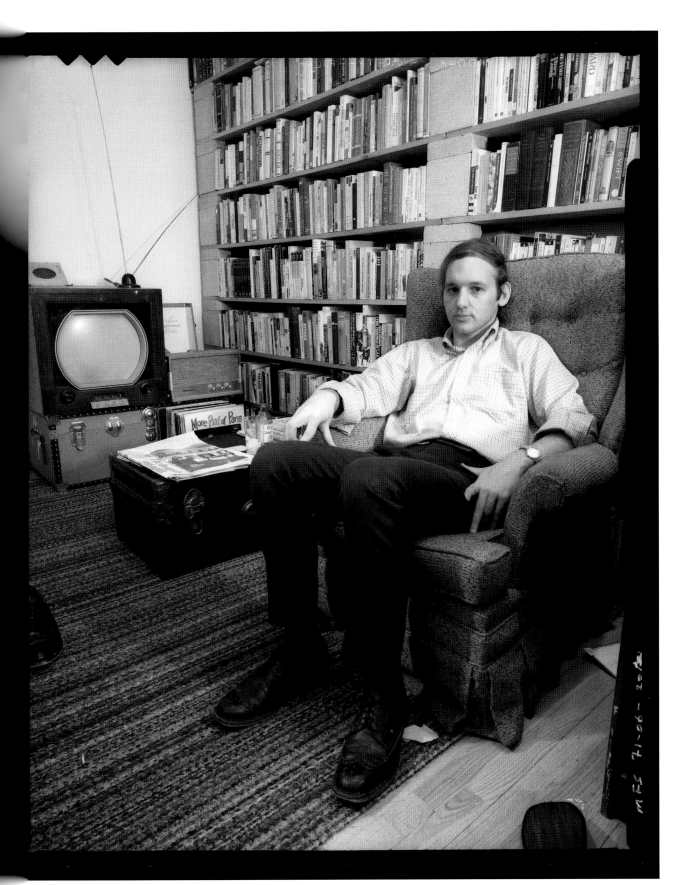

22

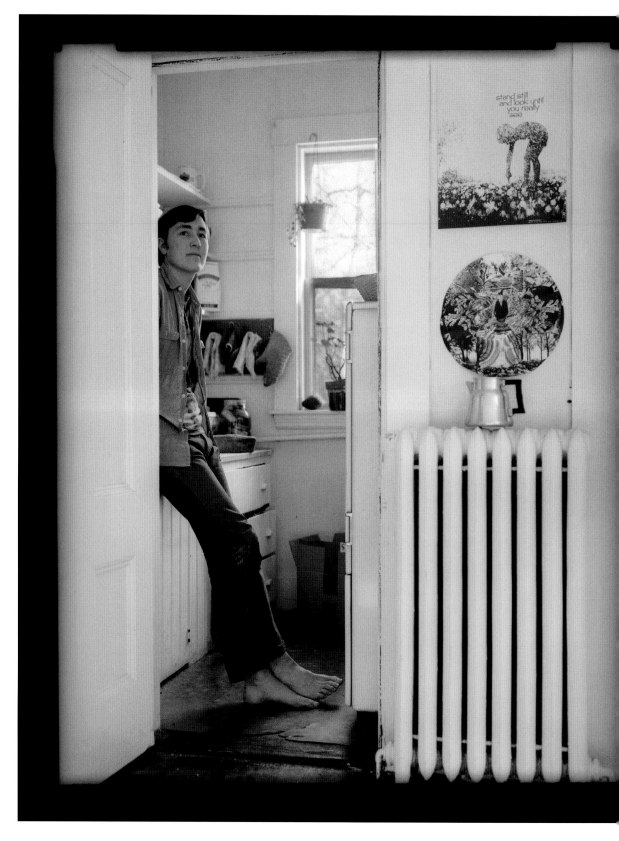

Previous page: *Gordon*, from the series *44 Irving Street*, 1971.

Above: *Don*, from the series *44 Irving Street*, 1971.
Right: *Hallway*, from the series *44 Irving Street*, 1971.

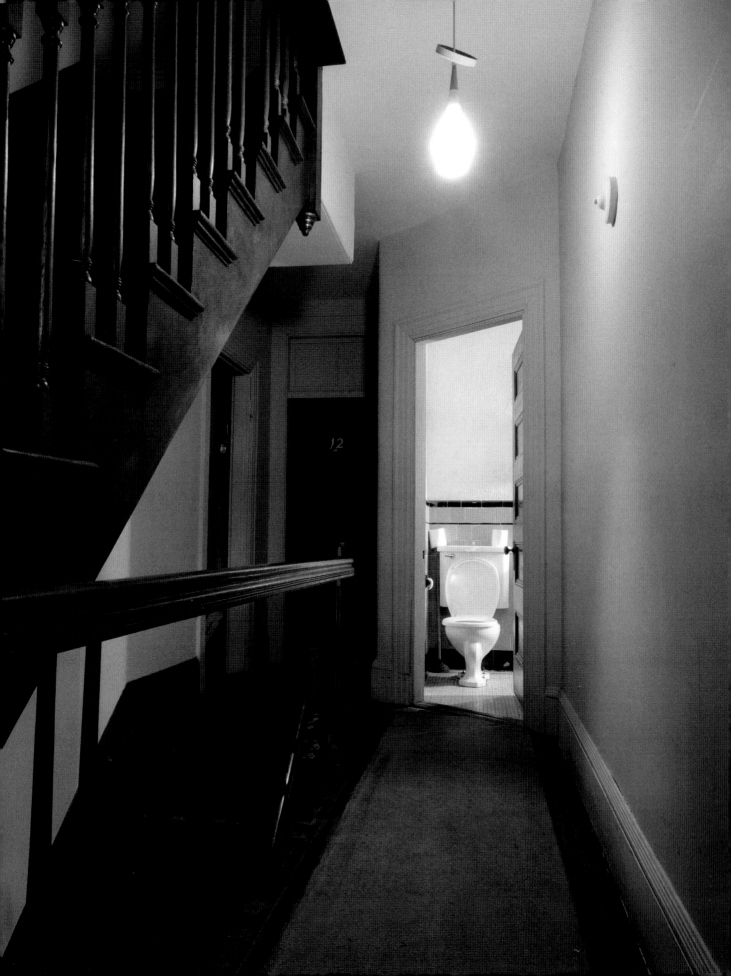

gordon

i wouldn't have chosen to live alone, i was forced to...that's the
way i am--somewhat distant, iget turned in on myself...
i look at this place as a way station. any place i was going to
stay in, i would try and create some stability . the books on those
shelves are not relevant to what i'm involved with now...did i shave
that day?

carol

this corner feels cocoon-like tome, i didn't know i could look like
that. i8d much rather have a picture where i'm doing something.
i have the capacity to withdraw from people and doing things and i
guess i don't like to see that...the room overshadows me...

haskel

this picture portrays the quiet meditative relaxed side of me...
the corner of the room portrayed here is the most organized and
least representative of my life...i distinctly remember trying to
appear matter-of-fact and as normal as possible...

don

i like
my picture, although rather stark and bleak, for it is a marked
contrast to the way about one-half of the people in my life perceive
me. i often find myself 'wearing the mask', getting caught up by the
mass of people hurrying in the morning, trying to get somewhere they reall
don't want to be, and then rushing home so they can try to forget about it
My company hired my degree, and i happened to come with it...my
apartment helps me move out of one world into another..."stand still
and look until you really see" shows the part of me that someday,
will be able to disconnect the other self and start living a fuller,
more complete life.

mike and alease

we are happy to be living among sociable folk ..this picture captures
us in a most relaxful mood which we find most necessary to take
advantage of whenever we can...

joan

i used to worry too much about my image...i look very serious and
quiet and contemplative...although i'm protective of myself i'm less
protectve than i used to be. i guess i feel that the people here
aren't so perfect and it makes me feel safer...here it looks more
like me when i was 12 and daydreamed alot. now i'm more energetic
and restless ...

sharif

i am divorced. the picture speaks for itself.

jane

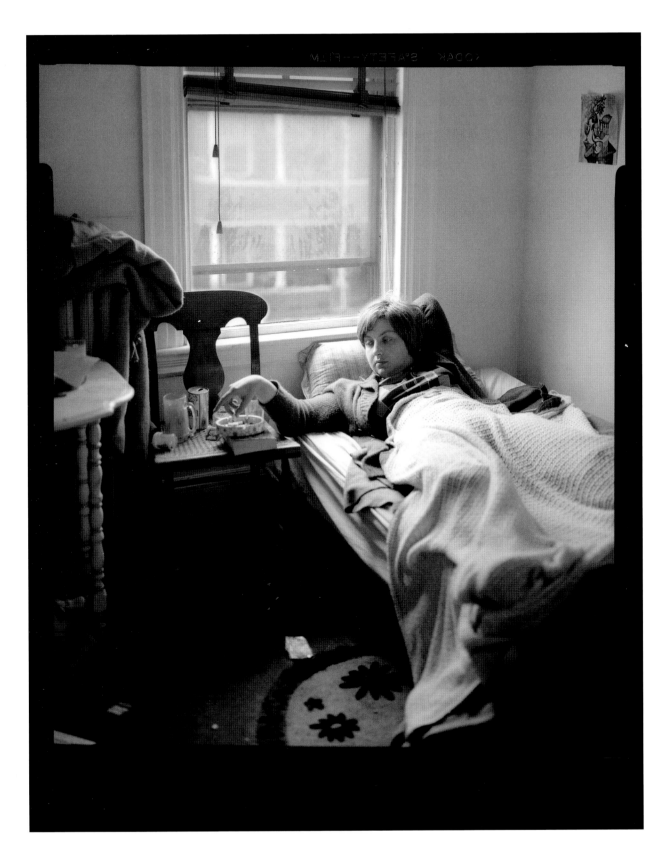

Above: *Ellen,* from the series *44 Irving Street,* 1971.
Left: Texts to accompany portraits from the series *44 Irving Street,* 1971.

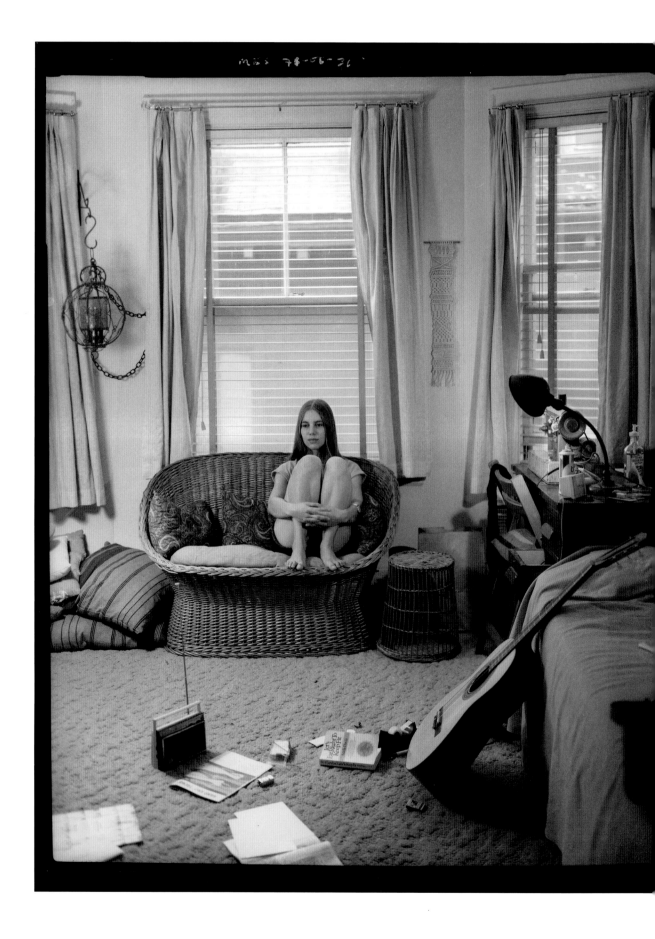

I like living at 44 Irving St. I think it's nicer than most rooming houses (no dirty old men). I like having people around + I also need lots of privacy which I can get by closing my door.

When you share an apartment with roommates you have too many obligations + this leads to hassles. I also like living in a male/female house. 44 Irving St. is such an interesting mish mash; It's a good cross-section of our luney-bin society.

I don't think the photo of me really gives the essence of me. In it I look very serious + quiet + contemplative. It looks more like me, when I was 12 + daydreamed a lot. Now I'm more energetic + restless.

Joan

Above: Letter accompanying portrait of Joan, from the series *44 Irving Street*, 1971.
Left: *Joan*, from the series *44 Irving Street*, 1971.

LEARN TO
SEE

A sourcebook of
photography projects
by teachers and students

Learn to See: A sourcebook of photography projects by teachers and students,
edited by Susan Meiselas (Cambridge, Mass.: Polaroid Foundation, 1974),
cover (above) and p. 26 (right).

FINGER PUPPETS

Individual and immediate reproductions of a
child's image are invaluable in reinforcing
the concept of self. If parents provide pictures
of all the family members, unlimited play
situations can stimulate creative dramatics,
emotional expressing, language develop-
ment and body/personal awareness. A photo
of the whole body or just a face can be pasted
to the tip of a finger or a glove.

26

Dorothie Wright
South Shore
Mental Health Center ●
Memorial School
Quincy, Mass.

PHOTO SWAP

Six children worked in teams of two; each team took three pictures. The teams kept one of their own photographs and exchanged one picture with the other two teams. They then wrote stories to link the photos together.

61

The telephone Pole is high over the ground. The wires on it ... of sound ... les on ... in ... res in ... e and ... protect ... it. The ... ratory. ... Then ... I sent ... chool

One day there were two girls name Donna and Mary Jo. They were playing in the Bushes when they found athing something with ahole in the middle of it. It was strang, They took it apart. But it did not help them They Put it back together. They touched it and it chick. It scard them, A pice of paper came out. They look at it, They could not belive it was Mary Jo picture. It was diffent than one of there drawing, It looked real, I didn't move, It felt smoth They could hold it and keep it forever.

Susan Meiselas
Riverview Elementary School ▲
Fort Mill, S.C.

Sam the dog

d

by Steven

PICTURE-LETTER FLASH CARD

For children who have problems with letter reversal, b-d; u-n; t-f; p-q; particular letter identification has been learned with the help of flash cards to reinforce letter-sound association. A flannel letter is added to each picture card for tactile reinforcement.

62

Tina Benhardt
Frolio School ●
Abington, Mass.

Learn to See: A sourcebook of photography projects by teachers and students, edited by Susan Meiselas (Cambridge, Mass.: Polaroid Foundation, 1974), pp. 61–62.

THREE-D MAP

A walk around the school block led a group
of students to make a 3-dimensional map
(and scale model) with various materials.
Cereal and match boxes edged the streets
in proportion to the buildings they repre-
sented. Photographs were taken of various
facades, then cut and pasted on to identify
their differences. Often clay, toothpicks, con-
struction paper, and fabric extended from the
photographs to give an added flavor of texture.

Susan Meiselas
C.S. 92 ▲
Bronx, New York

THREE GENERATIONS

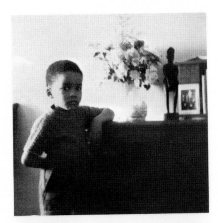

my grandson

my son, Junior

my husband, Harold

82

''I wonder if our grandchildren when they become adults as we are today, if they'll look back on the pictures we've taken today as we look back on pictures our grandparents took and whether they will think we're oddballs. ''

33

Bobbi Carrey
Housing for Senior Citizens ★
Putnam Square Apartments
Cambridge, Mass.
Photographs by Eleanor Hector

Learn to See: A sourcebook of photography projects by teachers and students,
edited by Susan Meiselas (Cambridge, Mass.: Polaroid Foundation, 1974), pp. 81–82.

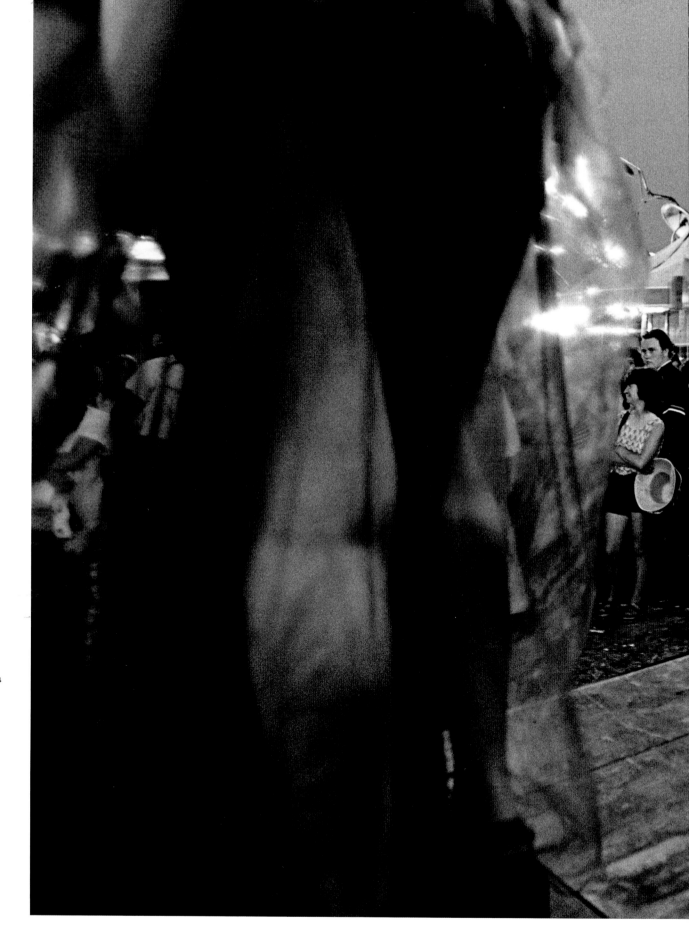

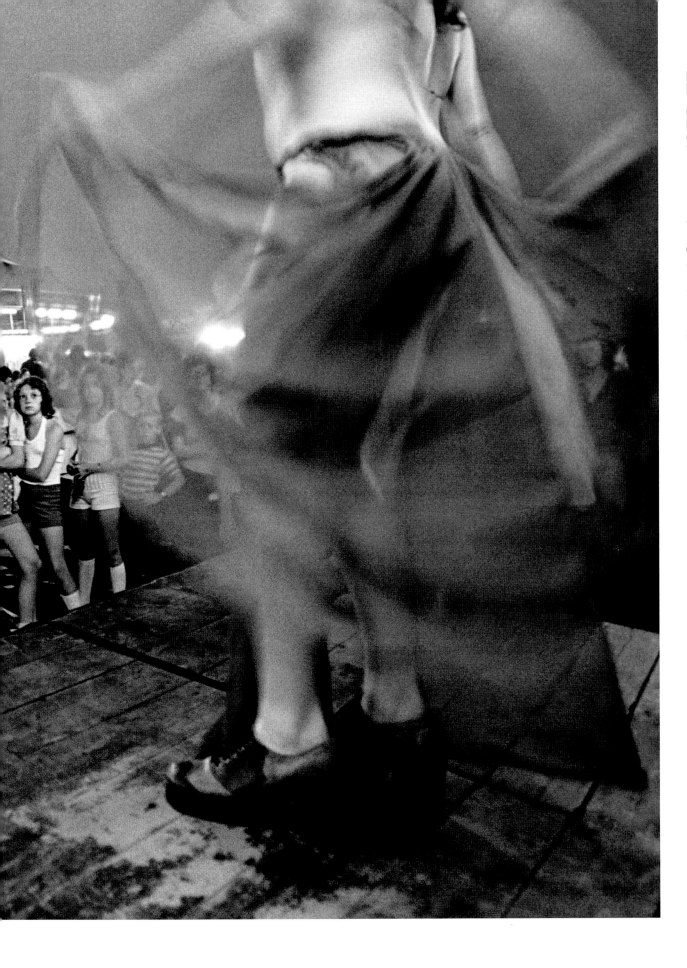

SUSAN MEISELAS

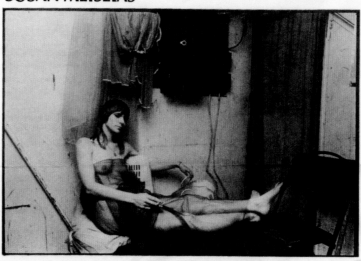

Carnival Strippers focuses on two women who work in a
girly show on a carnival midway. The photographs were
taken over six week period during the summer of 1973,
in which I followed the Club Flamingo from Northern New
England to South Carolina. The show is composed of women
aged 17 to 35 whose experience ranges from one week to
several years. A typical night is routine is made up of
a series of shows each beginning with a front stage bally,
to lure in the audience; progressing to the back stage
where each of three women singly strip and ending with a
grand finale with all three women nude on the stage
together. The all male audience traditionally includes
farmers, bankers, fathers and sons, "no ladies and no
babies". How "strong" a particular show plays depends
on the dynamic relationship with each audience. Toleration
of the "lunch counter" varies from town to town along the
the carnival circuit. At the end of each stand the truck
packs up, moves on, and the women follow. Night after
night ordinary space is transformed into a secret society.

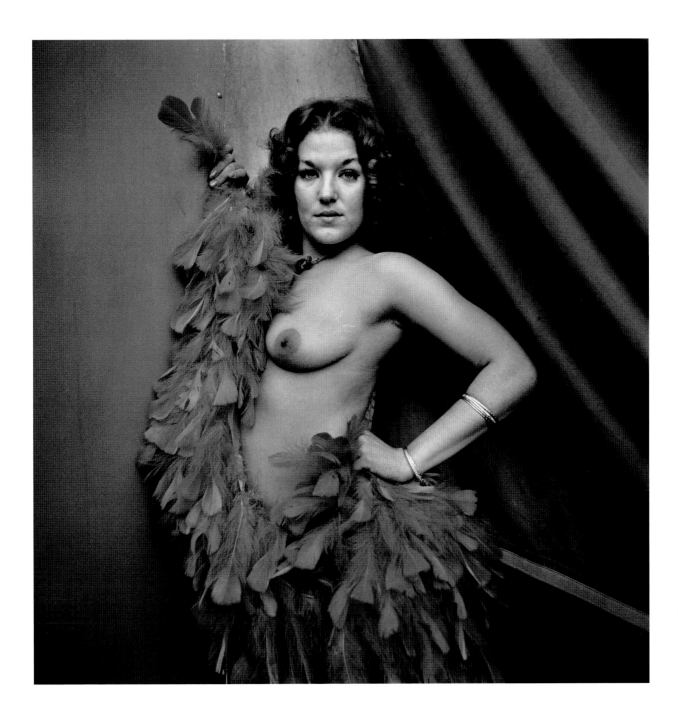

Above: *Mitzi, Tunbridge, Vermont*, 1974, from the series *Carnival Strippers*.
Left: Press release for an exhibition of *Carnival Strippers* at 218 Gallery in Memphis, Tennessee, 1974.
Previous page: *Teen Dream, Woodstock, Vermont*, 1973, from the series *Carnival Strippers*.

BALLY Call

Watch it! Watch it right now! Stop
the music! You're gonna see burlesque,
strip tease, hootchie kootchie, and
daddy-o, it's all the way. The show
starts right now...now's the time to go.
You can get right down front, right down
front if you go in now. Right down front
in the bald-headed row. Right down front
in the finger-lickin good row, where you
can look up and see the whole, i mean the
whole damn show. Let's go now! Time to
go...let's go to the hottest show in town,
we're starting in right now. Red, hot, a
and spicy. Hootchie kootchie, Carnival
style. Everything goes when the whistle
blows...

Girls. Girls. Girls...Candy. Now I'm
gonna tell you about Candy. Candy, her
dance makes the old feel young, and the
young go feelin. She's gonna give you
married guys something to go home and
fight about, you sailor guys'll walk the
street and sweat it out...

Right here's Troy. Zip it, zap it, Troy's
got more movements, more wiggles in her
body than a Singer sewing machine...and
tonight she'll use every wiggle, every
movement at the right place, at the right
time.

Then there's Tina. Now Tina, from the
shoulders up, nothin happened. Fron the
knee cap down, nothin happened. But bet-
ween the court house and the post offie,
have no fear, daddy o, the show is right
in here. She's gonna twitch it, twatch it,
so you can watch it. Shake it loose, like
a bucket of juice,...because she knows what
to do,...when to do it...and how to do it.

Now folks, we have some of your friends and
neighbors on the inside, waiting for the
show to begin. We can't keep them much
longer. This show is for the men, and the
men only,...no ladies and no babies. You
ladies out there, I'm sorry to say I can't
let you in to see the show. But do yourself
a favor, do your husband a favor. Buy your
husbands, your boyfriends, or someone else's
husband a ticket. Give him $2.25 and let him
come in to see the show. Because we guarantee

Above: Transcription of the Bally call, 1975.
Right: *The Managers, Essex Junction, Vermont*, 1974, from the series *Carnival Strippers*.

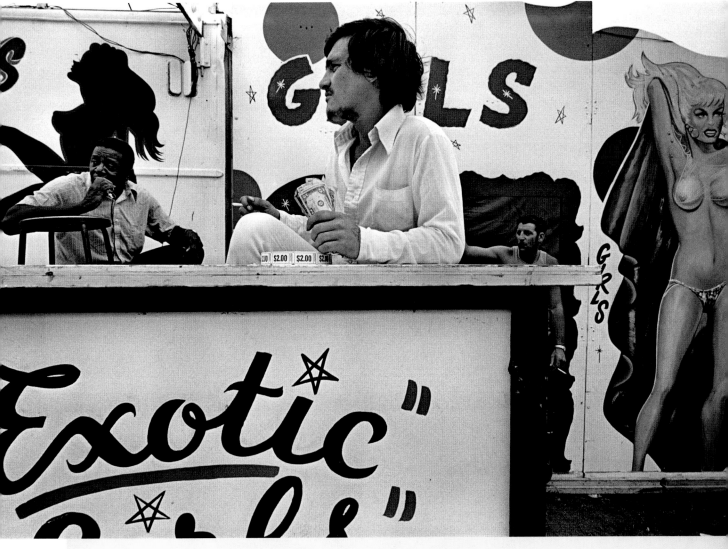

you, when he comes out of here tonight,
he won't go fishing no weekends. He's
gonna help you scrub the floors. Then
tomorrow he's gonna cut the grass, he's
gonna wash the dishes, and on top of
that, he's gonna teach you the hootchie
kootchie...all night long. Once they
see the show tonight, we're gonna charge
their battery, wind their clock, and
they're gonna put pepper in your pepper
box...

We're gonna send the girls back now fellas
it's getting near showtime. Don't be shy,
take your hands out of your pockets, take
your money out of your wallets...get a
little yellow ticket here...go on in the
inside...rest your elbows on the stage...
and look up into the whole, the whole god
damn show...

Showtime! Where they strip to please,
not to tease....

June 4, 1977

DEAR Susan,

Well, I made the Dean's List! I got 5 B's. I wasn't sure I'd make it and when when I got my grades I was so surprised, happy, & proud. I still can't quite believe it. We started the Lamaze classes last Wednesday. They run 5 wks, but according to Dr. Morrison I may not make all the classes. He has moved up the due date a week or more, so at most I've got 3-4 wks left and possibly less, anyway sometime before the end of June. The Doctor also says I'm positively going to have a girl! I've thought right along that I was going to have a girl. The classes are interesting and I think they'll help. The exercises are easy; all breathing and relaxing, though relaxing is pretty hard to do. Richard's Mother & Dad were up a few wks ago. I was nervous about them coming. His mother just has a way of making me feel uncomfortable. I don't think she much cares for me & if she knew I was a stripper once she'd hate me. She asked me how you & I met. I told her you were in Maine doing a story and I was there and that's how we met, not the truth altogether, but not a lie either. Oh, well if she knows, she knows. Anyway, they brought up a great many things for the baby and for us. Kathy, Rich's sister, sent a set of clothes and Mom Egan brought china & a tea pot along with a cradle and much things. The baby's room is all set up and ready. The only things left to get are bottles and a few things like baby powder, ect. My mother is feeling better now

We went to see Grampa a few days ago. His sister is up from Orlando for the summer. I think he feels a little better with her there. It takes so long, forever, to heal the hurt, and it makes me angry and hurt to see the pain in his eyes, and know that there is nothing I can do.

Now is your Mom? Doing well, I hope.

Do you think you will be coming up this way sometime soon? If you do let me know. Kathy sent up some wedding pictures she and Mike took. Some of them are pretty good. They didn't get a picture of us with my grand parents though, which is sad. Richard will call you when the baby is born. I wish you could come up. We both miss you. How is your work coming along? Did you see the play you were telling me about? Was it realistic and good? I wish I was an actress, then I could play one. That would probably be the hardest part to play, though. No one likes to "see" themselves as they appear to others, especially when that person sees how foolish they sometimes are. (Meaning me of cause.

I am starting a volunteer job Monday with the Juvenile probation office in Lincoln County. I can't wait to start. The experience I'll get will be priceless and helpfull. If I'm good at it they may hire me part-time next fall. I'm going back to school nights in the fall. I'll take psychology. I'd like to go full time, but that's impossible since I went more to

take care of our baby. Did I tell you that Louie & his wife had a baby girl? Louie's sister is in our Lamaze class. She wasn't really nasty, but she sure wasn't pleased either. George isn't around much lately. He's talking about not going back to school for his Senior year. I tried talking with him about it, but he thinks I'm crazy & pushy. I may be pushy, but I hate to see him mess up now. Lee Anna is living in Bath with Mickey. Oh, there are some pictures, good pictures of you at the reception. I finally have some of you. That's a switch! Well, I guess that's about all the news. Try not to work too hard (though you will anyway). Write when you get a chance. I miss you and wish you were closer. Maybe we'll see you soon. If we come to N.Y. we'll definitely see you. Take care.
Lots of love,
Lena

"Hi" Dick

June 10, 1977
Hi again. You should hear from us anytime now. The baby will be born in 1 wk, 2 wks, or today! We learned 5 more exercises in Lamaze. Our instructor showed us the labor and delivery room as we may not make it to the last class. Rich is sure he will be a father for Father's Day. Lately I've been very, very depressed. Everything Richard says gets to me. I feel he doesn't really love me and that he is totally

dissatisfied with me. A few days ago he said he was sorry we were married 'cause now he couldn't play with my sisters tits. Not a very nice thing. It hurt me a lot. He could have been "kidding", but he does wish he could take her to bed, or at least I think he does. Anyway, I feel inadequate. I wish I could change myself for him, but I can't, and I need so much for him to love me as I am. He says he does, but I really don't know. Maybe it's just my state of mind that makes me feel these things, but whatever it is I do feel very bad, hurt, & just plain terrible. You don't want to hear all this, I'm sure, so I won't burden you with anymore. Just feels better to be able to tell someone. Richard has gone off with some people, seems he's always gone. I don't say anything, don't want him to feel "tied down", but it would be nice to have him near now. Must admit I'm kinda scared & Gotta go, got a pie in the oven, write again, Lena

Above: Letter from Lena,
June 4–10, 1977.

Right, top: *Lena's first day, Essex Junction, Vermont*, 1973, from the series *Carnival Strippers*.
Right, bottom: *Lena, third season, Lehighton, Pennsylvania*, 1975, from the series *Carnival Strippers*.

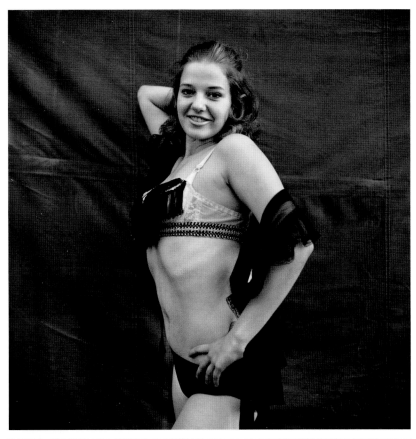

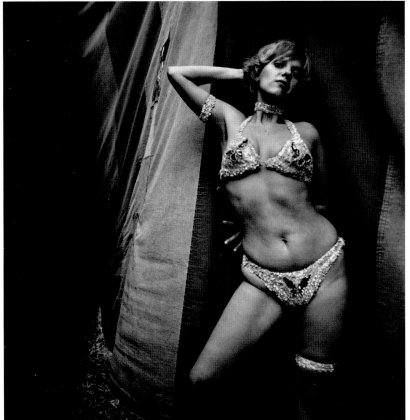

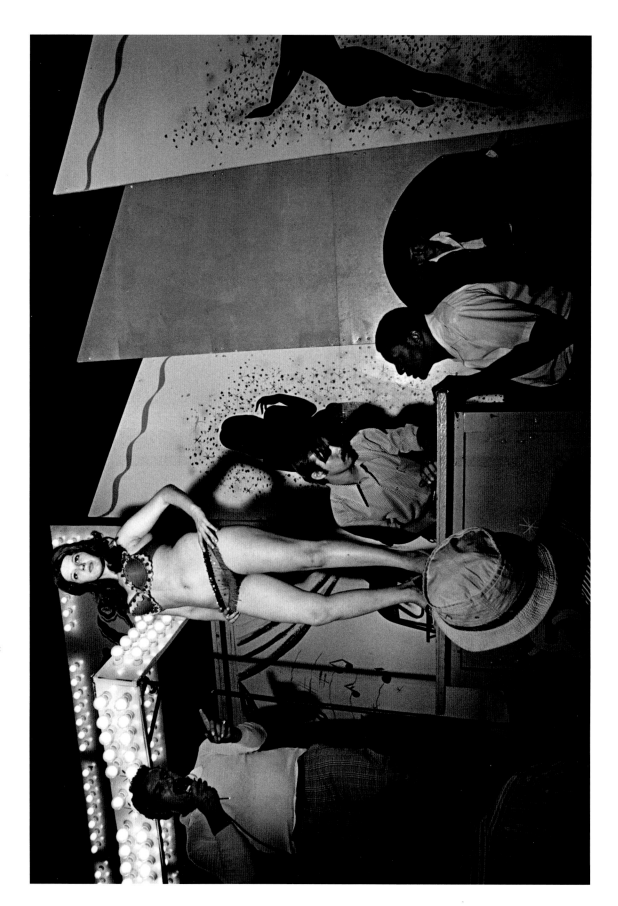

Above: *Lena on the Bally Box, Essex Junction, Vermont*, 1973, from the series *Carnival Strippers.*
Below: *Before the show, Tunbridge, Vermont*, 1974, from the series *Carnival Strippers.*

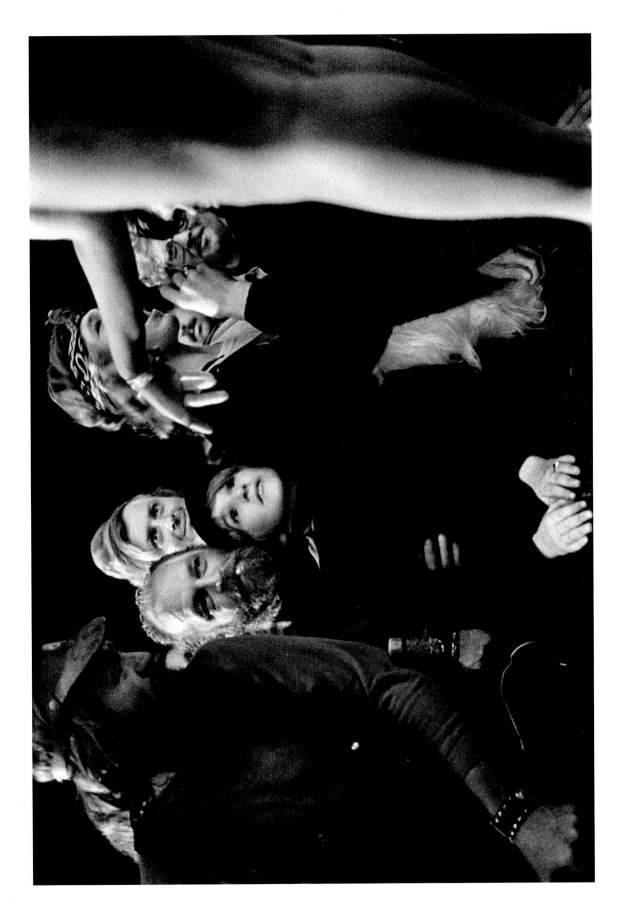

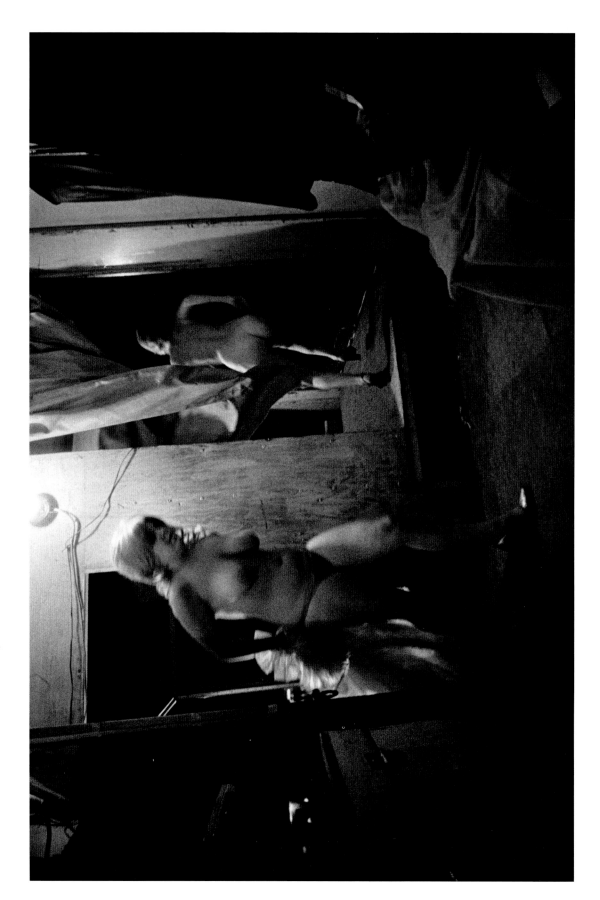

Carnival **Strippers**, 1972–75

44

Above: *Through the dressing room, Barton, Vermont,* 1974, from the series *Carnival Strippers.*
Below: *Lulu and Debbie, Tunbridge, Vermont,* 1974, from the series *Carnival Strippers.*

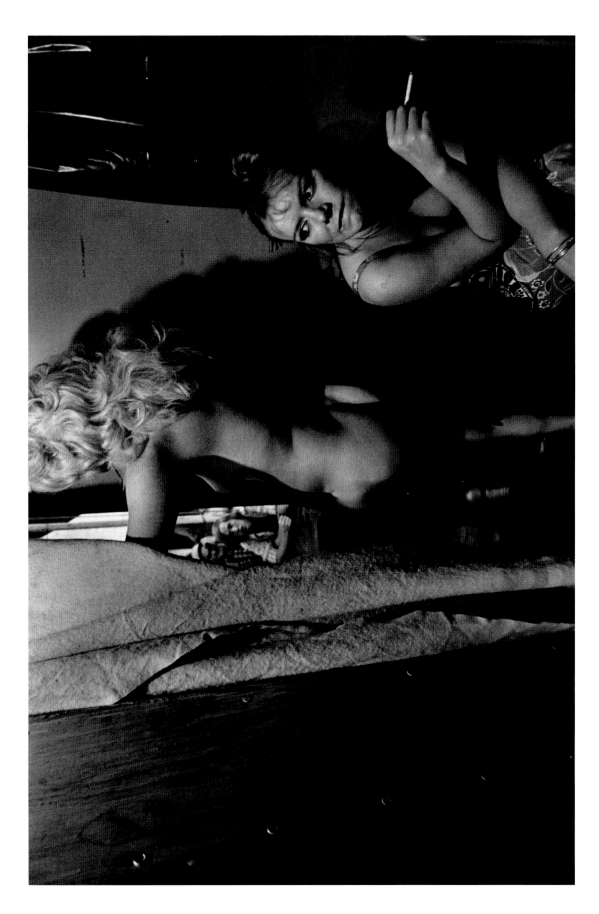

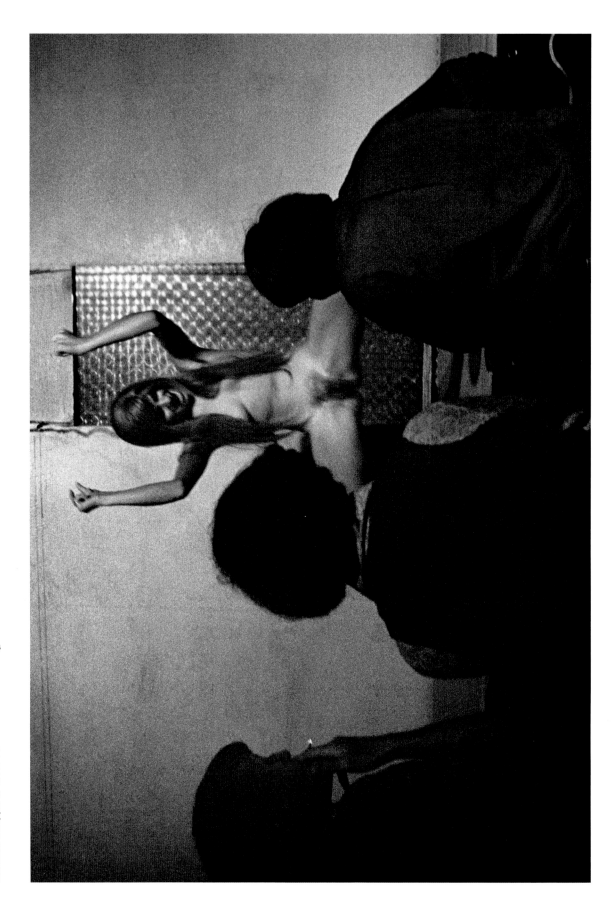

Above: *Shortie at work, South Carolina, 1973,* from the series *Carnival Strippers.*
Below: *Between shows, Fryeberg, Maine, 1975,* from the series *Carnival Strippers.*

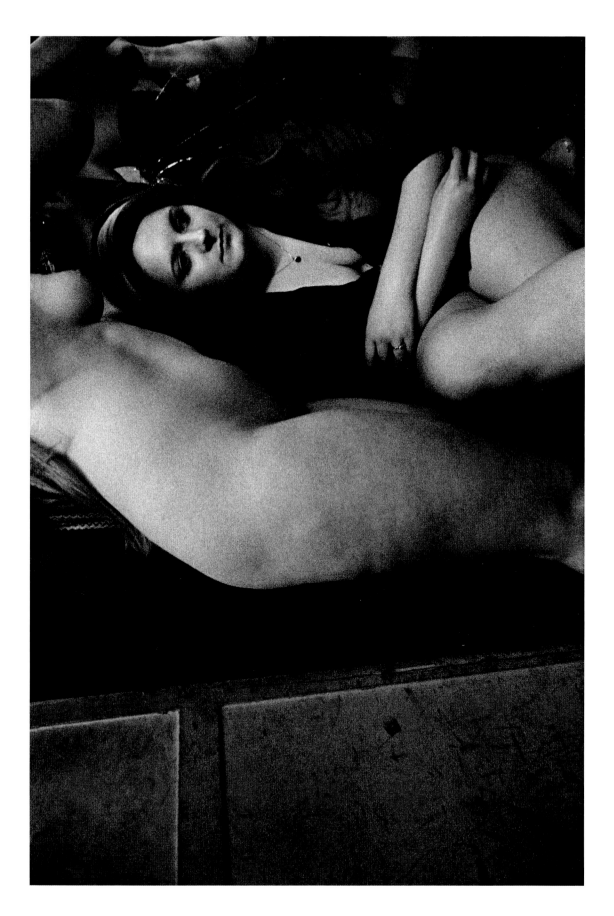

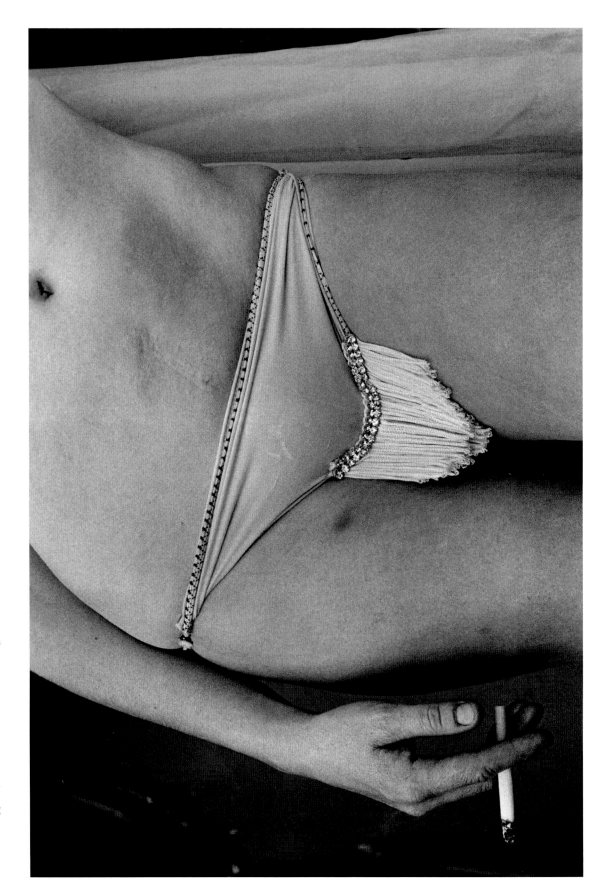

Above: *Shortie on the Bally, Barton, Vermont*, 1974, from the series *Carnival Strippers*.
Below: *Returning backstage, Essex Junction, Vermont*, 1973, from the series *Carnival Strippers*.

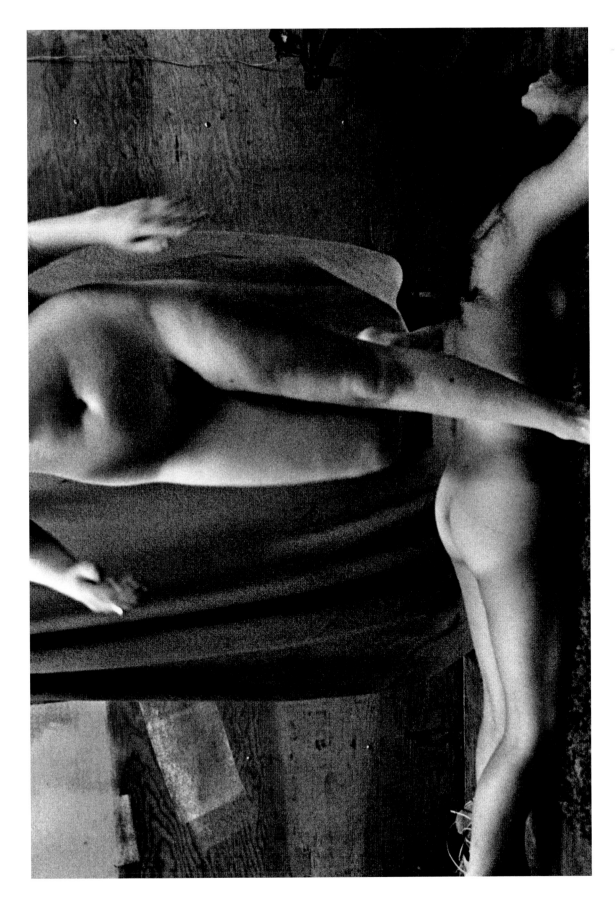

to convey
 exploitation of women
 implicate audience - into humiliation

 to understand:

STRUCTURE where girls from
OF SOUND: how began
 HS exper.
 sexual exper
 familial

bally call why girly show
men's expectations expectations
other women's attitudes disappointments

SOCIETY
Intrappment vs choice
 Economics of decision
 consciousness class
 degree of determinism

They are somebody's lover, mother, daughter

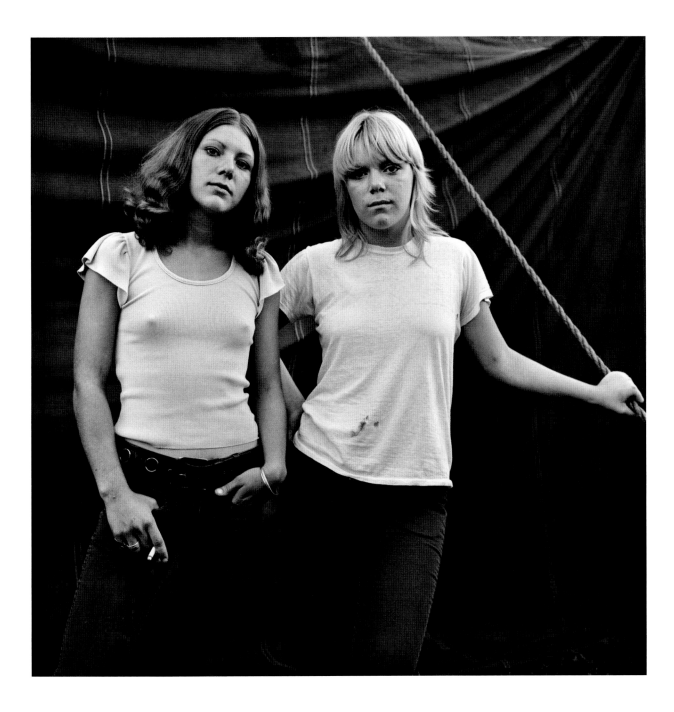

Above: *Debbie and Renee, Rockland, Maine*, 1972, from the series *Carnival Strippers*.
Left: Sound recording notes, 1973, for the series *Carnival Strippers*.

STRIPPERS

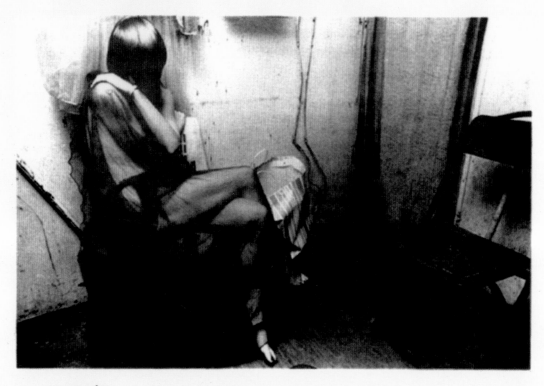

a new play

CONCEIVED AND DIRECTED BY RICARDO E. VELEZ

PRODUCED BY DOLORES F. CREGAN

based on "carnival strippers"
by susan meiselas

previews: may 12 · 15
performances: may 19 ·22, may 26 · 29
thursday through sunday at 8 p.m.

reservations: 857-7753

donation $2.50

THE EVERYMAN COMPANY OF BROOKLYN 725 UNION ST., BROOKLYN, N.Y.

brother jonathan, o.s.f. & geraldine fitzgerald, artistic directors

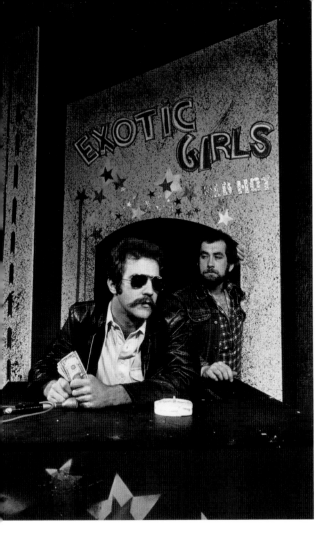

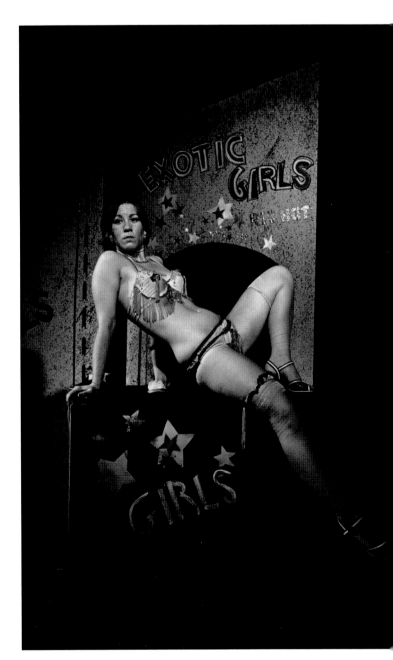

Above and right: Rehearsal photographs by Meiselas from the play *Strippers*, based on the book *Carnival Strippers* and produced by the Everyman Company of Brooklyn, 1975.

Left: Advertisement for the play *Strippers*, based on the book *Carnival Strippers* and produced by the Everyman Company of Brooklyn, 1975.

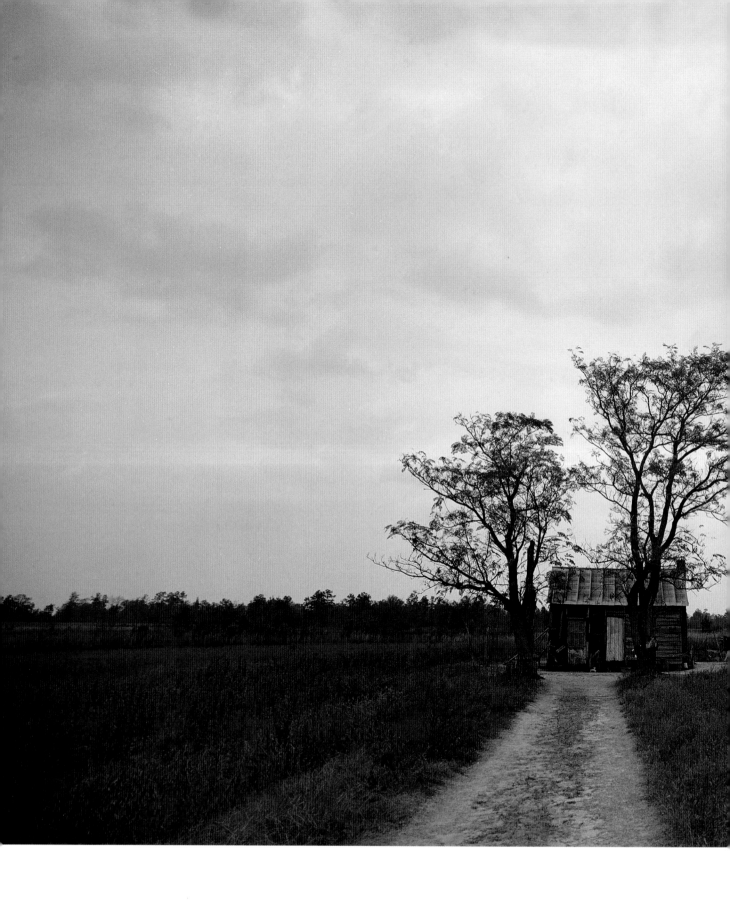

End of the Road, from the series *Porch Portraits*, 1974.

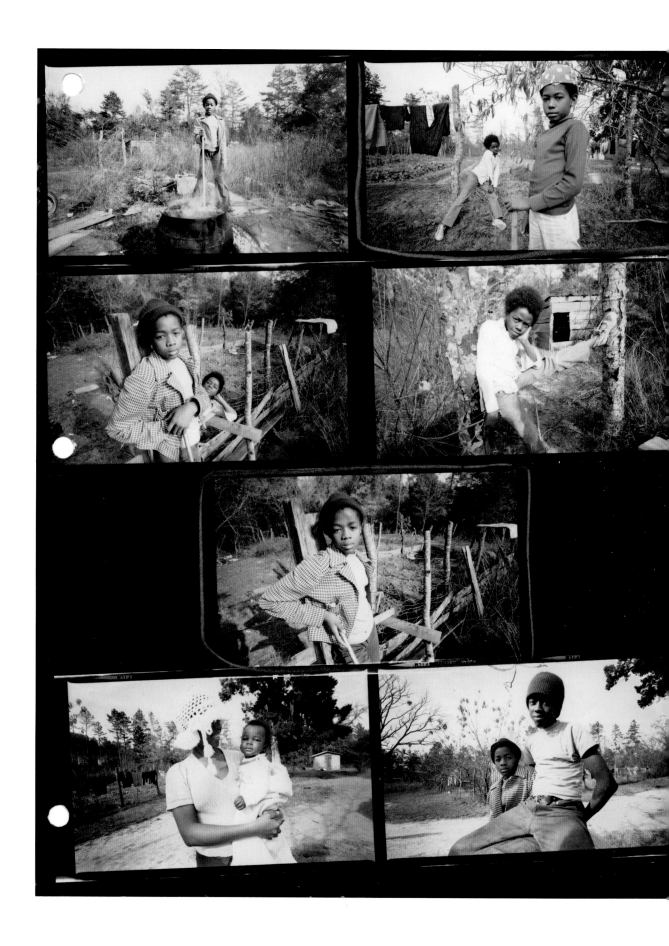

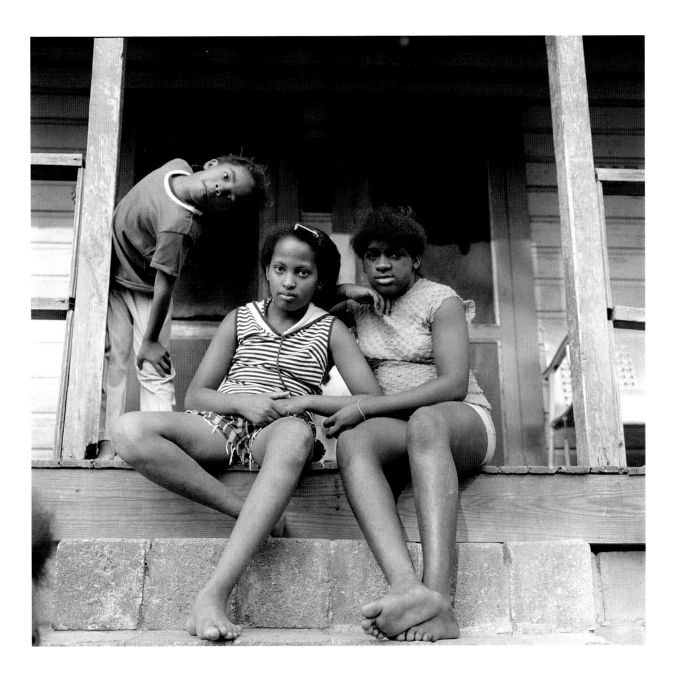

Above: *Myra and friends, Greenville, South Carolina,* from the series *Porch Portraits*, 1974.
Left: Contact sheet from the series *Porch Portraits*, 1974.

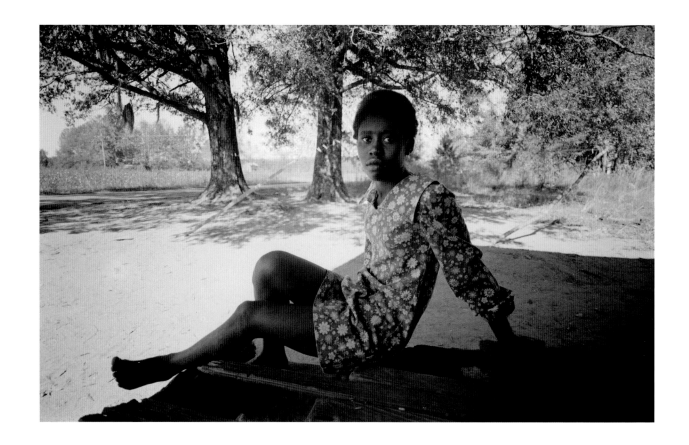

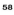

Porch Portraits, 1974

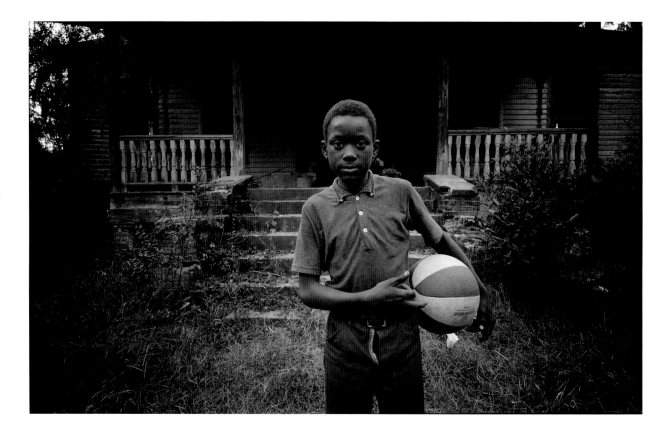

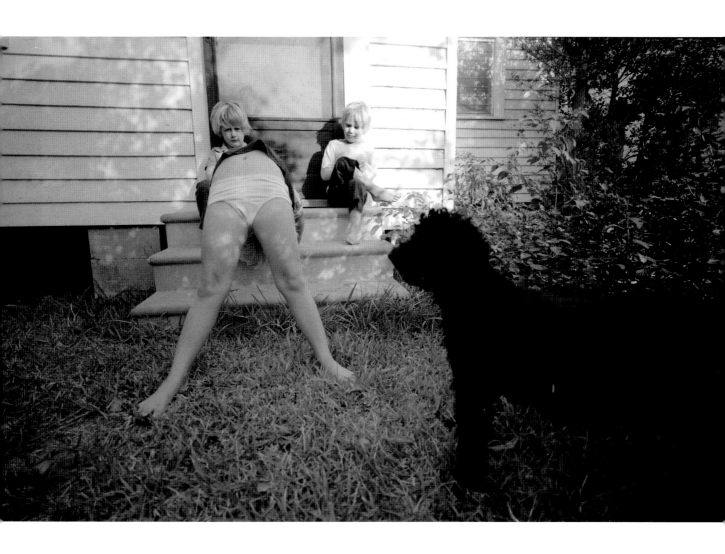

Above: *Palmer family, Gulfport, Mississippi*, from the series *Porch Portraits*, 1974.
Left, top: *Diane, Lake City, South Carolina*, from the series *Porch Portraits*, 1974.
Left, bottom: *Son of Elsie Smith, Salters, South Carolina*, from the series *Porch Portraits*, 1974.

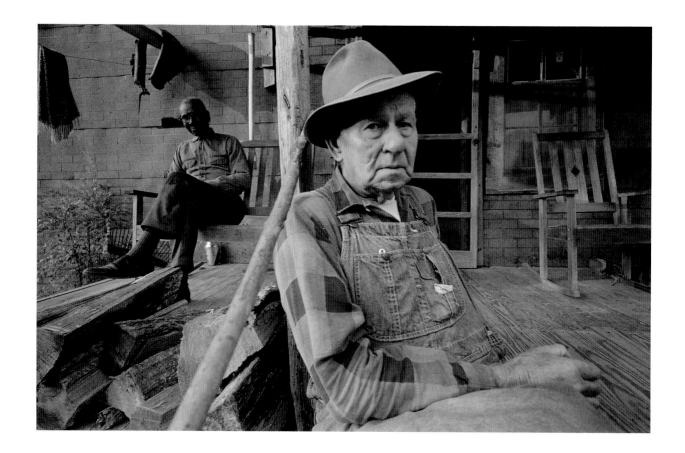

John A. Smith, Chunky, Mississippi, from the series *Porch Portraits,* 1974.

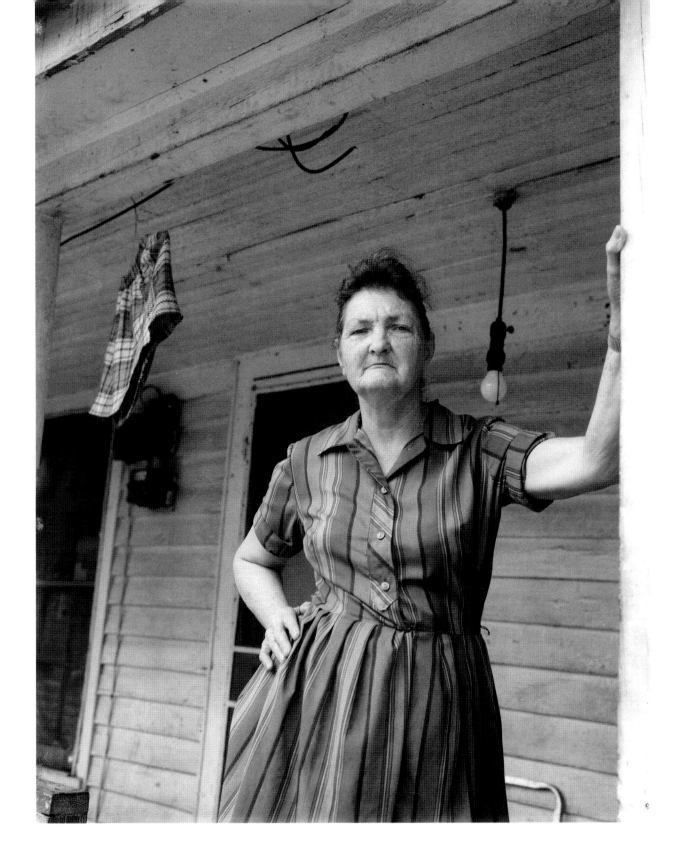

Untitled, from the series *Porch Portraits*, 1974.

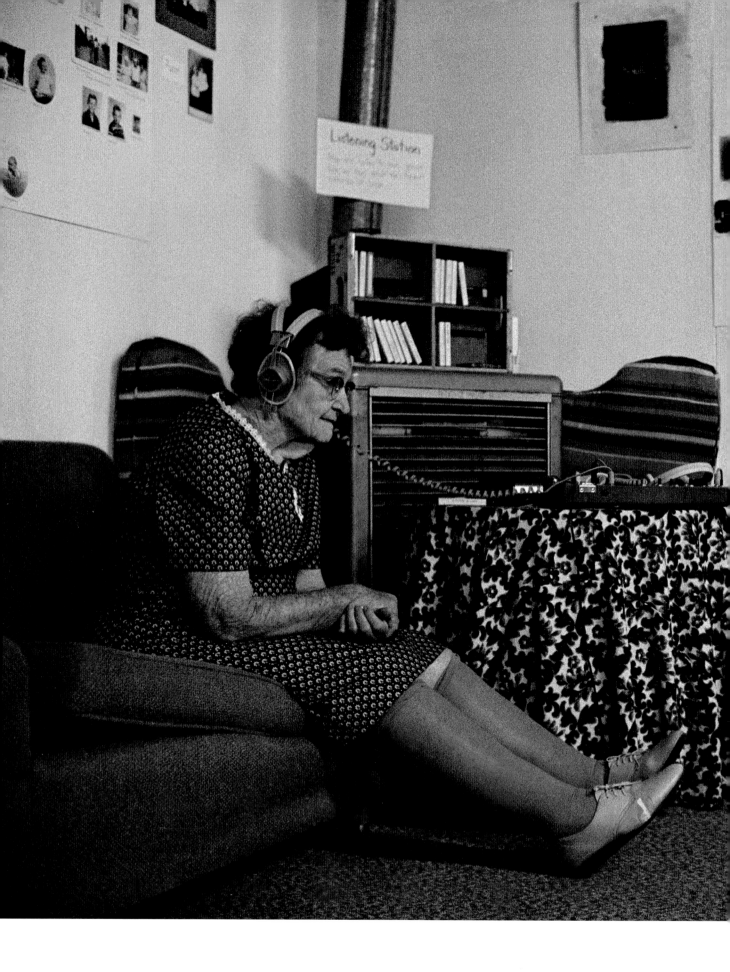

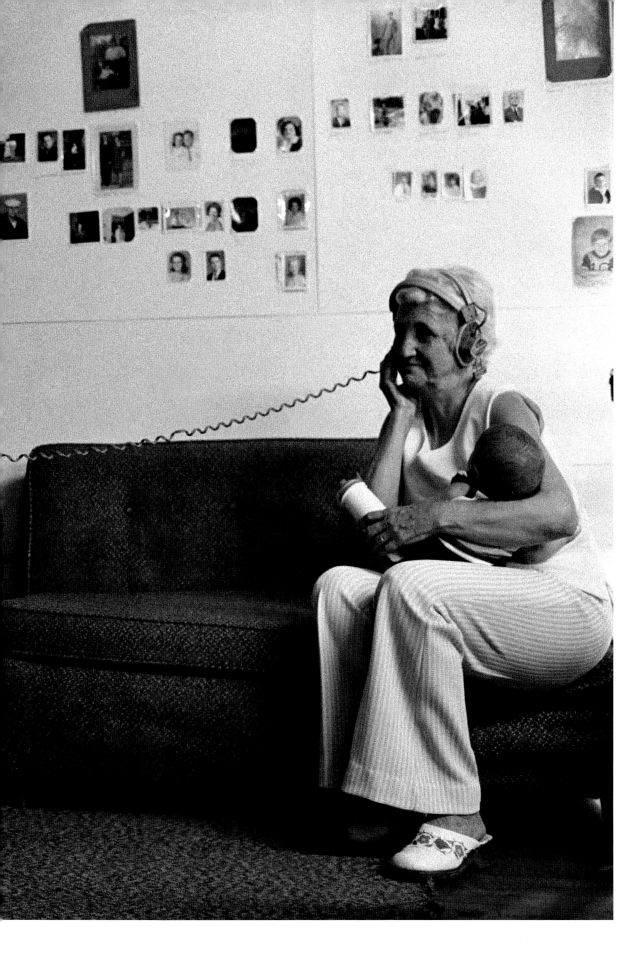

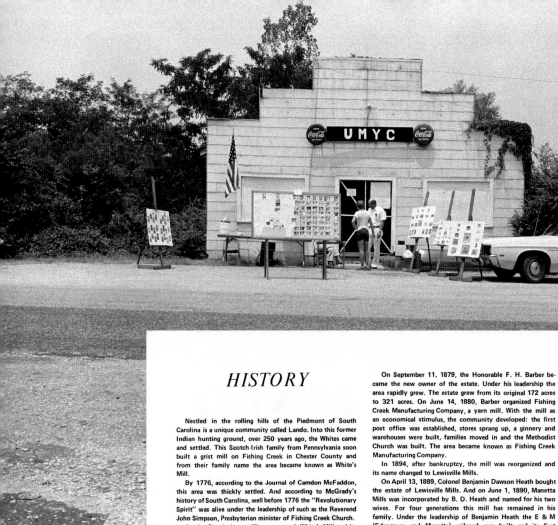

HISTORY

Nestled in the rolling hills of the Piedmont of South Carolina is a unique community called Lando. Into this former Indian hunting ground, over 250 years ago, the Whites came and settled. This Scotch-Irish family from Pennsylvania soon built a grist mill on Fishing Creek in Chester County and from their family name the area became known as White's Mill.

By 1776, according to the Journal of Camdon McFaddon, this area was thickly settled. And according to McGrady's history of South Carolina, well before 1776 the "Revolutionary Spirit" was alive under the leadership of such as the Reverend John Simpson, Presbyterian minister of Fishing Creek Church.

As the Revolutionary War progressed, White's Mill and its surrounding community played a significant part in our nations freedom. Under the notorious Captain Christian Huck, White's Mill became a Britist outpost until it was liberated and Huck killed by local loyalist.

White's Mill continued in the White family until after the Revolution. On January 16, 1844 Major Eaves bought the plantation and mill and kept it until his death in 1870. Then on January 3, 1870, Alexander Williford bought the plantation with its grist mill and a saw mill and houses.

On September 11, 1879, the Honorable F. H. Barber became the new owner of the estate. Under his leadership the area rapidly grew. The estate grew from its original 172 acres to 321 acres. On June 14, 1880, Barber organized Fishing Creek Manufacturing Company, a yarn mill. With the mill as an economical stimulus, the community developed: the first post office was established, stores sprang up, a ginnery and warehouses were built, families moved in and the Methodist Church was built. The area became known as Fishing Creek Manufacturing Company.

In 1894, after bankruptcy, the mill was reorganized and its name changed to Lewisville Mills.

On April 13, 1889, Colonel Benjamin Dawson Heath bought the estate of Lewisville Mills. And on June 1, 1890, Manetta Mills was incorporated by B. D. Heath and named for his two wives. For four generations this mill has remained in his family. Under the leadership of Benjamin Heath the E & M (Edgemoor and Manetta) railroad was built and its first locomotive purchased. During these early days the mill and the community were greatly improved and increased in size. By 1907 the school was built by the mill, and the name Lando was given to the community by the Seaboard Railroad Company in memory of Captain Lane, its first conductor, and in memory of Captain Dodson, its first superintendent.

CHARLES R. INABINET

Drawing of Lando

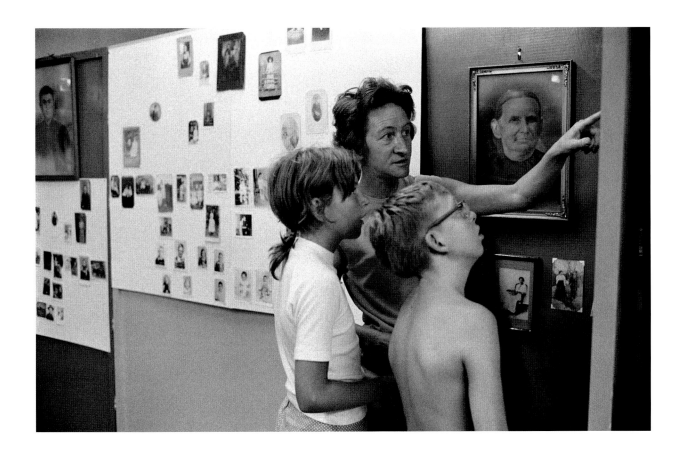

Above: Family viewing the exhibition *A Photographic Genealogy—The History of Lando*, 1974.

Left, top: Exterior of the United Methodist Youth Center where *A Photographic Genealogy—The History of Lando* was installed, 1974.

Left, bottom: Page from *The Old Mill Stream*, community publication from Lando, South Carolina, December 1975.

Previous page: Mrs. Mary Stephenson (left) and Mrs. Ruth Mosley (right) listening to their neighbors at the exhibition *A Photographic Genealogy—The History of Lando*, 1974.

IN THE BEGINNING there was a group of young people; Charles Inabinet, a Methodist minister; Judi Inabinet, a mother wife and educator, Susan Meiselas, a free-lance photographer; and Lando, a rather sleepy mill village.

Because of the combined interests of each of these people and the involvement of the South Carolina Arts Commission and the Polaroid Foundation, it became possible for these separate entities to become a working whole which culminated in an exhibit held in the United Methodist Youth Center in Lando, S. C., in July, 1975.

The exhibit included old photographs, a photo-geneaology of many of the families in Lando dating back seven generations, artifacts from the past, and the recorded oral history of the community.

The community response was tremendous and the demand began to be heard for a more permanent form of the exhibit. "The Old Mill Stream" is the upshoot of that demand.

It is our hope that through this publication, generations yet unborn can know the hopes, the dreams, the failures and the successes that have helped to mold this unique community and its stout-hearted citizens.

As one reads through this publication, it becomes obvious that without the cooperation of the entire community, this could never have become a reality. For their openness and trust we are truly grateful. For those of us who have worked on the financial side, we know that without the support of the S. C. Arts Commission, the Polaroid Foundation, and those ladies who worked so hard selling subscriptions, this would not now be a reality. To Jack Westmoreland and the staff of the Clover Printing Company we are also indebted, for they made it possible for this magazine to be done professionally. And finally to Susan Meiselas — "Thanks" — for so many, many things, but most especially for her friendship and her ever-present encouragement.

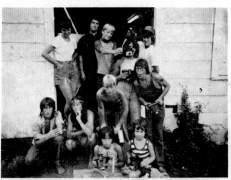

The first of classes in which Ms. Meiselas taught photography to interested youth in the community. Back row, l to r: Judi Inabinet, Charles Inabinet, Kelly Curtis, TyAnne Downs, Bruce Coggins, 2nd row, l to r: Tom Ramsey, Robbie Wade, Kent Curtis, James Thompson, Bottom row l to r: Angie Langley, Chris Inabinet. (Photo by Susan Meiselas)

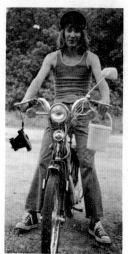

After his first photography class, Robbie Orr heads out on his scooter armed with his Polaroid Camera and negative cleaning tank to photograph some of the older citizens of the community as well as current points of interest. (Photo by Charles Inabinet)

66

Chris Inabinet carefully examines an old tobacco cutter on display in the exhibit (Photo by Susan Meiselas)

Helen and Homer Miller look closely at a part of the seven generations represented in the Tadlock-Hinson geneaology. (Photo by Susan Meiselas)

Mrs. Annie Hyatt enjoys recalling the past as she peruses through Mrs. Myrt Long's photo album. (Photo by Susan Meiselas)

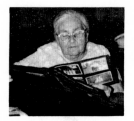

Mrs. Mary Stevenson (left) and Mrs. Ruth Mosley enjoy the listening station where they hear their friends relating childhood memories of Lando. (Photo by Susan Meiselas)

2

Above: Page from *The Old Mill Stream*, community publication from Lando, South Carolina, December 1975.

Right: Community viewers at the exhibition *A Photographic Genealogy—The History of Lando*, 1974.

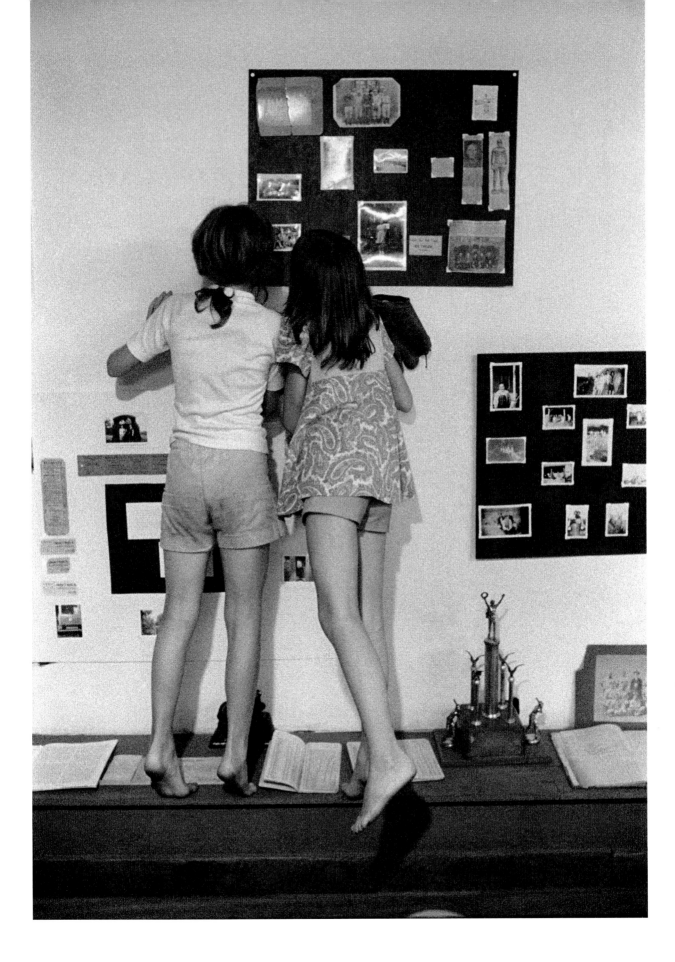

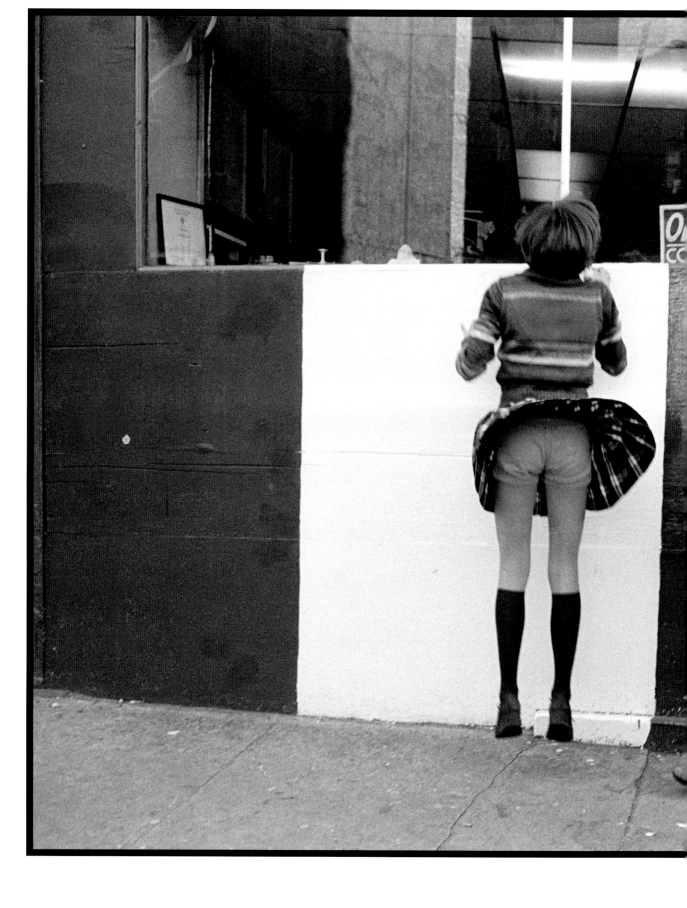

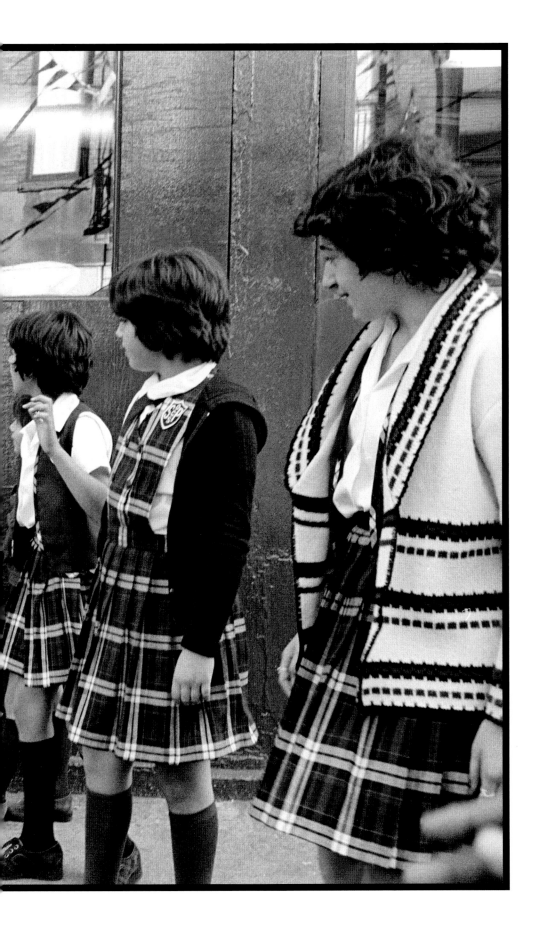

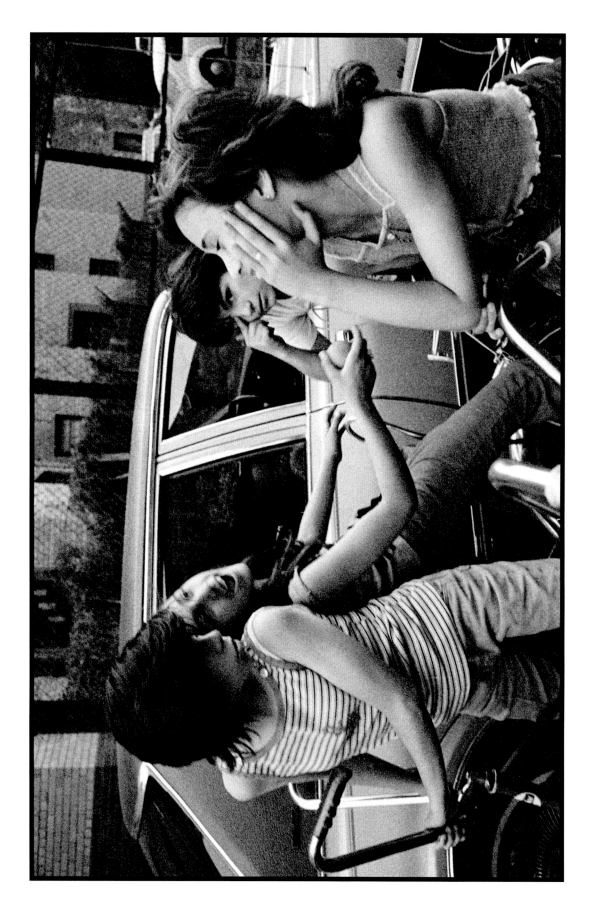

Dee, JoJo, Frankie, and Lisa after school on Prince Street, Little Italy, New York, 1976, from the series Prince Street Girls.

Previous page: *Dee, JoJo, Pina, and Ro on the corner of Prince and Mott Streets, Little Italy, New York, 1976, from the series Prince Street Girls.*

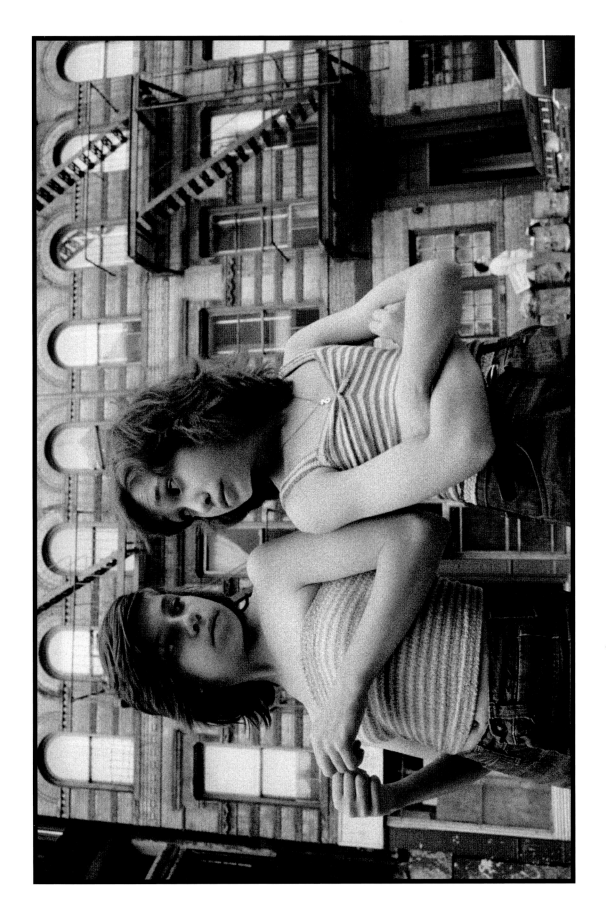

Dee and Lisa on Mott Street, Little Italy, New York, 1976, from the series Prince Street Girls.

71

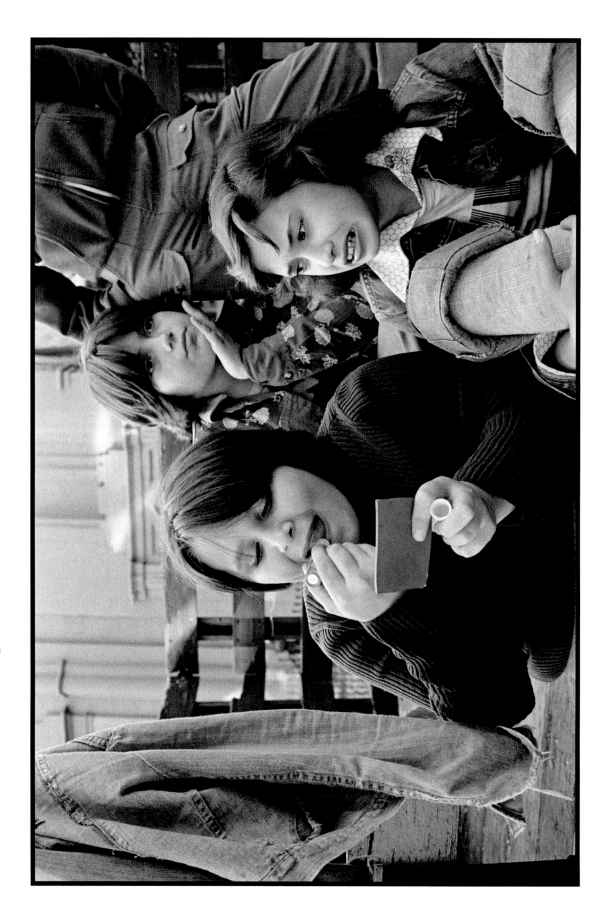

Carol, Pina, and Lisa, Little Italy, New York, 1976, from the series Prince Street Girls.

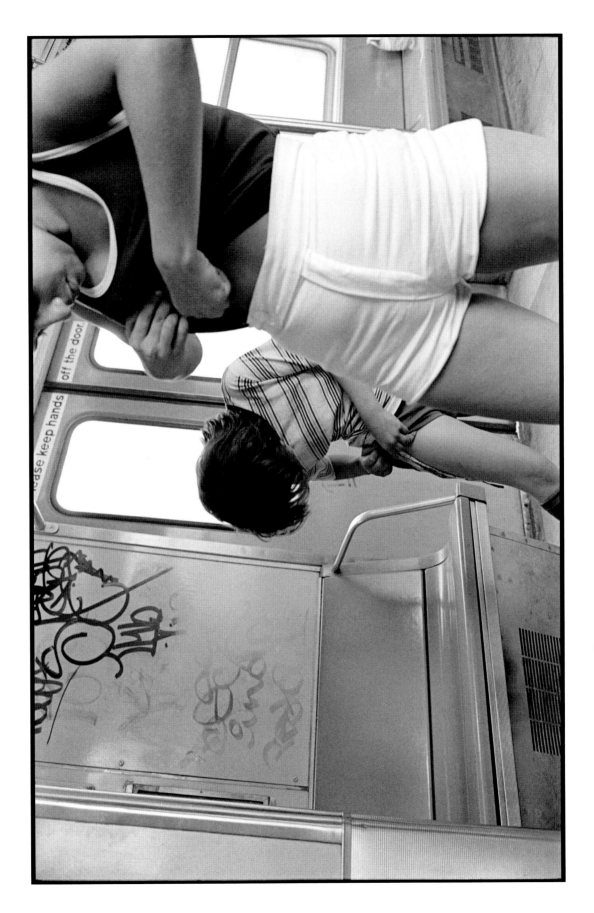

Pebbles and friend on the A train to Rockaway Beach, New York, 1978, from the series Prince Street Girls.

73

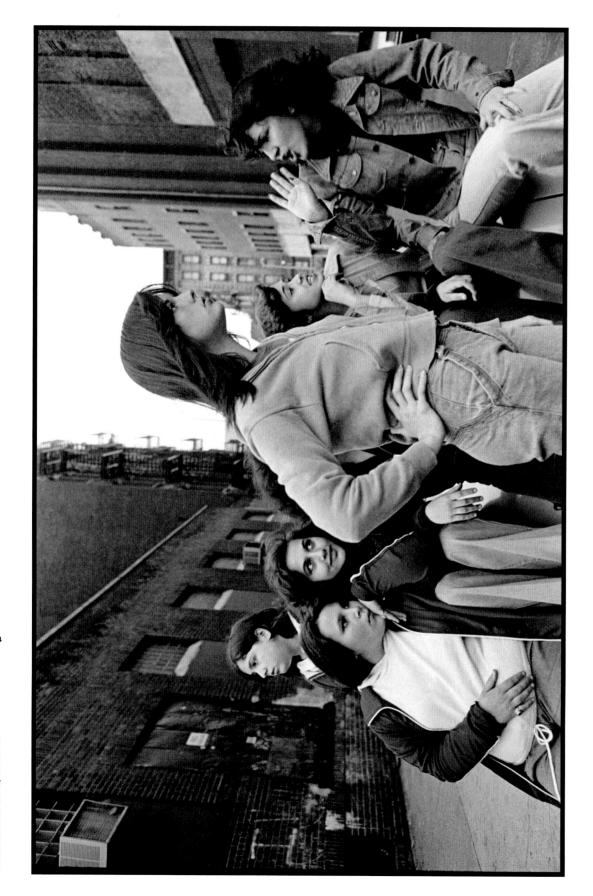

Carol, Ann Marie, JoJo, Tina, Lisa, and Carol P. on Baxter Street, New York, 1978, from the series Prince Street Girls.

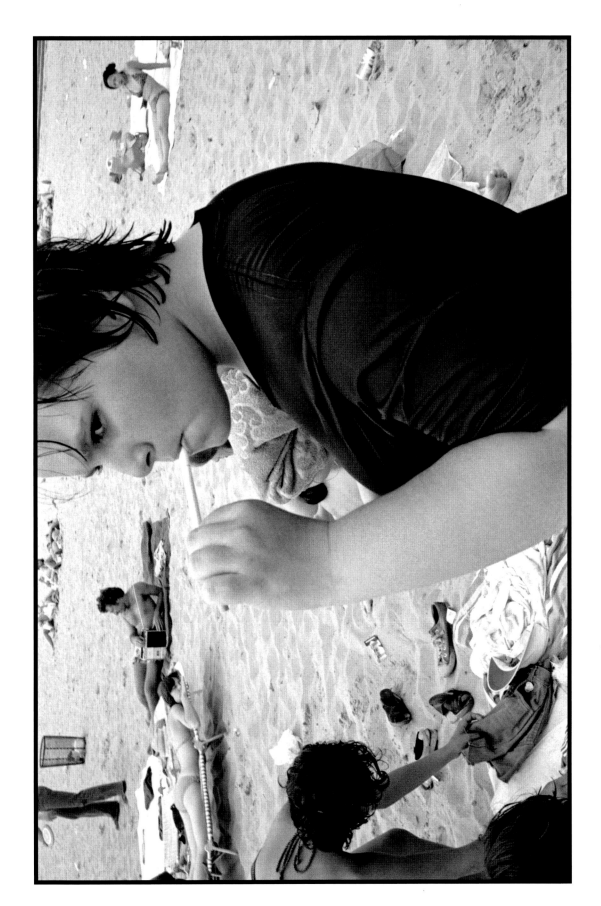

Carol at Rockaway Beach, New York, 1978, from the series Prince Street Girls.

75

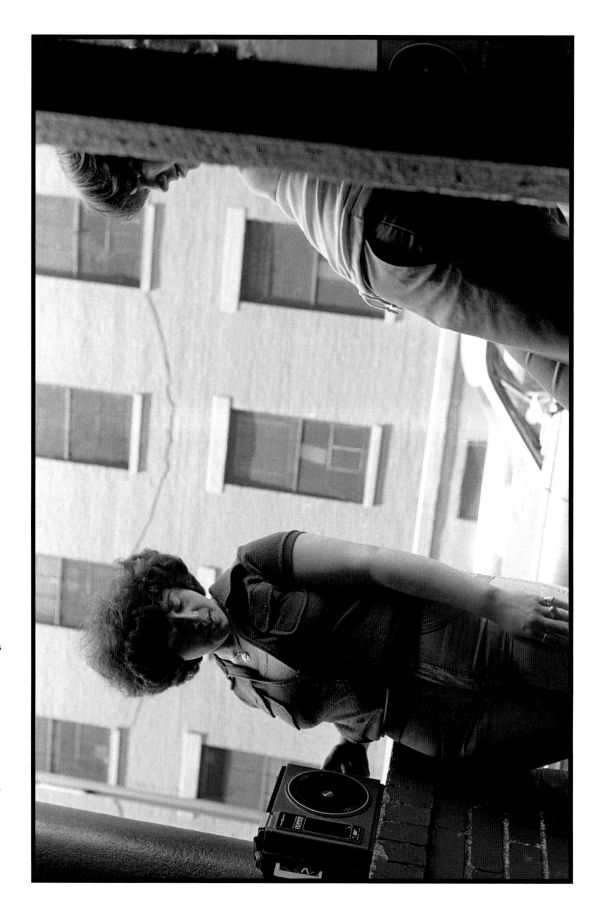

Ro and Pina in front of their home on Mott Street, Little Italy, New York, 1978, from the series Prince Street Girls.

Below, left: Notes on the series *Prince Street Girls,* May 23, 1978.
Below, right: *Pebbles, JoJo, and Ro on Baxter Street, New York, 1978,* from the series *Prince Street Girls.*

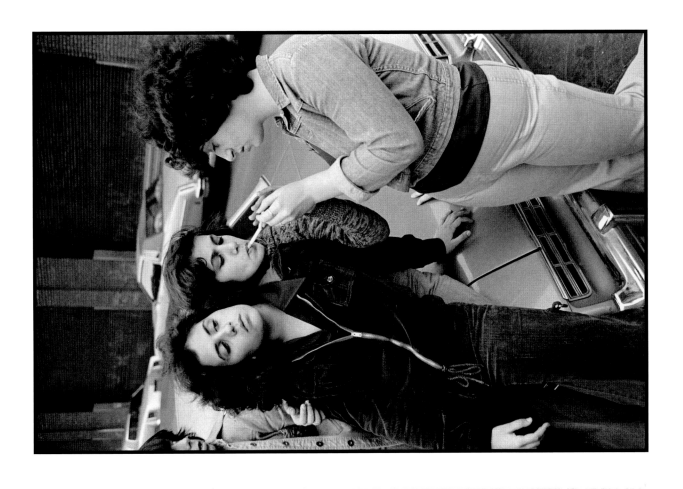

The Prince Street Girls ... 5/23/78

I've spent a day looking at old pictures, The first that I took of some kids on the block, remembering how it began, that we became friends. Just then the bell rang and it was him o see even up the stairs - "You're such a good friend," into the darkroom together. to laugh at how they've changed - we were so ugly, we worked like witches. "Why do you take pictures, why did you need dirt, pictures in here, I mean, pictures not were dirty." I've have love banana budding life. He asked if I'm afraid to be alone, if I get time o will spend the night alone." She'd planned to be alone at night with & Anthony, 'Dee o Teresa' won't do anything. 'Cris's a fix') Smoke a cigarette & be gone.

Life has come in o gone out my door. I return to the darkroom.

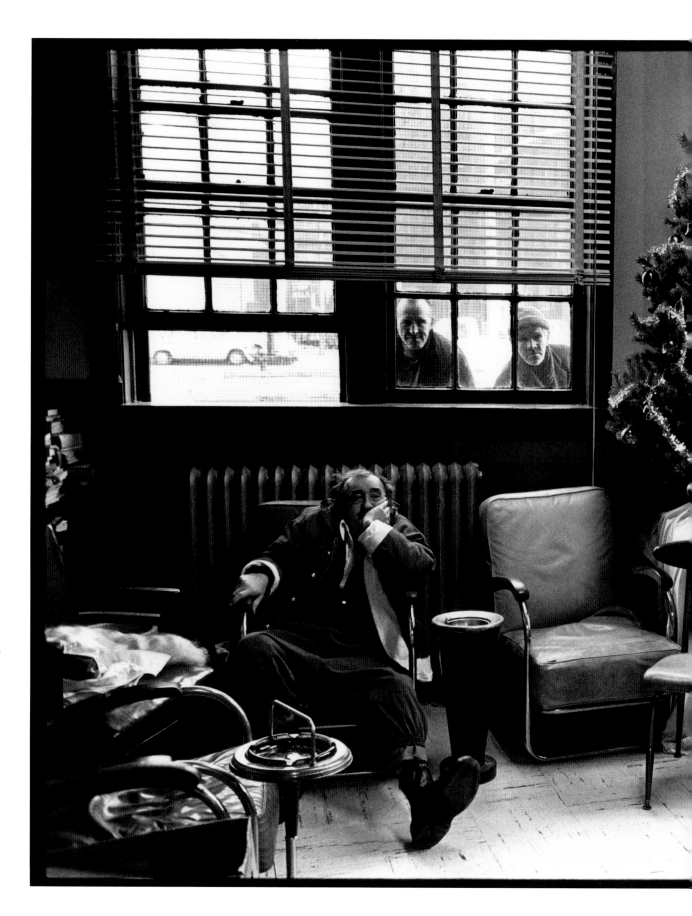

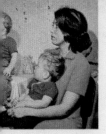
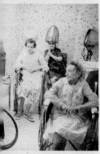
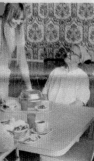

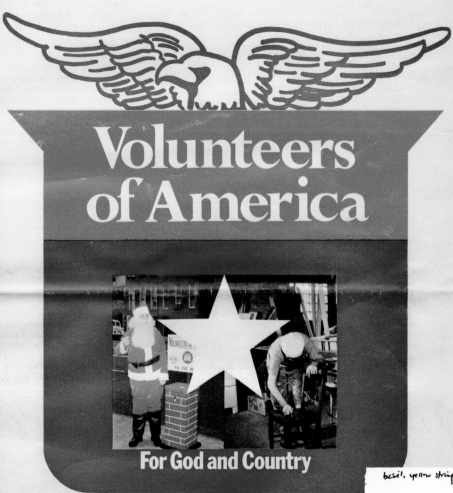
Above: Volunteers of America advertisement, *New York Times Magazine*,
March 7, 1976.

Right, top: *Off to Work, New York*, 1977, from the series *Volunteers of America*.
Right, bottom: Notes for the series *Volunteers of America*.

Previous page: *Prep at the Men's Shelter, New York*, 1976, from the series
Volunteers of America.

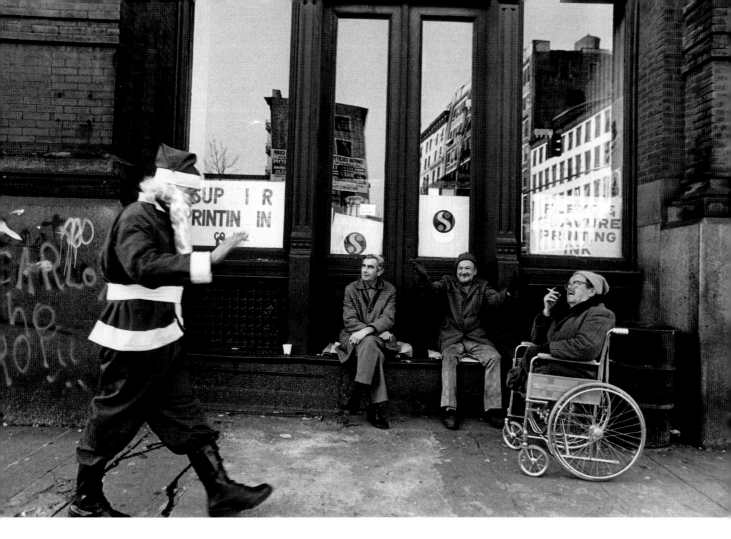

MARS

6 LUNDI Ste Colette 65-300

5000 in bowery, 1200 MUNY

They don't think to sleep till
midtime. They're not oriented
to anything but the here
& now today

Life is very fragile on the B.,
men get hurt, beaten up, killed
it's not a world of possessions
it's what they carry on
their backs & being protective
all the time, trusting
no one.

The anxiety, grim paranoia,
nothing is permanent.
there is no reserve in &
no positive concept of self.

What the soc yells these
men is they're worthless
& they believe it.

What makes you an indiv
is your abil to determine who
you are & what you want to
do —. These guys have
no decisions to make.

MARS

7 MARDI Ste Félicité 66-299

They can't choose what they
eat, they can't change
their clothes, they
have no determining voice
in what they do.)

125 staff
25-30 ~~prof~~ trained service staff
8-10 prof trained

81

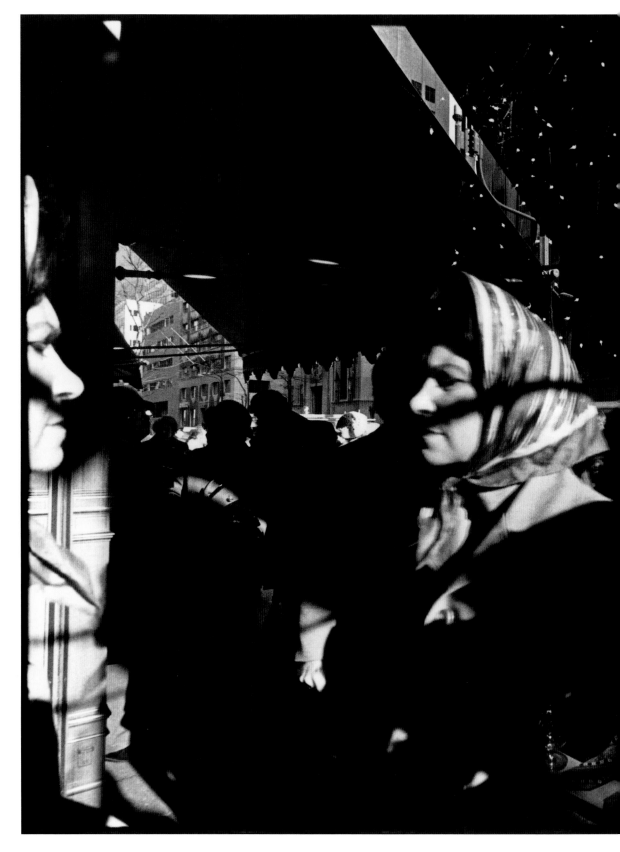

Fifth Avenue, New York, 1977, from the series *Volunteers of America*.

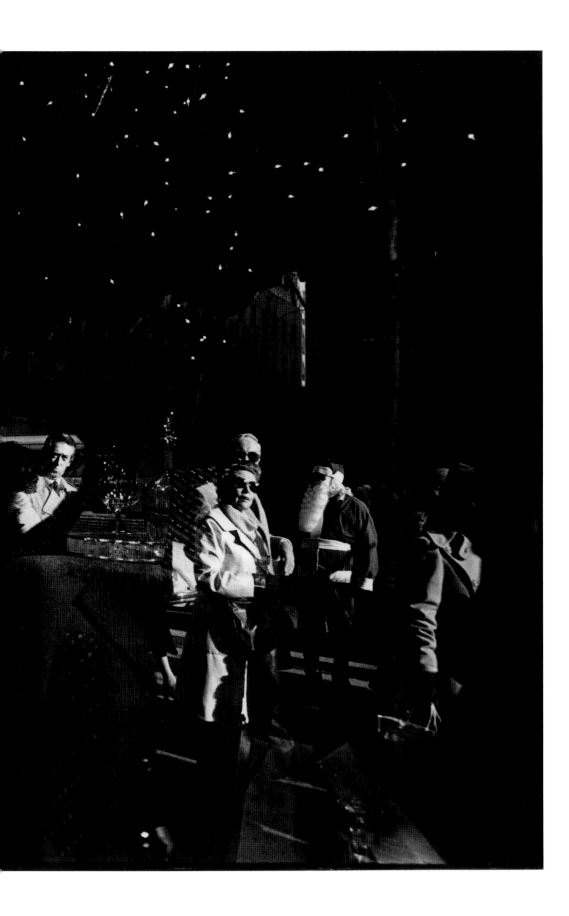

Clockwise from top left:

Notes for the series *Volunteers of America*.

In Front of Tiffany's, New York, 1977, from the series *Volunteers of America*.

Rockefeller Center, New York, from the series *Volunteers of America*.

Chris Schmidt, at the men's shelter, New York, 1977, from the series *Volunteers of America*.

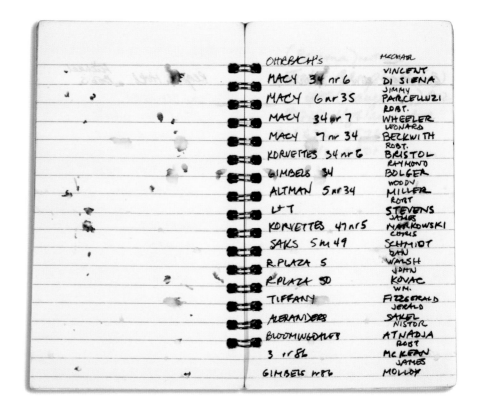

Volunteers of America, 1976–78

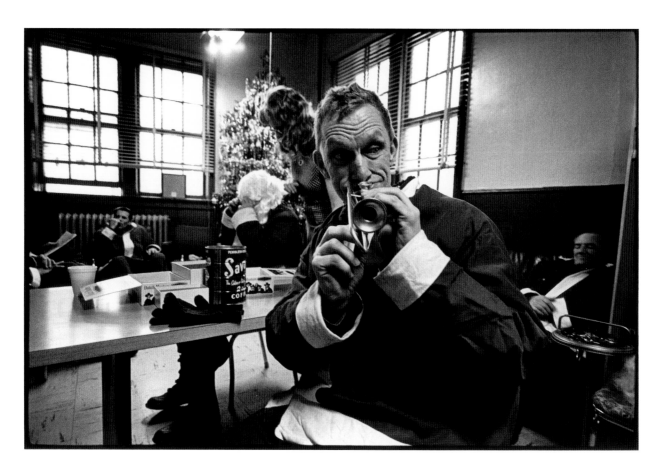

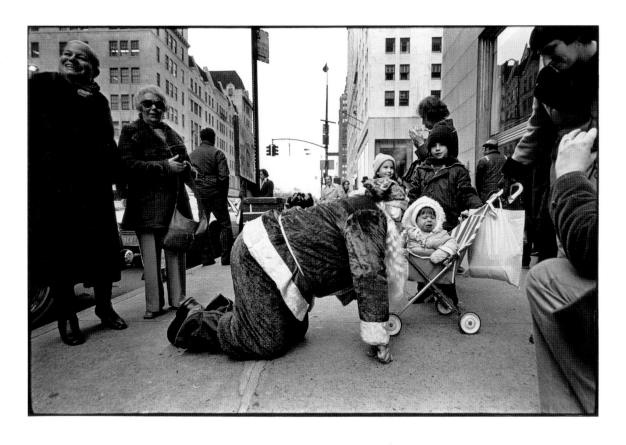

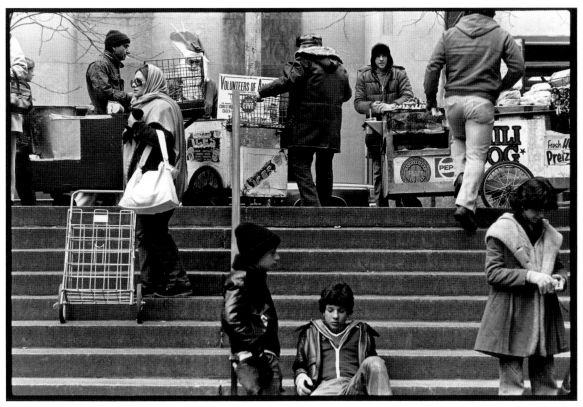

Following page: *On the Bowery, New York*, 1978, from the series *Volunteers of America*.

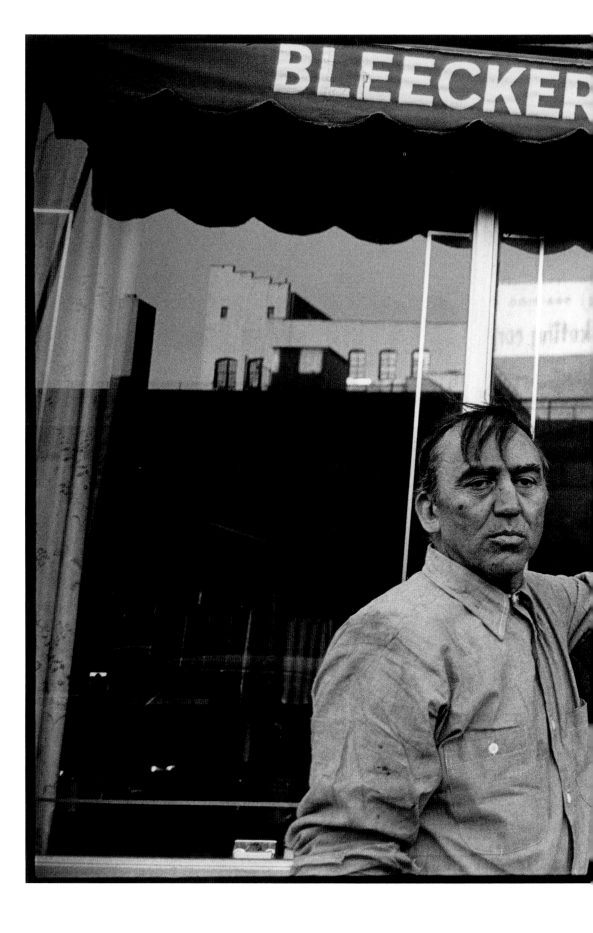

Chapter 1 Essays:

Abigail Solomon-Godeau
Caught Looking

Caroline Brothers
"Beyond our ever knowing":
Susan Meiselas and the Necessity of Return

David Levi Strauss
"An Amplitude That Information Lacks"

Meiselas taking Ginger's portrait, 1975.
Photo: Cate Muther.

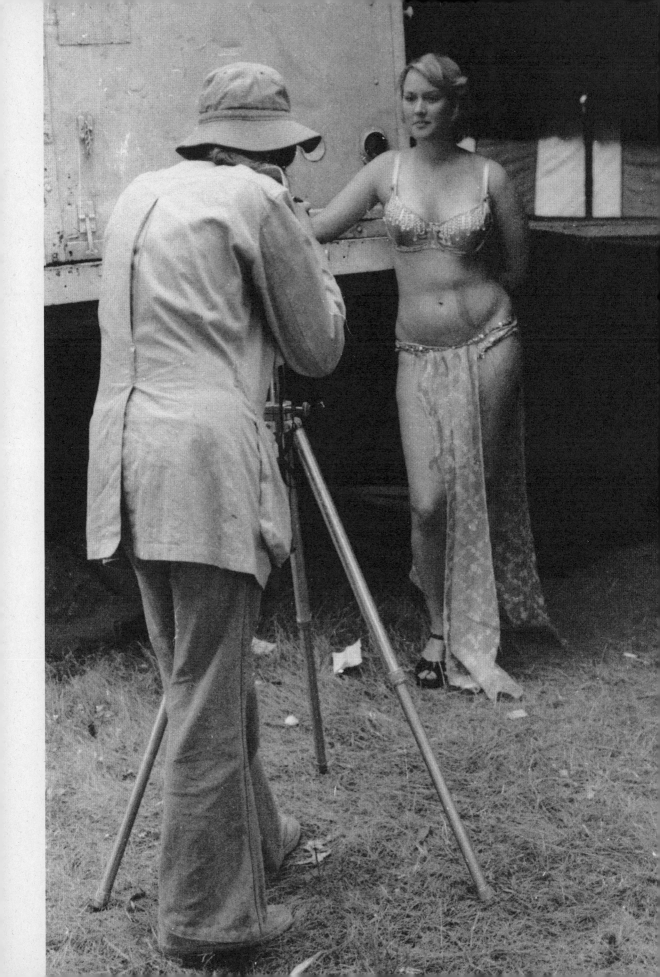

Caught Looking

Abigail Solomon-Godeau

(Carnival Strippers, pp. 34–53)

In the consecutive summers of 1973, 1974, and 1975, the years of Gerald Ford's presidency, Susan Meiselas, then in her twenties, photographed the strippers, barkers ("talkers"), managers, bouncers ("roughies"), and audiences of several itinerant girl shows installed on the grounds of fairs and carnivals in rural New England and Pennsylvania. In addition to the photographs, Meiselas recorded many hours of audiotape, including conversations with the strippers, other workers, and comments from spectators. Thus, from very early in its inception, the project that became *Carnival Strippers* rejected the notion of the "purely visual" as adequate to its depiction of its subjects, their work, their place, and their milieu.[1] This expanded approach to photographic meaning, however, was hardly the norm in the 1970s, and it was doubtless Meiselas's departure from it that occasioned commentators to remark on her undergraduate major in anthropology and her youthful desire to become an ethnographic filmmaker.[2]

Be that as it may, both in its first edition (1976) and its revised reissue of 2003, *Carnival Strippers* counterpoised the photographs with texts excerpted from transcripts of the recordings. When the project was first adapted to exhibition format at CEPA in Buffalo, Meiselas used the sound recordings throughout the exhibition space so that the voices of those photographed were part of the environment. In keeping with her emphasis on the voices, the 2003 edition also includes a CD in a pocket consisting of commentary by one of the strippers (Lena) gathered over the course of four years, the collage of voices, an interview with Meiselas made in 1977, and texts by Sylvia Wolf and Deirdre English. Meiselas has also produced a digital presentation, using the still images from the book and an audio track.

Although sometimes grim, the pictures are less shocking than some of the accompanying texts. And while pictures of the male customers—women were not permitted entry to the shows—reveal expressions ranging from rapt fascination to aggressive leering, the faces of the strippers (when not performing) mostly suggest boredom, introspection, or fatigue. It is only in the second part of the book, made up of relatively formal portraits where the women themselves chose how to present themselves, that the occasional cheesecake pose or come-hither expression appears. But with the exception of a few pictures redolent of drunken hilarity, no one seems to be having a particularly good time.

These gritty, *noir*-esque pictures were—and are—unsettling in a number of ways. Part of this effect has to do with the project's subject matter, the bleak and tawdry domain of fairground striptease, a poor relation of the elaborately orchestrated floorshows of, say, Las Vegas. In the relatively low-end circuit of carnival stripping, the boundaries between performance and sex acts, depending on venue and law enforcement, might be significantly breached; "working strong" is the strippers' argot for letting customers perform cunnilingus during the show; "lunch counter," the term describing this activity from the customer's side of the stage.

1. As Victor Burgin long ago remarked, "Treating the photograph as an object-text, 'classic' semiotics showed that the notion of the 'purely visual' *image* is nothing but an Edenic fiction . . . whatever specificity might be attributed to photography at the level of the 'image' is inextricably caught up within specificity of the social acts which intend that image and its meanings." Victor Burgin, "Looking at Photographs," in *Thinking Photography*, edited by Victor Burgin (London: Macmillan, 1982), p. 144.

2. For a detailed review of the history and development of the project, see the excellent essays by Sylvia Wolf, "Behind the Ballyhoo," and Deirdre English, "Stripped Bare: Nude Girls and Naked Truths," in Susan Meiselas, *Carnival Strippers*, 2d ed. (New York and Göttingen: Whitney Museum of American Art and Steidl, 2003).

Yet another discomfiting element is the way that Meiselas shot certain images to create the visual sensation of extreme proximity to the women's bodies. These bodies, moreover, are not likely to be confused with those of dancers, athletes, or models, the perfection of which functions itself as a kind of clothing. Fat or thin, the women's breasts, bellies, and thighs evoke the carnal in its most literal sense. As Deirdre English observes, their bodies bear the marks of mortality—pregnancies, nursing, age. Indeed, this is one of the ways one distinguishes between the unclothed human being—the naked—and the aestheticized concept recognized as the nude. There is, in fact, only a single photograph—remarked upon by English—that could pass muster *as* a nude, depicting the stripper named Lena asleep on a bed. In both editions of the book, this atypical photograph closes the first section.

The grainy, contrasting quality of the images, the blurred bodies in movement, the casual obscenity of much of the dialogue—all these function to produce a sense of spontaneity, "real life" captured on the run. This, of course, is not to gainsay the *artifice* of Meiselas's work; the artifice is precisely the art, and nothing could less resemble work made on the run than Meiselas's long-term engagement with her project. This deliberation is especially clear when one compares the 1976 version with the later one. Although several photographs were dropped from the former and added to the later edition, the texts and images were variously resequenced. The new organization reinforces the perception of a spatial movement from outside to inside, and a temporal movement from early evening to late night. Sometimes the text appears to be generated by the person photographed, other times, not. Although different girl shows, different places, and different years are intermingled, *Carnival Strippers* is not structured as a day-in-the-life narrative but a virtual journey that begins with the Bally call (*"Watch it! Watch it right now! Stop the music! You're gonna see burlesque, striptease, hootchie-kootchie, and daddy-o, it's all the way"*) and ends with the dismantling of the show-in-a-truck that signals the itinerancy of the small world it has documented.

Most of the pictures, including those depicting the women dancing on the makeshift stages, lounging in their dressing areas, or lying on their motel beds, were made with a small, unobtrusive Leica and shot with ambient light and without zoom lenses. In certain of the close-ups, it seems extraordinary that Meiselas drew no attention to herself. It is as though the men—or boys—were so mesmerized by the strippers on the platform above them as to be unaware of the small young woman in the act of photographing them.

Framed in close-up and often shot in confined spaces, the women, too, appear oblivious to the camera. In photographic practice, such spatial proximity is presumed to be a function of familiarity or intimacy with the subject(s). In the past few decades, however, this manner of working has become itself a *topos* of a certain genre of art photography and is often taken to be a kind of ethical immunization absolving the photographer from the charge of exploitation. Insofar as it signals the photographer's insider status in the world he or she depicts, the assumption is that the problems posed by the politics of representation are more or less resolved. But as is demonstrated, for example, by the photographs of Richard Billingham, the photographer's intimacy with his or her subject matter guarantees nothing.[3] In fact, insider or outsider status in and of itself does not prevent or facilitate empathetic or objectifying

3. This genre can be traced from Larry Clark's 1971 *Tulsa*, recording the alcohol-drugs-and-guns lives and occasional deaths of his teenage friends, through the more recent careers of Nan Goldin, Richard Billingham, Wolfgang Tillmans, Jack Pierson, and so forth. I have discussed the question of the photographer's relation to his or her milieu in "Inside/Out," in *Public Information: Desire, Disaster, Document* (San Francisco: San Francisco Museum of Modern Art, 1994). See also Martha Rosler's withering discussion of Billingham's work in "Post-Documentary, Post-Photography," in her *Decoys and Disruptions: Selected Writings, 1975–2001* (Cambridge, Mass.: MIT Press, 2004), pp. 229–30.

forms of viewing, does not in and of itself inculpate or exonerate the photographer. Viewing relations are (also) social relations, and what we might make of *Carnival Strippers* or how we respond to it depends on a multitude of factors. These include its discursive framing, the context of viewing, a host of cultural assumptions and beliefs, and our own subjectivity, conscious and unconscious. And it goes without saying that the meanings of any cultural object are more dependent on these determinations than they are on the photographer's intentions.

In regard to Meiselas's apparent "invisibility" as she made her pictures, a few further points might be made. Considering her documentary projects overall, from the strippers to Nicaragua to the Kurdistan work and the extraordinary *Encounters with the Dani*, one cannot but be struck by a quality of discretion, of consistent self-effacement which should not be mistaken for that of either the work of the surreptitious street photographer or the workaday photojournalist. If Meiselas's photographs do not manifest a conspicuous signature style (as do a number of her contemporaries who are also Magnum photographers), it is perhaps indicative of a lack of artistic self-importance, a form of ethical *tact* before her subjects (in both senses of the word *subjects*). *Encounters with the Dani*, for example, contains a bare handful of her own photographs; *Kurdistan: In the Shadow of History* is ongoing, exists in multiple forms (including its website), is mosaiclike and receptive to all forms of documentation beside her own.[4] This ability to minimize oneself in the act of observing and photographing is a taken-for-granted attribute of professional photojournalism, but is less often the case with those who aspire to the mantle of "artist," or those for whom documentary projects are intended as recognizably "personal" productions (a generally hopeless enterprise in documentary practice).

In this context, although the "look" of the pictures in *Carnival Strippers* might resonate with certain kinds of documentary realist film practice (cf., Frederick Wiseman), and where black-and-white imagery now circulates in mass media as a calculatedly retro style, it would seem to be accurate to view the project as informed by a desire to understand, even as one acknowledges the limits of such an enterprise, and indeed, the limits of photography itself.

How and why these striptease road shows have disappeared, making of *Carnival Strippers* a kind of historical artifact, has many determinations.[5] As English rightly observes, the eclipse of the girl shows had much to do with the advent of newer, glitzier, and more diverse forms of sexual entertainment, along with, needless to say, the "mainlining" of sexually explicit material. As an in-depth visual and aural documentation, *Carnival Strippers* might thus be considered as a sociological or, given the passage of time, historico-sociological study. Equally, it could be approached as a significant example of the genre of photographic documentary; indeed, it was on the strength of this body of work that Meiselas, at the age of twenty-eight, became a member of the prestigious photographic agency Magnum. Yet another way to situate and contextualize the book would be with reference to the more or less contemporary documentary photography books that appeared with increasing frequency from the late 1960s on. This is one of the reasons that the book form is so well adapted to photographic documentary projects in the first place; it permits for narrative structures (either with or without text); it permits for the viewer/

4. Susan Meiselas, *Nicaragua, June 1978–July 1979* (New York: Pantheon Books, 1981); Susan Meiselas, *Encounters with the Dani* (New York and Göttingen: International Center of Photography and Steidl, 2003); Susan Meiselas, *Kurdistan: In the Shadow of History* (New York: Random House, 1997).

5. In this regard, see English, "Stripped Bare."

6. In the introduction to *Carnival Strippers*, Meiselas analogizes the structure of the book to that of the performance it represents: "Any book allows its reader to distance himself. The curtain closing on the girl show stage is replaced by the page turning over. Like the show, the book represents coexistent aspects of a phenomenon, one which horrifies, one which honors."

7. According to Wolf, Meiselas felt a particular kinship with photographers such as Larry Clark, whose book *Tulsa* was published in 1971, and Danny Lyon, whose book *The Bikeriders* was published in 1967. Both books (neither of which employ parallel texts) are meant as collective portraits of marginal groups. Especially in the case of *Tulsa*, the photographer was himself part of the milieu he photographed. I would, however, also mention such remarkable photographic books of the period as Leonard Freed, *Black in White America* (New York: Grossman, 1969), Leonard Freed, *Made in Germany* (New York: Grossman, 1970), Bruce Davidson, *East 100th Street* (Cambridge, Mass.: Harvard University Press, 1970), and Eugene Richards, *Few Comforts or Surprises: The Arkansas Delta* (Cambridge, Mass.: MIT Press, 1973). The point here being that whatever the strengths or weaknesses of these forms of photographic documentary, the period

seems to have witnessed a revival of this particular genre, a development linked to the relative vitality of leftist, progressive, or reformist politics.

8. Rosler, "Post-Documentary, Post-Photography," p. 225.

9. For example, pictures shot by Meiselas in Nicaragua during the U.S.-supported contra wars were deposited in the Magnum library. Once there, *Business Week*, for example, could use a picture she took of people lined up on a street in Managua to receive free milk from the Sandinista government with a caption stating it depicted food shortages.

10. English notes that when Meiselas first brought her pictures to the recently founded *Ms.* magazine, they were not interested. This suggests that absent a kind of exposé-type reportage, it was unclear what the work was intended to *mean*.

11. This absence of an identifiable position within the forms of photographic documentary is traditionally the bugaboo of left photographic criticism, a critique first developed in Walter Benjamin's well-known essay of 1936, "The Author as Producer." Benjamin's criticism, based on the inadequacy of the photograph *qua* image to perform any analytic or explanatory function, has been subsequently seconded by many others—including Roland Barthes and Susan Sontag. But because *Carnival Strippers* departs in so many ways from the conventional forms of documentary, including its use of narrative structure and its deployment of the protagonists' voices, it is, as I have suggested, closer perhaps to the *cinéma verité* of Frederick Wiseman than to those documentaries predicated on the silent image with or without explanatory captions.

reader's reconsideration and reflection; and it allows for intimate as well as more social perusal.[6] Certain of these books are significant *vis à vis* Meiselas's work, not merely because she has indicated their importance for her, but because they exemplify a certain concept of what qualities distinguish the work of a documentary photographer from that of a professional photojournalist.[7] Martha Rosler's description of these differences is useful:

> *Documentary and photojournalistic practices overlap but are still distinguishable from one another. Photojournalists are primarily employed to work on specific journalistic "stories," supplying images while others provide copy, and their feelings and sympathies about what they are photographing remain unsolicited. In contrast, documentarians choose their subjects and treat them as they will, but with no guarantee of publication. In reality, however, many photographers engage in both practices, and the same images may function in both frames as well.[8]*

As a professional photographer, Meiselas has operated on both sides of this putative divide. Moreover, the production of photographers like Meiselas who belong to photo agencies and often work on assignment appears in different venues, at different times, to different ends. If not purchased outright by the magazine or newspaper that initially commissioned them, their pictures often end up in their agency's archives, where they can be reused in any number of contexts with any type of caption.[9] But the distinction Rosler draws here, however blurred in actual practice, is based on the notion of a photographer's *choice*. One might quibble with this insofar as during the heyday of picture magazines such as *Life*, now-canonized documentary photographers such as W. Eugene Smith might choose their subjects *and* be commissioned to shoot them *and* work with the feature's writer. But present-day practice probably conforms more to Rosler's distinction than not. What Rosler does not indicate (although it is implicit in her discussion) is that most photographic production designated as "documentary" and defined as an individually motivated rather than commercially commissioned project would seem to have been generated exclusively from the liberal end of the political spectrum. I can think of no well-known documentary photographer associated with conservative, much less reactionary, politics. Which is not to deny that many documentary projects intended as "progressive" are nevertheless politically problematic: this particular practice and the issues it raises (e.g., paternalism, careerism, exploitation, objectification, etc.) can be traced as far back as Jacob Riis's 1899 *How the Other Half Lives* and has long been the target of left critique.

This critique is worth mentioning in relation to *Carnival Strippers* (in any of its incarnations) because there is little, if anything, within it that permits one to identify a particular politics, a *parti pris*.[10] Which is to say that this is not a project that takes its place in the honor role of "progressive" and ameliorative enterprises exemplified by Lewis Hine's documentation of child or sweatshop labor.[11] Nevertheless, the fact that the project originates at the historical moment of the reemergence of feminism is itself significant, although *Strippers* is not in any simple manner an "obviously," that is to say, tendentious feminist enterprise. Which is by no means to suggest that it is antifeminist, or to deny that it is entirely compatible with feminist readings (as is clear from the essays by English and Wolf). If one is looking for an unambiguous political and

feminist significance in the work, one can easily deduce that in the rural U.S.A. of the mid-1970s, uneducated and unskilled women had (and have) few vocational options, that it was possible for a woman to make more money stripping than working in a sardine factory, that women are subject to abuse from men, and that the world of what pundits like to call the "heartland" is remote from the metropolis. None of these conclusions are especially newsworthy, and do not in any significant way constitute the meanings that *Carnival Strippers* generates.

Part of the difficulty of identifying a clear and unambiguous point of view in *Carnival Strippers* (in contrast to Meiselas's justly famous *Nicaragua*, for example) is that it takes voyeurism as its central thematic, an activity that implicates subject, photographer, and, obviously, viewer. This is the central point to be made and is the source of its power to unsettle and disturb even though we know that *what* we are observing is long vanished. Photographic point-of-view is therefore a central problematic in the work, consistently if implicitly acknowledged through its emphasis on the activity of looking in its external and internal mechanisms, determinations, and significance. The word *stripper* itself is dense with associations even before we bring those to the image. As such, and as Victor Burgin has argued, there is no nonideological viewing position, no innocent eye, no possibility of visual perception or reception independent of already established meanings and connotations. "The structure of representation—point of view and frame—is ultimately implicated in the reproduction of ideology (the 'frame of mind' of our 'points-of-view')."[12] In the broadest sense, therefore, even the pictorial conventions of geometric perspective, or the constitutive acts of framing and cropping, are implicated in producing or reproducing social and psychic relations. Because it so directly engages with these aspects of photographic representation, *Carnival Strippers* raises issues about the activity of looking itself and the forms by which looking is bound up with gender, with sex, by mechanisms of objectification, fetishism, and projection, especially when the depicted subject is to do with the female body. Aside from the activity of striptease itself (to which I will return), many of the photographs in *Carnival Strippers* represent the act of looking itself, sometimes with the performers in the same frame as the spectators, others in which they are absent. Certain of the pictures depict the strippers observing the spectators from behind the curtain that separates off- from on-stage. Still others depict individuals looking at one another, in the midst of some kind of interaction. *Carnival Strippers* can therefore be described as a work about voyeurism and sexual difference. And insofar as the viewer's look replaces that of the photographer, Meiselas's original look through the lens of her Leica becomes structurally and necessarily our own.

Given the prevalence of the word *voyeurism*, a now-commonplace term in film and photography criticism, and, for that matter, in everyday parlance, it is surprising to learn that its initial appearance in English was as late as 1924. It appears first in an English translation of the second volume of Wilhelm Stekel's *Disorders of the Instincts and the Emotions*, where it duly repeats the definition first given it by Sigmund Freud in his "Three Essays on a Theory of Sexuality" (1905). Although he did not return to the subject until many years later, Freud maintained his basic assertion that voyeurism was an independent drive, iden-

12. Burgin, "Looking at Photographs," p. 146.

tifiable in children's sexual curiosity and characterized by the desire to see the body's "hidden parts."[13] Freud's use of the word is sometimes interchangeable with the more clinical sounding "scopophilia," but in either locution he considered the activity as a perversion, exemplified by the activity of the peeping tom. Nevertheless, in keeping with the notion that modern Western culture is characterized by the production and consumption of images, and, more profoundly, that it conforms to Debord's theorization of the society of the spectacle, voyeurism has ceased to be limited to the designation of pathological behavior. This is reflected in the Oxford English Dictionary's examples of the word's history, indicating that by 1976 it could be unremarkably employed as much as a social diagnostic as a form of pathology. Interestingly, the OED refers to photography in one of its examples: "1976 *Listener* 25 Nov. 682/3 A beggar's expression captured by a camera costing enough to feed, clothe and house him for maybe five years. Is this kind of photography good or bad? Is it just an obscene form of voyeurism, a record of what one privileged class finds quaint or interesting in another?"

In terms of both voyeurism and sexual difference, striptease itself might well be considered an exemplary subject, for in most instances this form of performance is based on women removing their clothing, usually to music and sometimes in the form of a dance. Thus, striptease is by definition a quintessentially voyeuristic entertainment in the way that tennis, for example, or tap-dance is not. Although the dictionary definition of striptease allows for its performers to be of either gender ("1. A kind of entertainment in which a female [occas. a male] performer undresses gradually in a tantalizingly erotic fashion before an audience, usu. to music . . ."), the default meaning presumes a woman as the performer.[14] Notwithstanding the phenomenon of male striptease, the spectacle of striptease pivots on what Roland Barthes claimed to be a performance of *de*-sexualization:

> Striptease—at least Parisian striptease—is based on a contradiction:
> Woman is desexualized at the very moment when she is stripped
> naked. We may therefore say that we are dealing in a sense with a
> spectacle based on fear, or rather on the pretence of fear, as if eroticism
> here went no further than a sort of delicious terror, whose ritual signs
> have only to be announced to evoke at once the idea of sex and
> its conjuration.[15]

Given that "Striptease" was written in 1956 and refers only to Paris, it does not necessarily apply to the kinds of performance depicted in *Carnival Strippers*. To state the obvious, the furs and furbelows, jewelry and other accessories, lighting, production values, etc., all operate, as Barthes observes, to occult the presence of a living female body:

> The classic props of the music-hall, which are invariably rounded up
> here, constantly make the unveiled body more remote, and force it back
> into the all-pervading ease of a well-known rite: the furs, the fans, the
> gloves, the feathers, the fishnet stockings, in short the whole spectrum
> of adornment, constantly makes the living body return to the category
> of luxurious objects which surround man with a magical decor.[16]

13. Sigmund Freud, "Three Essays on a Theory of Sexuality," in *The Standard Edition of the Complete Psychological Works of Sigmund Freud* (London: Hogarth, 1953–74), vol. 7, p. 156.

14. The term is itself of modern coinage, the current meaning dating only to 1937, as the OED specifies: "(i.e., "*Daily Tel.* 29 Apr. 22/2 Can anything be said in defense of the present public interest in 'strip-tease' and nudist or semi-nudist displays on stage?").

15. Roland Barthes, "Striptease," in *Mythologies*, translated by Annette Lavers (New York: Noonday Press, 1972), p. 84.

16. Ibid., p. 85.

As for the climax, as it were, of this type of theatricalized striptease—the baring (almost) of the entire body, Barthes's witty analysis makes very clear his debt to Freud's androcentric theory of fetishism:

> . . . *the nakedness which follows remains itself unreal, smooth and enclosed like a beautiful slippery object, withdrawn by its very extravagance from human use: this is the underlying significance of the G-String covered with diamonds or sequins which is the very end of striptease. This ultimate triangle, by its pure and geometric shape, by its hard and shiny material, bars the way to the sexual parts like a sword of purity, and definitively drives the woman back into a mineral world . . .*[17]

"Smooth" and "hard," the "pure and geometric shape," "a mineral world"—here Barthes describes the female body magically and reassuringly transformed into the phallus itself. In arguing that fetishism was an unconscious formation produced by the little boy's traumatic misperception of the mother's body as castrated, a trauma perpetually denied (and therefore memorialized) by fixation on a substitute object, Freud based his conclusions on his analysis of actual fetishists. But like the word *voyeur*, which, as I have indicated, has come to signify sociocultural as well as psychosexual phenomena, so, too, has fetishism come to far exceed the clinical meaning Freud first gave it.[18] Furthermore, the entirely conventionalized insignia of the eroticized female body (high heels, net stockings, garter belts, corsets, and the like) are fairly obvious examples of the banalization of what was once the purview of an erotic underworld, the subcultural domain of stag movies and men's magazines.[19]

Nevertheless, one difficulty with Freud's theory of fetishism is that it so insistently associates female genitals with lack and mutilation as to make it hard to understand why heterosexual men would wish to look at them at all, much less engage in oral sex.[20] Many feminist theorists generally deal with this contradiction by yoking together a wide array of responses as alternatives to the formation of a literal fetish object. These include, *pace* Barthes's striptease description, the transformation of the female body itself into a fetish (permitting its overvaluation or idealization no less than the denial of its supposed mutilation), obsessively investigating it, punishing it, and so forth.

As it happens, the strippers Meiselas photographed avail themselves of little in the way of accessories that might hide, much less transform, the visceral and carnal reality of the female body. In this respect, Meiselas's photographs of the strippers "working strong," splaying their legs to display their sex, enticing or merely permitting the spectators to perform cunnilingus, might seem to belie the fetishistic structures of the masculine gaze. But certain pictures of male spectators—especially two pictures of seemingly spellbound young boys—remind us of what was so central, and still so disturbing, in Freud's work. I refer here to Freud's theory of the unconscious mind, and its corollary manifestations of the irrational, the contradictory, and the phantasmatic, including the mechanisms of sexuality and the difficulties that attend the negotiation of sexual difference. Certainly one of the many troubling aspects of *Carnival Strippers* is its unflinching testimony to the violence to which women are subjected, be it the violence of social, familial,

17. Ibid.
18. Sigmund Freud, "Fetishism," in *The Standard Edition of the Complete Psychological Works of Sigmund Freud* (London: Hogarth, 1953–74), vol. 21.
19. See in this regard the classic essay by Laura Mulvey, "You don't know what's happening, do you Mr. Jones?" in her *Visual and Other Pleasures* (Houndmills, Basingstoke, Hampshire: Macmillan, 1989).
20. Apropos of heterosexuality, in his essay on fetishism Freud hypothesized that recourse to fetishism operates to prevent men from becoming homosexual. Freud was, needless to say, a man of his time, class, religion, etc. He considered everything except heterosexual vaginal intercourse as more or less a deviation from the norm (even as he relativized the very concept of the normal) and in a number of his writings indicated his opinion that no one could possibly find genitals "beautiful."

intimate, or professional relations. That the sex acts that occurred in the course of performance were so highly fraught, that—as Freud indicated—men's responses to the recesses of the female body are at the very least ambivalent, is amply demonstrated in one of Lena's horrifying accounts: "I have been pulled off the stage and beaten and I've been stepped on and I've had people cut me. I know that the guys that come in here have to be a little bit off—a lot of them are really sickies. Especially the ones who come in every show . . . They say come down here and they bite your clit, the blood's running down your leg . . ."[21]

Looking at these pictures, reading these texts so many years after they were made, acknowledging the "pastness" that is the condition of all photography does not appreciably diminish their effects. Moreover, the knowledge of at least one of the women's deaths, that of Lena, so vividly alive when Meiselas photographed her at eighteen, the first day she was hired as a stripper, provides its own somber coda. But the more important point is that the *Carnival Strippers* of today is not the *Carnival Strippers* of 1976, and not only because its form of presentation or exhibition is different from its earlier presentations. When Meiselas first decided to devote herself to the documentation of what was likely an utterly alien milieu, the reemergence of feminism and the various groupings and political formations of the women's movement were still relatively recent. And just as feminist theory and politics posed searching questions about real women in the real world (including complicated issues around sex work, pornography, and the commodification of women and their bodies), so, too, did it pose challenging questions about gender and representation, the politics of looking, the mechanisms of dominance and subordination as these were played out in all aspects of women's lives. Within another subculture—that of professional documentary photography and the still nascent world of contemporary art photography—such questions were not wholly absent. Indeed, this was the period when critics and theorists of various stripes reanimated the field of photographic inquiry. Thus, if *Carnival Strippers* was considered controversial, or objectionable, or incomprehensible *as* the project of a young woman photographer, it was because so many of these issues, questions, problems were on a political as well as a theoretical agenda. That these have apparently been wholly eclipsed by the infinite capacity of contemporary culture to neutralize or transform even the imagery of abjection into easily consumable spectacle should give us pause. As Rosler has mordantly remarked, "Voyeurism as a naked motive for photography is increasingly expressed and rewarded, in art and mass culture, even in polite society."[22]

But it is not just voyeurism that is at stake; it is no less the case that an unapologetic fetishism—perhaps one should say an unembarrassed fetishism—seems not only ubiquitous, but possibly invisible as such. What else is one to make of a recent exhibition by Philip-Lorca diCorcia entitled *Lucky Thirteen*, a series of large-scale (5½ x 4 feet) color photographs of mostly nude pole dancers? These are tellingly described in the Pace/MacGill Gallery's press release:

> DiCorcia's pole dancers are suspended in time and space within the theatrically transfigured environments of strip clubs . . . "Lucky Thirteen" is, at its essence, a series of psychologically penetrating portraits.

21. Meiselas, *Carnival Strippers*, p. 85.
22. Rosler, "Post-Documentary, Post-Photography," p. 229.

*Referred to by their stage names—Harvest Moon, Lola, Pepper, Sin—
the women in diCorcia's photographs can be likened to sculpture
insofar as they are simultaneously immortalized and monumentalized.
The dancers' bodies are rigid and their expressions appear as if frozen;
diCorcia abstracts the dancers into a realm that is larger-than-life.*

To characterize these as "portraits" is, to understate, quite a stretch, but
like the photographs themselves (significantly described in the press release
as "rigid," "sculptural," and "monumental"), diCorcia's nudes are textbook
examples of photographic fetishism. In terms of their lavish production values
as well as their physical scale, they bespeak the grandiosity that is fully in
keeping with the inflated and voracious art market that fostered, if not
generated, their production in the first place. Their most recent display this
summer at the Los Angeles County Museum of Art is a reminder, should we
need one, that museums are more than willing to legitimize whatever the
marketplace endorses. These are images that have little or nothing to do with
the putative "psychology" of women pole dancers, notwithstanding the actual
women who were photographed, but everything to do with the patriarchal
imaginary, the ultimate source of the fetish's formation.

But in its admixture of sensationalism, cynicism, and artistic pretension,
Lucky Thirteen serves to further illuminate the psychological depth and
complexity, critical self-awareness, and great integrity of Meiselas's project.
Inasmuch as many of her photographs are indicative of her taken-for-granted
presence among the women, it is evident that she was not perceived as an
interloper, was, in certain cases, a confidante or friend. That this was possible
given class, age, and other differences was surely facilitated by Meiselas's
personality, character, and the respect she accorded the women whose
working lives she depicted. But even judging from the photographs alone, it
seems clear that Meiselas understood that sex work (of any kind) is, before all
else, *work*. "*Carnival Strippers*," observes English, "is, as much as anything,
a social documentary about a workplace." Such a perception was hardly wide-
spread in the early 1970s; the all-purpose designation "sex worker" for those
who sell their sexual services postdates *Carnival Strippers*. The photographs
of the strippers in states of fatigue or exhaustion are thus as essential to the
project as those depicting the spectators and performances. In this and in
other respects, one can see that even as Meiselas drew on her own instincts,
her picture-making artistry, her own emotions, investments, responses, so, too,
did she bring to her work an understanding of the politics of representation
well before these were fully theorized elsewhere. It seems retrospectively
obvious that Meiselas conceived and developed her work (including her non-
judgmental recognition of stripping and prostitution as labor) within the frame-
work of the progressive and critical impulses emerging from the late 1960s: in
the work's manifest acknowledgment of economic inequities, sexism, misogy-
ny, violence against women, in its willingness to explore the complicity of pho-
tography as medium with the entwined operations of spectacle and voyeur-
ism, and hardly least, in its capacity to reflect on the photographer's own com-
plicated role as agent and observer. In this regard, *Lucky Thirteen* might well
be considered as a kind of epitaph to the complex and serious themes that

Meiselas took on as her own. Although the manifest *differences* between Meiselas's project of 1976 and that of diCorcia's in 2006 are in all respects greater than the single motif that appears in both (i.e., the spectacle of eroticized femininity), it is perhaps the *distance*—political and ethical, no less than artistic—that separates these two bodies of work that is the most troubling and disturbing issue of all.

"Beyond our ever knowing":
Susan Meiselas and the Necessity of Return

Caroline Brothers

Susan Meiselas is a long-exposure photographer. In an era of high-speed image-making, when the Internet sends cellphone videos spinning instantly around the globe, the significance of her work can take years to be fully revealed. Her raw material is time—sometimes whole decades of it—as much as light, and because of it, her pictures are constantly on the move. Their meanings defy the rigidity of the frame in acquiring a second and sometimes a third life so that for her, snapping the shutter is not the end, but only ever a beginning.

It is above all her commitment to going back—to the people she once photographed, to the places she once lived—that makes her images so susceptible to change.

Whether to the carnival strippers of her earliest major work, or to Central America whose resistance movements propelled her to the cover of the *New York Times Magazine*, or, more recently, to the fragile communities of Kurdistan, the idea of return is a defining one for Meiselas; the necessity of it runs through the entire body of her work. Yet each return to the scene of a photograph is also a new journey because in doing so she discovers new things: facts she could never have known in the heat of conflict that inflect or transform the reading of a picture; knowledge of what the protagonists of her images achieved, or failed to achieve.

Out of her unfinished business with the past, then, Meiselas sets new things in motion. She identifies the points at which history telescopes into memory. She lifts her photographs out of their immediate context and fits them back into the longer narratives of her subjects' lives, restoring a personal dimension to eminently political acts. Meanings in a Meiselas photograph are never fixed, but take jolting, ninety-degree turns; what is captured in the split-second moment of creation gets layered with richer, and sometimes more complicated, truths. No other photographer so consistently breathes life into what was frozen and sets it back in motion, freeing her subjects from their quadrilateral frames and giving them back their history through her impulse always to return.

Going back, Meiselas says, is driven not by nostalgia, but by an urge to understand what she encountered the first time round. There is also caring and curiosity about what followed. She seeks to rekindle sparks and discover what happened after she, the photographic moment, and the world's attention moved on. Things stay with her, and years later, the faces in her slow-burning pictures still live with her and inhabit her imagination.

Underlying her desire to return is a sense of responsibility that is connected to her discomfort with the photographer's usual role of taking away and not giving back. Meiselas is among those who regret the demise of the Polaroid, which allowed her to give pictures on the spot to people who had never owned a camera in their lives, so that taking a photograph also became a gesture of respect. The mere act of photographing generates an unspoken pact with her

subjects that has its roots in empathy and a deep respect for what is human, and makes the idea of returning empty-handed almost unthinkable for her. For there is a powerful sense in Meiselas's work that her photographs are artifacts that only partially belong to her, and need to be repatriated—not just personally, as in the case of the carnival strippers, but communally and culturally, with regard both to her work in Central America and to her monumental gathering of photographs of Kurdistan. "We take pictures away and we don't bring them back," Meiselas said in a recent conversation. "That became a central quest for me—relinking, revisiting, the repatriation of work: it's become a kind of motif in my thinking."

This motivation to circle back was present in the work she did even before *Carnival Strippers*, when she took her first portraits at a boarding house in Cambridge, Massachusetts, and brought the pictures back to show to their subjects. Then, it was a way of opening a space for discovery, for seeing the things she might have missed, for delving into the camera's blind spots. At the same time, she was exploring the very notion of seeing, and the mysterious gulf between representing and being represented. "I was fascinated by the difference in how I saw people and how they saw themselves," she said. "I wanted them to look at the photographs and tell me what they did or didn't share about who they were." In a sense, she was learning new ways to see.

Later, her returns were driven by other things—caring, conscience, and curiosity about what happened after she left evolved into a desire to reconnect, and an urge to anchor a history in danger of being erased.

Meiselas herself is aware that returning to the scene of a photograph is a rarity in a journalistic world that discourages involvement in its restless quest for the new. "I think the tendency to want to move on and do something new is very strong, to move on with the story, to be current," she says. "You say that's enough, and maintain your distance." Her willingness to turn back sets her apart from a modern zeitgeist that, almost by definition, is not reflective.

"It's a strange experience in that the photograph is like an object that is frozen in time, and people's lives go on. There is something in that space, re-visiting and rethinking, of my trail crossing theirs and how they feel about it," she says of return journeys she has undertaken that have so often added a deeply personal layer to pictures that remain overtly political.

Alma Guillermoprieto, who first met Meiselas as a young journalist in Central America, recognized early on Meiselas's desire to go beyond the superficial in relating to the people in her frames. "What distinguishes Susan's work—aside from its great beauty—is her insatiable desire to connect with the subject," Guillermoprieto said. "It is true that she examines her approach to a story and agonizes over it endlessly in order to make sure she isn't turning her subject into an object, and that she knows as much as there possibly could be to know about a given person or circumstance while she is shooting."

Guillermoprieto discerned an "almost erotic" charge in the intensity of Meiselas's attachment to her subjects: "She will photograph someone over a period of years, or return ten years later to catch up, and she frequently maintains a personal relationship with her subjects long after she has finished a shoot."

After the portrait series, Meiselas's compulsion to go back developed at the time of *Carnival Strippers*—her first major body of work and the one that brought her to the attention of Magnum—into a more active exchange with

her subjects. This time, in returning, Meiselas allowed them more than a passive role in their own representation.

Because she could only follow the girl shows as they moved around New England on weekends, she had a chance to develop her contact sheets and bring them back with her the next week. "I would go home to Boston and process them and come back to the women," she said. Then she would show them their photographs. "They'd see how I saw them," she said.

Accompanied by sometimes revelatory interviews with the girls, their managers, and the men they entertained, the pictures she published confront the viewer with the un-airbrushed realism of a Brassaï or a Diane Arbus, and push back at the viewer's own sense of voyeurism. But her nonjudgmental vision of sometimes disturbing acts—which she put to the test again years later in photographing the New York S&M club, Pandora's Box—is Meiselas's own. The women would initial frames on her contact sheets if they wanted copies. In a process that inversed the usual power relationship between photojournalist and subject, she not only gave them portraits to give their boyfriends or use to get auditions for other acts; she also made the pictures they selected an integral part of her 1976 *Carnival Strippers* book, and included more of them in its 2003 reproduction.

Meiselas recalls her disappointment if a girl had left the show before she could return, depriving the photographer of the stripper's response to her own image. In compensation, however, there was the constancy of friendships with women like Lena and Shortie that developed over the course of the project.

Nearly thirty years later, it was her relationship with the women, rather than any "then-and-now" frisson, that rose to the fore when Meiselas agreed to reexhibit those photographs at the Whitney Museum of American Art in 2000. After her initial shoots, and her return with the contact sheets, Meiselas decided to seek out the women she had photographed once again, and the passage of time gave the pictures she had taken in the early 1970s a new depth of meaning.

Lena, whom Meiselas photographed as a baby-faced eighteen-year-old in home-made spangles the day she debuted as a stripper, and whose image recurs in various guises throughout the work, had died of an overdose; others had disappeared without a trace. But some Meiselas did manage to track down, and often the encounters were unsettling.

One, named Stormy, had left the road a year after Meiselas photographed her, had revamped her life and become a bank clerk. Meiselas discovered her renting an apartment in a nursing home near Philadelphia, although she was not disabled. With a shock, Meiselas learned that the woman was just five years her senior. Another, Debbie, was living within a mile of her mother—an irony given that she and Shortie, in order to become strippers in the first place, had run away from home. Other encounters were more painful, and reinvest the hardcore grit of these images with great poignancy.

"With Shortie I had a very dramatic contact—she had a child at the time I knew her and this child, he felt extremely betrayed and abandoned by her," Meiselas said. "He felt so angry at her for being a stripper, and having been abusive to herself really, drugs, drinking and all that kind of stuff, and later in life he didn't want to be in touch with her." Yet Shortie still had her costume, and told Meiselas that she would do strip shows again if she could. "Neither Debbie

nor Shortie actually rejected or regretted their past, but it had cost them something in terms of their family," Meiselas said.

This later knowledge changes how we see those pictures. Potent symbols of defiance, neediness, and exploitation in puritan New England in the context of early feminism, they morph into something even more complex when one learns the price these women paid for their circumscribed freedom.

Meiselas's interest in return lies not in the tradition of before-and-after pictures, in the way *Fortune* magazine in 2005 searched out the families and descendants of the people Walker Evans photographed in the Great Depression, or the way Steve McCurry returned to Afghanistan in quest of the girl with the green eyes who was featured twenty years earlier on the cover of *National Geographic*. Indeed, when she finally located the strippers, Meiselas neither photographed them nor transcribed their interviews. "I was much more interested in how they remembered their former lives," she said.

You get the sense that sometimes, for Meiselas, other things take over, that she knows when to put down the camera and stop shooting. "I think I probably have more doubt about the necessity to just produce more pictures," she says.

When she saw Meiselas's photographs of the carnival strippers, the late Magnum photographer Inge Morath wrote that Meiselas had attained "that state of near-invisibility and empathy that is required in the approach of delicate subjects." That same empathy and near-invisibility continued to characterize Meiselas's work as she moved on from the girl shows of New England to Latin America, and later still, to Kurdistan.

Meiselas regrets that working conditions in Central America, where she covered the civil wars in Nicaragua and El Salvador in the late 1970s and early 1980s, meant that she had no contact sheets to show her subjects there. Rolls of color film were dispatched to New York for processing. War also made it difficult to find many of her subjects once they had been photographed. But the sense of obligation, and an ongoing desire to give back, remained with Meiselas until she was able to return to Nicaragua a decade later. The resulting 1991 documentary, *Pictures from a Revolution*, is a kind of road movie of her journey revisiting the places where she worked as a twenty-eight-year-old freelancer on her first international assignment. With little more than the pictures themselves to go on, she seeks out the faces in her photographs, showing those she encounters copies of images that have gone many times around the world, often unbeknownst to their subjects.

One of the most memorable encounters is with Augusto López-Gonzáles, whom she had photographed in a street, a .22 rifle in his hand and a bandanna round his head, pointing and shouting something urgent to his *compañeros*. When she finally locates him in 1989, by word of mouth and by going from house to house with her book *Nicaragua* in hand, his wife produces a creased copy of a local newspaper in which Meiselas's same photograph of him was printed, dog-eared and torn but still intact [p. 160]. Her picture had become a touchstone for him, too, and the way he related to it, with a mixture of precision and pride, was revelatory. With his children crowded around, he fills in the context of the photograph for Meiselas, telling her that he was standing outside the Masaya movie theater, close to the National Guard barracks, and that

his rifle contained a mere six bullets. "I was saying, 'Here come the guardia!'" he tells her. "We were fighting with our hands, with our fingernails, with contact bombs, with .22 rifles, because we didn't have automatic weapons."

Meiselas had no way of knowing at the time how very little ammunition he had, and this later knowledge changes how she, and how we, view the photograph. At the time, she sensed his exposure instinctively. "Seeing a man on a street with a gun was the most vulnerable act and yet a tremendous affirmation," she says in the film. "I saw it as a heroic moment and then the image took on a life of its own and became a greater symbol. I wanted to see the man behind that symbol."

She photographs his six children lined up from biggest to smallest, and films the cottage industry production of caramels upon which their survival now depends. She records Augusto and his wife carrying the candy in boxes on foot to the nearest store. "We make a superhuman effort just to survive," Augusto tells her of their life after a revolution that failed to fulfill their hopes. "We have six children. We have to do better than this."

Her return to Nicaragua and her encounter with Augusto, whose personal story seems to encapsulate the history of the country's revolution for Meiselas, open her photographs of that time to fresh interpretations. Her film brings new knowledge of the degree of risk, and the hardness of outcomes, in a way that shifts the thrust of those photographs from the drama of conflict to something much more nuanced.

"I needed to believe it was possible to change something, that's why I was so powerfully moved in Nicaragua, because they were willing to risk their lives just believing in the possibility," Meiselas says in the film. But the experience of return was painful. "To come back after the kind of war they fought and see the same houses with dirt floors, and the swollen bellies, and nothing moving fast enough, was just impossible," she said.

Another encounter was just as intense, but in different ways. Meiselas manages to track down a woman she photographed a decade earlier in a red dress, pausing and turning back as she pushes the dead body of a man on a wheelbarrow. Grief and remembered anger course across the woman's face when Meiselas shows her her published photograph. Neighborhood children gather round as they talk, fleshing out the people in the picture with feelings, stories, names. She tells Meiselas things the photographer could not have known or did not recall—that she was fourteen years old at the time; that no one would help her bury Maximo, her husband, who had just been killed; that she had to tie him to a plank with ropes and move him on the barrow on her own. Nor could Meiselas have known that the dress, whose bright vermilion makes the dark photograph so luminous, nearly cost the woman her life because it made her a target; she describes bullets raining down from helicopters, and having to use her husband's body on the wheelbarrow as a shield.

The woman recalls Meiselas taking the photograph, but she had never seen the picture itself. Under her gaze, details leap out newly charged with significance. She points out Maximo's shoe just visible in the corner of the frame, and tells Meiselas his footwear was brand new, and that although she had no coffin she was able to bury him honorably, still in his shoes. And that the earrings she was wearing as they spoke were the same ones that caught the light in the anguished photograph Meiselas had taken ten years before.

Meiselas takes a new picture of her, this time with her youngest child on her knee. As Meiselas hands her the still-developing image, you realize she has never seen a Polaroid photograph before. The woman laughs and covers her silver teeth, and it is hard to believe she is only twenty-four [p. 160].

Meiselas's next major act of return was for the twenty-fifth anniversary of the Sandinista uprising, when she brought giant reproductions of her pictures back to Nicaragua and displayed them in the places where they were taken, thrusting history defiantly into a present that had moved on. The 2004 film of that project, *Reframing History*, shows little boys born long after the revolution looking up at the photograph she now calls Molotov Man, in which a man hurls a Molotov cocktail over a barricade, and you wonder what they know and don't know of their parents' lives.

She finds the wall on which graffiti was once scrawled, hurriedly, black on pink: "Where is Norman González? The dictatorship must answer," and erects a lifesized reproduction of the photograph before it that speaks, in its anguish and its clandestine defiance, to all Latin America's disappeared.

The most harrowing of all her photographs—indeed it is among the most harrowing war photographs ever taken—is a kind of counterpart to that picture of graffiti. Against a serene backdrop of mountains and lakes, a mauled backbone in a pair of jeans lies beside a dismembered arm on a lonely hillside where the bodies of the disappeared were dumped and preyed upon by animals. It is an atrocity photograph whose shockingness stills words; it still changes people who see it [p. 133]. At the same time, it depicts, in a sense, Meiselas's own loss of innocence; though she had heard of such things happening, and that bodies were discarded in such a manner even more regularly in places like El Playón outside San Salvador, this was the first time she had smelt, and then seen it for herself.

"Disappeared bodies didn't mean anything until you confronted it," she said of a place, and a moment, of manifest horror. She strings up a copy of that photograph, too, in the now peaceful landscape where it was taken, like a sort of memorial, and the fulfillment of an obligation.

Meiselas's journeys to Kurdistan mark yet another shift in the process of exploration and return, another chapter in the weaving of relationships. Though she takes her own photographs there—she tracked the aftermath of Saddam Hussein's assault on the Kurdish people in Northern Iraq in the early 1990s, venturing into devastated towns, photographing the unearthing of mass graves—her subsequent involvement has taken a completely different turn. In a way, she is stepping back from her own photographic imperative so as to privilege the work of others. In establishing a web-based photographic history of the Kurdish people, she has mined archives, connected with Kurdish diasporas around the world, and traveled across the region in search of old family pictures—vernacular photographs preserved in private albums and homes—that she has assembled online and in a landmark book, *Kurdistan: In the Shadow of History*, which she published a decade ago.

Even more than her book on the carnival strippers, the Kurdistan project was generated collaboratively and communally, and involved its subjects centrally in their own representation. Traveling to remote Kurdish communities with early versions of the book in hand, Meiselas was meticulous in seeking

the responses of Kurdish scholars and families to the history she was assembling. Photographs taken by journalists, missionaries, anthropologists, and travelers, some produced so long ago they lay forgotten in the attics and archives of distant countries, were included alongside pictures that had been cherished within families for decades. With painstaking care, she worked in makeshift darkrooms, mixing her own chemicals to recover images from glass negative plates that one owner kept buried for safekeeping in the earth. The process was a marathon undertaking; the result is a vast project of repatriation that restored a dispersed history to the culture from which it sprang. "I can't escape the tradition of the colonial foreigner," Meiselas wrote in her introduction to that book. "I travel and collect, take and treasure, classify, consume and possess. Yet I also feel the need to repatriate what I uncover as I attempt to reconstruct the past from scattered fragments."

Meiselas's return to the region in late 2007 was less formulated than her other journeys back, but was no less full of surprises. She was amazed at how many people had returned to make new lives from very disparate parts of the Kurdish community, allowing her to renew relationships she had previously struck both there and abroad. "'You've come back!'" people said to her. "It led on from there," she said. "There were lots of different encounters in wonderful ways."

She found her way back to an old photographic studio in Sulaymaniyah, in the north of Iraq. "It was still plastered with photographs just as it was in the early 1990s," she said, and spent time with its owner, Rafiq, who feared that his son would not be able to continue his work.

For a photographer of her standing, the self-effacement of the Kurdistan project, in which Meiselas works more as a photo editor than a photographer in her own right, might seem curious. In a sense, though, it is consistent with how she has always worked in that, for her, the camera always has been an instrument for engaging and forging relationships with the world. As with the carnival strippers she tracked down years afterward, those relationships can sometimes be more important to her than simply taking more pictures of her own. At the same time, the act of return puts her in the path of serendipity. "Things happen because it's out of control," she says of the way published photographs so often have a life of their own. "There is this splintering out, and so many things happen because other people are touched and moved by it way beyond our ever knowing."

The impact of a photograph may well be beyond our ever knowing, but returning images to the places and people that figure in them is a way, at least, of restoring some control to their protagonists. Ultimately, however, you sense it is not their reactions, not new knowledge, not necessarily even a desire to ensure that her own or others' photographs live on that is her primary quest. Instead, it feels more like a sense of completion, the squaring of circles, of making things right—a way of taking things home.

"So often the pictures are not seen back in the culture from which they come," Meiselas says, in remarks that could refer as easily to New England or Kurdistan as Central America. "But it's not just me going back," she adds. "It's putting things where they belong."

"An Amplitude That Information Lacks"

David Levi Strauss

**If you've been to India, you see the storytellers sitting on
the side of the road; people come by and listen to a section,
throw in a few pence, and leave. The storyteller goes on.
—Nicolas Roeg**

In the summer of 1975, I'd finished my first year at Goddard College in Plainfield, Vermont, and stayed on to work for the local farmers. The scale of farming was very different in Vermont than what I was used to growing up in Kansas. These hardscrabblers planted a bit of everything, put up a little hay, kept a few cows, chickens, ducks, sheep, and hogs, and did everything themselves in a makeshift way. At the end of the week, we sons and hired hands went out looking for trouble, and usually managed to find it, in the small towns scattered among the Green Mountains.

I had just turned twenty-two, but had already been around the world and seen some things. Even so, the traveling "girl shows" that came through towns like Rutland and Hardwick shocked me. The spectacle of drunken farmers and lonely woodsmen lining up to ogle and grope down-and-out battered women in the back of trucks was like nothing I'd ever seen. I was curious at first, but seldom went beyond the front stage, where barkers displayed the girls like livestock before separating the rubes from their money and herding them in. The men's actions didn't surprise me much, but I couldn't figure out why the women put up with it.

That next spring, back at Goddard, my photography teacher Jeff Weiss gave me a new book called *Carnival Strippers*. The author, Susan Meiselas, had somehow gotten inside the girl shows, and told the story with the simplest of means: saturated black-and-white photographs of the scene and players juxtaposed with straightforward testimonies of participants from both sides of the "stage." Meiselas managed to catch it all—the strange symbiotic relations between "the talkers" and the girls, the mind-numbing tedium between shows, and the camaraderie and intimacy among the women, outside of their anaesthetized stupor. And underneath it all lay the tawdry theater of desire on which all consumer advertising depends, leading to the monotonous hustle: the come-on, the tease, the exchange of money, the bait-and-switch, and the inevitable letdown.[1]

Meiselas's approach was remarkably cool and impartial, but not clinical or dull. If one looked at the images and read the statements by the strippers closely, it was clear that Meiselas had found something here with which to identify, and risked the exposure. This is Lena, who appears on the cover of *Carnival Strippers*:

*Maybe I'm a daredevil, because I've always preferred being around
men to being around women. I can identify with men. The girls I hung
around seemed so finicky and childish. They seemed like they had to
have somebody to make them whole. The men were more open.
They could do or become anything they wanted to. They didn't whisper*

1. Twenty-five years later, Meiselas took this tawdry theater into another socio-economic realm, photographing inside the exclusive S&M club Pandora's Box in Midtown Manhattan, where wealthy executives went to get a little "discipline" from Mistresses Raven and Delilah (*Pandora's Box, NYC* [London: Magnum Editions, 2001]). As in *Carnival Strippers*, questions about power and agency are put into a frame where the answers become much more complicated (and revealing) than before.

107

about people. . . . I don't want to be like a man, I want to share with men. I still want to be a woman, but I want to be able not to whisper. . . . Being a stripper is as close to being in a man's world as you can be.[2]

I had seen the girl shows from a distance, but Meiselas got up close, and told the story in a way that allowed me to understand something about them that I never would have gotten to on my own. Her storytelling carried a strong implicit political critique, without ever stating it explicitly. She represented the people involved with dignity and respect, but revealed the brutality of the situation they found themselves in truthfully, without pulling any punches, in a way that implicated us all. She made this look easy, but I knew it wasn't. And I wasn't embarrassed by the method, but I noticed that a lot of other people were.

More and more often there is embarrassment all around when the wish to hear a story is expressed. It is as if something that seemed inalienable to us, the securest among our possessions, were taken from us: the ability to exchange experiences.
—Walter Benjamin[3]

Wanting to hear each others' stories is an embarrassment because it means we've already lost something. Telling someone else's story puts one in an almost untenable position. *How dare you put yourself in that position!* And yet, without the risk, so much would again be lost.

After *Carnival Strippers*, Meiselas was accepted into Magnum and went off to cover the war in Nicaragua, publishing her chronicle of the revolution, *Nicaragua, June 1978–July 1979*, in 1981. Once again, she told the story in her own images and in the words of the people involved in such a direct and full way, and in a self-implicating way, that it became the story for a generation in and outside of Nicaragua that saw real hope in that struggle.

But the Nicaragua book also came out into the teeth of a trenchant new critique of the whole documentary approach. This critique held that documentary practice (the art of telling other people's stories) was so contaminated by the underlying assumptions of colonialism and imperialism that it could never serve a radical purpose. It held that documentary works like Meiselas's were products for consumers in the United States, selling the hope of political action while in fact helping to preclude such action, by making of it a spectacle, and an *image*. Books like Meiselas's were based on exploitation, a manipulation of history for the aggrandizement of the individual heroic photographer. In her groundbreaking essay, "In, around, and afterthoughts (on documentary photography)," first published in 1981, the same year that Meiselas's *Nicaragua* appeared, Martha Rosler wrote:

Documentary testifies, finally, to the bravery or (dare we name it?) the manipulativeness and savvy of the photographer, who entered a situation of physical danger, social restrictedness, human decay, or combinations of these and saved us the trouble. Or who, like the astronauts, entertained us by showing us the places we never hope to go. War photography, slum photography, "subculture" or cult photography, photography of the

2. Susan Meiselas, *Carnival Strippers* (New York: Farrar, Straus & Giroux, 1976), p. 148.
3. Walter Benjamin, "The Storyteller," in *Illuminations: Essays and Reflections*, edited by Hannah Arendt (New York: Schocken Books, 1969), p. 83.

David Levi Strauss

(Nicaragua, pp. 128–173)

foreign poor, photography of "deviance," photography from the past—
W. Eugene Smith, David Douglas Duncan, Larry Burrows, Diane Arbus,
Larry Clark, Danny Lyon, Bruce Davidson, Dorothea Lange, Russell Lee,
Walker Evans, Robert Capa, Don McCullin, Susan Meiselas . . . these
are merely the most currently luminous of documentarian stars.[4]

In a review of Nicaragua first published in In These Times in June 1981,
Rosler moderated her view of Meiselas's contributions a bit, and blamed more
of the shortcomings of Nicaragua on its publishers. And when the complete
version of the review was later included in her collection Decoys and Disruptions,
Rosler prefaced it by saying that "In the intervening years I have gotten to
know Susan Meiselas, and my admiration for her commitment, skill, and re-
sourcefulness . . . has grown."[5] But that did not prevent her from reprinting
the essay as it was, beginning by lampooning the narrative of Meiselas's book
as a "fairy tale":

Once there was a brutal dictator in a small banana republic in steamy
Central America who so abused his people, grabbing most of the wealth,
stifling initiative, and causing misery, that waves of discontent spread
throughout the entire population until finally peasants, lawyers, house-
wives, businessmen, and even priests and nuns rose up in outrage.
Despite incredible atrocities, they eventually succeeded in driving out
the beast and his minions, and they looked forward to living in peace
forever after.[6]

Rosler questions "the book's ability to inform and mobilize opinion," be-
cause of its inclusion of "mystery" and "romance." She points to the incom-
patibility of information and story, or news and art, concluding that "as 'art'
takes center stage, 'news' is pushed to the margins," leading to "an antirealist
effect."[7] The assumption is that art is inferior to news, and story is inferior to
information, when it comes to political effect.

This critique of documentary is largely based on a set of assumptions
about how this kind of work is actually received and used by the public. When
I first met Susan Meiselas in San Francisco in 1991, she questioned these
assumptions:

I think that one of the things that's difficult about this whole area is
that we really don't know very much about what happens when people
look at photographs. We assume things. Theorists assume a great deal,
and they often raise questions that are legitimate and valuable, but
their analysis is not often based on real research I think it is an area
about which we know very little, certainly not enough to make the kinds
of assumptions we're dealing with here.

In thinking about political effects, you have to ask to what extent is
politics about action and to what extent is it about creating conditions
for action. As much as I have at times wanted someone to do something
in response to having seen an image that I made, I don't know that
there's any proof of that. People have told me they saw my book and
then went to Nicaragua and spent the next five years of their lives, but
who knows what role the book actually had in that process?[8]

4. Martha Rosler, "In, around,
and afterthoughts (on docu-
mentary photography),"
in Martha Rosler: 3 Works
(Halifax: Press of the Nova
Scotia College of Art and
Design, 1981); reprinted in The
Contest of Meaning: Critical
Histories of Photography,
edited by Richard Bolton
(Cambridge, Mass.: MIT Press,
1989), quote p. 308.
5. Martha Rosler, "Wars and
Metaphors," in Decoys and
Disruptions: Selected Writings,
1975–2001 (Cambridge, Mass.:
MIT Press, 2004), p. 245.
6. Ibid., p. 246.
7. Ibid.
8. David Levi Strauss,
"The Documentary Debate:
Aesthetic or Anaesthetic?
Or, What's So Funny About
Peace, Love, Understanding,
and Social Documentary
Photography?" Camerawork:
A Journal of Photographic Arts
19, no. 1 (Spring 1992), p. 8.

Meiselas has spent a great deal of time in recent years trying to increase her understanding of the reception of images and their effects. She has returned to Nicaragua to find out what happened to her images and people's memories of them. When filmmaker and anthropologist Robert Gardner returned to the Baliem Valley in Papua New Guinea in 1988, looking back to the Harvard Peabody Museum expedition of 1961 and his film *Dead Birds*, Meiselas went with him to find out what had changed, and ended up making the book *Encounters with the Dani*—a recollection in images and words of the cultural impact of previous images and words on the Dani people.[9] When Meiselas returned to Chile in 2006, I was lucky enough to accompany her as she revisited the brave photographers of the Pinochet years, whose work she collected and published in the book *Chile from Within*.[10]

Meiselas's goal for the past thirty-five years has been to find effective ways for her chosen subjects—from women in the girl shows in New England, to peasant revolutionaries in Nicaragua, to the Kurdish people—to tell their own stories clearly, forcefully, and memorably. The principle assumptions underlying this documentary drive are the reciprocity of experience, and the idea that the experience of an individual or group can be communicated to others through an intermediary; and, further, that such communication of experience is salutary, that it can lead to greater understanding.

These assumptions or beliefs can be fairly characterized as "liberal," in the sense of leading to reform rather than revolution and emphasizing individual freedom over the claims of the community or the state. And these character-izations have brought documentary practice as a whole into the larger debates about the limits and failures of liberalism, especially concerning its tendency toward moral indifference—seeing morality as a private rather than a social and political matter—and, worse, moral philistinism—promoting individualistic, selfish, middle-class values to the exclusion of more public, social values. This is exactly what Rosler was aiming at in 1981:

> The liberal documentary, in which members of the ascendant classes
> are implored to have pity on and to rescue members of the oppressed,
> now belongs to the past. The Jacquelines of the world, including
> Jacqueline, dance on its grave in upholstered mausoleums like the
> home of "Concerned Photography," Cornell Capa's International Center
> of Photography, at its ritzy New York address.[11]

But Meiselas's work in Nicaragua certainly complicates these characteriza-tions. This was, after all, the documentation of a revolution, a revolution that was continually and blatantly misrepresented by the U.S. press and by U.S. government propaganda (President Reagan called the Sandinistas "terrorists"), and undermined by counterrevolutionary military forces, or "contras," backed by the U.S. government, first directly, and later covertly. Meiselas's book was an incendiary device thrown into that history. As she said in her epigraph to the book, "NICARAGUA. A year of news, as if nothing had happened before, as if the roots were not there, and the victory not earned. This book was made so that we remember."[12]

The way that this work was made and presented led to it being embraced by the people of Nicaragua as their own in a very unusual way. This is a history of subjects embracing their representations that could usefully be placed

9. Susan Meiselas, *Encounters with the Dani* (New York and Göttingen: International Center of Photography and Steidl, 2003).
10. Susan Meiselas, ed., *Chile from Within* (New York: W. W. Norton, 1990).
11. Rosler, "In, around, and afterthoughts (on documentary photography)," p. 325. [Note: Jacqueline Kennedy Onassis was an early supporter of ICP.]
12. Susan Meiselas, *Nicaragua, June 1978–July 1979* (New York: Pantheon Books, 1981).

in contradistinction to that of others reacting against theirs in the cases of Florence Thompson and Dorothea Lange or Allie Mae (Burroughs) Moore and Walker Evans, referred to by Martha Rosler in her "In, around, and afterthoughts" essay. One particular instance of this is the various migrations of the Molotov Man image from Meiselas's Nicaragua book, which she traces in her 1991 film *Pictures from a Revolution* [pp. 168–73]. She revisited this in 2007, in a defense of the rights of the man in the image, Pablo Araúz (called "Bareta" during the war), against the decontextualizing appropriation of the image by artist Joy Garnett, who made a painting based directly on Meiselas's photograph and included it with images of angry skinheads, screaming punk rockers, and frat boys jumping over bonfires in her *Riot* series. Meiselas responded:

I made the image in question on July 16, 1979, the eve of the day that Somoza would flee Nicaragua forever. What is happening is anything but a "riot." In fact, the man is throwing his bomb at a Somoza national guard garrison, one of the last such garrisons remaining in Somoza's hands. It was an important moment in the history of Nicaragua—the Sandinistas would soon take power and hold that power for another decade—and this image ended up representing that moment for a long time to come.

There is no denying in this digital age that images are increasingly dislocated and far more easily decontextualized. Technology allows us to do many things, but that does not mean we must do them. Indeed, it seems to me that if history is working against context, then we must, as artists, work all the harder to reclaim that context. We owe this debt of specificity not just to one another but to our subjects, with whom we have an implicit contract.[13]

Meiselas has always taken that social contract with her subjects very seriously. "It is important to me—in fact, it is central to my work—that I do what I can to respect the individuality of the people I photograph, all of whom exist in specific times and places."[14] Stories are told about individual people, in specific times and places, by individual people. If you're telling the story, you're in the story.

There is a tension in social documentary practice between liberal and radical ends. On the one hand, the tradition has had a reformist intent; on the other, it finds its existence only in the social, and therefore has a radical core. This tension activates many parts of Meiselas's work, perhaps most visibly in the Kurdistan project. Traveling to Northern Iraq in 1991, then working with Human Rights Watch to document Saddam Hussein's Anfal campaign against the Kurds by photographing the refugees and mass graves, she became aware of the extraordinary lack of an image history of the Kurds, and set out, over the next six years, to recollect these images, these shards of the story, and to try to place them in context. In the introduction to her book, Meiselas registers the difficulties of such an endeavor, and her doubts about its efficacy:

Every picture tells a story and has another story behind it: Who's photographed? Who made it? Who found it? How did it survive? I wonder what we can know of any particular encounter by looking at

13. Joy Garnett and Susan Meiselas, "On the Rights of Molotov Man: Appropriation and the Art of Context," *Harper's* (February 2007), p. 58.
14. Ibid., p. 56.

111

such a picture today. We have the object, but it exists separated from the narrative of its making.[15]

More information does not necessarily increase realism. Information can be indigestible in its raw form, and must be prepared differently in order to be effective, to be of use. Masses of data are not memorable. Images are memorable. Stories are memorable. As we move headlong into a world in which the delivery of information, in images and words, becomes more fluent and more rapid every day, the task of the storyteller is becoming more necessary, and more endangered. In his 1936 essay on "The Storyteller," Walter Benjamin put the dilemma in temporal terms, and looked forward to a future that we are now inside of:

Information . . . lays claim to prompt verifiability. The prime requirement is that it appear "understandable in itself." Often it is no more exact than the intelligence of earlier centuries was. But while the latter was inclined to borrow from the miraculous, it is indispensable for information to sound plausible. Because of this it proves incompatible with the spirit of storytelling. If the art of storytelling has become rare, the dissemination of information has had a decisive share in this state of affairs.

Every morning brings us the news of the globe, and yet we are poor in noteworthy stories. This is because no event any longer comes to us without already being shot through with explanation. In other words, by now almost nothing that happens benefits storytelling; almost everything benefits information. Actually, it is half the art of storytelling to keep a story free from explanation as one reproduces it. . . . The most contradictory things, marvelous things, are related with the greatest accuracy, but the psychological connection of the events is not forced on the reader. It is left up to him to interpret things the way he understands them, and thus the narrative achieves an amplitude that information lacks.[16]

In all of her work, from *Carnival Strippers* on, Meiselas has taken the task of the storyteller to heart. It takes time to tell the kind of stories Meiselas pays heed to. Ultimately, it takes all the time one has.

15. Susan Meiselas, *Kurdistan: In the Shadow of History* (New York: Random House, 1997), p. xvi.
16. Benjamin, "The Storyteller," p. 89.

Chapter 2:

Media:
Resistance and Memory

1978–2004

Cuba

Nicaragua

El Salvador

Argentina

Colombia

U.S.–Mexico Border

Reframing History

REPUBLICA DE
NICARAGUA
12 02 2 0 8 0

REPUBLICA DE
NICARAGUA
4 02 2 0 8 0

VISA A EXTRANJEROS
CONSULADO DE LA
REPUBLICA DE NICARAGUA

Lugar Honduras

Visa No. 105 Recibo

Clasificación: Turista

No de Pasaporte B-889023

Se Otorga a Susan Cloy M.

Visa para entrar una sóla vez y permanecer en el territorio Nacional, por un período de 30 dias días a partir de la fecha de su entrada al país.

Esta visa vence pasados los 30 días de haber sido autorizadas.

Fecha 18 ENE 1982

FIRMA AUTORIZADA

CONSULADO GENERAL DE
Tegucigalpa, D. C. Hondu

16

(**Meiselas interview**, continued from page 20)

Transitions

KL: The shift from your early projects—*Carnival Strippers*, *Prince Street Girls*—to your work for the international media was a dramatic one. How did you negotiate the transition from local documentary work, over which you had creative control, to working with the mainstream media? Did your earlier work carry through into what you tried to do in Central America?

SM: The question for me was: how do you bring documentary values into photojournalism? That was what I was confronted with, the attempt to sustain those values in a different environment. The emphasis on *staying*—as opposed to coming and going like many photojournalists did—that approach came from doing the earlier work.

 The thing about photojournalism is, either you think it is useful to go out into the world or you don't. I am someone who does see the value in that. But it is only worth doing if you become a bridge for information and ideas. Like my colleagues Gilles Peress or Eugene Richards, the media has been a platform for me, but it is not my principle focus; it's about using the press as a medium for production rather than working "for" it—then creating something else such as a book or exhibition with the work you generate.

Nicaragua (1978–79)

KL: Your first trip to Latin America was to Cuba in 1977 with the Center for Cuban Studies. Did it open up an interest in the region for you?

SM: The Cuba trip was my first exposure to Latin America. I went with a small group of photographers. We captured what we could, portraying all sides of life, on the streets, in factories, schools, sports centers, hospitals, to bring an image of Cuba back home to Americans just at the time when President Carter opened up a new dialogue between Washington and Havana.

KL: In Cuba, and even more so in Nicaragua, where you went the following year, the relationship to your subject necessarily changed. Your subject was no longer a person with whom you had a one-on-one relationship, but a movement, a society, a historical shift. How did you reorient yourself?

SM: The relationship that has fueled my work is as much with a particular place and time, with history-making, as it is with individuals. Frameworks are also important. The architecture of 44 Irving Street or the girl shows was very specific; those were very physical spaces. In Nicaragua, El Salvador, even Kurdistan, the framework is geographical. But even more importantly, it was a historical process.

KL: But that's an enormous framework, compared with a rooming house in Cambridge, Massachusetts.

SM: True. In Nicaragua, there were three million people, but in a confined territory that I could move around in myself and begin to get to know. A narrative was created through that movement, and what was happening all around me. I was propelled by what was unfolding there, and the element of unpredictability. You felt this momentum like a snowball rolling down a hill.

KL: You went to Nicaragua for the first time in the summer of 1978. There was escalating repression and resistance in the country, but the possibility of revolution was remote at best. Why did you go? Were you photographing with magazines in mind, trying to establish yourself as a working photographer? Or did you think you would produce another book like *Carnival Strippers*?

SM: I had read in the *New York Times* about the assassination of Pedro Joaquín Chamorro, the editor of *La Prensa*, an opposition newspaper in Nicaragua. That is what initially sparked my interest, which really took root the more I read about what was going on. It took more than five months to actually get myself there, since I wasn't sent on an assignment. I was pursuing my own curiosity in what was evolving, and hoped that a forum for the pictures would follow. This was a way of working that was encouraged and supported by my new community, my Magnum colleagues.

 So I got on a plane and went. I didn't know how or what I would photograph—even where I would stay—and I didn't speak Spanish. But during my first day or two, I went to *La Prensa* and met with Carlos Fernando Chamorro, the son of the man who had been killed. I also met Margarita Montealegre, who was a young photographer at the newspaper. Those contacts were key to helping me get oriented, and they remained important relationships for me.

 In those first weeks in Nicaragua, I heard about things going on, but I could only find expressions of them after

Passport, 1981–86.

the fact. For example, I took photographs of political graffiti: somebody had been there, written something, but I was not watching them write it. I was looking for who was behind those actions. I felt the frustration of trying to find the manifestation of something I knew was going on, but sometimes couldn't find a way to photograph.

KL: How did Nicaraguans react to you? Were you self-conscious about being an American?

SM: Oh, completely. Right from the beginning. On the one hand, being an American gave me access to Somoza and the military. Through the U.S. embassy, I was able to photograph the training exercises of the National Guard. On the other hand, I was discovering the reality behind the face of American foreign policy. I'm pretty sure that, at the time, the average American didn't know the U.S. was supporting Somoza with military aid. I certainly didn't.

One day, after a shooting in Jinotepe, some students carried around the portrait of a young woman named Arlen Siu who had been killed months before in the mountains. At one point, as they charged down the street chanting, someone confronted me with a bullet made in the U.S.A. and asked me what I was doing there, which side I was on. It went beyond the question of "Why am I taking photographs?" or "Who am I taking pictures for?" It was a pivotal moment.

It gradually became clear to me that as an American, I had a responsibility to know what the U.S. was doing in other countries. Throughout the period of work in Latin America, I looked at American power relations. That determined, to a large extent, why I was in one place versus another.

KL: None of the work from your first six weeks in Nicaragua was published, until your photograph of rebels wearing traditional masks while training in Monimbo ran on the cover of the *New York Times Magazine* on July 30, 1978. But when the National Palace was taken in August, leading to the September insurrection, your photographs appeared internationally—a huge shift for you.

SM: Once the palace was taken, it was clear to me that a momentous process was underway, and I was committed to staying and watching that process unfold. Many of my images over the coming year were published in magazines, so they had a public life, but one that was dispersed. I wanted to gather them back, make sense of them and give them coherence—as well as permanence.

KL: When you began to conceptualize the Nicaragua book, did you consider ways to integrate different voices, as you had in the *Carnival Strippers* book? Or was the subject too vast?

SM: I did that through the inclusion of quotes, letters, poems, and statistics in the back of the book. I began to assemble all of that once it started to take shape.

My challenge was trying to figure out how to tell the story in seventy-one or two pictures. It was terribly hard to compress. I was preoccupied about what I was missing. Sometimes I was in the wrong part of the country when a town was taken, so I had nothing to include. I also still remember the pictures that I had to leave out, that I really felt should have been there, but I couldn't find the thread to bring them into the sequence.

It was a different kind of structure than the girl show, moving from the outside to the inside of a tent, which I recreated in that book. It was a much more difficult visual narrative, to fill in all the little steps of how the revolution had progressed. I thought of the book as a bicultural object in that it would be for people who had only seen fragments in magazines over the last year, as well as for the Nicaraguans. So the issue was creating a context for the work to be read by both.

KL: *Nicaragua* was one of the first books of war photographs in color. This was at a time when photographs in newspapers were still in black and white, as was traditional documentary and war photography. Color was associated with commercial photography, and some critics thought that the use of color glamorized the conflict, romanticized the young Sandinistas.

SM: The irony is that this debate has evaporated entirely as color photography has increasingly become the norm. At the time, I wasn't taking a position in the debate about whether war should or shouldn't be shown only in black and white. And I wasn't responding to editorial pressures to work in color, as has also been suggested. I initially worked with two cameras, one in black and white and the other in color, but increasingly came to feel that color did a better job of capturing what I was seeing. The vibrancy and optimism of the resistance, as well as the physical feel of the place, came through better in color.

El Salvador (1979–83)

KL: After an intense year of work in Nicaragua, you became increasingly involved in the conflict in El Salvador. Did you have a growing overall awareness of the region?

SM: After the Nicaraguan insurrection and triumph of July, I stayed a bit longer to watch the beginnings of post-revolutionary activity and then headed back to New York to see the film I had sent back and to think about what I could do with the pictures from that year of work. A book was already in my mind, but of course I had no idea if any-one would be willing to publish it. I had already been to El Salvador when the October coup occurred so it came naturally for me to head back there. In fact, the Nicaragua book was delayed because I got pulled in so quickly to the events in El Salvador and stayed for so long, nearly four years.

KL: In 1983, at the height of El Salvador's civil war, you organized a book called *El Salvador: Work of Thirty Photographers*. It included your work and that of twenty-nine fellow photographers, some international, some local. Why produce a book, when so many of the photographs were already widely distributed in the press? How was the story that you were telling in the book different?

SM: Many of us had published in the media, but we felt that a collective testimony would be more effective than any individual perspective. We produced a show from the book that toured all over the U.S., starting at ICP in New York, and then on to public libraries and colleges for over two years. We wanted to provoke a public dialogue, especially with all the Salvadoran immigrants crossing the border at that time. We were also seeking to engage Americans with the larger context of the war and the growing involvement of the U.S.

Working within the Media

KL: Were you given assignments in other parts of Latin America after the publication of your Nicaraguan photographs?

SM: Assignments were never continuous. A lot of work was "on spec" or "guarantee," which paid the expenses, even if there was no day rate. *Time* magazine would often provide film and processing instead, but at the time, that kind of support kept me going and staying to shoot more,

as did the logistical help provided by Magnum. I began proposing stories—women in the Nicaraguan army; what the FSLN leadership was doing postwar. And then magazines also had their ideas, such as portraits of Latin American writers, which is what first took me to Argentina—to photograph Borges.

As I became more aware of social movements within Latin America, human rights issues became more of a focus for me: assassinations in Guatemala, the Mothers of the Disappeared in Argentina, political violence in Colombia, the Pinochet referendum in Chile. I was also in and out of Nicaragua over that decade as the contra war was launched.

I rarely left the region in the 1980s. Once I went to Mozambique for *Geo*, and then regretted the trip when it caused me to miss the assassination of Archbishop Romero, which was incredibly important in shaping events in El Salvador. When Haiti erupted against Baby Doc [Jean-Claude Duvalier] in 1986, I chose not to leave, though many of my colleagues went.

KL: When you were working on *Carnival Strippers*, *Prince Street Girls*, or other early documentary projects, it was just you and your subjects. When you began to work in the media, you became part of a larger community of people covering the same events. What was your relationship to other photographers and journalists when you were working in Latin America? Did you choose whom to work with, or was that dictated by assignments? Were those relationships supportive, or were you competing with one another?

SM: I developed sustained relationships with some of the writers I was working with, such as Ray Bonner. Working as a team, we documented the El Mozote Massacre in Morazán and years later traveled together to Nagorno-Karabakh [Azerbaijan] and Kurdistan. Of course, some mag-azines also assigned me after the stories had been written and I was on my own to find ways to visualize them. Sometimes it was like a blind date—being set up with someone and having to endure ways of working which were different than my own. Most important to me was not to be constrained or dictated by deadlines, but instead free to discover what was evolving around me.

In those days, magazines would have a number of pho-tographers working simultaneously, usually from several agencies, with teams sometimes collaborating on cover-age, while at the same time being secretive about their in-tentions for international distribution of the work.

I often worked with local reporters, which offered us

mutual protection. This was particularly true in El Salvador, where as a woman it was too dangerous to drive alone, as I had often done in Nicaragua. There was safety in numbers: we were huddled into the same hotels in El Salvador in fear of the death squads. Sometimes we used codes on our telephone exchanges so as not to reveal the roads we were taking, but we would have to entrust someone with our plans. We were both competitive and supportive of each other.

KL: Much of your work, but particularly your war photography, has positioned you within very male-dominated environments. Are there definable ways in which being a woman influenced the way that you work, your relationship to Magnum, the way your work has been received?

SM: There is a subtlety of maintaining one's presence and clarity, while simultaneously seeming to be absent. I'm very aware in many situations—Magnum being one, and with larger male communities of traveling media bands in the 1980s—of feeling that I was safer as an absent force than as a present one.

KL: Are you saying that as a woman, you could be more effective if you were invisible?

SM: I was so often treated as invisible that some part of me accepted the idea that invisibility could work strategically. Even when I was photographing the girl shows, I remember thinking that I was able to do this work because, as a young woman, no one took me seriously and that worked to my advantage. Or in the early years in Central America, I could approach people because they weren't afraid of women the way they were fearful of men. In these highly militarized environments, a woman was perceived as less threatening. Blending in, being unobtrusive, is key to surviving, assimilating, absorbing, observing.

Debating Documentary

KL: What did it mean to be doing this work in Central America in the context of the critical debates about documentary practice, which were very much in the air in the early 1980s?

SM: I was a million miles away from those debates in the U.S. They were irrelevant to the issues I was dealing with. Which was *how* to do the work, just how to do it. I was dealing with the fact that people were being killed every

day and the murderers were hiding the bodies. My job in El Salvador was to find the bodies. I would wake up at four in the morning and drive down roads looking for corpses. That's what I was thinking about in El Salvador. I had to document what I knew to be happening there.

KL: For . . .?

SM: For it to be known. For it to be seen. For it to be felt. Maybe to compel people to act. But it all begins with witnessing, the least that one can do. So I couldn't be involved in an intellectual discussion as to whether or not it was worth it. I was immersed in another community that was very passionate about what we were doing. Not just the photographic community. Journalism. Another world, with a different set of concerns. And I was deeply involved in what people were fighting for, what they were willing to risk, to make change.

Also, I couldn't relate to what was happening in the art culture in New York. It took me a long while to grasp the work of someone like Cindy Sherman, which seemed to be about artifice, reenactment. The photographic culture was changing all around me.

For me, the eighties was a difficult period of revisiting and reassessing. The installation *Mediations*, in which I tried to examine the selection and circulation of my images in the media, is one reflection of that process. The retrospective films *Voyages* and *Pictures from a Revolution* were attempts at raising questions about journalistic practice and also the tension between the object of a photograph and the subject, those real ongoing lives of the people in my photographs.

Beyond Nicaragua and El Salvador

KL: For much of the 1980s, you worked elsewhere in Latin America—Colombia, Guatemala, Chile, Argentina—on magazine assignments and independent projects. How would you characterize those later projects as compared to the work you did in Nicaragua and El Salvador?

SM: In Chile and Argentina, I was catching up with histories I had read about, connecting with them at a certain point, but this was very different from being pulled into the events happening in Nicaragua and El Salvador.

The most coherent project from that period is the partnership with Chilean photographers that resulted in a book of their work, *Chile from Within*. In Nicaragua, and more so in El Salvador, I had become aware of the work

of regional photographers. We worked alongside one another, though they operated in a more limited space than any of us did, with the privilege of our passports. Over time, as the wars developed and foreigners stopped going, local photographers became the primary source of images. In Chile, it seemed only natural that the story of the Pinochet years should be told by those who had lived through that time.

Although the Chile project fits into the overall arc of my own work in the 1980s—the first world/third world dialogue—in editing the book with the Chilean photographers I saw my role as a facilitator, so that their work would have the circulation it deserved.

KL: Was that book your first experience of the notion that you could make a powerful statement with images other than your own?

SM: Actually the first time I acted as a curator was for the first anniversary of the Nicaraguan revolution, in 1980. I collected photographs from half a dozen foreign photographers who had worked in Nicaragua, and organized an exhibition in Managua. There's a backstory to this: *La Prensa*'s photo archives had been completely destroyed in July 1979, when Somoza ordered the Nicaraguan Air Force to bomb the newspaper's offices. It seemed to me imperative to help restore this history to Nicaragua in some form by bringing together images from foreign

photographers whose work was mostly sitting in agency archives in New York. The material in the exhibition was then donated to the Museum of the Revolution in Managua, but during the contra war it was secretly put somewhere. It may now be in the Instituto de Historia in Managua.

Leaving Latin America

KL: In your 1991 film *Pictures from a Revolution*, you and your collaborators Dick Rogers and Alfred Guzzetti returned to Nicaragua to locate the subjects of your earlier photographs. The film describes the disappointment and frustration of many Nicaraguans who felt that the promise of the revolution never materialized. What led to the making of the film?

SM: Each time I went back to Nicaragua in the years following the insurrection, I had a strong desire to find out what had happened to the people in my photographs. The film began with that genuine search out of curiosity, and the filmic form came later.

Alfred and Dick were both filmmakers and colleagues teaching at Harvard. The three of us had made an earlier film together, *Living at Risk*, which was a portrait of the Chamorro family. We worked well together, complementing each other's skills and collaborating as codirectors, which

Detail of contact sheet from Nicaragua showing *Cuesta del Plomo*, 1978.

is pretty rare. Dick did most of the cinematography, Alfred the sound, and I coordinated the production.

But there's another element to the film that may not have been consciously introduced. Embarking on the kind of journey I did through Nicaragua and El Salvador is a bit like stepping into a body of water, the depth of which is unknown until you take the plunge. There's the tension between how deep the water is and how far you're willing to explore. You can be overpowered by a current and lose your balance. I know there were times when I allowed myself to experience that. The pull of history is powerful.

But at some point one has to rebalance, recalibrate, get to the other side of the river. *Pictures from a Revolution* is the point where I pull myself out of the river, I'm on the bank at the other side, I'm looking at the end of the story, at least my part in it. It's going on without me. And there's a lot of sadness.

KL: That definitely comes through in the film.

SM: It's a huge loss. When people talk about photojournalists being junkies, they're right. They are addicted to action and without it they don't know what to do. But it wasn't just the loss of the "action." I also had to retreat from the heartbreak of Central America.

KL: What was the heartbreak?

SM: The heartbreak was the idealism of this small country with a big dream. They had a spirit and confidence at that time that they could really transform Nicaragua and it was of a scale that no one anticipated. No one in Latin America, none of the leftist writers or analysts abroad, be they in Washington or Cuba, believed that the Sandinistas would overthrow Somoza. The power of that popular insurrection was so unimaginable.

But then very quickly you begin to see that what comes next is not going to be determined by what happens in Nicaragua, who they are and what their hopes are for themselves, but by the climate of the Cold War. Those possibilities were crushed when they inspired others in Latin America, the Salvadorans and Guatemalans. With the fear of a "domino effect," the contra war of the mid-1980s was unleashed.

That's when it really starts to be ugly, painful to be an American, watching what's happening, with an American population completely disengaged. That's the environment in which we made *Living at Risk*, with the hope that we might engage Americans through the lives of one upper-

class Nicaraguan family who were committed Sandinistas, embracing the transformation of their country, even counter to their class.

KL: So is part of the heartbreak not just what's happening but also the fact that you're an American, and so in some way complicit in what the U.S. is doing?

SM: Yes, I'm an American and I think I say this in *Pictures from a Revolution*: the most difficult part was thinking, how will anybody see me as different from that American policy, especially if there is an invasion? I was just watching the demise and the destruction and the demoralization.

KL: Your work in Latin America begins in the most promising, hopeful place: the popular uprising in Nicaragua. But as the decade wears on, with coverage of the drug war in Colombia, for example, which gets increasingly . . .

SM: Dark.

KL: . . . dark and violent, with no possibility of political redemption, there is nothing that you can latch onto. Your role becomes less clear; you are not photographing a struggle that you believe in, and there is less possibility that your photographs can . . .

SM: Intervene. Not like my coverage of the Mozote massacre in El Salvador (1982). That's the place where I still believed that if people saw *this* they might actually pay attention. Not to so much *do* something, but at least *know* something and care.

KL: And it was at that point, at the end of the 1980s, after over a decade of deep involvement in Latin American politics, that you began to extricate yourself. You went to Northern Iraq in the wake of a violent campaign against the Kurdish population—worlds away from Latin America. You were able to maintain the continuity of human rights–related work, but without the personal history.

SM: In retrospect, you can identify the path. I didn't recognize how far away it would take me at the time. The next ten years were really defined by my work in Kurdistan, but my roots in Latin America remained deep.

Reframing History (2004)

KL: Returning images to the cultures and histories from which they have come is a persistent concern running throughout your work. For the twenty-fifth anniversary of the triumph in Nicaragua, you transformed nineteen of your pictures into murals and hung them in public places, on the sites where they were originally taken twenty-five years before.

SM: I was digitizing part of my archive, and I was looking at all that work thinking, "Why bother to digitize it? What value do these pictures have, and for whom?" I thought, "Would they be of any value to the archives in Nicaragua? Are they of interest even to the people who were in the pictures twenty-five years ago, or the people who weren't there but had heard about it?" That's what led me to the idea of bringing mural-sized images back.

I collaborated with the Instituto de Historia, which contacted the mayors of the four towns, and I chose nineteen pictures—symbolic for July 19, the day of the Triumph over Somoza in 1979. Everything got negotiated—in each town, with each mayor, with each wall. You know the famous photograph on the cover? The man who lives in that house didn't want the photograph on the wall of his house, so we hung the banner over the street. He was fine about that. He just didn't want to have anybody mistakenly think that he was a Sandinista. Other people identified with the photographs. The mother of a man who had died during the struggle was deeply honored having the photograph of her son running across the street illuminated at night by a street lamp. That was very moving. There were many different kinds of reactions to the murals, which we recorded on video; listening to the comments and watching people look at the images back in the landscape.

KL: In Nicaragua today, you have said that there is a romance surrounding the revolution that a younger generation is interested in accessing through your photographs. There is also renewed interest in the book *Chile from Within* in that country, where it's part of a larger cultural process of coming to terms with the end of the Pinochet years. In El Salvador, on the other hand, your work has recently been used in a series of prosecutions related to the civil war. These different countries are in different places in their histories, and the uses to which your photographs are put—from commemoration to prosecution—reflect that.

SM: That's right. It's only recently that Chileans have been prepared to examine the past. *Chile from Within* was published in 1991 but only now, over fifteen years later, is it being translated into Spanish, and those photographs were only recently exhibited in Santiago. The situation in El Salvador is even more complicated, because the repressive apparatus is still in place. The work we did has been used in a number of civil trials in the U.S. to indict former Salvadoran military now living here who were responsible for assassinations at that time.

KL: It must be gratifying that your work has a second and third life, that it still has utility to the community it's taken from.

SM: The value of this work historically to people *of* the community is what sustains me. And maybe this is the connecting thread to my very first project, *44 Irving Street*, when I asked subjects what the image did or did not say about them.

KL: This is analogous to bringing back the contact sheet and saying, "This is what I saw. Do you see yourself in this?" But rather than one-on-one, you are doing that with a whole nation and its recent history.

SM: It's a big responsibility. I want my subjects to recognize themselves in my representation of them. And that's magnified when you're talking about a collective history. Am I fairly representing the complexity of people's lives, especially when I am coming from outside? That's at the core of the process.

Magnum Photos ID card, 1978.

Above: *Old Jibacoa, Cuba*, 1977.
Previous page: *Havana, Cuba*, 1977.

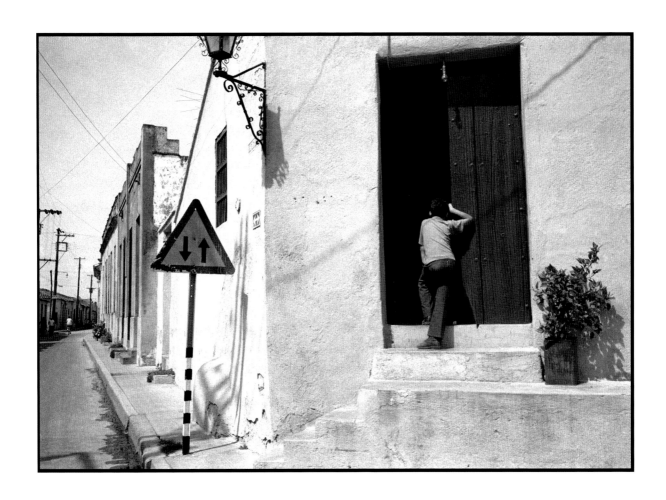

Camaguey, Cuba, 1977.

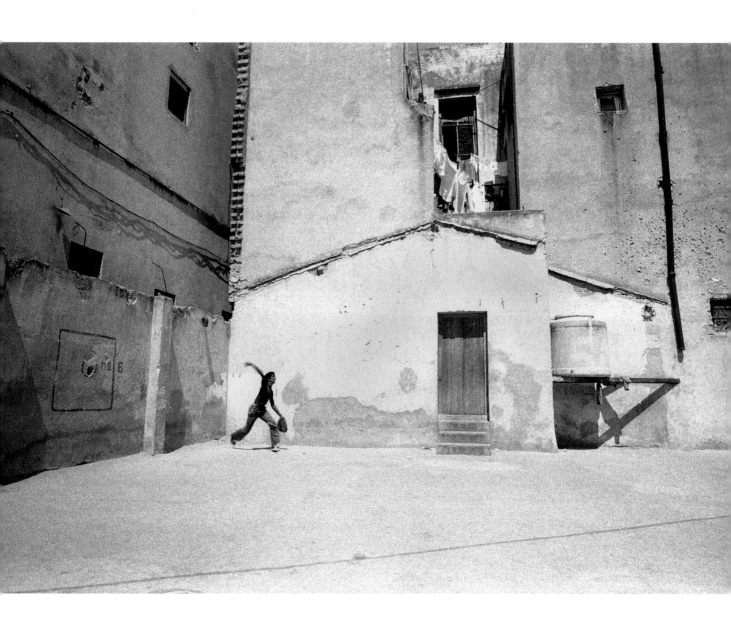

Above: *Havana, Cuba*, 1977.
Right: Poster for the group exhibition *Impressions of Cuba* at
Parsons School of Design Gallery, New York, 1977.

The Center For Cuban Studies Presents

IMPRESSIONS OF CUBA

SUSAN MEISELAS

FRANK STEWART

RENÉ GELPI

HARVEY FINKLE

MEL ROSENTHAL

EDE ROTHAUS

WILLIAM PRICE

IMPRESSIONS OF CUBA

School of Design Gallery 2 W. 13th St.
21- August 31

127

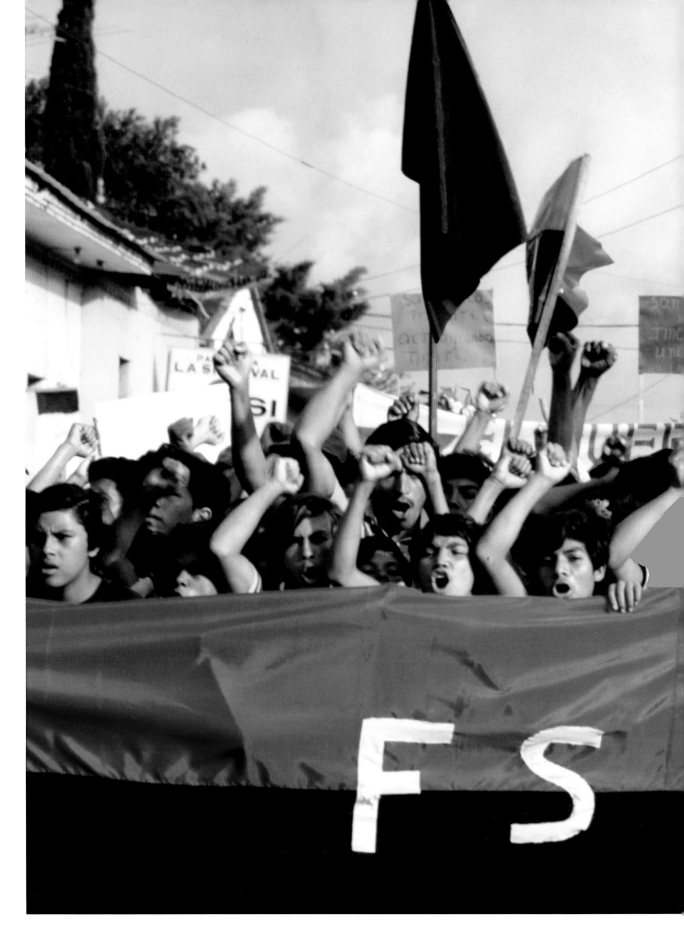

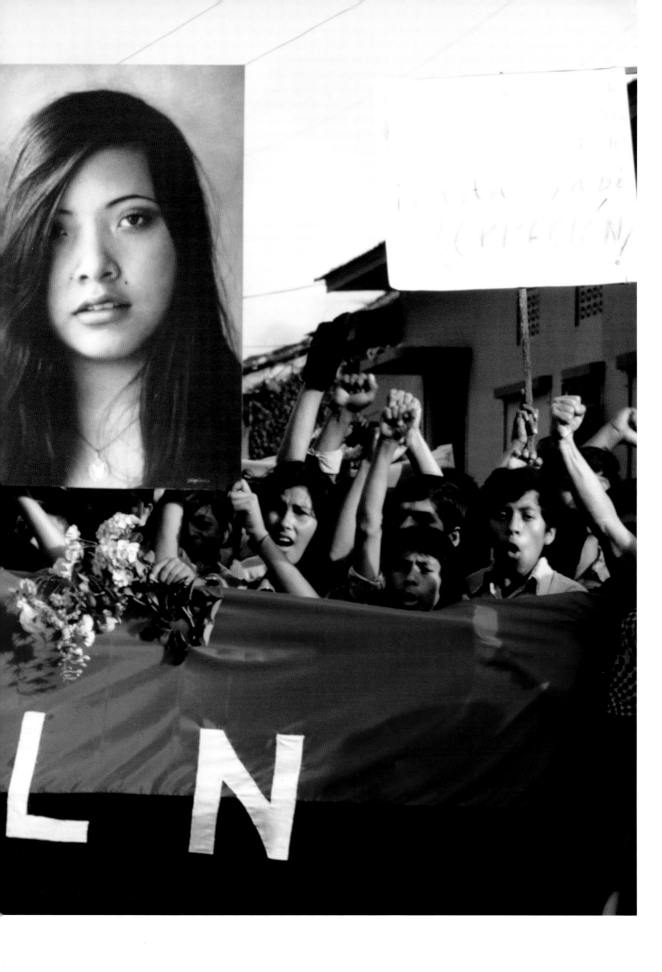

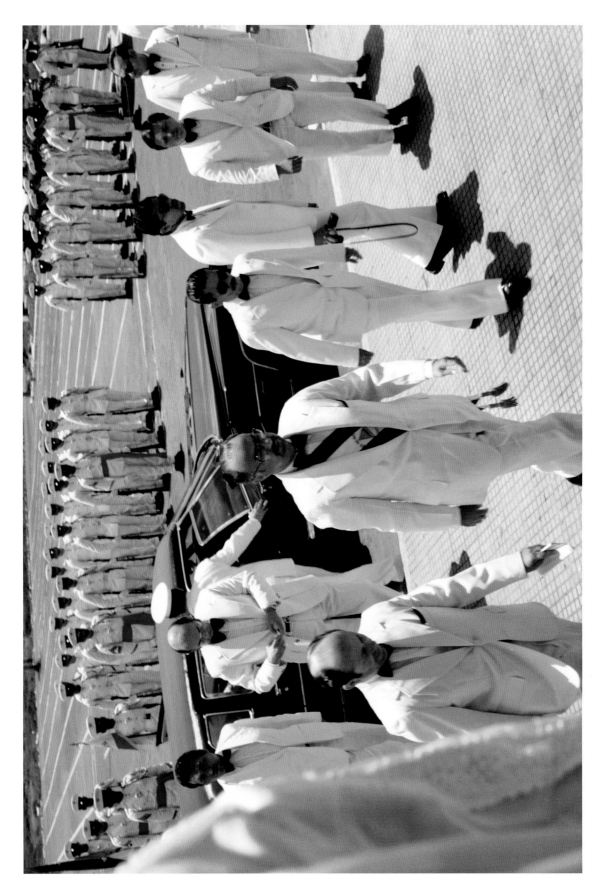

President Anastasio Somoza Debayle opening new session of the National Congress, Managua, Nicaragua, June 1978.

Previous page: A funeral procession for assassinated student leaders. Demonstrators carry a photograph of Arlen Siu, an FSLN guerrilla fighter killed in the mountains three years earlier, Jinotepe, Nicaragua, 1978.

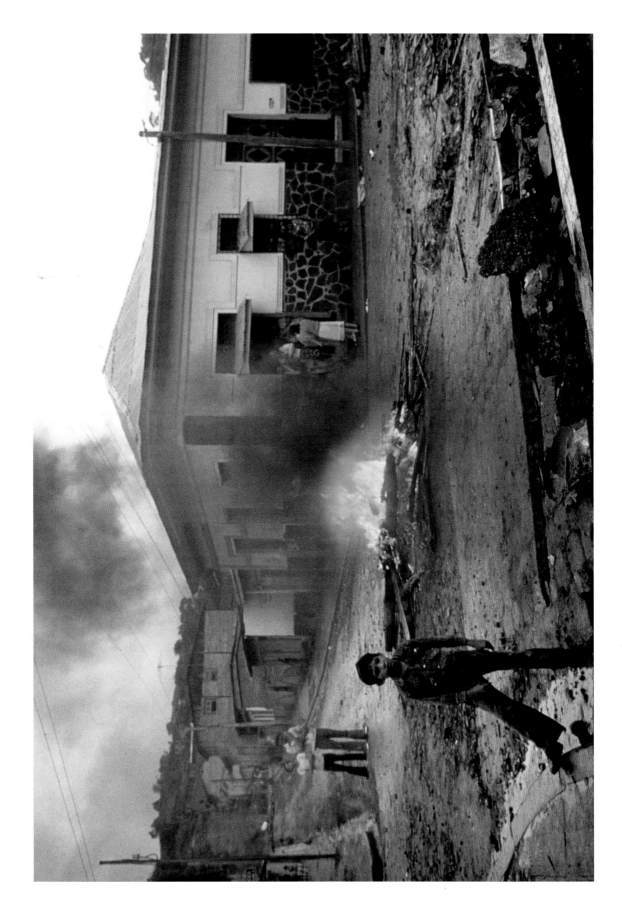

Residential neighborhood, Matagalpa, Nicaragua, 1978.

131

Nicaragua, 1978–91

"Cuesta del Plomo," hillside outside Managua, a well-known site of many assassinations carried out by the National Guard, Managua, Nicaragua, June 1978.

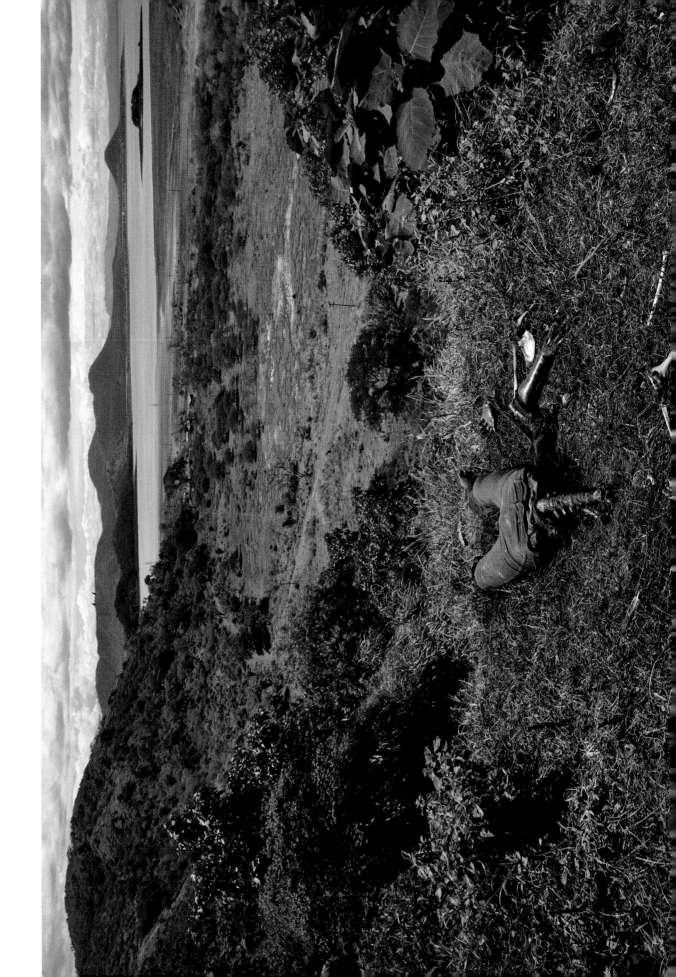

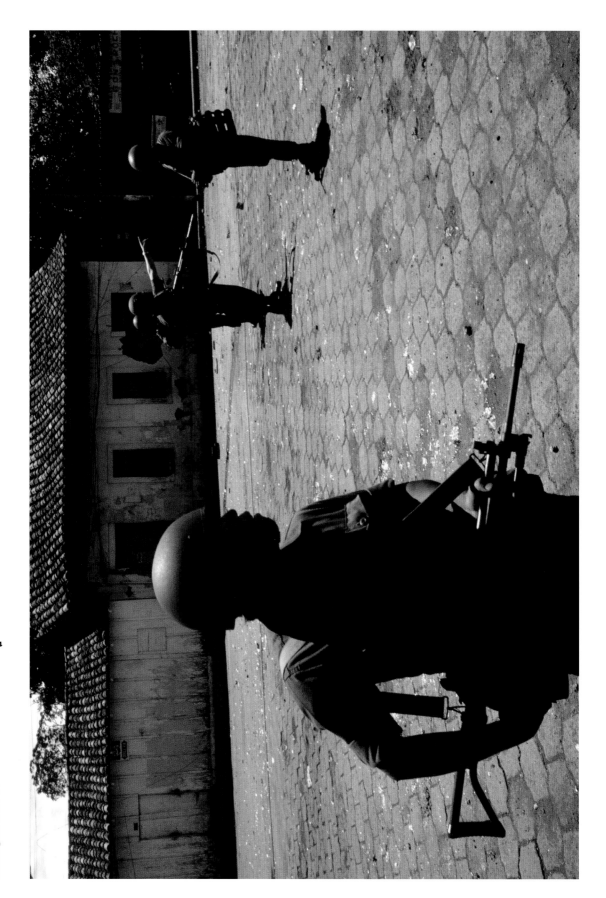

Guard patrol beginning house-to-house search for Sandinistas, Masaya, Nicaragua, 1979.

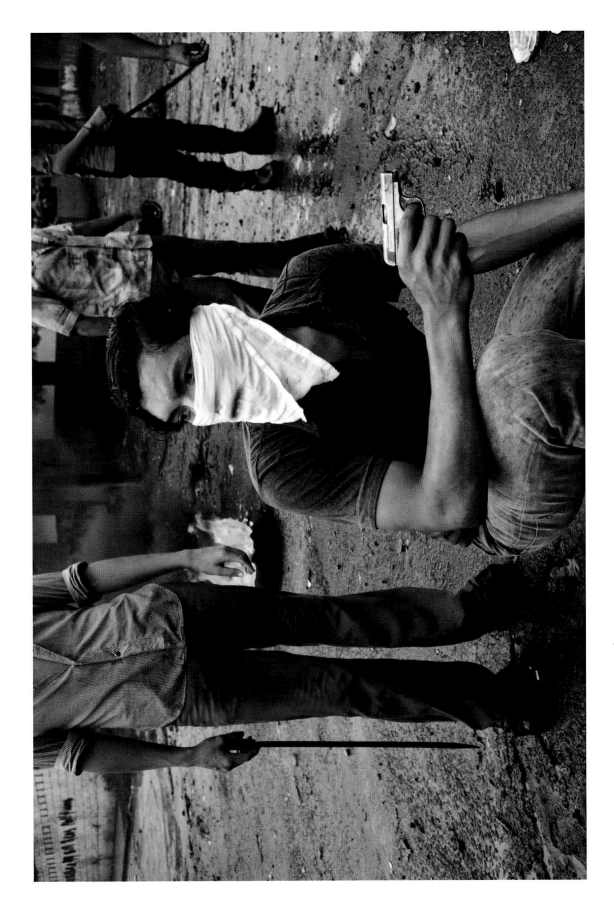

Street fighter, Managua, Nicaragua, 1979.

135

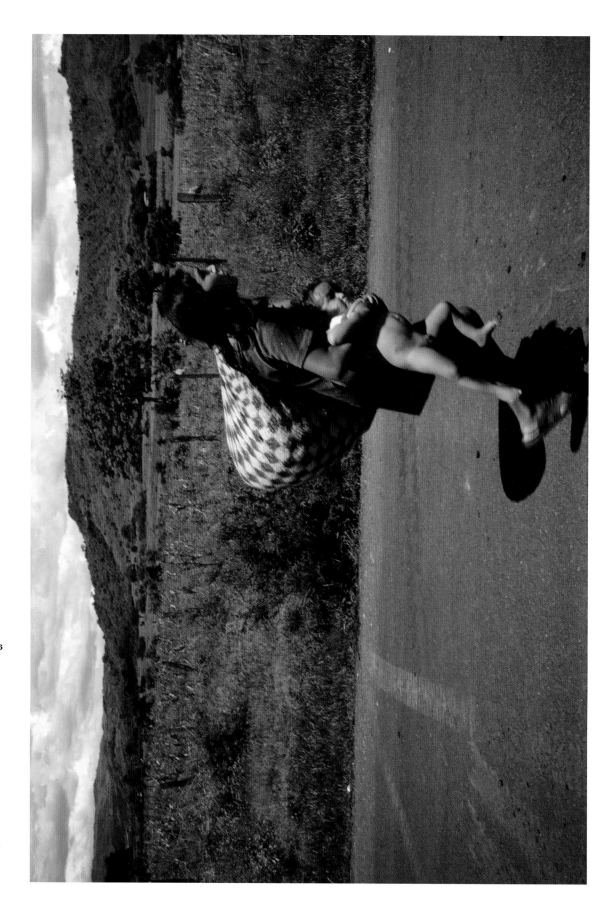

Nicaragua, 1978–91

Fleeing the bombing to seek refuge outside of Estelí, Nicaragua, September 20, 1978.

Returning home, Masaya, Nicaragua, September 1978.

6

Pictures of everydayness

~~The Decision to look out the window. although people with me~~
Pictures that say nothing.
~~all~~ ~~say no~~

There is ~~now~~ a picture
~~there is~~ *but*
with no tension in it

The experience is not in the image.

And ~~And~~ still ~~knowing~~

need~~ing~~ experiences
meaning *h*
with ~~tem~~ *them*

to make images.

To experiment their fears

and their reality

otherwise

you cover their li*f*e with

your own culture

National palace

Nicaragua in the news
many
~~Every~~ journalists ~~around~~ come. Most leave. *No time to wait.*
I don't want to go.
~~Eight days later, going~~ back to Matagalpa

Glasse~~s~~ across the road...

w~~a~~lking in
sensing
something in the air

The next day the insurrection began.

~~The insurrection began~~
staying
~~I stayed~~ for three days.

Be~~i~~ing there

In the church with screaming children

behind the barricades ~~with×ka~~

with boys masked

pistols and old shotguns

informal quality
only content
with no power of its
not close enough.

still by stated images
read the expr.

still

nothing sure
to happen.
(nothing important
if they're not
there)

Nicaragua, 1978–91

Draft introduction for the Nicaragua book, 1980.

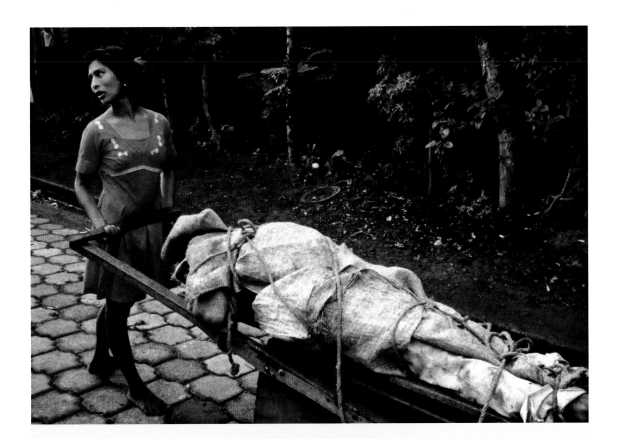

Masaya.... the city that reeks of burning bodies. Nicaragua. 14 Sept 78 # 78-81

Groups of Red Cross workers burned unidentified corpses to avoid the spread of
disease, as the Government troops of President Somoza wiped out the remaining
pockets of rebel resistance in the city of Masaya some 15 miles north of Managua.
National Guards carried out house-to-house searches arresting any men they still
found, although it will never be known howmany guerillas and civilians died in
battle between pro Sandinista rebels and national guards. The city had been placed
under martial law after 3 days of fierce fighting, as most of the 80,000
population fled the heart of the burning city.

　　　　　　　　　　　　　　　　　Photos by Susan Meiselas/MAGNUM Photos.

Above: *Monimbo woman carrying her dead husband home to be buried in their backyard, near Masaya, Nicaragua,* 1979.
Below: Extended caption for Magnum distribution, Masaya, Nicaragua, September 1978.

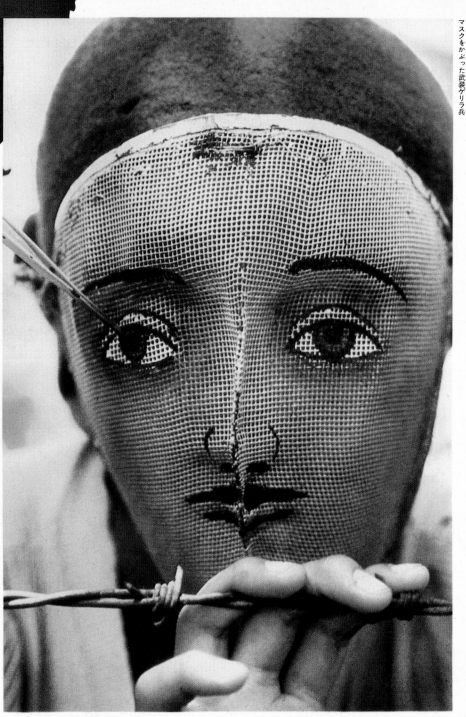

マスクをかぶった武装ゲリラ兵

43年間の独裁を崩壊させたニカラグア内戦

——解放までの一年間を現地ルポ

43年間にわたる一族独裁支配を続けて来た〝ソモサ王朝〟を崩壊に追い込んだニカラグア内戦が激化した昨年9月から　新政権樹立に至る約1間　戦火の中に身を置いて30歳の女性カメラマン　スーザン・メゼラスはシャッターを押し続けた　手投げ弾がすぐワキに落ちた　が幸い不発弾で九死に一生を得てこの〝誰よりも早く　誰よりも長く〟内戦を記録した写真は撮られた　これらの写真で彼女は今年度ロバート・キャパ賞金賞を受けた

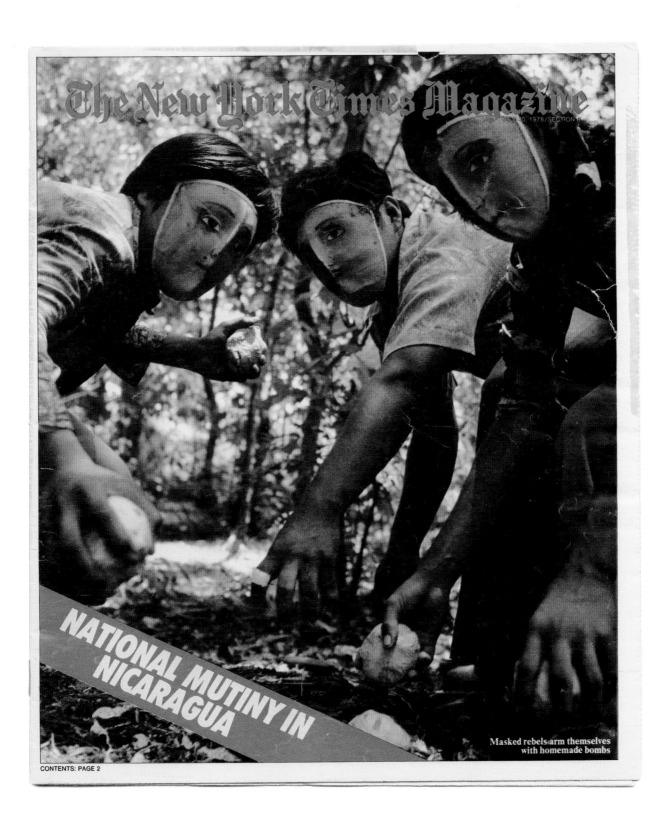

The New York Times Magazine

JULY 30, 1978 / SECTION 6

NATIONAL MUTINY IN NICARAGUA

Masked rebels arm themselves
with homemade bombs

CONTENTS: PAGE 2

141

Above: Cover of *New York Times Magazine*, July 30, 1978.
Left: *Mainichi Graphic Weekly* (Tokyo), September 9, 1979, p. 67 (image reversed).

142

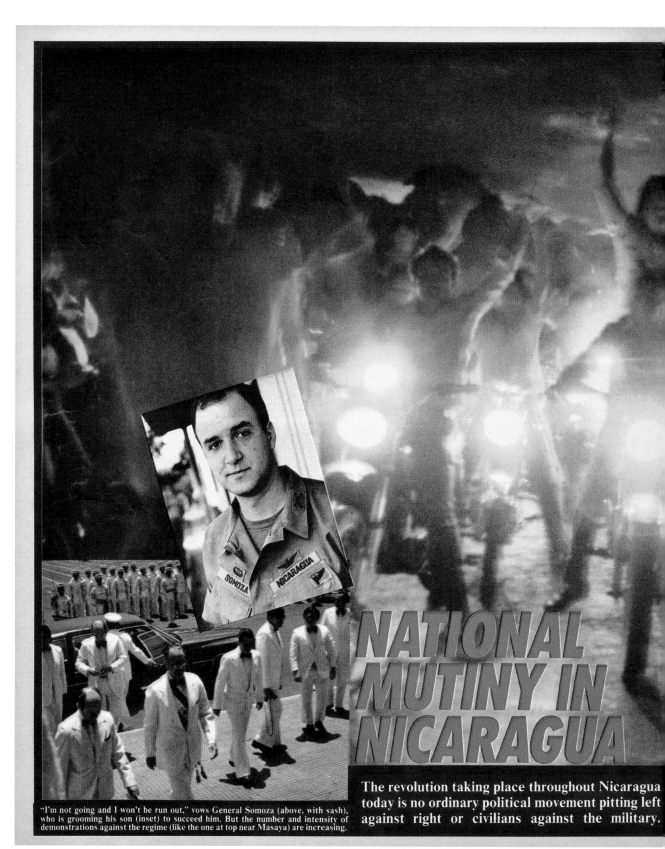

"I'm not going and I won't be run out," vows General Somoza (above, with sash), who is grooming his son (inset) to succeed him. But the number and intensity of demonstrations against the regime (like the one at top near Masaya) are increasing.

NATIONAL MUTINY IN NICARAGUA

The revolution taking place throughout Nicaragua today is no ordinary political movement pitting left against right or civilians against the military.

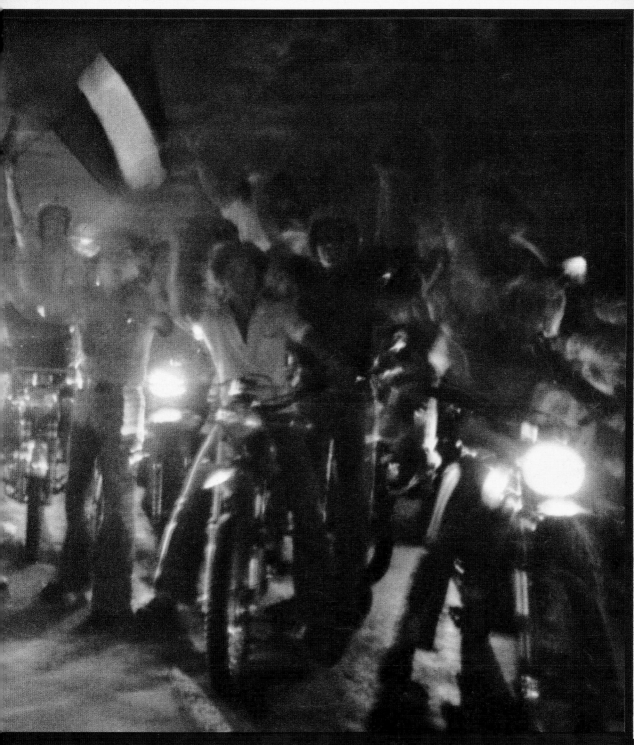

143

Almost every sector of the country — radicals and conservatives, rich and poor — is rising up against a dynastic dictatorship that can no longer count on the support of the United States. After more than four decades in power, time seems to be running out for the Somoza regime. *Photographs by Susan Meiselas.*

"National Mutiny in Nicaragua," *New York Times Magazine*, July 30, 1978, pp. 86–87.

Tehran? Beirut? La Paz? This young man, as it happens, is Nicaraguan. He and his comrades have driven the National Guard into their headquarters and dominated the streets of Masaya for several days, but now the Guard is coming back.

The scene calls to mind one of the enduring symbols of the 19th century, when regimes were overthrown by barricades, oratory and sudden seizures of indignation: Rude's sculptured "Marseillaise" on the Arc de Triomphe de l'Etoile in Paris. But it was Rude's hero, Napoleon, who demonstrated that it required no more than "a whiff of grapeshot" to put down the mob. Napoleon has had many successors, great and small. They may call themselves nationalists, populists, fascists, communists, socialists, even democrats. Ulbricht or Nasser, Hitler or Stalin, Somoza or Idi Amin. And the grapeshot has long since given way to machine guns and tanks. But the formula remains the same. This poses a cruel dilemma for the peoples who, needing and wanting social and political change, lack the orderly constitutional processes to bring it about. Torn between fear and desire, between hopelessness and rage, they live permanently "on the eve," like Turgenev's generation of rebels; on the brink of a liberating movement that can neither come without violence nor (in the depressing majority of cases) survive if violence comes.

Nicaragua

"Nicaragua: A People Aflame," charter issue of *Geo* (1979), pp. 32–33.

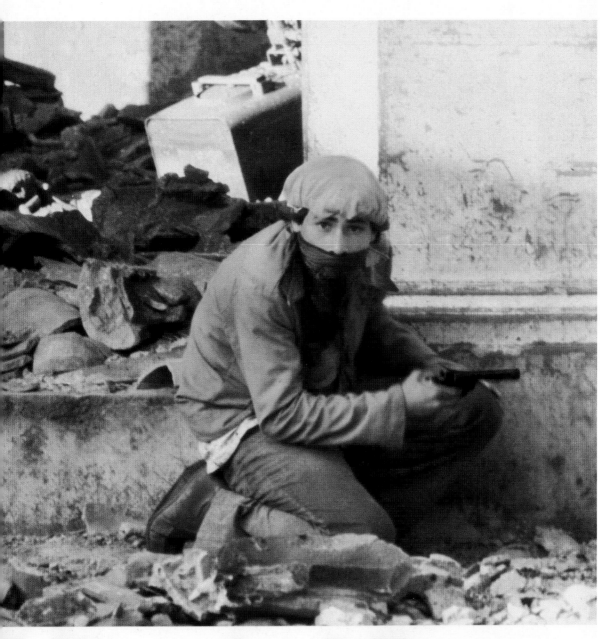

A People Aflame

Following page: "La Revolution des Foulards," *Paris Match*, September 15, 1978, pp. 42–43.

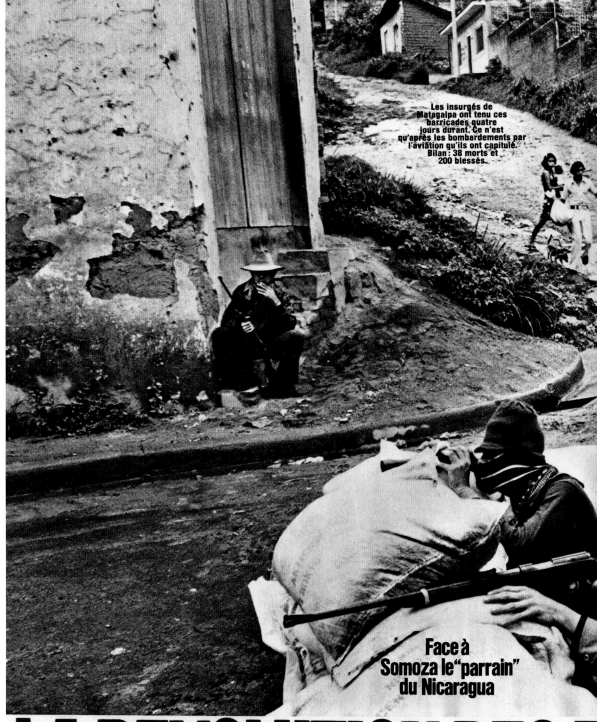

Les insurgés de Matagalpa ont tenu ces barricades quatre jours durant. Ce n'est qu'après les bombardements par l'aviation qu'ils ont capitulé. Bilan : 38 morts et 200 blessés.

Face à Somoza le "parrain" du Nicaragua

LA REVOLUTION DES F

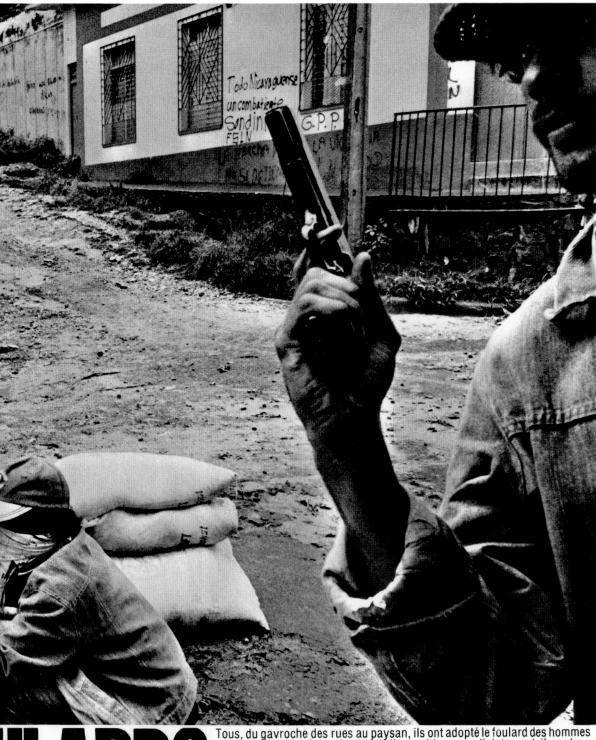

ULARDS

Tous, du gavroche des rues au paysan, ils ont adopté le foulard des hommes du commandant « Cero » le chef de l'opposition « sandiniste » qui, il y a deux semaines, a réussi la plus formidable entreprise de libération de prisonniers politiques : 200 otages, dont 60 parlementaires, en pleine capitale du Nicaragua. Pour le pays, uni dans la grève générale, ce foulard devient, comme le béret du Che Guevara, le symbole de la lutte contre la dictature qui règne depuis 44 ans, et de père en fils. Ecœuré par la rapacité folle des Somoza l'archevêque de Managua a béni les drapeaux dressés sur les barricades.

Article by Richard Elman
Photos by Susan Meiselas

In Nicaragua, ordinary people took arms against a tyrant and his elite National Guard. GEO turns a current event into a timeless moment in which you feel what happens when a country burning with a passion for freedom literally bursts into flame—flames that test American political courage. Here, behind a barricade in Masaya, six rebels who started by spitting contempt for photographers change their minds and strike this dramatic pose for GEO.

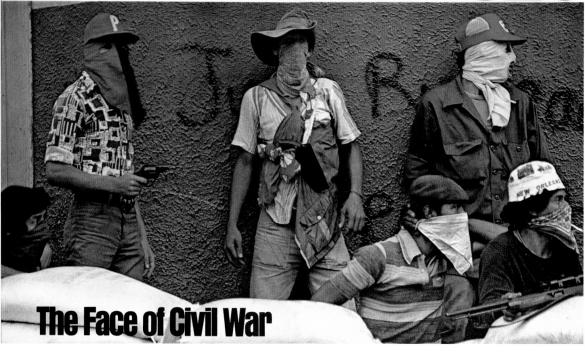

The Face of Civil War

Above: "The Face of Civil War," charter issue of
Geo (1979), pp. 49–50.
Right: Cover of charter issue of *Geo* (1979).

Following page: *Mainichi Graphic Weekly* (Tokyo), September 9, 1979, pp. 70–71.
Below: *La Prensa,* May 28, 1979: Nicaraguan newspaper announcing Meiselas's reportage in *Geo*.

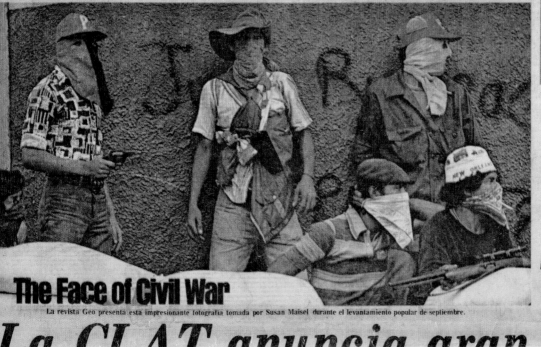

Director:
Don Pablo Antonio Cuadra
Director·Gerente:
Ing. Xavier Chamorro C.
Sub-Director:
Dr. Danilo Aguirre S.

diario de los
caragüenses

LA PRENSA
AL SERVICIO DE LA VERDAD Y LA JUSTICIA
Por las que vivió y murió Pedro Joaquín Chamorro C.

18 Páginas **C$1.00**

Diario editado por
LA PRENSA, S.A.

Managua, D.N., Domingo 28 de Enero de 1979

TELEX PRENSA 3751051 · Dirección Cablegráfica Laprensa
CENTRAL TELEFONICA 27502 · 27503 · 27504 · 27505 · 27506 · Apdo. 192.

AÑO LII No. 15,261

Fe, plegaria, meditación, unidad

Papa vuelve a la tradición

Denunció ayer lo que llamó la indisciplinada teorización liberal.

Sigue viva la expectativa sobre la definición papal.

Estiman que Juan Paulo no dará una consigna al CELAM y serán los obispos quienes profundicen el análisis.

MEXICO, D.F., 28 (LATIN)— En una vigorosa declaración sobre la política y la Iglesia Católica, el Papa Juan Paulo Segundo denunció la indisciplinada teorización izquierdista o liberal entre los sacerdotes.

Durante la homilía pronunciada ayer en la Basílica de Guadalupe, el Papa reclamó una mayor unidad espiritual y énfasis en la fe y las plegarias.

Se aguarda que hoy el Santo Padre amplíe sus conceptos cuando inaugure la Tercera Conferencia General del Episcopado Latinoamericano en la ciudad de Puebla.

Se estima que alrededor de 10 millones de mexicanos congregarán esta semana a lo largo de los 135 kilómetros que separan la capital del asiento de la conferencia para saludar al Sumo Pontífice, continuando la multitudinaria y entusiasta recepción brindada a Juan Paulo Segundo al pisar tierra mexicana.

Ayer mientras era escoltado hasta la Basílica de Guadalupe, más de seis millones de fieles cubrieron literalmente las calles y se agolparon en las terrazas de los edificios, árboles y techos de vehículos para poder observar el desplazamiento del Pontífice, mientras miles de palomas y globos multicolores ascendían hacia el cielo.

El Sumo Pontífice celebró misa y pronunció una homilía en la basílica y se dirigió por separado a los sacerdotes y religiosas mexicanas.

CRITICA A TEORIZACION LIBERAL

El Papa criticó la teorización liberal o izquierdista entre los sacerdotes, algunos de los cuales —particularmente en America Latina— abogan por la adopción de un papel político por parte de la iglesia como medio para combatir la pobreza.

"Ustedes no son líderes sociales o políticos ni agentes de un poder temporal", dijo a los sacerdotes.

Aquellos que mantienen contacto con Dios deberían saber como interpretar "las opciones de los más pobres y las víctimas

Pasa a la última página No. 10

Un reportaje alemán
"El drama de Nicaragua"

La revista alemana "Geo" publicó en diciembre recién pasado un formidable reportaje escrito y gráfico sobre lo que llama "El Drama de Nicaragua".

Es tan impresionante la cobertura escrita y gráfica realizada por los periodistas Richard Elman y Susan Meiselas, que LA PRENSA ha decidido reproducir una de las fotos más espectaculares del reportaje.

Una de las fotos más impresionantes muestra a una mujer conduciendo a su marido y su hijo, cubiertos en un carretón, después de haber sido ellos muertos por la Guardia Nacional durante la guerra civil en León.

ATENCION DEL MUNDO

El periodista Elman señala que durante dos semanas todo el mundo puso los ojos sobre "la pequeña Nicaragua", don-

Pasa a la última página No. 3

Aprueban acta constitutiva del Frente Patriótico

En una reunión efectuada ayer, fue aprobada definitivamente el Acta Constitutiva del Frente Patriótico Nacional (FPN), según informaron los miembros integrantes de esa organización opositora en el comunicado hecho circular.

El FPN invita por otro lado en su comunicado, a un acto

Cambió lote de tiros por marihuana

The Face of Civil War
La revista Geo presenta esta impresionante fotografía tomada por Susan Maisel durante el levantamiento popular de septiembre.

La CLAT anuncia gran

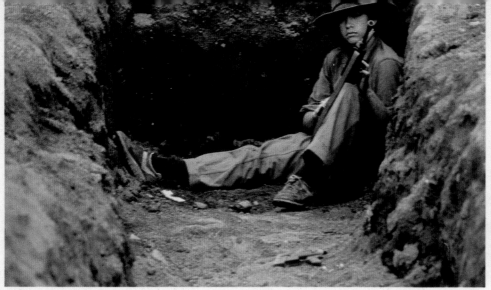

国家警備隊の装甲車の進攻を防ぐため道路ははがされ　バリケードと塹壕が作られたマナグア

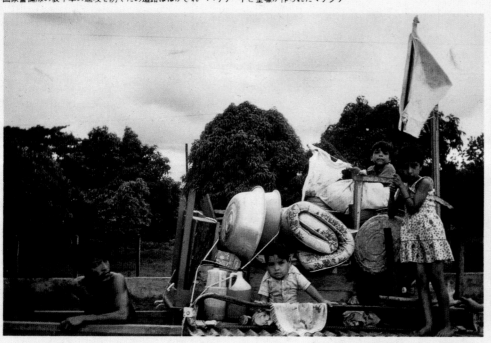

ニカラグア政府空軍は　サンディニスタ・ゲリラが潜伏して
いるマナグアの貧民街を高度1千㍍からロケット攻撃した
その結果　学校に逃げ込んだ多数の民間人・子供が死傷した

難民たちは　家財道具の一切合財を荷車に積ん
で　北ルートに沿って戦闘地域から逃げていく

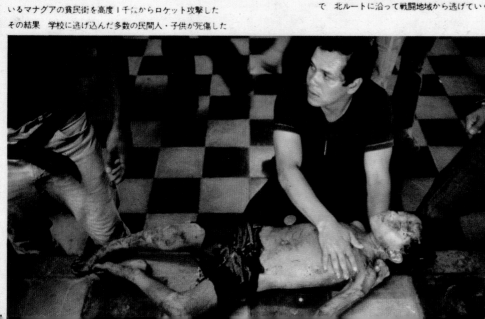

された女子学生の写真を掲げた大衆デモンストレーション

アナスタシア・ソモサ前大統領

マサヤの爆破された商業地区

国家警備隊を視察する大統領の子息ソモサ少佐

炎上するバス

北部の町　サン・イシードロにて

Nicaragua........ the final days.

The Somoza dynasty has come to an end, President Anastasio Somoza has fled
to his luxurious exile in the United States has been replaced by Francisco Urcuyo,
after 43 years of a Somoza family regime. The Sandinistaa are trying to install
their 4 men and 1 woman at the head of the country, as they presently hold 26
cities. Under the cover of darkness Pres. Somoza (53) together with his son
and halfbrother and 33 friends they boarded a Lear Jet and flew in exile to
Miami.

National Guard planes bombed the rebel hit cities of Esteli, Leon and
Matagalpa trying to destroy Sandinista guerrilla units. There are now more than
500.000 persons dislocated by the war, the United States is helping by flying in
food and supplies aboard C.130 transport carriers. In Managua alone the Red Cross
is trying to feed 250 persons, at present the nation requires 1500 tons of food per
week. Guerrillas control 26 cities and towns, and have circled and strangled the
support lines of the National Guard. The rebels could afford to be patient, as
they slowly tightened their noose around Managua. The war has left Nicaragua in
shambles, over 10.000 persons have died since the fighting started anew in May,
thousands of refugees are housed in camps or centers and daily line up for their
half rations of rice, beans and cornmeal. Now that Somoza has left, the National
Guard which he considered as his personal army live in fear as to what might happen
to them in a change of government, in comparison to the Imperial Guard of the Shah
of Iran upon the arrival of Ayatollah Khomeiny.

colour captions;

1 to 5 blocked off barrios rebel held zones of Managua, defended by modern
 automatic rifles and sandbags against Somoza's National Guards.

7 Sandinista guerrilas resting during street fighting.

8. young guerrilla volunteers holding a rebel town, nearby a pile of street
 blocks used for making barricades.

9 there is still time for a romantic guitar melody as a girl guerrilla
 rests near a wall painted with the Sandinista slogan.

10 - 13 the rebel Army of the Sandinista receive warm welcomes as they move from
 town to town, capturing Somoza National Guard held outposts.

14 - 16 the destroyed parts of Managua, the result of rocket firing by the
 National Guards the war having so far killed 10.000 Nicaraguans.

18 a guerrilla in his overnight resting place.

17. the body of a National Guard soldier killed in street fighting.

19-22 refugee centers and camps housing the thousands of homeless.

23 the funeral of a child killed in the street fighting.

Photos by Susan Meiselas/MAGNUM Photos

Left: Text and captions accompanying the Magnum distribution of *Nicaragua . . . The Final Days*, 1979.

Below: *Body of National Guardsman burned with the official state portrait of President Somoza, Jinotepe, Nicaragua*, 1979.

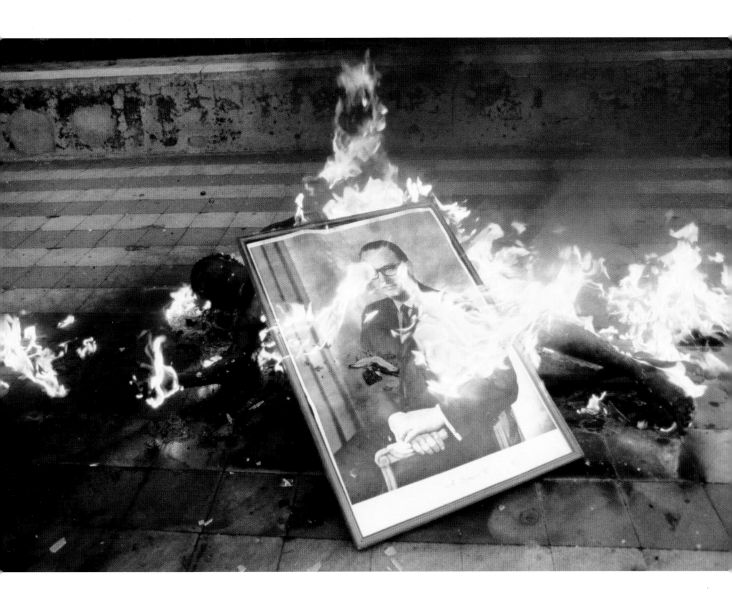

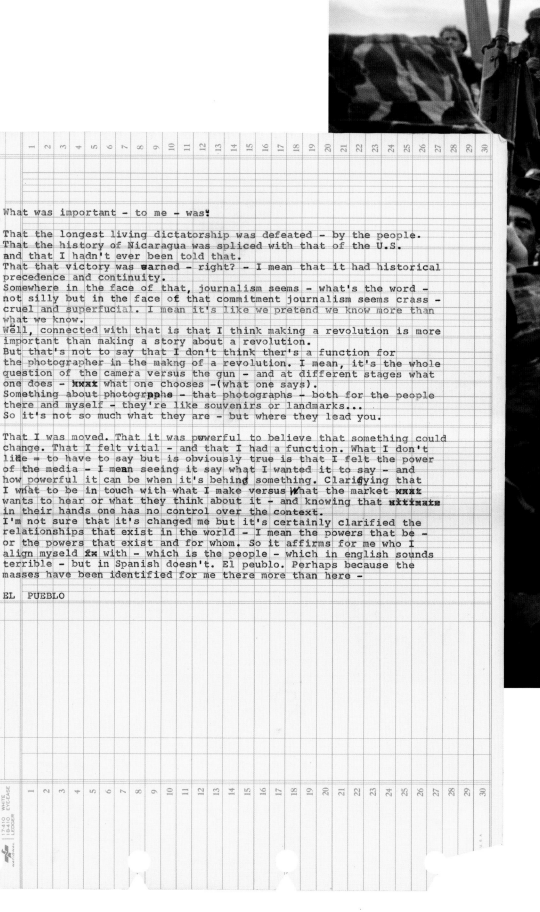

What was important - to me - was:

That the longest living dictatorship was defeated - by the people.
That the history of Nicaragua was spliced with that of the U.S.
and that I hadn't ever been told that.
That that victory was earned - right? - I mean that it had historical
precedence and continuity.
Somewhere in the face of that, journalism seems - what's the word -
not silly but in the face of that commitment journalism seems crass -
cruel and superfucial. I mean it's like we pretend we know more than
what we know.
Well, connected with that is that I think making a revolution is more
important than making a story about a revolution.
But that's not to say that I don't think ther's a function for
the photographer in the makng of a revolution. I mean, it's the whole
question of the camera versus the gun - and at different stages what
one does - xxxx what one chooses -(what one says).
Something about photographs - that photographs - both for the people
there and myself - they're like souvenirs or landmarks...
So it's not so much what they are - but where they lead you.

That I was moved. That it was powerful to believe that something could
change. That I felt vital - and that I had a function. What I don't
like - to have to say but is obviously true is that I felt the power
of the media - I mean seeing it say what I wanted it to say - and
how powerful it can be when it's behing something. Clarifying that
I what to be in touch with what I make versus What the market xxxx
wants to hear or what they think about it - and knowing that ultimate
in their hands one has no control over the context.
I'm not sure that it's changed me but it's certainly clarified the
relationships that exist in the world - I mean the powers that be -
or the powers that exist and for whom. So it affirms for me who I
align myseld fx with - which is the people - which in english sounds
terrible - but in Spanish doesn't. El peublo. Perhaps because the
masses have been identified for me there more than here -

EL PUEBLO

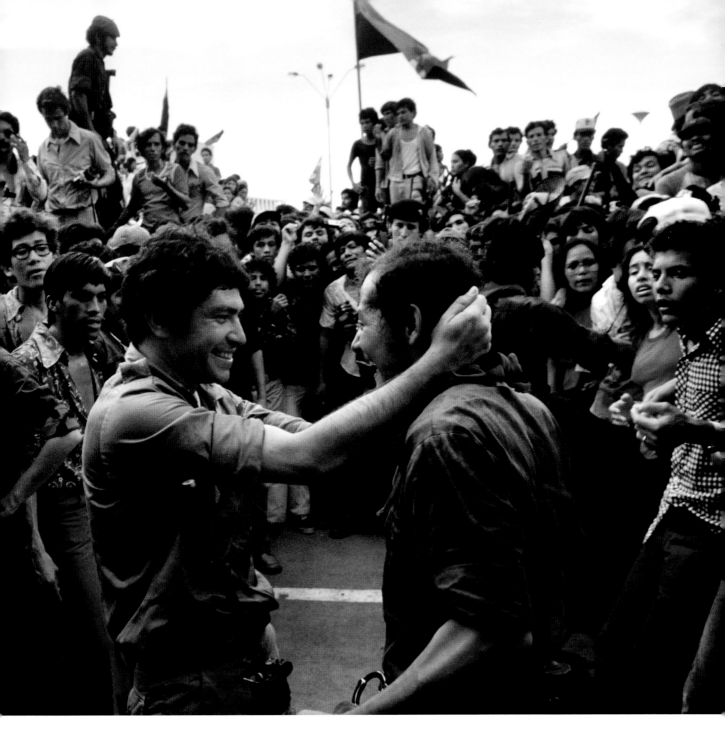

Above: *In the central plaza, renamed "Plaza de la Revolución,"*
Managua, Nicaragua, July 19, 1979.

Left: Preparatory notes for the making of *Voyages*, 1983.

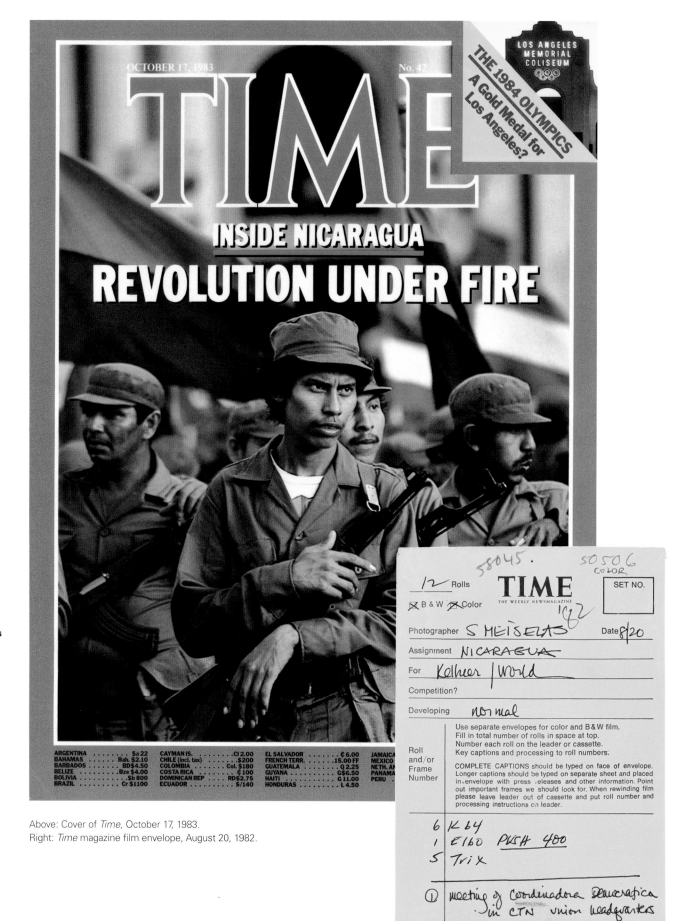

Above: Cover of *Time*, October 17, 1983.
Right: *Time* magazine film envelope, August 20, 1982.

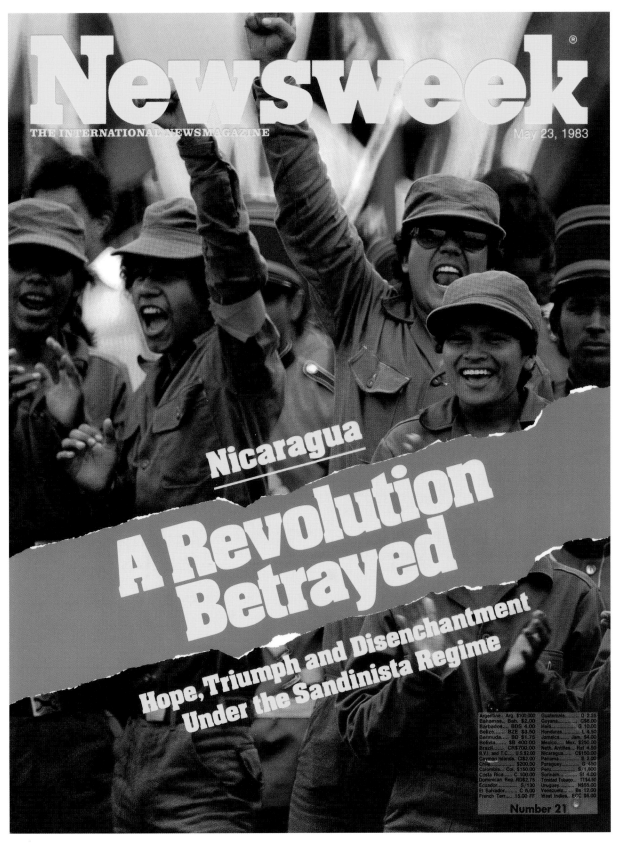

Argentina.. Arg. $100,000
Bahamas... Bah. $2.00
Barbados... BDS 4.00
Belize....... BZE $3.50
Bermuda.... BD $1.75
Bolivia...... $B 400.00
Brazil........ CR$700.00
B.V.I. and T.C.... U.S.$2.00
Cayman Islands. CI$2.00
Chile......... $200.00
Colombia.. Col. $150.00
Costa Rica.. C 100.00
Dominican Rep.RD$2.75
Ecuador..... $/130
El Salvador..... C 6.00
French Terr.... 15.00 FF

Guatemala...... Q 2.25
Guyana......... G$6.00
Haiti........... G 10.00
Honduras....... L 4.50
Jamaica....Jam. $4.00
Mexico.. Mex. $250.00
Neth. Antilles.. Naf 4.00
Nicaragua..... C$150.00
Panama........ B 2.00
Paraguay...... G 450
Peru......... $/1,800
Surinam....... Sf 4.00
Trinidad Tobago.. TT$4.50
Uruguay...... N$55.00
Venezuela.... Bs 12.00
West Indies.. ECC $6.00

Number 21

Cover of *Newsweek*, International Edition, May 23, 1983.

I first photographed in Nicaragua during 1978. While I continue to photograph the widening regional conflict in Central America, I have also been reexamining my earlier work and the various ways it has been used.

In 1981, I produced a book documenting the popular overthrow of the U.S.-backed Somoza regime in Nicaragua. By combining an extended photographic sequence with a historical chronology, political documents, and personal testimony by various Nicaraguans, the book attempted to overcome the sensational quality of fragmentary news reports by placing these events in the context of an evolving political process.

Completion of the book left me with many questions about my own process of selection and the extent to which it differed from the use of my photographs in the mass media. In order to engage the reader, I had still emphasized the more dramatic moments and tended to omit the more ordinary scenes of daily life. The book stressed a mass rebellion rather than focusing upon individual leaders, yet by ending with the victory of the popular forces, it did not document the problems of reconstruction.

Since the book's publication, the same images have been used by the Nicaraguans. Their own choices of graphics appropriate for murals, posters, stamps, etc. identify which images have a special symbolic resonance within the culture where the photographs were first made.

The present exhibition reconstructs the process of making a a book which documents social change in juxtaposition to a diverse range of other uses of the same body of imagery.

<div align="right">Susan Meiselas, January 1984</div>

captions for front wall

a. 1979 poster advertising charter issue of the U.S. edition of GEO; copies of the poster were promised to all initial subscribers.

b. GEO cover for charter issue of U.S. edition.

c. Table of contents reproducing another photograph from Nicaragua along with images from five other stories.

d. Cover of book, Nicaragua, published in the U.S., England and France in 1981.

e. Page from Nicaragua; alternative image eliminated by the photographer from the final book selection.

Nicaragua:Mediation:Meiselas

During December–January 1982–3, Camera-work Gallery showed an exhibition of photographs by Susan Meiselas in Nicaragua during a crucial phase of the Nicaraguan revolution (June 1978–June 1979). Meiselas' exhibition attempted to deal with the media's use of photographs. Three lines of pictures were presented, each of which represented the revolution in different ways: The central line, containing images from her book, *Nicaragua*, provided a chronology of events. The line above it consisted of cuttings from the magazines which used her photographs; it provided views of the Nicaraguan revolution as seen through the eyes of the international press. One could compare these two lines to see what the media included and edited out. The third line included many of the photographs that were edited out of the book: they formed the body of work from which certain choices were made for display and publication, and themselves provided other possible views of the revolution.

Graham Evans

The following is a transcript of a discussion held on the opening night of the show. Speakers include: Sarah Kent, David Hoffman, Carlos Augusto Guarita, Colin Jacobson, Willhelmina Oroszo, Chris Steele-Perkins, Martin Slavin.

Aud: Do you see any problems with the exhibition?
SM: To most people, books seem like 'the place to go' . . . but there were lots of real limitations, especially as the book constrains things to a linear structure (though I had complete control over sequencing). My frustrations led me to work on the exhibition: you in England are very lucky to have spaces in which to play and try to make different ideas work. The failure of the show is that the bottom line should be very thick and dense to give you a sense of that density of images that gets reduced into a book. So then, when you see a magazine, you realise how much more there has been. I'm saying that that's not fair to the public. If the show were working completely you would feel the gaps where the magazines don't publish, and that raises for us the question of 'why'?
 The history of the book began for me with an image of a body on a hillside which was never published, and as I understood would never be published. Part of my obsession was to build a book that would explain that picture, an image which you see constantly in, for example, El Salvador. The books aims to speak both to Nicaragua (as much as it could) and to people outside Nicaragua. It speaks differently to Latin Americans and Americans. In fact, to try to make a form which is very specific to your culture (which in my case is middle class American) capture another experience, is a very strange thing to do. I tried to make something that moved and brought the reader 'in'. Some of what you see on the walls represents where I made those decisions.

WO: Did the people in Nicaragua have a voice in how they were represented?
SM: I was in a sort of communication process with many of the Nicaraguans. The book had a function for them: the world would know something more than if the book didn't exist. I think what *they've* done with the images is much more meaningful in a strange way – for them, not necessarily for us.
Aud: I hear that subsequently a number of the images were used as billboard images in Nicaragua?
CSP: I was there until about six weeks ago: what's interesting and unusual is the way that these pictures have actually been taken up as symbols of the revolution.

SK: The whole process of making photographs is a process of selection. And that's what your exhibiton is about. Personally, however, I don't see any radical difference between the three layers of the exhibition. I don't look at the top row and see how *they're* left things out in the media. I really can't pinpoint any gaps, any 'lies through elimination', if you like.
MS: What stands out for me as a difference between the top and bottom line is that the bottom line is the work of a woman photographer (very distinct from what a male photographer would have done with war) and the top line, the choice made by male picture editors. A lot of the female content apparent in the bottom line is not apparent in the top line.

Aud: When it comes to events such as Beirut or Nicaragua, the images they are going to print are equivocal, ones you can read either way, according to an editorial stance that accommodates itself to the prevailing mood of the political situation.
MS: Violent pictures entertain and sell magazines. At the same time they are confusing: if you give the same kind of space to pictures of the victory celebrations they require a description of the political content of that victory. They are not confusing in the way that violent pictures are. The people who own those magazines do not wish to acknowledge the particular nature of that political content, because it is uncomfortable. People who own magazines don't generally approve of peasants taking over.
CJ: At some level there is entrepreneurial interference in any publication. But by far the most vivid influence on the selection of pictures consists of banal, down to earth considerations such as space, time, deadlines, what you ran last week.

CA: In all these situations there are photographers that actually live there and *do* take pictures whilst things are going on, yet you never see their photographs. The whole thing is tied up with the monopoly of news that's under the control of the multinational news agencies.
Aud: But what do you do? Either you take pictures or you don't. In any case it's better to take them.
CA: Yes and no. What I think is unusual about this exhibition is that the pictures are affirmative. They are for the guerillas, the revolution, unlike the coverage of similar situations, for example, Vietnam, where 99% of the photographs were taken with the US army. Some of them were critical of course, but you rarely saw anything taken behind North Vietnamese lines.

SK: Someone said that these photographs were clearly sympathetic to the revolution. Yet, I would have thought that, for example, the one on the cover of *Geo* could have been read either way depending on the caption. Do you have any control over that?
SM: *Geo* actually captioned it: 'Here behind a barricade in Massaya six rebels who started by spitting contempt at photographers change their minds and strike this dramatic pose, for *Geo*.' I was not on assignment for *Geo* when I took this picture. It's a complete construction.
SK: One of the things that strikes me looking at the photographs is that a genre of rebellion photographs gets created. A group of people behind the barricade with masks on look much the same in one country as in another.
DH: The selection is exotic. The easily assimilated. The ones that make Nicaragua seem 'somewhere else' and exciting. The exoticness is the criteria for their selection.

SK: This whole business of making a living out of other people's disasters or wars seems a difficult area.
SM: While living with that as one of many contradictions, I felt functional there, that people wanted me to take pictures.
Aud: Why were you so free to take pictures in Nicaragua when if you try and take pictures in Brixton you get your head beaten in?
SM: I was an American. We were paying to train the National Guard.

Draft text for the exhibition *Mediations* (far left), held at Side Gallery, Newcastle-on-Tyne (1982–83), and Camerawork, London (1984), along with installation view (below) and transcript of a discussion (left) held during the exhibition.

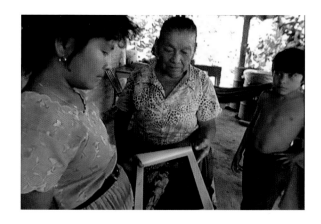

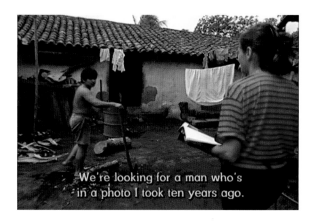

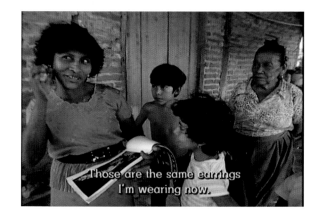

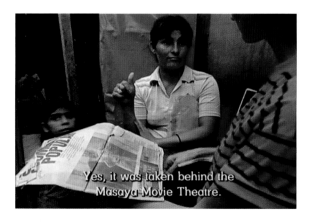

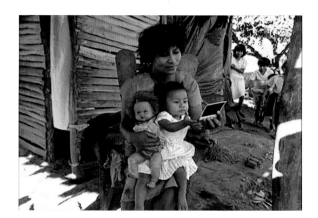

Left: Video stills from *Pictures from a Revolution*, codirected by
Susan Meiselas, Alfred Guzzetti, and Richard P. Rogers, 1991.

Series on left: Search for Augusto López-Gonzáles, Monimbo, Nicaragua, 1989.
Series on right: Finding Nubia Galan López, Los Altos, Nicaragua, 1989.

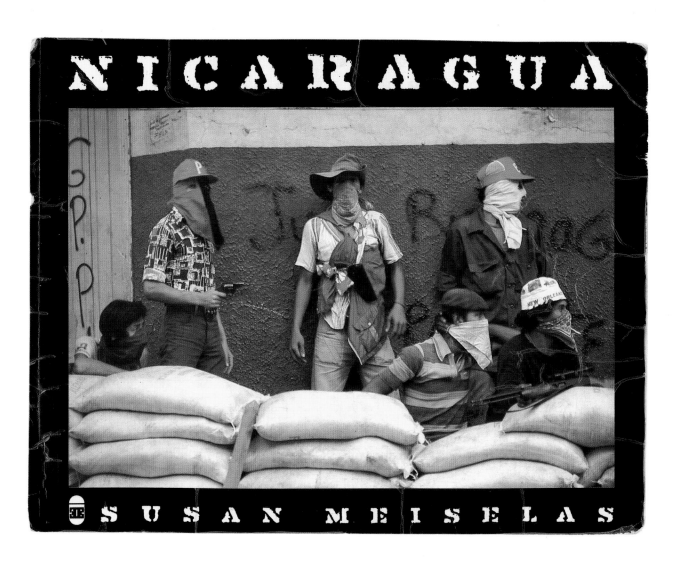

Cover of annotated copy of *Nicaragua, June 1978–July 1979* (New York:
Pantheon Books, 1981), used in the filming of *Pictures from a Revolution*, 1991.

Matagalpa - Cerca del parque pequeño
Cerca de la esquina del Hotel
Bermudez o una cuadra mas
cerca de la Iglesia

Nuria Salinas 45 años - oldest
10 años in photo
31 años
sembrando
ventas

Padre 76 años
7 hermanos vivos
Youngest
84 to Dario
1 año
82-84 - EPS
Primera BLI - Cero de Angeles
May '89 - has to do SMP

Del Banco 1 c. al este,
½ c. al sur

Octavio Castillo 59 años
(Padre)
Javier 34 años soltero

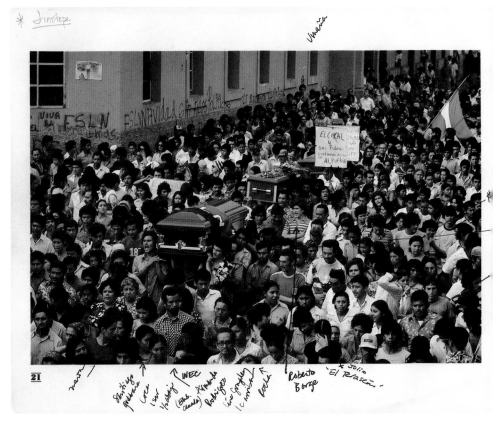

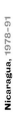

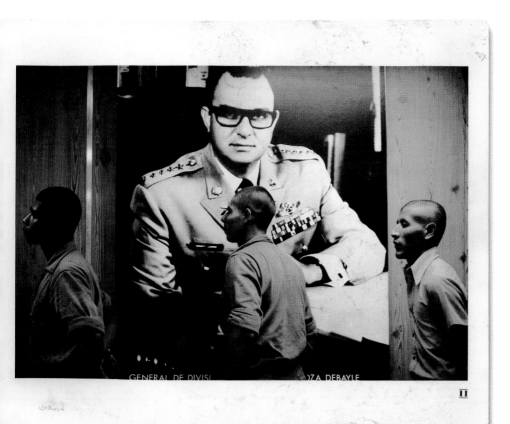

Annotated *Nicaragua, June 1978–July 1979* (New York: Pantheon Books, 1981), with field notes from the search for the original subjects in the photographs for the film *Pictures from a Revolution*, 1991.

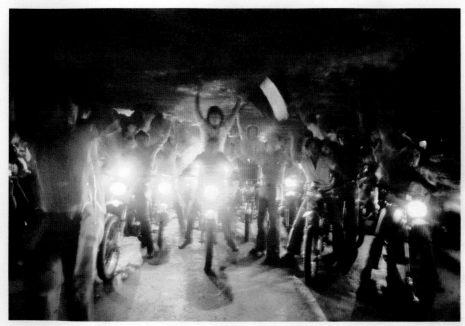

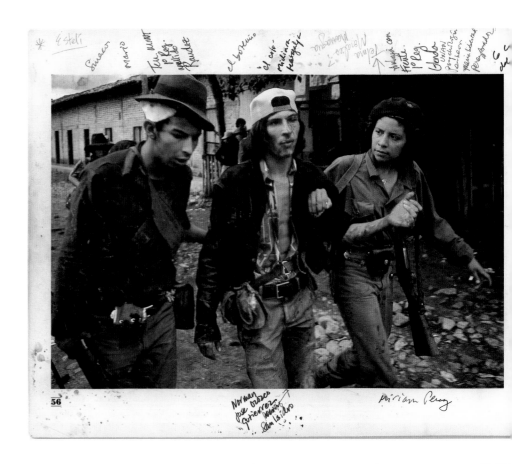

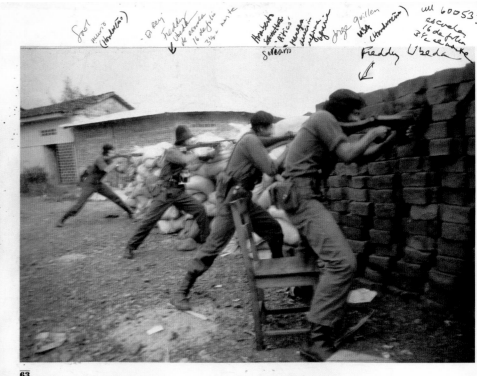

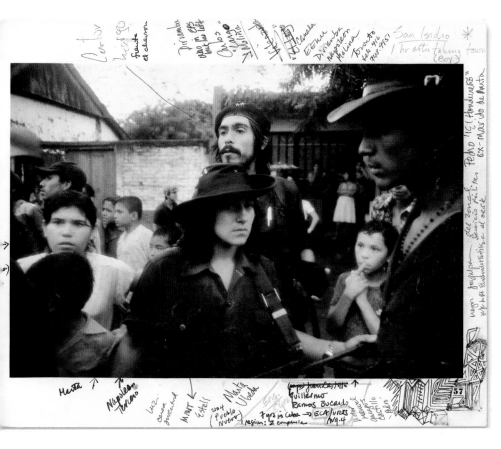

Annotated *Nicaragua, June 1978–July 1979* (New York: Pantheon Books, 1981), with field notes from the search for the original subjects in the photographs for the film *Pictures from a Revolution*, 1991.

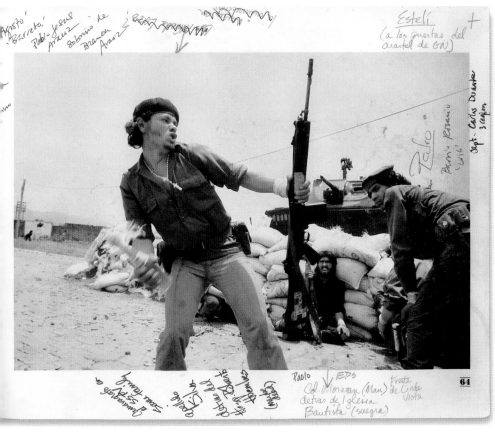

165

ESTO NO

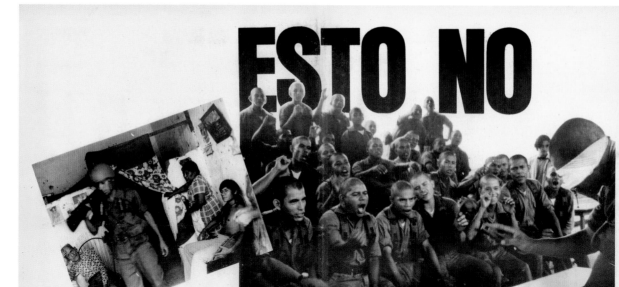

VOLVERA JAMAS

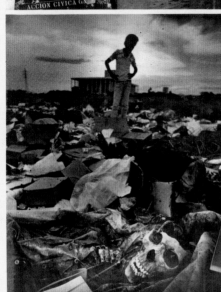

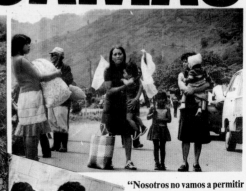

"Nosotros no vamos a permitir más, que lo que fue derribado en el pasado, aparezca revivido en el futuro. El futuro es del pueblo y para garantizar ese futuro estará nuestra Vanguardia y estarán nuestras armas y estará nuestra abnegación, nuestro sacrificio, nuestro sudor y nuestra sangre".

Dirección Nacional

TODOS A LA DEFENSA DE LA PATRIA

DEPARTAMENTO DE PROPAGANDA Y EDUCACION POLITICA (FSLN)

Left: "Esto no volvera jamas" (This will never return). Sandinista poster using one of Meiselas's photographs, Nicaragua, 1983.

Right: "Viviras Monimbo" (Monimbo will live). Cassette tape with cover art based on a Meiselas image from Nicaragua, 1980.

Below: Nicaraguan stamps based on a photograph by Meiselas, July 10, 1980.

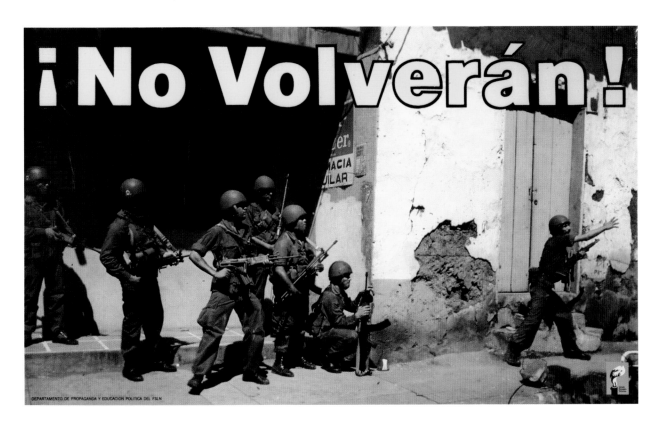

"¡No Volverán!" (They will not return!). Sandinista poster using a photograph by Meiselas, Nicaragua, 1983.

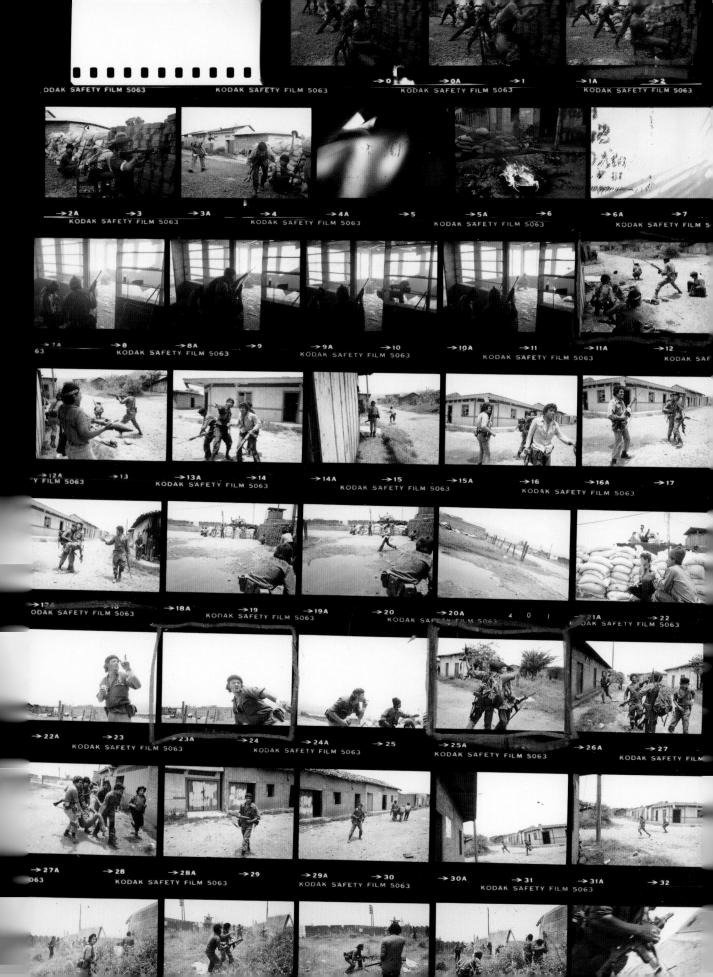

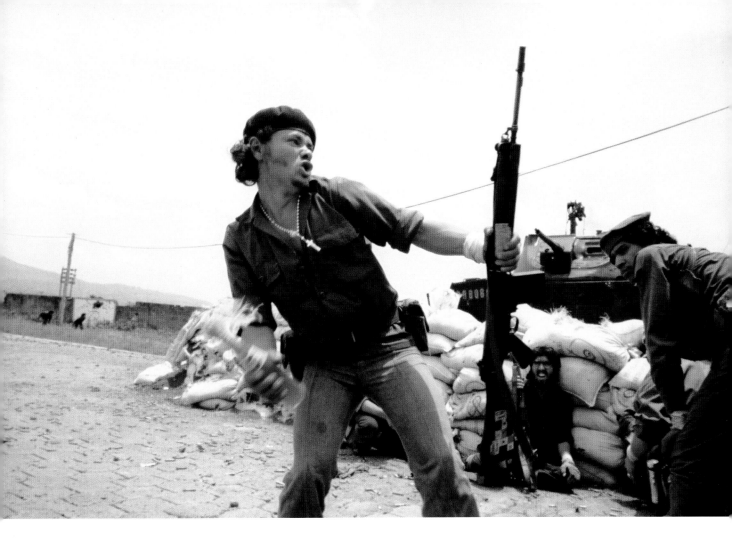

Above: *Sandinistas at the walls of the National Guard headquarters,*
Estelí, Nicaragua, 1979.

Left: Black-and-white contact sheet including the Molotov Man series,
Estelí: photographs of Pablo Araúz ("Bareta"), Nicaragua, July 16, 1979.
The signature image above was shot in color; Meiselas was also using
a second camera loaded with black-and-white film.

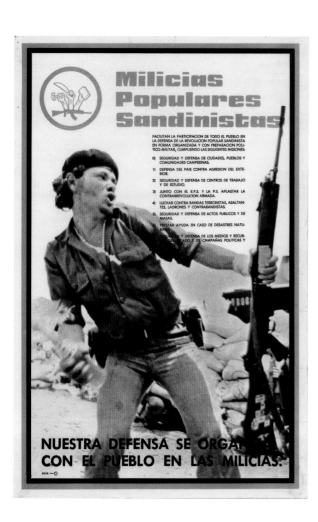

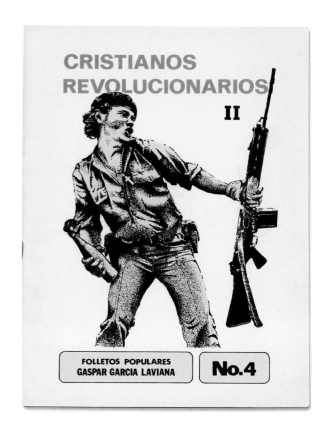

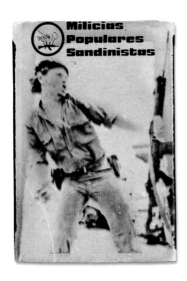

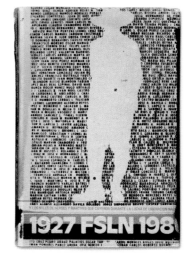

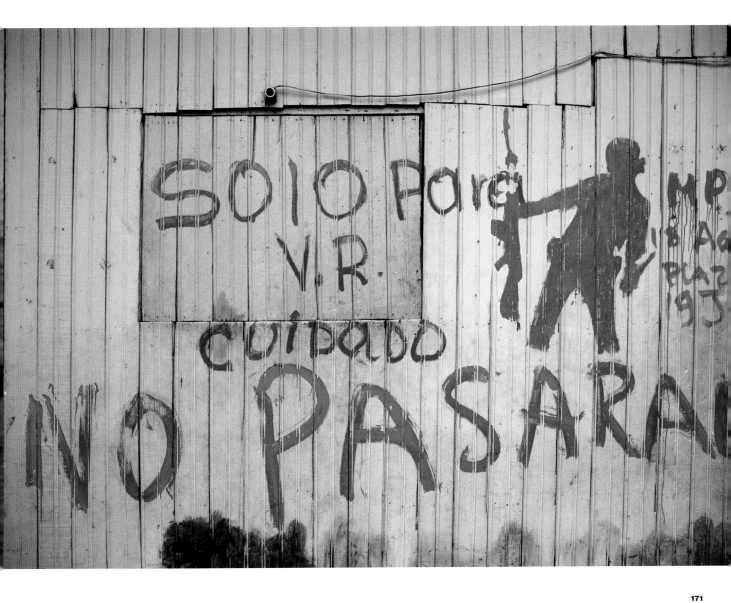

Above: Wall stencil based on Meiselas's Molotov Man,
Estelí, Nicaragua, 1982.

Left (clockwise from top left):

Sandinista poster to raise a popular militia, Nicaragua, 1982.

Church publication, Nicaragua, 1980.

Matchbook (recto and verso), Nicaragua, July 1980.

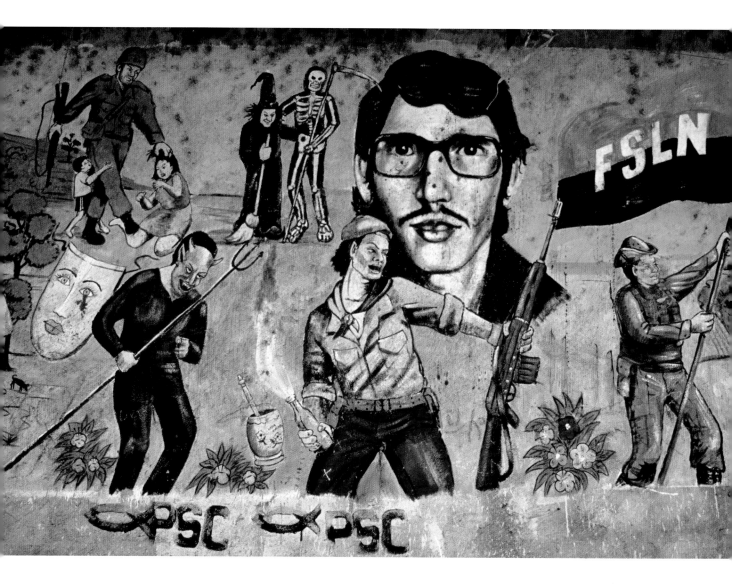

Mural featuring Nicaraguan folk legends including the Molotov Man, Masaya, Nicaragua, 1986.

Wall previously painted with the Molotov Man, blackened before
election campaign, Masaya, Nicaragua, 1991.

El Salvador: The Stat

By Richard J. Meislin

In a conference room behind the high gray walls, heavy steel latticework and thick bullet-proof glass of the United States Embassy in San Salvador, one of the highest-ranking members of the diplomatic mission is offering his view of the facts of life to a group of American visitors. The delegation, which includes a Congressman, two entertainers active in human-rights causes and several others concerned about American policy, is angry; they have seen and spoken to political prisoners who say they've been tortured, Salvadoran officials who say they are doing their best and refugees who say little but suffer a lot. The diplomat is tired. This is the 17th delegation the embassy has shepherded through the Salvadoran labyrinth during the past few weeks. "The semiannual precertification flying circus and hootenanny," another embassy official calls it.

"We take as a given that this country is a horror," the beleaguered diplomat tells his visitors. "There are things here which are frightening and appalling to any sensitive human being. And those of us who work in this environment and see our friends killed, murdered, tortured by one group or another are not insensitive to these things."

The diplomat asks not to be identified by name for "security reasons" — a reasonable request, even for someone who works in an urban fortress, lives in a home guarded by a Salvadoran carrying a semiautomatic rifle and commutes between the two in an armored car. In El Salvador, silence and safety still go hand in hand.

As the diplomat speaks, officials at the State Department in Washington, some 2,000 miles away, are feverishly putting the final touches on a report that will certify El Salvador's progress in improving human rights and in meeting the other conditions set by Congress for six more months of United States military aid. "The situation is not perfect," the 67-page

Richard J. Meislin, a New York Times correspondent based in Miami, covers the Caribbean and Central America.

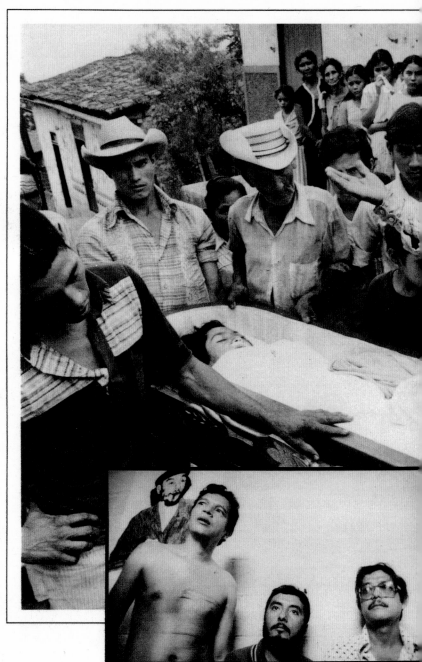

Previous page: *Firing range used by U.S.-trained Atlacatl Battalion, Usulután, El Salvador*, 1983.

f Siege Continues

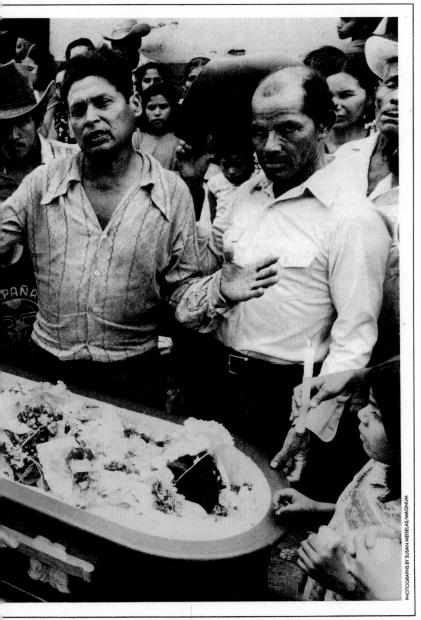

PHOTOGRAPHS BY SUSAN MEISELAS/MAGNUM

A mother and daughter killed in a clash between Salvadoran Government and guerrilla forces share a common coffin (above). Prison inmates (left) tell of being tortured; one of them displays scars he says were caused by hydrochloric acid.

report will say when it reaches Congress two days later, on Jan. 21, "and the progress was not as great as desired, but it is progress nonetheless."

In San Salvador, the diplomat and his visitors assume this will be the outcome — it has happened twice before — and the diplomat offers an explanation in advance: "The criterion is not whether you come up with the bare minimum standards of social justice in the country, but has there been some progress toward that goal. And the question is really, 'All right, so there has been some progress. So what?'"

The certification process's increasingly tenuous connection to the realities of El Salvador is raising new questions in Congress and even within the Reagan Administration it-

Despite conditions attached to U.S. aid, human-rights abuses continue in El Salvador.

self. The feeling, variously, is that it is not bringing about the desired improvements in El Salvador, is continuing to provide aid to a Government whose actions are at least questionable, or is diverting attention from the deeper questions facing the United States in its policies toward El Salvador and the rest of Central America.

Recent talks with American diplomats and Congressmen found an increasingly urgent desire for a cogent political strategy to complement, or even replace, United States military support for the Salvadoran Government, yet nothing seems to be immediately forthcoming. Talks with the provisional President, Alvaro Alfredo Magaña Borja, other Salvadoran officials and political prisoners in their cells help indicate why this is so difficult to attain.

The aid and advice provided by the

177

"El Salvador: The State of Siege Continues," *New York Times Magazine,* February 25, 1983, pp. 34–35.

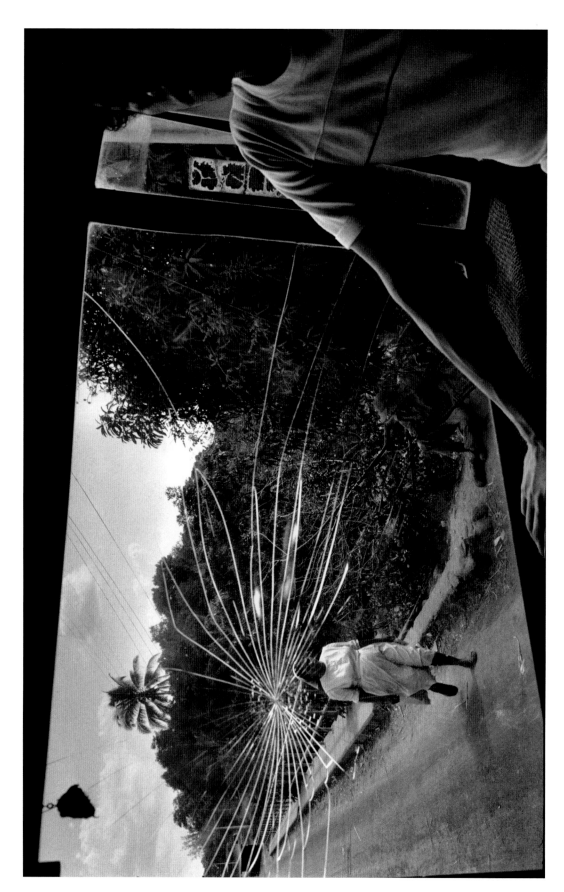

Road to Aguilares, El Salvador, 1983.

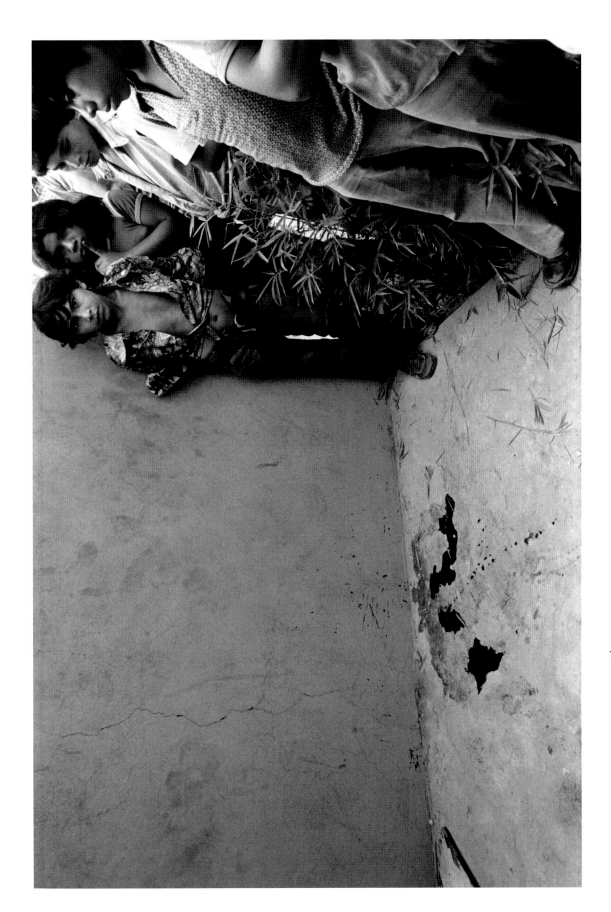

Blood of student slain while handing out political leaflets, San Salvador, El Salvador, 1979.

179

El Salvador, 1979–83

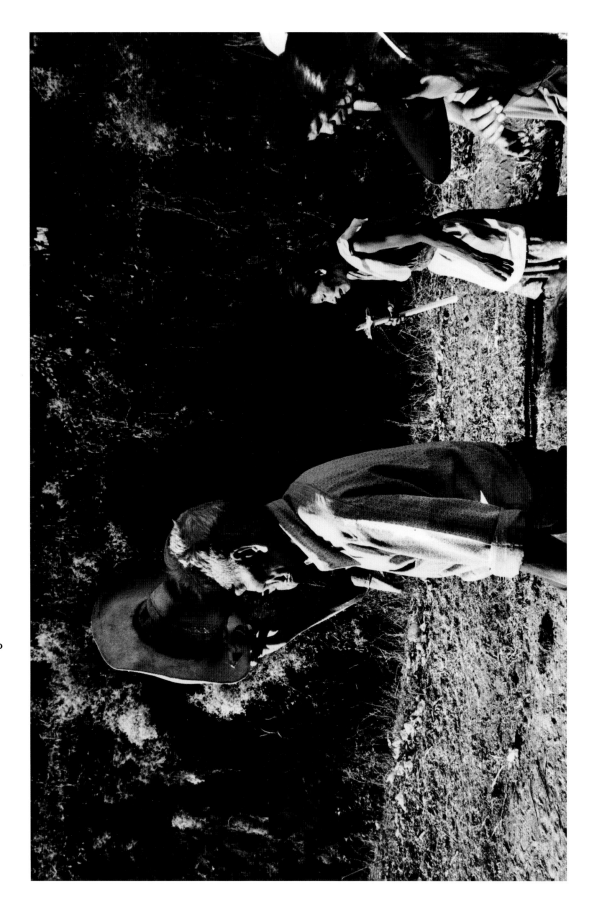

Funeral procession for member of the civil defense, El Triunfo, El Salvador, 1982.

Soldiers search bus passengers along the Northern Highway, near Suchitoto, El Salvador, 1980.

181

El Salvador, 1979-83

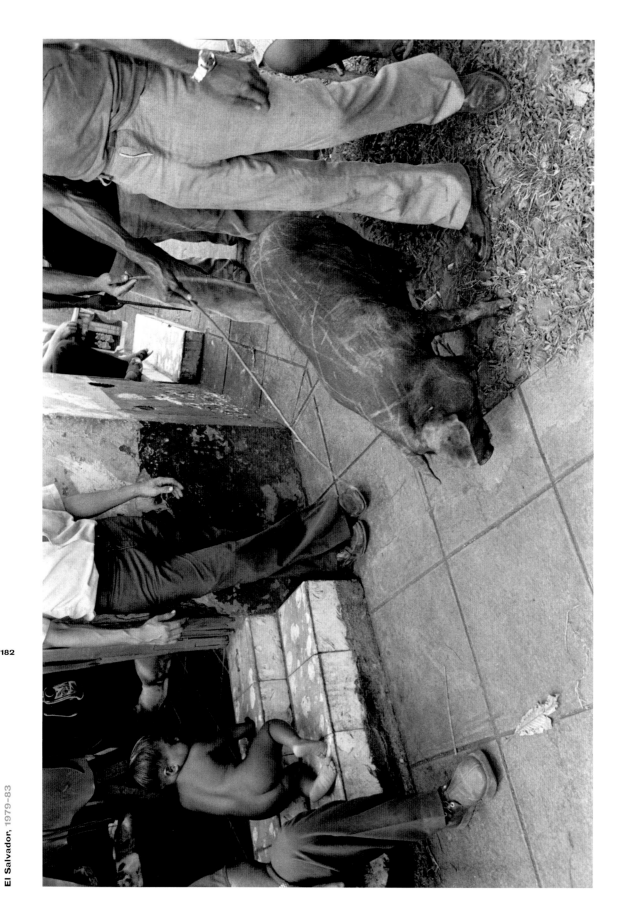

Streets of Sonsonate, El Salvador, 1980.

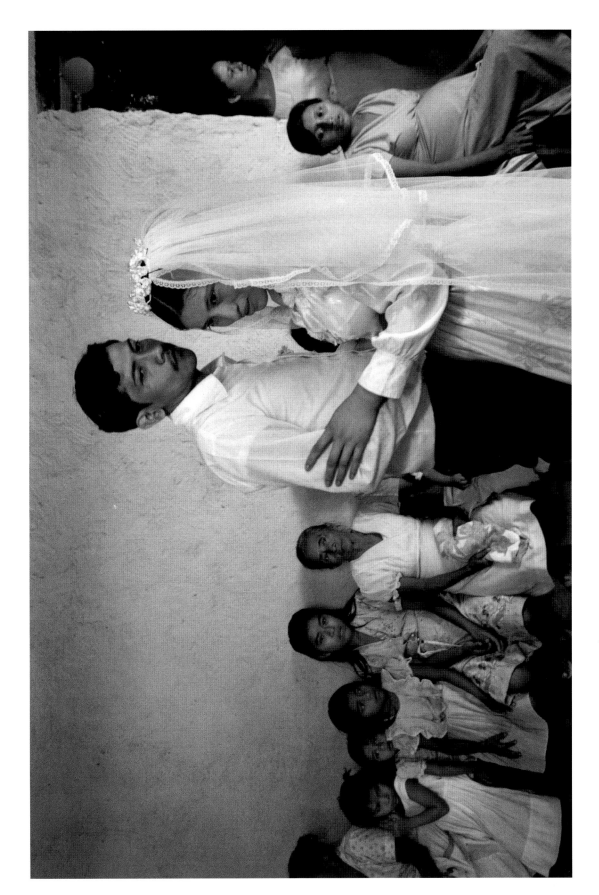

Wedding reception in the countryside, Santiago Nonualco, El Salvador, 1983.

183

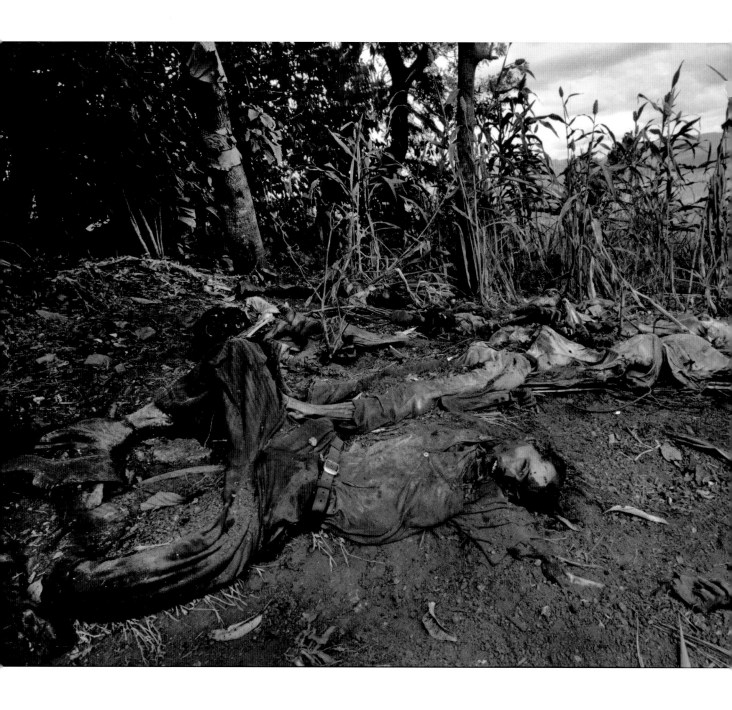

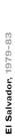

Above: *Victims of the El Mozote Massacre, Morazán, El Salvador*, 1982.

Right: Cover of *The New Republic*, December 26, 1983, with Meiselas's image of the *mano blanca*, a signature of the death squads, Arcatao, El Salvador.

DECEMBER 26, 1983 · $1.50

The use and abuse of J.F.K., by Henry Fairlie

BASHING THE SYRIANS, SORT OF · ROGER SHATTUCK: STRAVINSKY'S BODY · GROUP RIGHTS & WRONGS

THE NEW REPUBLIC

The Truth About The Death Squads

by Christopher Dickey

185

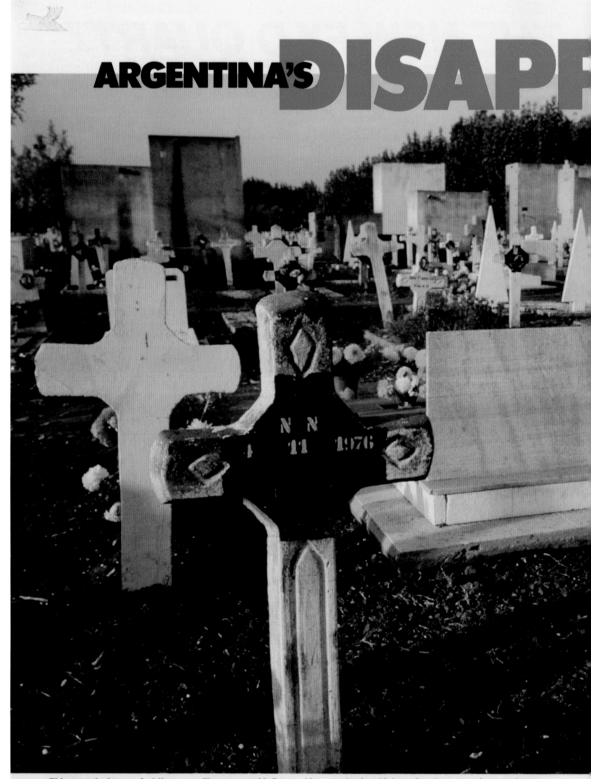

This unmarked grave of a "disappeared" person outside Buenos Aires was dug just 18 days after the present junta took over.

EARED

" PEOPLE HAVEN'T GRASPED THE ENORMITY OF WHAT HAPPENED "

In graveyards throughout Argentina, one comes upon simple markers, all but hidden among elaborately carved headstones; each bears only the stenciled date of burial and the letters NN—*No Nombre*. No name. Until recently there were hundreds upon hundreds of such monuments to the nameless dead (not to mention scores of unmarked mass graves), but the country's military junta has been plowing them under, trying in vain to bury both the fact and the memory of its bloody rule.

These corpses are euphemistically known in Argentina as the "disappeared." Most are innocent victims of a reign of terror as brutal as any the free world has suffered in decades. It started as a counter-campaign against Marxist guerrillas and middle-class anarchists who, in the early and mid-'70s, savaged Argentine society. They freely roamed the streets, gunning down more than 700 military officers, politicians and businessmen. Those they did not kill they kidnapped and held for ransom.

Finally, in 1976, with the country on its knees, a military junta seized control of the government, promising to subdue both terrorists from the left and the fascist gangs that had sprung up in opposition. The armed forces immediately set to work not only killing the terrorists but also abducting, torturing and assassinating the very citizens it had promised to protect. Thousands were jailed without charges, executed without trials. Families were never informed, names never released, bodies never returned. By the end of 1979 more than 10,000 people —and perhaps as many as 30,000 —had "disappeared." Most are presumed dead.

All this is in the past. In the last two years the killings and abductions have dwindled to a handful. But intimidation and detention continue, and the right to due process and a fair trial—never the country's strong suit—are now nonexistent. About 1,000 political prisoners are still being held in "preventive detention," their future unknown. Argentina, in fact, has become the most nettlesome test of President Reagan's hotly disputed human rights policy. Arguing that the situation in Argentina has improved, and that allies, even when wayward, must be supported, the White House has asked Congress to lift its ban on arms sales imposed in 1978.

Policemen in riot gear carry away a demonstrator in the early '70s.

Photography: Susan Meiselas Reporting: Steve Robinson

187

"Argentina's Disappeared," *Life* (September 1981), pp. 38–39.

COLOMBIA
BLOEDT DOOD

■ Het is er een en al geweld. Drugs-handelaren die een cocaïne-oorlog voeren, criminaliteit in de steden en de krottenwijken, guerrilla's die het regeringsleger bestrijden en de doodseskaders die snel en geruis-loos hun werk doen. Logisch dat in Colombia ook de "gewone" criminaliteit enorm stijgt.

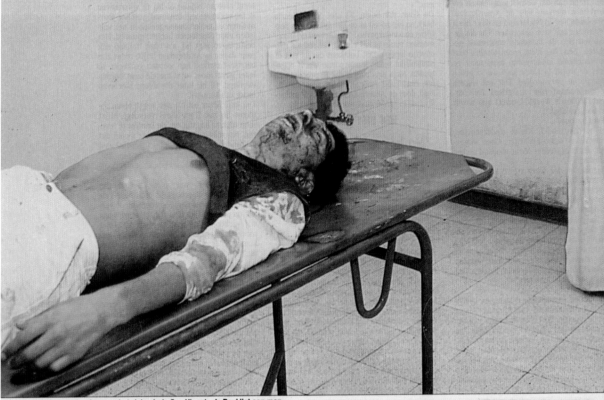

■ In het mortuarium van het ziekenhuis San Vicente de Paul ligt een man die met vijf kogels door het hoofd om het leven is gebracht.

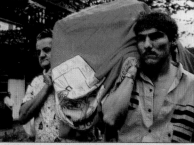

■ Vakbondsleider Hector Velasquez wordt door leden van zijn bond naar zijn laatste rustplaats gedragen.

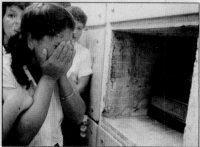

■ Familieleden van de vermoorde leraar Jairo Gomez van het Camilio Torrescollege, vernoemd naar de priester-revolutionair, huilend bij de plaats waar zijn dode lichaam ligt opgebaard.

■ De doodkistenmakers beleven drukke dagen. De deksel van de kist wordt met de hand van figuren voorzien.

DOOD Een eenvoudige sloppenbewoner wordt met vier kogels in het hoofd op de weg gevonden. Niemand had de schoten gehoord.

De mannen uit de Amerikaanse ambassade parkeren hun kogelvrije 4x4-combi's naast het politievliegtuigje en laden olijfgroene legertassen uit. Het is vijf uur in de morgen en nog donker. Een koude wind stuwt motregen over het vliegveld, waarvan de markeringslichten een zwart bergmassief lijken op te houden. Bogota ligt op 2.640 meter in een dal.

Ze zijn met z'n drieën. Nummer één draagt zijn legertas zoals een gelukkige huisvader op weg naar een vakantiebungalow. Nummer twee knoopt een uniformjack met het opschrift 'Coast Guard' dicht. Nummer drie steekt een sigaret op en overhandigt een kaart met zijn naam en het simpele opschrift 'US Department of State'.

Nummer drie valt verder niet op. Een vierde man komt aanrijden in een Lada met brede banden en met lijfwachten erin. Hij draagt een groot kaliber pistool met verlengd magazijn tussen zijn broeksband: Colonel Garzon Ernesto Condia, plaatsvervangend commandant van de anti-drugs-politie van Colombia.

ALS DE TWEEMOTORIGE Twin Otter zich door de wolken ploegt, wordt het licht. We vliegen in zuidwestelijke richting over een van de drie armen van de Andes, die evenals de Rio Magdalena een spoor dwars door Colombia trekken. Drieëneenhalf uur later landen we op een baan van roestige luchtlandingsplaten van een militair steunpunt aan de grens met Ecuador. Op de controletoren lezen we: Leguizamo. Anderhalf uur en vele flesjes cola later hebben de mannen van de Amerikaanse ambassade zich als rambo's uitgedost. Nummer een draagt behalve wapen en kampmes een reddingslamp in een schoudertas. Nummer twee een nood-kompas aan de pols. Vijf helikopters hangen boven de ijzeren baan en drukken het junglegras plat.

DE ACTIE – DEEL één van het miljoenenplan waarmee Washington het drugsbestrijdingsprogramma financiert- loopt al ▶

"Colombia: Bloedt Dood," *Nieuwe Revu* (The Netherlands) (July 1988), pp. 26–27.

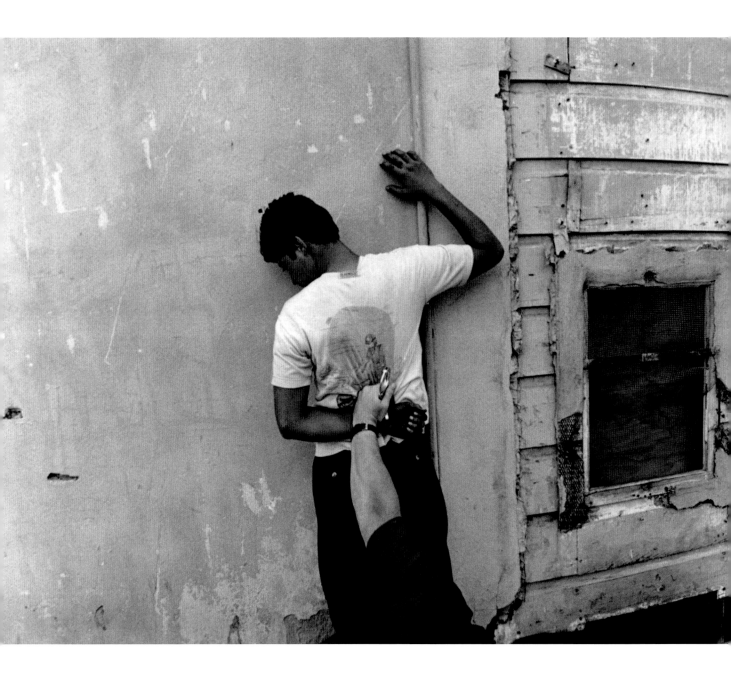

U.S.–Mexico Border, 7:30 am, arrest of undocumented workers by U.S. Border Patrol in downtown San Diego, 1989, from the series *Crossings*.

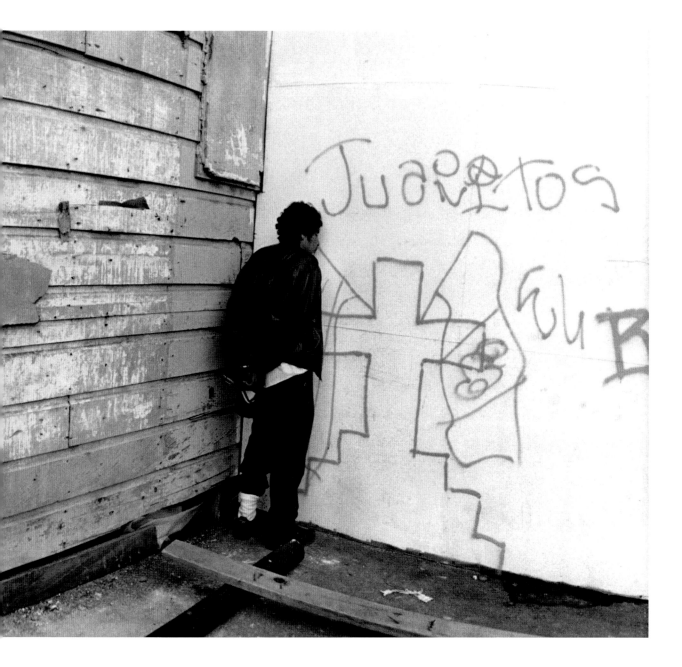

U.S.-Mexico Border, 1989–90

Left: *U.S.–Mexico Border, 8:00 am, undocumented workers discovered in "drop site," Interstate 5, Oceanside, California, 1989,* from the series *Crossings.*

Below: *U.S.–Mexico Border, 10:00 am, "drop site," near Interstate 5, Oceanside, California, 1989,* from the series *Crossings.*

U.S.–Mexico Border, 1989–90

Left: *U.S.–Mexico Border, 3:00 am, carload of undocumented workers captured by Border Patrol, Chula Vista, California*, 1989, from the series *Crossings*.

Below: *U.S.–Mexico Border, 2:00 pm, holding cell for undocumented female detainees, El Cajon, California*, 1989, from the series *Crossings*.

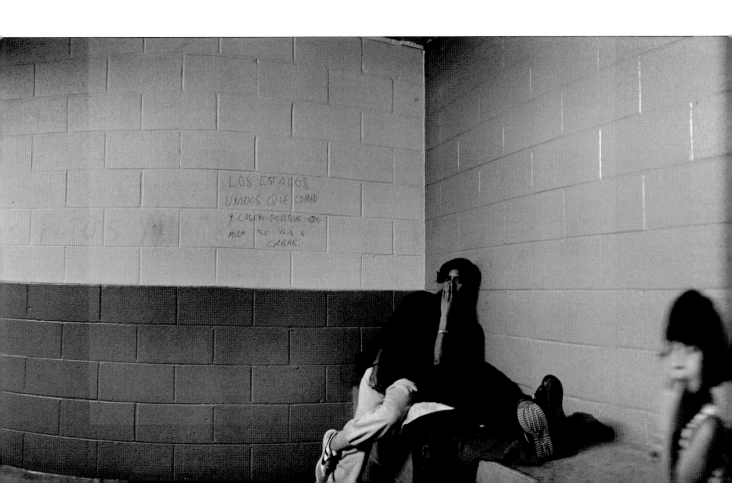

SAN DIEGO SECTOR APPREHENSIONS OTHER THAN MEXICAN
BY SPECIFIC NATIONALITY
FY 1988

COUNTRY		COUNTRY		COUNTRY	
Algeria	1	Guatemala	3,243	Peru	237
Argentina	19	Guyana	6	Philippines	11
Australia	2	Honduras	608	Poland	6
Bangaladesh	6	Hungary	3	Portugal	29
Belguim	1	India	20	Senegal	2
Belize	24	Iran	18	Somolia	1
Bolivia	49	Ireland	2	South Africa	4
Brazil	266	Israel	3	South Korea	53
Canada	7	Italy	1	Spain	3
Chile	12	Jamaica	7	Sweden	1
China (PRC)	45	Japan	1	Switzerland	1
Colombia	347	Jordan	5	Syria	2
Costa Rica	37	Lebanon	1	Turkey	16
Cuba	10	Netherlands	1	United Kingdom	8
Dominican Rep.	439	New Zealand	1	Uruguay	40
Ecuador	377	Nicaragua	458	Venezuela	9
Egypt	3	Nigeria	1	Yugoslovia	46
El Salvador	4,471	Norway	3	West Germany	6
France	1	Pakistan	11		
Gambia	1	Panama	4		
Greece	2	Paraguay	23		

1988	1987	% INCREASE
11,016	8,051	+36.8%

Above: U.S. Border Patrol Report, 1988.
Below: Postcard, date unknown.
Left: United States Border Patrol recruiting brochure, date unknown.

RETURNING BACK TO THE STATES AFTER VISITING TIJUANA, MEXICO. 7

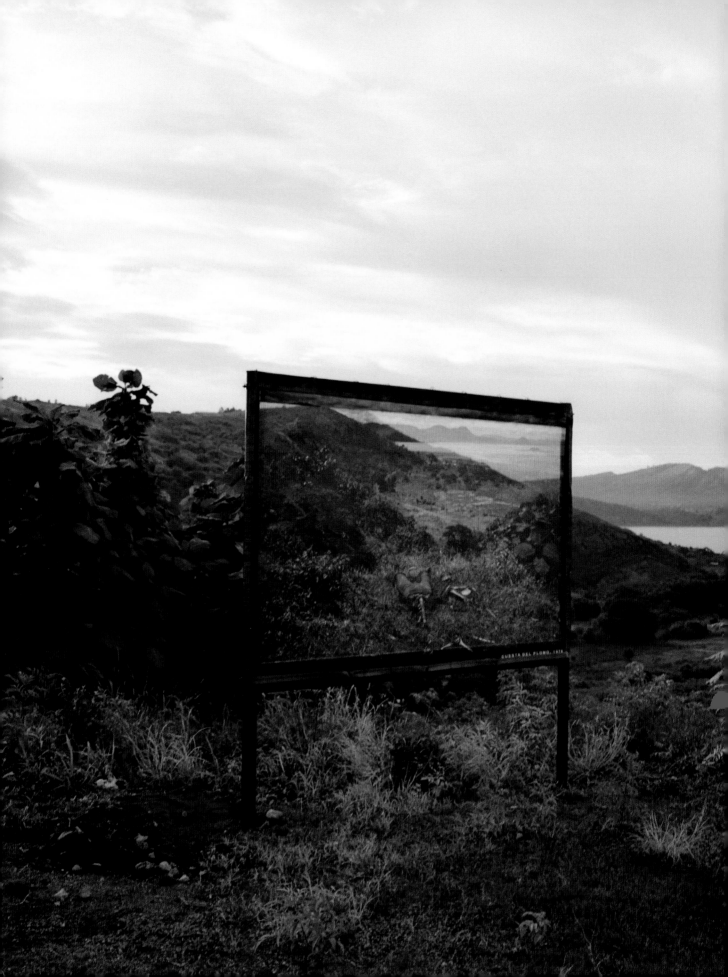

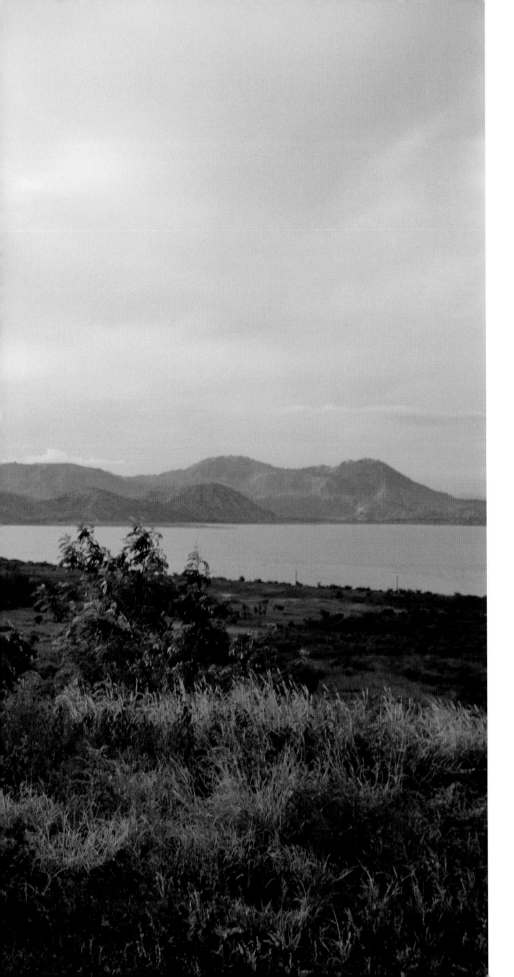

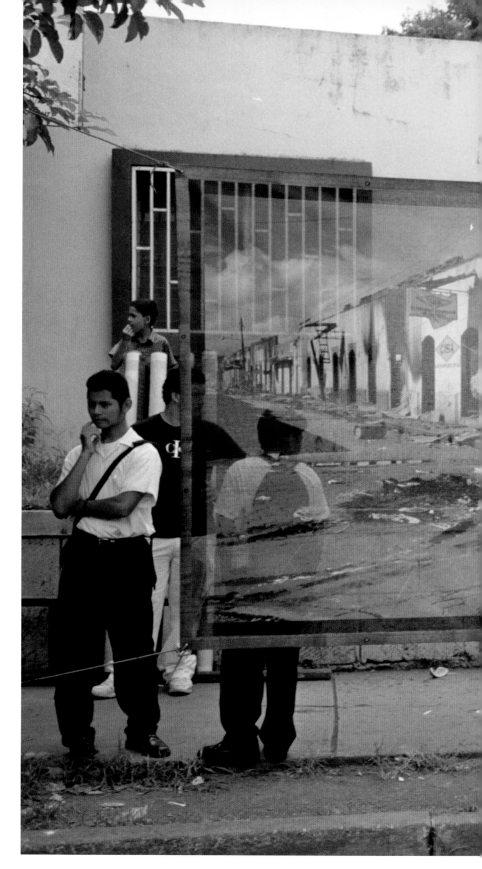

Muchacho withdrawing from commercial district of Masaya after three days of bombing, September 1978, from the series *Reframing History*, Masaya, Nicaragua, July 2004.

Previous page: *"Cuesto del Plomo," hillside outside Managua, a well-known site of many assassinations carried out by the National Guard. People searched here daily for missing persons. July 1978*, from the series *Reframing History*, Managua, Nicaragua, July 2004.

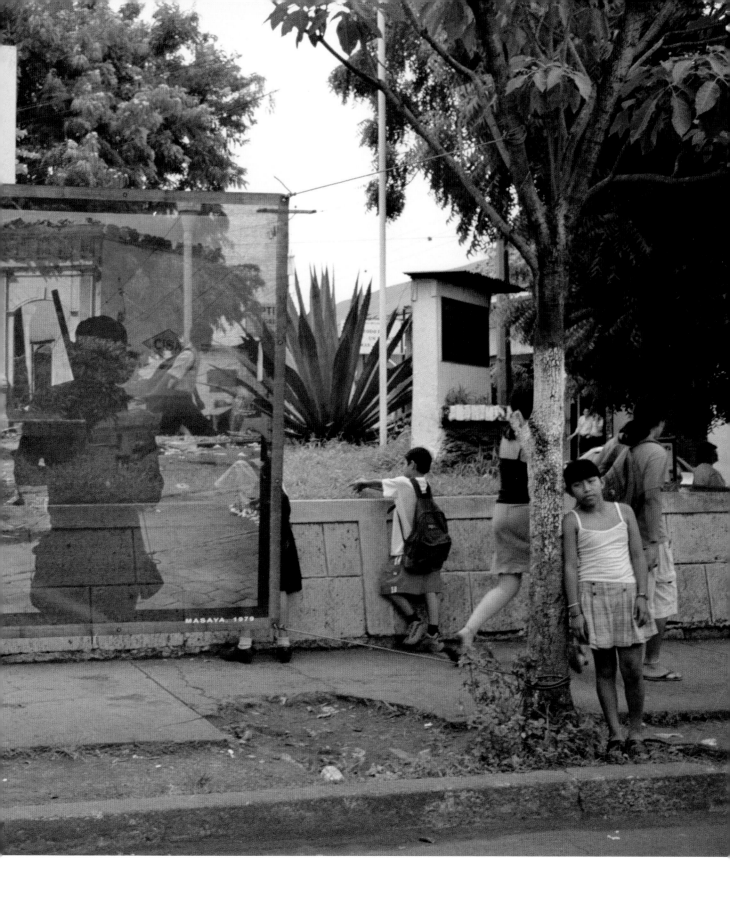

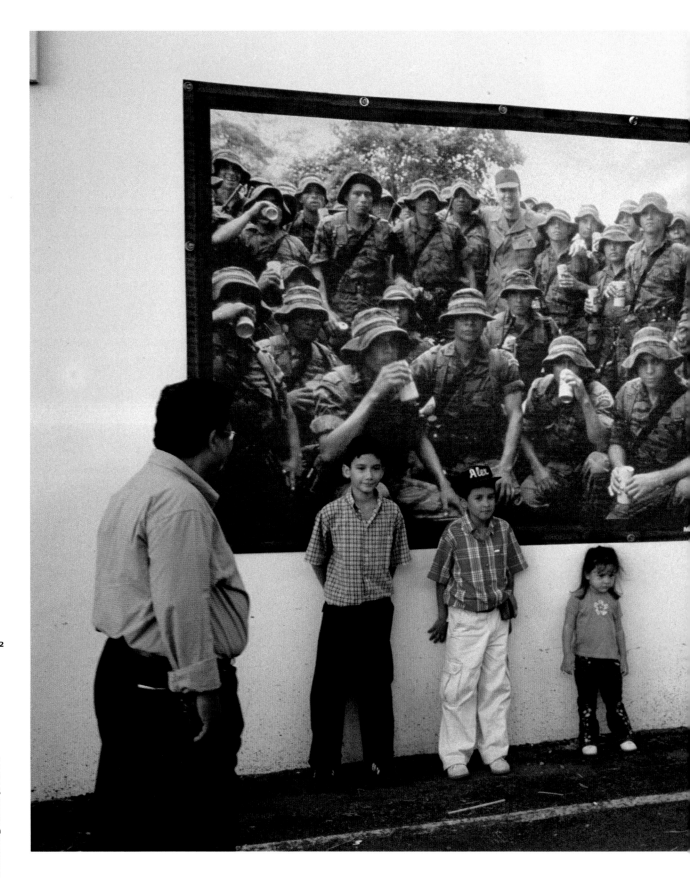

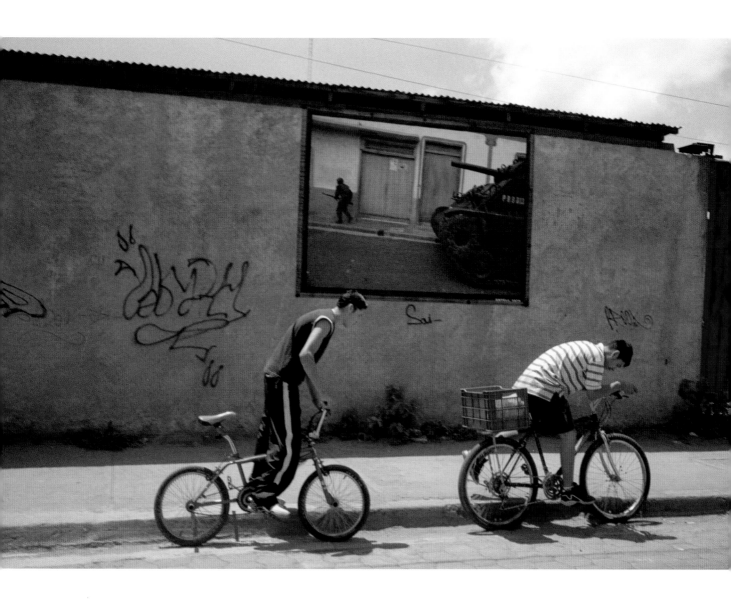

Above: *National Guard entering Estelí, September 1978,* from the series *Reframing History*, Estelí, Nicaragua, July 2004.

Left: *Awaiting counterattack by the Guard, September 1978,* from the series *Reframing History*, Matagalpa, Nicaragua, July 2004.

Muchacho withdrawing from commercial district of Masaya after
three days of bombing, July 1978, from the series *Reframing History*,
Masaya, Nicaragua, July 2004.

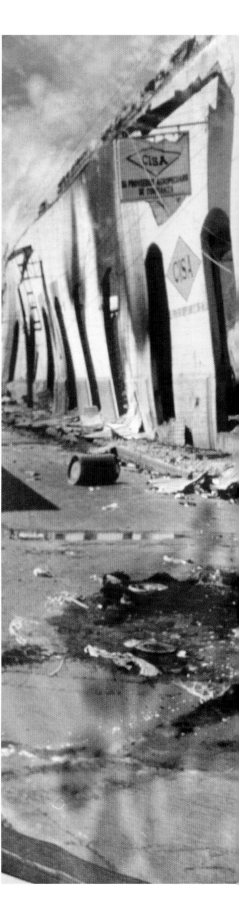

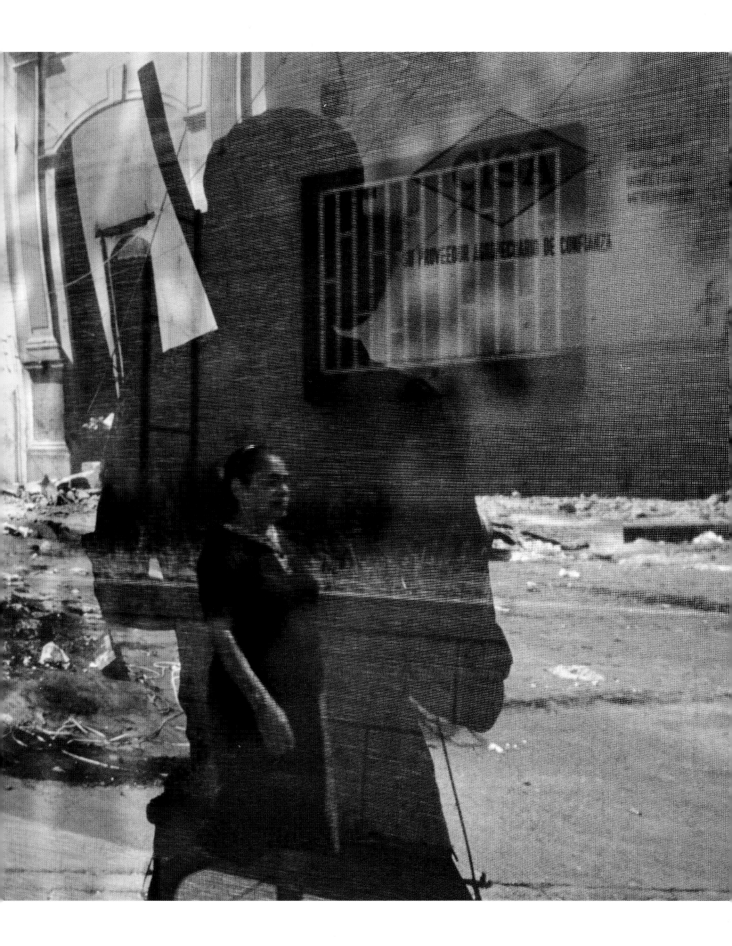

Chapter 2 Essays:

Lucy Lippard
Susan Meiselas: An Artist Called

Edmundo Desnoes
The Death System

Voyages: Transcript of a Film
by **Marc Karlin** with **Susan Meiselas**

Diana Taylor
Past Performing Future:
Susan Meiselas's *Reframing History*

Meiselas with Alan Riding of the *New York Times*
in background, during the September Insurrection,
Masaya, Nicaragua, 1978. Photo: Alain Dejean.

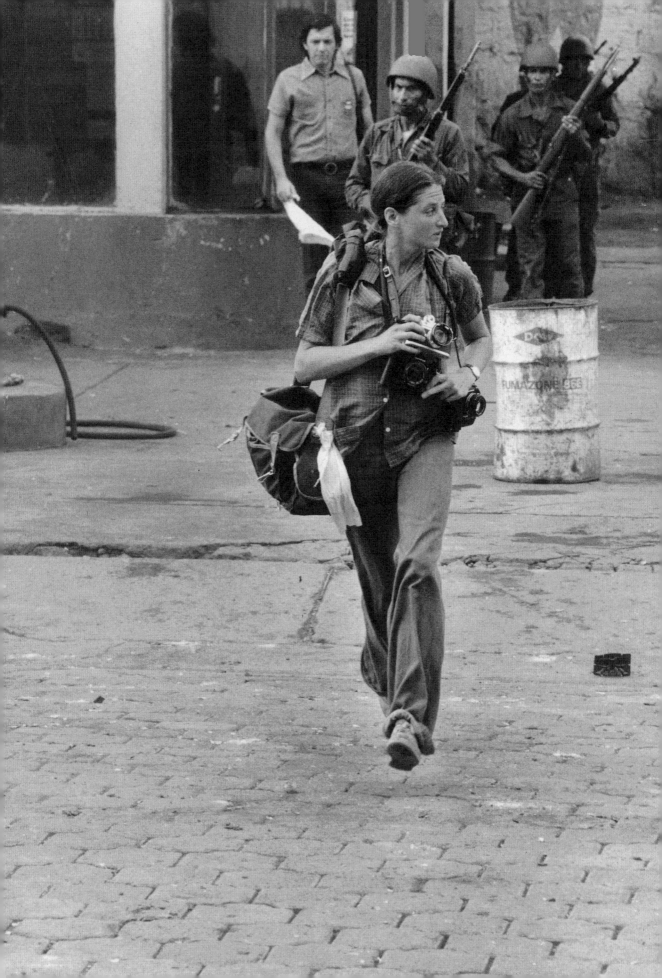

Susan Meiselas: An Artist Called

Lucy R. Lippard

**How far away is Central America? Near enough to hurt, far enough
to forget. . . . It can't possibly happen to me so it's going to have to
happen to you . . . Last week the Artists Call organizers laughed
louder, danced harder, stayed up later and later each night. . . .
we smelled the dark dirt of El Salvador and the flowering bushes
of Nicaragua. Central America is breathing down our dreams.**[1]

Susan Meiselas's anguished voyages through the Nicaraguan insurrections,
triumph, and contra invasions (in color) and through a silent El Salvador
strangled by fear, repression, and death squads (in black and white) provide a
nuanced case study of a committed journalist/artist dealing with the two-faced
role of photography in times of deep social crisis. Few, if any, have questioned
Meiselas's integrity, or the moving strength of her images, but the increasingly
problematic nature of her medium and the abyss between experience and
representation have haunted her Central American work. "The authority of the
frame is very problematic," she says, "because you work very hard to make
a frame around something with any assurance. Then you come back under-
standing how limited it is . . . Photography generalizes what are very specific
experiences. . . . There's always that tension in still photography between
what is inside and outside the frame . . ."[2] "What we bring back are pictures
of fragments or souvenirs of what we've shared" with the people there, she
says, "and as powerful as that might be for us, and perhaps as valuable to
them in communicating, there's always a discomfort factor for me. What does
it mean to be doing this? . . . For whom am I doing this work?"[3]

In her retrospective musings over this transformative period of her life,
it becomes very clear that Meiselas was doing it for the Nicaraguan (and
Salvadoran) people, even as she was well aware of being an outsider—some-
times trusted, sometimes mistrusted—and equally aware of the contradictions
of being a journalist who also wanted to be of use to those she photographed,
by recording fragments of their history *for them*. "The line between the jour-
nalist and the participant gets vaguer by the moment," she wrote home,[4]
and she introduced her 1981 book with the following words: "NICARAGUA.
A year of news, as if nothing had happened before, as if the roots were not
there, and the victory not earned. This book was made so that we remember.
(July 1980)."

But still more important, in terms of the effectiveness of her advocacy, was
"the other other—the viewer . . . [who] needed me as a bridge, but once ex-
posed to the image shouldn't need me intervening and mediating any more."[5]
This was the international audience, but particularly U.S. citizens, whose Cold
War government feared the export of "communist" revolution. Just as these
fundamental photographic issues have haunted Meiselas, they also lurk be-
neath the entire spectrum of progressive/antiwar art over the last forty years—
from Vietnam to Central America to the desert storms of today.

Beginning in the late 1970s, American artists gradually became aware of
events in Central America, an area about which few were knowledgeable

1. "Happy Newsyear from
Lucy Lippard and Jerry
Kearns," *The Village Voice*,
January 31, 1984. This
combination of sarcasm and
romanticism characterized my
approach to the subject before
two trips to Nicaragua.
2. "Susan Meiselas: The
Frailty of the Frame, Work in
Progress: A Conversation with
Fred Ritchin," *Aperture* 108
(1987), and in *Voyages* (a film
made by Meiselas and Marc
Karlin for Channel 4, UK, 1985;
transcript published in this
volume).
3. Susan Meiselas, in *City Arts*,
Show 1, Netstation Thirteen
WNET, June 7, 2002, p. 3.
4. Meiselas, in *Voyages*. She
was asked to take up a gun
and she said no; they asked if
she would die for their country,
and she said no. But she could
take their pictures before they
left on missions from which
they might not return.
5. "Culture Maker—Jay Kaplan
Interviews Susan Meiselas,"
Culturefront (Fall 1993), p. 51.

(think Iraq and Afghanistan before 9/11). Over the decades since 1959, some progressives had managed to travel to Cuba, despite the U.S. embargo, but the beleaguered little nations of Nicaragua and El Salvador were still below the radar for most of the cultural Left. Susan Meiselas's photographs from the whispered beginnings of the uprising against the long-time dictator Anastasio Somoza Debayle were a wake-up call. She gave us all the sense of being there, as she was, when the FSLN (Frente Sandinista de Liberación Nacional) entered Managua in triumph on July 19, 1979.

Among the solidarity community in the U.S., the sense of hope and excitement was extraordinary. Unfamiliar with the scale of its challenges, we saw the Nicaraguan revolution as a success from the grassroots, inspired of course by Cuba, but more ideologically "American" (as in *Las Americas*) and less bound (at the time) to the Soviet Union and conventional Marxist theory. In addition, there was a strong cultural, especially literary, sector among the new Sandinista revolutionary government. Several of its leaders were poets, and rousing music played a large part in maintaining the revolutionary spirit. But *El Triumfo* was temporary. By 1983, as the revolutionary government was coping with a devastated economy and infrastructure, and memories of some 50,000 dead, just as it was getting into gear with its various reforms, a contra army covertly supported by the Reagan administration and aimed at destabilizing the Sandinistas, was attacking the rural north; the largely indigenous east coast had its own problems.

At the same time, El Salvador degenerated into full-scale civil war. Three events in particular focused international attention on the situation there and mobilized widespread protests against U.S. aid—financial and tactical—to the Salvadoran military. In May 1980, Archbishop Oscar Romero, a vocal critic of the government's human rights abuses, was assassinated by a right-wing group headed by former major Roberto d'Aubuisson. In December 1980, four American Maryknoll churchwomen were savagely murdered by a military death squad (Meiselas photographed the discovery and exhumation of their corpses). Meanwhile, the infamous Atlacatl Battalion, a counter-insurgency unit groomed at the U.S. Army's School of the Americas, began a decade-long reign of terror. They were responsible for some of the worst atrocities of the war, including the El Mozote Massacre on December 11, 1981, when 1,000 civilians were murdered.

These events catalyzed a national organizing committee—Artists Call Against U.S. Intervention in Central America—begun in New York in 1983 at the urging of Daniel Flores y Ascencio. A Salvadoran poet and filmmaker, Flores had initiated the Institute for the Arts and Letters of El Salvador in Exile (INALSE), a support group for the national university in San Salvador, exiled from its own campus and surviving in an office building with card tables representing each faculty. Artists Call, founded by Flores, artist Doug Ashford, and myself, was a national and then an international campaign that activated a network of artists who organized events in twenty-eight cities in the U.S. and Canada. (A model was WEB, the feminist network of the early 1970s.) Meiselas functioned as an informal but invaluable bridge between the oppositional art world of Artists Call, the Central America solidarity groups (who tended to respect her a lot more than they did artists in general), and the "real politics" of events in Nicaragua, El Salvador, and eventually Guatemala as well.

In a sense, the Central American wars came at a pivotal moment for a

generation of young artists just emerging from art schools and experiencing yet another round of disenchantment with the art marketplace and its indifference to social justice. At the same time, a "movement for cultural democracy" was also spreading nationally among community arts activists, and an older generation of socially engaged visual artists was coming together again after a loss of momentum in the mid-1970s. Feminism had become a strong arm of the Left. Alternative groups such as Franklin Furnace, Printed Matter, Heresies, and PAD/D (Political Art Documentation/Distribution) were founded in New York from 1975 to 1979. It was a heyday of a new wave of streetworks, performance, postering, and local (mostly young, sometimes Punk) artists' groups innovatively exhibiting "beyond the gallery"—such as Collaborative Projects (CoLab), which commandeered unexpected spaces all over the city including the famous "Times Square Show" in a former massage parlor, Fashion Moda in the South Bronx, and ABC No Rio, World War 3 Comics, Group Material, and Carnival Knowledge on the Lower East Side.

The letter sent by Artists Call to "fellow artists," recruiting work for "the first salvo in a broad-based series of cultural actions," began: "We're starting down the Vietnam road again" (a phrase still ominously familiar as we resist yet another misguided U.S. war/occupation in Iraq) and continued: "Artists, writers, poets, musicians, journalists, and teachers are among the more than 35,000 victims of torture and murder over the last 3 years by the U.S. backed forces in El Salvador alone. They are already fighting a 'secret war' in Nicaragua. . . . Artists have to join together to affect public opinion."

The campaign was kicked off on a weekend in January 1984, when the first block of West Broadway, in the heart of New York's SoHo gallery district, was transformed into *La Verdadera Avenida de los Americas* ("The Real Avenue of the Americas") by a forest of banners that provided the set for guerrilla theater and other events. (This, too, had a precedent. A decade earlier, soon after the September 11, 1973, death of Salvador Allende and Chilean democracy, art activists painted a temporary reconstruction of a Chilean mural on the same block of West Broadway.)

Next came the memorable "Procession for Peace," dedicated to the dead and disappeared of Central America. Dressed in black and led by the dramatic creations of Bread and Puppet, we marched from the War Museum on the ship *Intrepid*, docked at 47th Street, through Times Square, then down Fifth Avenue to Washington Square. Everyone wore the name of a dead or disappeared person from Central America; each name was read out loud at the culminating rally, accompanied by the ringing of church bells and the beating of drums to "celebrate the contribution of the dead to the rebirth of Central American culture." The leaflets handed out along the way consisted simply of single photographs and the accompanying stories of an individual victim. People took them and wept.

Peter Gourfain designed a striking button that was produced by the thousands. Claes Oldenburg (with Coosje van Bruggen, a very active member of the Artists Call steering committee) designed a poster of small figures pulling down a towering monument—a half-peeled banana. We tried to get all the art magazines to use it on their covers at the same time, but only *Arts* did so. Media coverage was pretty good, because Artists Call could not be ignored, given its scope and the number of powerful artists and institutions participating. Despite reactionary redbaiters calling us commie dupes and ineffective

careerists, we raised over $100,000 for Central America, ran a full-page opinion ad in the *New York Times*, and provided a roof and stage for the ASTC (Sandinista Association of Cultural Workers) cultural center in Managua.

There was an eight-night, fifteen-concert music festival, evenings of dance and performance art, films, poetry readings, and demonstrations. New York's Latin American exile community was on board from the beginning and Central American visitors participated whenever possible. The writers were an especially powerful voice. Among them were the jovial Ernesto Cardenal, who was the Sandinista minister of culture, Nicaraguan poets Roberto Vargas, Gioconda Belli, and Daisy Zamora, among others, and Salvadoran writers Claribel Alegría and Manlio Argueta, as well as Guatemalan author Arturo Arias (who wrote the Guatemalan portion of the film *El Norte*).

In New York alone, Artists Call organized over thirty art exhibitions in a range of art galleries (from Leo Castelli to fringe spaces all over the city), with a huge signature show at Judson Church on Washington Square, where a series of panels were hosted with Leon Golub's raw, unstretched painting of mercenary interrogators looming behind the stage. At Central Hall, Meiselas and Fae Rubinstein curated an exhibition of photographs based on the collaborative El Salvador book which had just appeared.[6] Meiselas remembers Artists Call as "empowering, creating the feeling we could do something . . . a collective effort of artists across arts and mediums that gave me a respect for collaborative energy, for the spirit of exchange so common at that time"— a phenomenon missing in this overlinked digital age.[7]

In the early to mid-1980s, many of us traveled to Nicaragua to confirm the Sandinistas' successes. We were deeply impressed by the sacrifices this beleaguered population was making to defend their revolution against the onslaught of the contras, whom Reagan famously called "the moral equivalents of our Founding Fathers." Although I traveled to "war zones" in Nicaragua twice and El Salvador once, and wrote about these trips, I was basically a political tourist (a "Sandalista"). Susan Meiselas's work was as close as many of us came to the war. (In fact, I suspect she saved my life. When I was planning to undertake a dangerous and foolhardy project to hike over the mountains from Honduras into the liberated zones of El Salvador, Susan made it clear that "the fear factor is tremendous; you should only go if you're totally convinced that what you will do there will make a difference." It wouldn't have. I didn't go.)

Meiselas, on the other hand, was a committed participant, constantly at risk. "I think the camera gives you an illusion of protection," she told an interviewer. "It's a false shield that makes you think that you can see the world but that the world can't see you."[8] This illusion was lost after she was wounded, after she contracted "mountain leprosy," after five of her friends and colleagues were killed in Central America. Modest, harried, sometimes seriously frightened, Meiselas continued to do what she decided she had to do. She freely admits that she was compromised at times, noting a photograph of a woman fleeing with a naked baby tucked awkwardly under her arm; several photographers took her picture and none of them stopped to help her. Meiselas's photo agency, Magnum, once sent her a 400-millimeter telephoto lens because they thought she was getting too close to the action. She used it only once, then rejected the illusion of participation: "I wanted to be up close."[9]

6. Harry Mattison, Susan Meiselas, and Fae Rubenstein, eds., *El Salvador: Work of Thirty Photographers* (New York: Writers & Readers Pub. Cooperative, 1983). The show became a traveling exhibition.
7. Phone conversation with the author, April 16, 2008.
8. "Susan Meiselas," *American Photo* (March 2003), p. 16.
9. Meiselas, in *Voyages*.

Although she was not trying to make art and was not involved in the art world as such, the impact of Meiselas's photographs on a generation of art activists was considerable. In 1981 she had shown color Xeroxes of her prints at P.S. 1, unframed, pinned to the wall, pointedly rejecting the preciousness of the fine-art object. Wary of being defined/confined as an "artist," and committed to her desire to make history rather than news, she chose a "presentation that was consistent with the material, rough and direct. . . . It gets down to what is really important, to have a set of pictures that exists as a document."[10] "I'm not interested in style per se," she said. "I just want to . . . find the place where I belong in relation to what I'm looking at."[11] Meiselas's book, *Nicaragua, June 1978–July 1979*, published the same year by Pantheon, filled that function for a larger audience, although she later regretted losing control of some of the publishing decisions, especially the separation of the pictures from their captions and contextual material—necessary in order to print the book in three languages. (This was mitigated in *El Salvador: Work of Thirty Photographers*, which Meiselas coedited two years later; when she took proofs to El Salvador to consult with the local contributors, they had to hide under a table to discuss the layout.)

Perhaps most importantly, during Artists Call, we "cultural workers" educated ourselves on Central America. (A lawyer advising us said, after a steering committee meeting, that he felt like he was "talking to a bunch of lawyers, not artists.") We initiated letter-writing campaigns, demonstrated, and some of us lobbied in Washington, where we were astounded by the level of ignorance displayed by our representatives in Congress. The campaign had the salutary effect of taking us out of ourselves and out of our studies and studios, our art "worlds." It also acted as a kind of unofficial cross-cultural exchange program, as we interacted with art exiles and ambassadors from Central America. But it was the outpouring of art—good, bad, and indifferent—that was effective, if only within a limited circle. I suspect that few of the individual works in Artists Call were as effective as the sheer breadth of the whole collective endeavor. If much of the art displayed in the many shows could be accused of a certain voyeurism, a second-hand fascination with death, turning grief into grievous spectacle, there was nevertheless a genuine passion to help the Central American people and to oppose the despicable politics of our own government, which was exacerbating the social problems "down there." Artists Call proved once again that art had a role to play in global events and that the art "world" could not be separated from all those other worlds. While rarely decisive, cultural work extends the arm of political action and political reportage, appealing to the senses and the emotions in ways that activism and journalism tend to avoid.

All of this happened around the time when "postmodernism" and French theory (Foucault, Derrida, Kristeva, Lacan, et al.) was infiltrating the New York art world. Irony was the preferred weapon for a "political art" (though there was a good deal of evidence, based on work with community artists, that the people's voice is not ironic). The Sandinistas, on the other hand, coming as they did from a very different context, contended that revolutionary art can emerge only from revolutionary experience, and that it need not reflect that experience superficially if it had absorbed it profoundly. "We learned to fight in the trenches," they said. "And we learned to dance in the trenches."[12] This combination of joy and tragedy was irresistible to the middle-class artists

10. Laurence Shames, "Susan Meiselas," *American Photographer* 6 (March 1981), p. 49. In *Voyages*, she says, "a photograph is *instead* of a relationship, and yet a photograph *is* a relationship."
11. "Culture Maker—Jay Kaplan Interviews Susan Meiselas," p. 53.
12. Lucy R. Lippard, "Hotter than July," *The Village Voice*, August 9, 1983, p. 72.

(Nicaragua, pp. 128–173)

Lucy R. Lippard

13. Martha Rosler, "The Revolution in Living Color: The Photojournalism of Susan Meiselas," *In These Times*, June 17–30, 1981, reprinted as "Wars and Metaphors," in *Decoys and Disruptions: Selected Writings, 1975–2001* (Cambridge, Mass.: MIT Press, 2004), pp. 245–58, quotes p. 253.

14. Ibid., pp. 250ff. Meiselas pointed out in *Voyages* that the un-uniformed combatants often wore two sets of clothes so that they could strip after actions and not be recognized. Rosler did cite approvingly Meiselas's characteristic reticence about her own accomplishments, the lack of "hype and puffery . . . her refusal to be lionized" (ibid., p. 254), and later softened her criticisms, noting with admiration the photographer's "commitment, skill, and resourcefulness" (ibid., p. 245).

15. Leigh Binford, "Representing Revolution: The Central American War Photography of Susan Meiselas and Adam Kufeld," *Estudias Interdisciplinarios de América Latina y el Caribe* 9 (January 1998), p. 102.

16. Ibid., p. 103. The praise and admiration of her peers in the field, quoted at length in Gloria Emerson's "Susan Meiselas at War," *Esquire* (December 1984), pp. 165–72, may be the best indication of her accomplishments.

creating Artists Call. Yet it also encouraged a disturbing conflation of universal suffering under the guise of a woozy "humanism." At times, Artists Call did leave itself open to accusations of being a self-centered expression of North American hegemony (and cultural powerlessness).

With the irrefutable power of first-hand photography came the inevitable criticisms, launched across what seemed an unbreachable abyss between working in the field and armchair criticism after the fact. Precisely because she aspired to be more than a journalist, Meiselas was dragged into theoretical debates about art's depictions of war. Critical thinking is a demanding and necessary task, but on the ever-divided Left, we often employed it to spite our own faces. Just as Artists Call was treated with less respect in the art world than in Nicaragua and El Salvador, Meiselas was criticized most often from within the progressive art community. We were all caught not only between the rage and ideals of Central America and our own national impotence, but between conflicting views of art's role in the double struggle.

Overt and unmediated political passion and sentiment were unfashionable in the art world, and somewhat embarrassing even to some of those who were committed to the cause. Thus Martha Rosler, a major practitioner of progressive photography and criticism, and a participant in Artists Call, was initially one of Meiselas's sharpest critics, declaring that "the sympathy the book [*Nicaragua*] intends to incite falls short of the political complexities of reconstruction," and accusing Meiselas of failing to challenge "the stereotypes of Latin American underdevelopment and carnivalism." Her photographs were deemed lacking because "they can nudge the viewer away from reading out of images toward reading into them."[13]

The color photographs in *Nicaragua* also shocked documentarians who found them too luscious to convey serious subject matter, a gripe that seems somewhat outmoded these days. Rosler compared their "fashion bizarrerie" and "color fantasia" to "representations of tourism of the colonized" and complained about a "sweating sack-carrier under a glorious sky" (implying that the weather, like the barrio-dwellers' clothing and house-painting choices, should have conformed to critical expectations).[14] Another critic contended, "Color photography shrinks the field of play of the imagination and, by virtue of that fact, strengthens the camera's 'truth effect.'"[15] (It can also be argued that color brings those events to life in a very different way from the documentarian's favored black and white by making them less arty, more ordinary, less removed from everyday life, more compatible with the ways we actually see.) The fact that Meiselas had such a good eye, and even her most perilous shots were so well composed, also irritated some purists. As part of his equation of photographers risking their lives to be "on the scene" and anthropologists' "presence 'in the field'"—both "authenticating their productions as accurate (true) representations of reality"—Leigh Binford, an anthropologist and author of a book on the El Mozote Massacre, criticized Meiselas's "kinetic" approach to violence (though stasis was hardly a rational choice when dodging sniper fire and bombs).[16]

Meiselas recalls being virtually "paralyzed at one point" by such attacks, which were often overdependent on the "aestheticization of tragedy" position, originally framed by Walter Benjamin in a different context. However, she responded with restraint: "I wouldn't want beauty to pull away from the essence of what I'm documenting. It formally complements and hopefully

creates greater effect or impact. . . . Not everything is driven by message. It's expressive of life."[17] Elsewhere, she remarked, "We really don't know very much about what happens when people look at photographs . . . Theorists assume a great deal . . . but their analysis is not often based on real research I think it is presumptuous to assume a cause-and-effect relationship with an image."[18]

The fact remains that mediocre work would not have received such acclaim or called so much attention to the events Meiselas was witnessing as her mission. At the same time, this line of criticism does continue to be useful as a kind of caveat, pulling the viewer back from overly sentimental responses, providing a necessary distance that could pass for objectivity, making people truly think about pictures, how they are created and how they are used. Michael Palmer, writing on this complex and crucial relationship (in regard to Sebastião Salgado, the best known perpetrator of romanticized photographic images of misery), cites "the uneasy negotiation among the space of origins, the framed space of the work, and the social space to which it has been removed, which is also a cultural space, of the esthetic"[19]—negotiations with which Meiselas is all too familiar and has taken to heart. Rejecting the outdated notion that photographs are absolutes with fixed meanings, she suggests that "part of the problem of believing is that we haven't been exposed to a multiplicity of views."[20]

Take one example of her Nicaraguan oeuvre that attracted a lot of attention (positive and negative), and was highlighted in the book by being printed opposite a blank page. In *Cuesta del Plomo*, a body half-eaten by vultures, leaving a bony spine attached to the still-fleshed-out dungarees below, lies in a rolling green landscape with Lake Managua in the distance. Meiselas recalls coming across this dreadful sight on a random trip through the countryside during her first two weeks in Nicaragua, as both insurrection and repression were gaining strength but could only be glimpsed (fires, broken glass, slogans hastily painted on the walls) from the outside. She had stumbled across a dumping ground for victims of Somoza's death squads. It was the first time she saw what she had so often heard whispered.[21]

"I used to get in the car as early in the morning as I could and just drive, looking for things that seemed unusual. One day I was driving on the outskirts of Managua when I smelled something. It was a very steep hill, and as I got closer to the top the odor overwhelmed me. I looked out and saw a body and stopped to photograph it. I don't know how long it had been there, but long enough for the vultures to have eaten half of it. I shot two frames, I think, one in color and one in black and white, then got out. The images I made of the body were powerful partly because of the contrast with the beauty of the landscape. For me [the photo] was the link to understanding why the people of Nicaragua were so outraged."[22] On the other hand, "The American public," Meiselas recalled, "could not relate their reality to this image. They simply could not account for what they saw."[23]

The power of this image lies not so much in its shock value as in its excruciating loneliness. While it is neither the most striking nor the most moving image in *Nicaragua*, its sheer graphic horror made it something of an icon of the unequal struggle taking place in Central America, as well as a target for critics of social documentaries. "For me, the essence of documentary photography has always had to do with evidence," said Meiselas, ". . . when you're working

17. Susan Meiselas, in Rosemary Jette, "Susan Meiselas: International Photographer," *The Artful Mind* (January 2000), p. 14.
18. Susan Meiselas, in David Levi Strauss, "The Documentary Debate: Aesthetic or Anaesthetic? Or, What's So Funny About Peace, Love, Understanding, and Social Documentary Photography?" *Camerawork: A Journal of Photographic Arts* 19, no. 1 (Spring 1992), p. 8.
19. Michael Palmer, quoted in Levi Strauss, "The Documentary Debate," p. 7.
20. "Culture Maker—Jay Kaplan Interviews Susan Meiselas," p. 50.
21. Meiselas, in *Voyages*.
22. "Susan Meiselas," *American Photo* (March 2003), p. 13.
23. Susan Meiselas, "Some Thoughts on Appropriation and the Use of Documentary Photographs," *Exposure* 21, no. 1 (1988), p. 11.

with evidence—say, when you're digging up grave sites—you don't want people to think that it is conceptual art, an installation, or that it's just invented."[24]

Leigh Binford has posed some valuable questions inherent in Central America war photography: "Putting aside the largely discredited vision of the 'photograph as truth,' how and what should a progressive photographer attempt to portray when he/she has (relative) control over the imaginational project? And since violence, physical violence of the most shocking sort, was a signature of these wars, to what degree might it be imaged without engendering either a pornography of violence (photographs of the dead and dying as commodities exciting viewers' hidden desires) or effecting desensitization (in which the specific quality of suffering in time, space and form dissolves in the sheer quantity of it)?"[25] He calls on photographers to "problematize the process of making objects, even sympathetic ones, of the lives of the have nots," and asks them (along with ethnographers "and other representational enterprises") to document and "to raise questions about the unequal power relations inscribed in the documentary project itself," to examine the ways they treated those "who, by virtue of their subordinate positions, do not have the absolute right of refusal to be grist for the photographic mill."[26]

If images of atrocities have become clichés, how has that affected our capacity for compassion? Sympathy is relatively easy to come by. Empathy, which resonates in Meiselas's work, is a lot harder. A "detached" photo of a corpse can be just as culpable as a prurient photo emphasizing gore for gore's sake. Yet by most first-hand accounts, the people of Central America wanted and even demanded that their pain be recorded for those who did not understand their circumstances. Journalist Richard Elman, working with Meiselas, wrote about barrio residents gathered round the body of a boy in the street. They "demanded that we look too, and take pictures. One man said 'Don't you think your President Carter would like to see this boy?'"[27]

All of which raises the question of whether it is really possible to avoid the "pornography" of war photography on site, to divorce oneself effectively from one's subject matter and still make its content matter. Cuban writer Edmundo Desnoes has distinguished between ways of seeing in Latin America ("centripetal") and North America ("centrifugal"):

> The images of Central America sliced out of the flow of events by Susan Meiselas belong to southern discourse and yet are printed and distributed mostly for a northern audience with a different way of decoding messages. Her work is prey to a whole range of distortions and ideological readings . . . The bodies are testimonies of how the people of El Salvador are willing and able to put their lives on the line, are willing to risk everything to improve their lot and mean something more than blood, something more than inert matter, something that transcends horror and calls for solidarity and a future.
>
> They are not over: they are beginning to mean.[28]

Meiselas's photographs "brought home" these elusive little wars, already so close to home, in the same way television had finally brought Vietnam into our living rooms. But she aspired to bringing home their meanings as well. The fact remained that the images only reached large audiences when they were featured in the *New York Times* or *Time* magazine, which severely affected "relative control over the imaginational project." She learned to negotiate the

24. "Culture Maker—Jay Kaplan Interviews Susan Meiselas," pp. 48, 50.
25. Binford, "Representing Revolution," p. 95.
26. Ibid., p. 107.
27. Richard Elman, "Nicaragua: A People Aflame," *Geo*, no. 1 (1979), p. 45.
28. Edmundo Desnoes, "The Death System," in *On Signs*, edited by Marshall Blonsky (Baltimore: Johns Hopkins University Press, 1985), reprinted in this volume.

217

An Artist Called

(Kurdistan, pp. 260–299)

tradeoffs between the exposure provided by the media and the personal necessity to recontextualize her images in books and films. Yet when her picture of the Salvadoran death squads' signature *manos blancas* (white hands) smeared on a red door appeared on the cover of *The New Republic*, she remarked: "I can't do better than that—I was scared shitless making that image, and this made the whole thing worthwhile."[29]

Meiselas's later Kurdish work on the Internet vastly expanded the audience for the beautiful (if unaffordable) $100 book that preceded it. Interestingly, little "critical thinking" was applied to this project, a history of representation of the Kurdish people, perhaps because Meiselas positioned herself inside the process, "both as someone who looks at the act of representation but is also an active representer,"[30] and perhaps because the Internet component allowed for a broad, ongoing dialogue. Comparing the two bodies of work, temporally and geographically so far apart, she remarks bitterly on the impact of U.S. support—denied the Sandinistas, and once denied the Kurds, who now enjoy its full benefits.[31]

In all her interviews and statements, Meiselas insists on the shortcomings of the still photograph: "it has to be recognized that behind each picture there is a whole lot missing . . . The problem with the photograph is that it always assumes that you've arrived, even before you've got there."[32] How, then, does a photographer suggest the narratives that lie beneath each decontextualized image? The ripple effect of the Kurdish project is one way. Another is to make films, which Meiselas did twice in Central America, both collaborations with Richard P. Rogers and Alfred Guzzetti.[33] *Living at Risk: The Story of a Nicaraguan Family* was shot in Nicaragua in 1984. The filmmakers followed four siblings of the anti-Somoza, upper-middle-class Barrios family, who with their spouses had fought with the Sandinistas and were working in rural Nicaragua, one as a doctor, two as government agronomists, and one as a community organizer—contra targets par excellence. One goal of the film was to counter the "Stalinist" image of the Sandinistas that was being disseminated in the U.S. media. Meiselas had expressed her frustration that "the larger sense of an 'image' [of the contras in Nicaragua] has been defined elsewhere—in Washington, in the press, by the powers that be. I can't, we can't, somehow reframe it." After Congress voted to give $100 million to the contras, "everything I framed suddenly had a sense of vulnerability, frailty, temporariness—to frame anything would just lead to the inevitable death. I didn't want to even raise my camera."[34]

Pictures from a Revolution was filmed by the same team in 1989, before and after the election that deposed the Sandinistas and elected Violeta Chamorro—ironically the widow of Pedro Joaquín Chamorro, dissident editor of *La Prensa* whose murder in 1978 had initially caught the young photographer's attention and led her to Nicaragua; Chamorro is also the mother of one of Meiselas's oldest Nicaraguan friends. Meiselas appears in the film now and then as she wanders with her book in hand through the barrios and small towns in an unscripted search for the people in the 1978–79 pictures. The interviews—mostly with Sandinistas, but also with a few former National Guardsmen—fill out their lives in the intervening decade.

This film tells a far sadder and less hopeful story than *Living at Risk*. There is still rampant poverty and children with swollen bellies. As Meiselas finds her subjects, she also finds disillusionment and even despair, a sense of betrayal:

29. Susan Meiselas, in Don Snyder, "Mixing Media," *Photo Communique* (Spring 1987), p. 35.

30. Susan Meiselas, *Kurdistan: In the Shadow of History* (New York: Random House, 1997); www.akaKURDISTAN.com; phone conversation with the author, April 16, 2008.

31. Phone conversation with the author, April 16, 2008. U.S. support for the Kurds as part of the Iraq war strategy has had an ironic effect on Meiselas's work there. It has been used, to her horror, to justify the war on Iraq.

32. Meiselas, *Voyages*.

33. *Voyages*, a film made by Meiselas and Marc Karlin for Channel 4, uses stills from the Nicaragua book and the words—read by Karlin, who mispronounced Spanish names—from a letter Meiselas had written home; it gives a moving sense of the photographer's experience but totally ignores the social context.

34. "Susan Meiselas: The Frailty of the Frame," p. 33.

"a Nicaragua that's exhausted. That's what we have now," says one survivor. "They cut the wings of the revolution," says her old *compañero* Justo Gonzáles, citing a growing distance between "those who are running things" and people like him who'd fought. The man throwing the Molotov cocktail in Estelí (one of her most famous images, which took on a life of its own) is a nephew of Sandino named "Bareta." He declares, "the revolutionary spirit is in my blood."

To continue the dialogue and the narratives, Meiselas returned once again in July 2004 for the twenty-fifth anniversary of *El Triumfo*, just before the reelection of Sandinista leader Daniel Ortega. This time she made public art, enlarging the now famous pictures to mural/billboard/banner size and posting them near the sites where they had been taken. They are printed on an almost transparent fabric, which serves to fuse the places of past and present. On the Cuesta del Plomo, a small white cross marked the spot where the half-eaten body (and many others) had been found. Among the comments, perhaps distinguishable by generation, were: "It's what I had fixed in my mind from that time"; "I lived that"; "It's worth the pain because today we know liberty and democracy"; "[We get] false information that globalization is good for Third World countries like us … it's a lie"; "A war leaves sadness, tears."

Thirty years later, we have to admit that the Nicaraguan revolution, for which we all had such high hopes, was a failure. (After two decades, it still hurts to write these words.) Today, Nicaragua is the poorest nation in Latin America. We in the U.S. "lost the luxury of a dream," Meiselas remarks. "But for the Nicaraguans, it was much much more."[35] Daniel Ortega's politics of compromise with the Right have split his party; he is opposed by some of his former comrades, whose MRS (Movimiento Revolucionario Sandinista) party holds parliamentary seats and is an important critical voice from within. Ironically, Meiselas points out, both the FMLN in El Salvador and the FSLN in Nicaragua are part of the political dialogues, "though conditions have not significantly changed for the poor in either country."[36]

If we tried to create an Artists Call today in solidarity with the Iraqi or Afghani people, it would be a very different affair. As in Vietnam, our own soldiers are dying, and as in Central America, our own government backed the "enemy" (until it became expeditious to reverse its position). But today there is no draft, we see no American corpses or coffins in the media, and the wars are being fought by the poor.[37] In the current climate of "hit and run" and embedded journalism, the kind of long-term, persistent, line-crossing work Susan Meiselas did in Central America is, she acknowledges, "clearly impossible . . . Freedom of access has definitely impacted the kinds of images we see [from Iraq]. We do not know the 'enemy' and they perhaps do not want to be seen by us. There is only a kind of self-representation that includes images of hooded men towering over their victims or the reports of anonymous suicide bombers. . . . I fear now that we know enough, even without the images, yet we simply cannot effectively challenge the politics of counter-terrorism within this climate."[38]

The multiple truths Susan Meiselas struggled so hard to make visible in Central America have been boiled down to polarizing lies. U.S. citizens, like the Nicaraguans in 1978, can only look forward to change, as history repeats itself in new disguises.

35. Susan Meiselas, in *Living at Risk*.
36. Phone conversation with the author, April 16, 2008. In fact, an AP article of February 10, 2008, reported that the return of Ortega "galvanized dozens of former Contras to plunge back into the politics of their Central American homelands. . . . Some even warn darkly that armed resistance is again a possibility." (Ortega's vice-president is a former contra spokesman.)
37. See *October*, no. 123 (Winter 2008), an entire issue devoted to the responses of artists, academics, and cultural institutions to the wars in Iraq and Afghanistan.
38. Joanna Heatwole and Mariola Mourelo, "Extending the Frame: An Interview with Susan Meiselas," *Afterimage* 33, no. 5 (March–April 2006), p. 20.

The Death System

Edmundo Desnoes

(Nicaragua; pp. 128–173)

> **We might say that the timid hero procures a restricted life**
> **for men, whereas the brazen hero brings them a promise**
> **of resurrection.**
> **—Claude Lévi-Strauss**

Susan Meiselas did not go South looking for dead bodies; she found them. When Susan left New York in 1977 to see and understand Nicaragua, she was anxious to live and live radically, to discover herself in the world.

In Nicaragua, she saw herself as a product made in the United States of America. Opposites—as Gide used to say—touch in me:

I think as an American. One thing became very clear to me in Nicaragua. Coming from the States I've never had to stand on one side of the line or the other side. Even in the sixties that could be easily avoided. One participated as an activist, but that did not fundamentally affect every-thing about one's life. One could still masquerade, to some extent. Very, very early in Nicaragua I was confronted with the meaning of people's actions. They took certain risks, and those risks became obvious, so obvious that they could lead to: actual death, isolation, or exile. The peo-ple had a capacity to determine what was public and what was private in a way that I didn't. I realized that everything about the way I dressed, the way I walked, the way I talked to people, was indicative of my cul-ture and my condition and my consciousness.

The photographer discovered one of the keys to understanding Latin America: a different context creates a different discourse. What she saw and what she shot in Nicaragua could not be plucked away and packaged in New York.

The United States is a fragmented society, a society where people are encouraged to live centrifugally. The parts never make a whole. The whole is removed by the subtle mechanisms of advanced capitalism and its multiple ways of escape and dispersion. In Latin America everything is centripetal, everything is striving after unity and an axis. These discourses are in conflict due to economic and political differences; it is not a matter of temperament.

The abundance and diversity of the United States economy encourage fragmentation and dispersion. The scarcity and contradictions of most Latin American economies lead to class consciousness and confrontation. The nature of the state in the North is organic, accepted by most citizens; most people see the state as representing, including them or able to include them with some minor adjustments. Only blacks feel outside the system, are against a state that fails to represent or include them in its dreams or material shares. In Latin America the state is an arbitrary entity, imposed on the people and the country and unable to satisfy their needs. The state, the system is alien and oppressive. These two factors—economic development and the

state—are at the root of the centrifugal and centripetal nature of social forces in America the continent.

The images of Central America sliced out of the flow of events by Susan Meiselas belong to southern discourse and yet are printed and distributed mostly for a northern audience with a different way of decoding messages. Her work is prey to a whole range of distortions and ideological readings.

The bodies may stand as metaphors, as epiphanies of war in Central America. The bodies are testimonies of how the people of El Salvador are willing and able to put their lives on the line, are willing to risk everything to improve their lot and mean something more than blood, something more than inert matter, something that transcends horror and calls for solidarity and a future.

They are not over: they are beginning to mean. There are two kinds of bodies in Central America: the bodies that are against history and the bodies that are on the side of history. Susan Meiselas has deliberately photographed only the bodies of those that want to change things, to improve the lot of the poor; I have never seen a photo of a dead government soldier taken by Susan. Her bodies are infused with the meaning of the New Testament read in Latin America today: *El que pierda su vida se salvará.*

Bodies have an effect and a meaning. They are practical weapons; they challenge the system. They resist the system; they fight the system. It is an absolute message: death or country. My death or my country. A country, a nation that I feel belongs to me, a state that reflects my needs and does everything to feed, educate, and give meaning to my existence.

The terrified dignity of the woman being questioned by government troops, who knows she can easily become a dead body. Bodies are obstinate signs; they are dragged by their feet on a dusty road, and each humiliation leads the onlooker to feel more indignant than fearful. In the North these bodies, for example, could lead to pity, horror, empathy, or indifference. The two discourses are at odds.

Contact bombs explode in children's hands, the bleeding stumps of their fingers are recorded. How should we decode this image? I would rather see his fingers blown away than his hand outstretched and begging in the streets of Managua or San Salvador. He does not know what he is doing, he is only a child; it is pure fanaticism. Or is it: the government that breeds such courage in a child should be abandoned by the people, defeated, destroyed.

The men and women that mourn their dead are not castrated, they cry and pray and then fight back. Death does not engender fear and passivity, it breeds rebellion, hope in the future—the right to decide the shape of that future.

The meaning of these bodies is not in the photo but outside. There are many possibilities, many angles from which to photograph a dead body. It is static. They are frozen images and you can move around these women, children, men. They were moving. Alive, when they were shot by a bullet; they are immobile now that they are shot by a camera. The difficulty is in being there, in El Salvador, in being there as a photographer who knows how to read the signs of death. Everything is happening around, outside these photos. The repressive state could appear at any minute. The photographer is shooting the statement made by a body that defied the government. The risk, though much

221

less than if you are a native, is taken by an *American* who hopes her photos will not lose too much of their original meaning. That is the agony of Susan Meiselas. The agony of her work. Images trapped in two discourses.

Most photos taken in the North are self-referential, rely heavily on what is happening inside the frame. They are images constructed or acted out for the camera. And they are often author referent. The photos of Susan Meiselas have a historical, social, political, and moral referent. And so the author wishes to banish, to lose her face. For safety reasons as well as respect for a moral cause she only purports to witness.

"You go to discover the nature of something, rather than to prove something," Susan told the *Soho News* (May 20, 1981). "When I see repression on the scale that I do, I respond humanly, but I try to document how the people respond, not how I respond. As a photographer you witness and document what happens. If people end up thinking simply that these are my pictures, I've failed in terms of what was important." The photo that illustrates this interview is not the standard photo of the smiling or intense face of the author. Susan refuses to lend her image, a face you can recognize and identify with, to any media promotion of her work. The photo she gave shows her walking away from the camera, her head bowed in respect or meditation; she is walking away from the camera and into the dense landscape of Central America. The only tender note that brings back to me the face of the moral photographer that Susan is is her blonde braided hair between her frail shoulder blades [p. 345].

There is a tragic element in the work and the way Susan Meiselas positions herself. In the West, it is difficult to decode photography within an alien code, it is almost impossible not to be author referential, and even more difficult to let form remain in the background. I do not wish to talk about her technical abilities, her warm detachment, the simple rigor of her composition, the deep cultural richness of her images: it is there to make her message more transparent, deeper, and as direct as a photographer can make a statement in the second half of the century.

These photos are not in art, these photos are in history. These images are not saved by Susan Meiselas; these bodies are rescued—if such a monstrous survival is possible—by society. "If we do not believe in God," as José Martí wrote and lived, "we believe in history."

I do not wish to proceed any further. My words cannot add anything to these bodies, cannot give meaning to the Central American war photos of Susan Meiselas. You can, *hypocrite lecteur!—mon semblable—mon frère!* It is too trite, too trivial, to continue decoding these bodies thrown at us by Susan. And it is also too easy to feel guilty for being alive, for surviving, for looking forward and writing about *mis hermanos muertos* in relative safety.

This text was originally published in Marshall Blonsky, ed., *On Signs* (Baltimore: Johns Hopkins University Press, 1985), and is reprinted here by permission of the author.

222

Edmundo Desnoes

Voyages

The following is a transcription of the experimental documentary *Voyages* which Meiselas produced in collaboration with director Marc Karlin for Channel 4 (UK) in 1985. Meiselas cowrote the narration reflecting on her work in Nicaragua in 1978–79.

Nicaragua, Part 1

"Maybe," she wrote to us, "it would be as well to begin at the end. If I'm going to write to you as your map-reader, and if I'm to answer some of your questions, let's begin at the end."

When the Nicaraguans, after a long separation, came together with shared hopes and a past on which they hoped they would be able to base a future, it was the ending of a period of struggle, which had left 50,000 dead, cities totally devastated, and an economy in ruins. There was no time to celebrate, there was no fiesta. By the end of that day of July the nineteenth, I was totally confused as to what my role was going to be. I had spent such a long time voyaging, getting close, being there and being with them, and in the process of that journey I'd come to realize that I was slowly losing my own country and beginning to feel that I had found a new one, only to find that on that day, July the nineteenth, it was their victory, not mine. I have pictures, they have a revolution.

It was the beginning of another kind of struggle, which was later to involve a painful and strange kind of separation. A lot of journalists were packing up again; the story as far as they were concerned was over. The intercontinental hotel was filled with members of the international Left wearing black and red scarves, colors that I could not wear even if I privately assumed them, as I am a professional, a journalist, a photographer. I photographed the clearing of the streets and wandered back to my room on my own. There's a call from my photographic agency: they suggest I come back home. Without any fore-thought, I replied, "I really don't have a home to come back to." Bridging these two worlds and feeling pulled apart, that's when my photographs end. I begin to feel that these two worlds may not be reconcilable, that I may not be able to change sufficiently and fast enough to give up one for the other. So as I said, it's just as well to begin at the end.

If you go to Nicaragua, like me you may cling onto images which are already pictures inside your own head. A collection of all the thousands of images you've already seen. You can't help it, despite your better instincts. You take images which drag you into taking them, and an inward anger results when you actually pull the trigger. I had left New York for Nicaragua not know-ing what was going to happen, and knowing even less about Nicaragua. I had picked up the *New York Times* and had read an article on the death of Pedro Joaquín Chamorro, the editor of Nicaragua's only opposition newspaper. Central America then was not often in the news and if it had occasionally been report-ed, the reports had not lodged in my memory. What had driven me there was

(Nicaragua, pp. 128–173)

223

that I knew nothing about it, and yet the size, and therefore the importance given to the article in the *New York Times*, assumed that I should.

I remember somewhat painfully the early days of my journey, those early days of wandering around, drifting and feeling very unstructured. One day it was very hot; just to get up in the morning was an effort. I just drove around, not even knowing what I was looking for. I was at the end of my patience; everyone else seemed to be rushing around doing what they had to do and I felt aimless. I was in a downtown area where people were living in rubble shelters when I came across this woman who was washing clothes by a sewer. We stopped and we talked, and out came this man who was totally drunk. He was very thin and forthright, and was swearing that one day he would get Somoza. As this was the first time I'd ever heard anyone declare his open opposition to the regime, I felt frightened for his life and hoped that he would not say these things just to anyone. I felt protective; on the one hand, I was relieved at hearing someone say what he felt. On the other hand, I felt his vulnerability. He asked me to go back to his house with his wife, who was the washwoman, and his children. His house was a pile of rubble. He asked me to sit down in a very authoritative manner. There was a semblance of a staircase, which led to an open sky, as there was no roof. He went upstairs and came back with a plastic bag wrapped up in rags. He carefully unfolded the rags and took out of the bag a gold bar. Pointing to it, he said, "That's what it's really like here. Believe it or not, I found this, but I can't do anything with it, because if I went to a bank they would accuse me of having stolen it." So he asked me if I could do anything with it. There it was, a gold bar, which had clearly come from a mine, and here he was with it. It could have changed his whole life, but there was nothing he could do about it. What was extraordinary about all this was that, from having floated around for so long, having no connections, feeling strange, almost useless compared to the middle-class opposition who were organizing against the dictator Somoza, or to journalists who had definite set tasks, or to a resistance that I kept on hearing about but could not see, I was suddenly to come close to someone in such peculiar circumstances. I never saw him again. Somoza cleared out the whole area that was full of refugees from the '72 earthquake. He was afraid that people would come crawling on their bellies through the weeds and reach his headquarters. He cut down all the weeds, and got the squatters out of the area.

I spent most of my time walking around, trying to get familiar with the place. Getting to know which quarters were the most militant by the amount of slogans that were written on the walls. I knew something was about to happen, and all my energy went into finding out what it was and where it was, but everything seemed secretive, unavailable, just tension and the heat. The tension could be seen, but photographed with difficulty. National Guard jeeps would rip around corners heading for destinations we dared to imagine. I remember asking people what was happening and being surprised how little they said, how quickly they would avert their eyes, which only much later on became a custom to them. It had to do with who was listening and who could make use of what was said. As for me, I felt safe, extending the idea of the familiar, the expected, the I've-been-here-before feeling. Taking photographs which are safe to take because everybody has understood their role. I was an American, I had a passport, I was safe. I could travel, trespass, and I

could leave. Photography seemed to be the perfect metaphor for this process; I could go from one point to another. Unlike the Nicaraguans, I was free.

I remember talking to another photographer after having been there just for two weeks. I said to him, "Nothing's happened, I haven't done very much." He told me to go out and just take pictures in the streets. "But you don't understand," I said, "There is something happening. It's just that I can't see it, I can't get at it." Value has always been placed on knowing, which I find has little to do with photography. But there is another kind of knowing, which is produced by sign-reading and knowing at another level. My involvement with Nicaragua really began with this picture [*Cuesta del Plomo, p.133*]. I found this place quite by accident. I'd heard about disappearances, but it was only after I had stumbled on it that I knew that it was really taking place. It was the first time I myself saw what I had so often heard whispered, hurriedly, in a bus queue or in a market.

Nicaragua, Part 2

She went on to write that after two weeks she still felt as if she was a detective. She was still looking for something, not knowing where it was. She was still at the stage of knowing what you're looking for but not being able to find it. You've heard about it, that is, you've heard about the word "repression." But it remains hidden; it has no concrete manifestation and you can't photograph it. And so—stumbling on evidence, coming out of darkness, information through signs, having to learn a new language—was at the same time being continuously acknowledged and treated as if she was an outsider. She tried to get rid of the notion that she had always been brought up with: namely, that everything should be constantly available, because there was little or nothing left to surprise one.

Behind each event lay an image that was never taken. Yesterday's newspapers never forecast what was going to happen next. No one could tell me things would happen, no one would tell me if they knew: the other side of being an American, a stranger, a potential enemy. So all I could do is to trace, anticipate, and try to learn a new vocabulary. Suddenly, walking aimlessly you would stumble on a fire burning, bonfires, one corner then another, broken glass, smoke and shouting slogans. Then the Guard would come: frantic scattering as gas tore through doors slammed shut. Then there would be silence. Someone would grab me as Guards on the outside shot, sprayed at the walls, at anything, for a bonfire, for nothing. Waiting, no one moved. To photograph or not, no aesthetic, just a decision to look out of the window. And so: a picture with no power, no tension, not close enough. The experience is not in the image.

I always seemed to ride in breathless at the end of events, just as they were finishing, adding emphasis and strength to the illusion that you could understand events without knowing why or from where they originated. You might say that's the condition of being a foreigner, not a journalist, whose professionalism should entail knowing. But we were living at a time when all

there was to know remained deeply hidden. It was as if we were watching a mime whose intentions were clear enough but whose images I was unable to place.

Do you remember the green picture of the gas bomb? I was outside the university and the paramilitary was slowly pumping live bullets into the campus. I stood outside, frozen, horrified, unable to go in, feeling distraught at being behind them. I decided to take the registration numbers of the paramilitary's cars and later give them to the students. It wasn't much, but I was beginning to trespass the bounds of simply being a journalist, an observer. It is worth repeating that it is always assumed that photographers know, but what we do not know is what scales we're in and that maybe fell from our eyes. And so it has to be recognized that behind each picture there is a whole lot missing.

Within all that time, there seemed to be an air of normality punctuated by hurriedly written slogans on the walls demanding whether such-and-such a prisoner was still alive until suddenly, out of nowhere would come the funerals. Eruptions, faces, and slogans; again, private rituals, private ceremonies, not for the foreigner's gaze. There were too many missing histories. It's not only the fact that pictures are always going missing, it's a whole other time which the photograph obliterates. At a funeral procession where the mourners were carrying a portrait of Arlen Siu, I did not know then who she was. It was only much later on that I realized that she had been a guerrilla who had been killed three years earlier and it was only now that people were beginning to feel confident enough to be able to give her a funeral oration.

Slowly, I was beginning to understand: the problem with the photograph is that it always assumes that you've arrived, even before you've got there. So in the picture of the return from exile of the twelve representatives of the revolution, a loose coalition of middle-class interests opposed to Somoza, I could have represented them as leaders, but the question begged itself: for whom were they leaders? During this demonstration I became aware that there were no foreign correspondents present. They did not think that the political situation would be altered by this event: a judgment confirmed by the belief that if they are not present the event does not exist.

Having come to Nicaragua as a stranger, I found myself being asked to act as an image-maker. Some Indians from the town of Monimbo asked me to take a photograph of them practicing throwing contact bombs in readiness for the coming insurrection. I was reluctant to take this picture, as I felt they were performing for the camera. I decided to take it because so much of Nicaragua's history remained unknown that I felt I had to respond to their demands to make their history visible. I went back to New York, and while there the photograph of the Monimbo Indians was used as the cover for the *New York Times Magazine*. This was the first photograph of the Nicaraguan revolution to be published in an American newspaper. The fact that this was the last issue of the *New York Times* before it went on strike meant that the Monimbo Indians lay around doctor's waiting rooms longer than usual. That's how a single photograph can gain significance.

Nicaragua, Part 3

Suddenly, on that Sunday, the kids who, as it were, had been behind the slo-
gans and the signs that I had seen in the previous voyage erupted. The insur-
rection had begun. I had never seen people taking a risk before. There was a
fascination for the kids with guns, but what qualified the fascination was the
fact that their decision to take up arms could so easily end in death. If you see
the kids first, and then you see them in relationship to airplanes and bombing,
then their photographs take on a very different dimension. As it is, their photo-
graphs hide the choice and the risk that they took. I have been accused of
photographing them as if they were in a fashion parade; it was they who chose
by necessity to dress that way. Their fathers had probably given them a set of
clothes, which they wore underneath so they could take off one layer and reap-
pear without being recognized. Again, an example of photography's sad limits.
The Nicaraguans would have understood, but as the photograph now faces
you, it is denied its historical content, and it is the exotic fashion which seems
immediately to justify it.

For the first time I'm aware of being forced in a professional kind of frame.
I have to compete, I'm aware of tasks, deadlines, demands. I realize that I can
only go in, shoot for two days, then I have to return to the capital to get the
pictures sent back in order to meet the deadlines of American magazines. The
beginnings of an ambivalence. I remember being on top of a hill watching the
bombing of Estelí and not being able to go inside. With me are a whole load
of television crews sitting by their trucks drinking their beer. You have no idea
what it was like standing outside, watching the bombing, and knowing what
it must be like inside. I was overwhelmed; I was experiencing my own fears.
I got sent by my agency a 400-millimeter lens because they felt I was getting
too close to my subjects, which is how I'm able to take that picture of the
airplanes bombing. There is a lie in that picture, because it seems that I am
very close; in fact I'm miles removed from it, which is why I decide not to use
that lens again, because I want to be close to what is happening. To be close
to the event is not sufficient to get rid of the contradictions. The danger of
being involved in this kind of profession is that you begin to fall short of the
responsibilities involved when taking photographs of people who are in danger
of losing their lives. In the picture I had taken of the kids with guns, I made
sure that I let the picture editor know that if he published these pictures he
must choose only the one where the fighters are masked. One morning, *Time*
magazine, in which these pictures appeared, could be seen lying around the
Intercontinental Hotel, which was just opposite Somoza's headquarters.
Some of the pictures published showed the kids unmasked. I rushed back to
Matagalpa, which by now is under siege, looking for the guys who were in
the pictures. Not finding them, I give them to a storekeeper, saying to him,
"Do you know who these kids are? I don't need to know, but make sure that
they know these pictures exist." That was the first time that I realized that a
photograph could kill.

I think that most journalists think of photographers as mere illustrators of
what they think. I don't agree; I did not trust what they thought particularly.
You have to remember I was working with journalists who mostly knew each
other. They had been together in Africa, Indochina, Asia. They had references

they had brought with them; I was an outsider. All this accentuated the conflict I felt between, on the one hand, having to work like a professional photojournalist, and on the other, wanting my photographs to be of some use to the Nicaraguans and their struggle. I was always conscious when taking photographs that I was trespassing on someone else's territory and then leaving again. I always felt the need to establish a dialogue between the photographer and her subject, always trying to give something back of what I had taken. But in this situation, amidst the bombing, the dead bodies, and the grieving, there is no time to think of these questions. Half the time I am working in anger, at myself, at the situation. I can't believe what is happening. I am stunned at what people are having to go through. No time to think of past references and the contradictions come pouring through. Look at the woman: running away from the bombing with her baby. That photograph is taken by at least five different photographers, all at different points during her journey. She is literally vultured by us. No one is thinking to help her, including myself. We know now that photojournalism normalizes what are specific, and very violent, experiences, and we have thought about the subject *ad infinitum*, feeling guilty about photographs of terror becoming mere spectacle. We come up again and again against the same irritations and we still find it impossible to do anything about it.

Nicaragua, Part 4

The people that are going up to the mountains are not guerrillas; they are mostly men who have had to leave their cities after the failure of the September insurrection, because the National Guard were arresting all young men between the ages of twelve and twenty-five as potential Sandinistas. I go to the mountains not because there is a possibility of a scoop or a magazine spread, but more in order to experience what the Nicaraguans are going through. Thousands and thousands went up to the mountains to take refuge. Germán Pomares was there, an extraordinary man who spent twenty years fighting the dictatorship in the mountains. I remember being struck by his honesty and his open exchange with people. When food was ready, he would wait until everybody was served, and he saw to it that food was split equally. Afterwards, when night would fall, he would tell stories, recreate histories. He was deeply loved; he died two months after this picture was taken, bleeding to death because there weren't any bandages. My decision to go to the mountains is the closest I've got yet to being involved in their struggle without actually taking up a gun. They ask me if I would do so; I say no. They're puzzled by my constant snapping and recording until they ask me to take their photographs before they go on a mission in case they don't return. I have the strange feeling of people coming and going without any sense of the direction they're headed in. I am still very much an observer. I'm learning a lot by putting together the pieces, and I remember going on top of a mountain and seeing all the little villages and towns around it and thinking to myself, "If I had been a Nicaraguan I wouldn't live down there, I'd be up in the mountains." I begin to observe how much is not in the picture, such as the relationship between the city and the mountains and the feeling that

in the city, where everyone has the potential of being an enemy, there is a lot that you can see but you can't photograph. Such as underneath a mountain of corn: packages of medicine, guns. And then there's the kids delivering secret messages, a constant to-ing and fro-ing, and everywhere, the fear.

My passport, which had no Nicaraguan entry mark due to my being smuggled to the mountains from Honduras, made me realize for the first time that I could be arrested and seen as a participant. The line between the journalist and the participant gets vaguer by the moment. This time is also about attempting to establish relationships. In this atmosphere of shoot-outs, arrests, torture, and executions, I'm not easily trusted. The mistake that Somoza is making is that he's arresting people at random. Suddenly, everyone is vulnerable. But all around me I can see activities which are giving me greater confidence because it is obvious that the people are preparing. When you're outside a process . . . and you are not privy to their plans, it's hard to sustain your involvement if you don't understand what is happening. So you wait and wait. In the first voyage, when I asked people what's happening, they inevitably answered, "They are coming." They would shrug to each other or laugh to each other and repeat, "They are coming." "Who are *they*?" No answer. When I asked this of women, they would giggle to each other, as if my very presence as a foreigner was something that reassured them because they knew something that foreigners didn't.

When the first insurrection had failed, they knew it was going to be a harder struggle than they had anticipated. But finally, when the guerrillas did arrive down from the mountains, the myth that they represented was very important. You have to remember that the Nicaraguans did not know who their leaders were; they'd heard their names, they'd been told their stories and legends but had never seen their faces. The same applied to their history because photographs of Sandino and his soldiers who had fought the Americans in the 1930s were censored out of all Nicaraguan history books. By knowing who and where they were in the mountains, I began to take photographs of the National Guard in a very different way than I had done before because I was beginning to sense their end and their inevitable defeat. That is not what I feel about the paramilitary, who are arresting people in the streets and on the buses because they are totally outside the bounds of responsibility and law. The fear and anxiety that the paramilitary created were such that women would wait outside prisons hoping that their sons and husbands would be inside because it meant that they at least would have a chance of surviving. To the paramilitary it was simple: men, women, and children who were not like them were an enemy, and therefore, to them everyone was an enemy.

Nicaragua, Part 5

In the final part of her letter, she wrote to us that up till then it had all been a process of trying to get closer, of trying to capture things as they were happening so that slowly people behind the slogans and signs would begin to appear. During all this time, she went on to write, she was being asked to act as an ambassador. "Please, tell them what is happening." The feeling that she had no power. "I could take a photograph," she wrote, "but I would have no control over where it

would end up, how they would use it. Your role as a free agent is being
continuously circumscribed by being asked to do something for the
revolution, not just for yourself."

And now, the final insurrection. I keep on going back to Estelí because of my knowledge of what's above them in the mountains. My estimation of the uprising in Estelí is wrong, as a result of which, I'm not in León when it is attacked by the Sandinistas. Estelí is finally under siege. They were experimenting with large slingshots to throw contact bombs and they got a crop-duster plane to drop bombs near the headquarters of the National Guard. They built bonfires around which people banged tins to make sufficient noise to detract from the noise of the crop-duster planes. In Managua, nineteen districts were taken by the Sandinistas. They had worked it and planned it and I had missed the barricade building and the organization behind it. I stayed there for two days. They don't see me particularly as a documenter, they still see me as an outsider, and it was very painful to me as I thought I had a very clear function. But they do not see me as such.

They're not sure whether they'll be able to hold the territory, so Managua is the only place where they're still wearing masks. As they could not take Managua, they had to escape at night to Masaya. During the final offensive they did not trust me, and in a sense quite rightly, because the professional side of me was coming to the fore. I'm now working for *Time* magazine on a guarantee; I'm like the others, I'm competing for the photographs. I feel a lot of anxiety about performing and yet at the same time I have a feeling for the sense of history that is evolving and escaping me. I was laden with images that I felt I had to get but could not get; it was a very chancy operation. If you're driving down the road you might come across it, it was not a matter of knowledge; the kind of knowledge I had was not useful. I think that the average journalist who had been there for the length of time I had been might have covered it better because he would have responded simply to the news development rather than always trying to anticipate it. The professional, on the other hand, maybe would not have photographed people passing a cup of coffee: everyday moments do not make news. I remember I was in New York when I learned that the final offensive would come soon. I wanted to get back as quickly as possible and I was trying to raise some commission money, but I was told in no uncertain terms that the pictures I had taken of the September insurrection would be just like the pictures of the coming offensive and that the newspapers could recycle them and use them again. After all, when you've seen one insurrection . . . I was outraged; I knew it could not be the same.

The young boy looking at the guerrillas reveals another sensibility at work and shows just how mystical the guerrillas were when they were in the mountains. As I said to you before, up till then it had all been a process of trying to get close and now I was as close to them as I could be. But however involved we are, the reality escapes you. We know we can always go back home. The Nicaraguans, of course, have nowhere else to go. It's more like playing for us; for them it's real and that's an unbridgeable distance. We are protected by passports, white faces, cameras. And yet,

there is always the continuous ambivalence as to who you are, and what you are in relationship to a violent political process. Are you simply a journalist? Can you be a sympathizer and a journalist? Are you a recorder, witness, or an image-maker? I keep on remembering when I was asked in the mountains, "Would you die for my country" and I had said "no." I reflect on the ambivalence as to whether I'm a messenger or a participant.

The Nicaraguans value the pictures as a memory. They have moved on and so are able to distance themselves from them. They print them on matchboxes, like the photograph of the young militant throwing a Molotov cocktail. For me, there is the inevitable sadness of seeing photographs of people with guns, which have already lost the sense of who is inside them. I was left with these pictures and I felt I had completely failed, as they seemed so partial compared to what had been the whole experience. When the war was going on, somehow you did not think that this was a war specific to only Nicaraguans. Its nationalism was temporarily suspended, as it were. After the victory, I felt separated. I was again an American, and the doors were beginning to close. The price of collecting information or news is at the cost of living like a human being. On the other hand, the price of becoming involved is that you may not be seen as a reliable witness. Sometimes I think that a photograph is *instead* of a relationship, and yet a photograph *is* a relationship. So as I said at the beginning of my letter, we may as well start at the end, when everybody was coming together with shared hopes and pasts on which they hoped they would be able to base a future. It was the ending of a period of struggle, which had left 50,000 dead, cities totally devastated, and an economy in ruins. There was no time to celebrate, there was no fiesta.

I have pictures, they have a revolution.

Past Performing Future:
Susan Meiselas's *Reframing History*

Diana Taylor

(Reframing History, pp. 198–207)

(Nicaragua, pp. 128–173)

"Photos are visitors."[1] They go back. Susan Meiselas's photographs of the
armed struggle between the Sandinistas and the U.S.-backed dictator
Anastasio Somoza in Nicaragua (1978–79) return, twenty-five years later, to
a place in which a violent history has faded imperceptibly into everyday life.
Reframing History, a twelve-minute video of that return in 2004, documents
the project of locating the original photos in the spot where Meiselas took
them: nineteen photographs (symbolic for the July 19 celebration), blown up
to 6 x 9 feet and printed on mesh, installed in four towns (Masaya, Matagalpa,
Estelí, and Managua).[2] Over the years, the video shows, the busy streets and
beautiful landscapes have shed their painful past—that corner building is now
only a store, not the scene of a brutal confrontation. Decomposing corpses
no longer litter the green hills. Army tanks have given way to Toyota pickups.
Gone, too, are the fiercely determined *guerrilleros* who fought back. The indict-
ing graffiti accusing the military of disappearing civilians has been wiped off
the walls. The blood has been bleached out of the pavement. But the photos
show that *here*, on this corner, in this very field, on *this* street, a watershed
conflict was played out. Those of us who lived that history or followed it from
a distance know that 50,000 people were killed, 150,000 exiled. The demand
for accountability—"the dictatorship must answer" for its crimes—went ig-
nored. The crimes, too, dissolved into the background, unpunished. The
people who move through those spaces now may not all remember; half of
Nicaragua's population today had not even been born in 1978. But they are the
product of those struggles. The return of the photos became a performance,
a live encounter among Nicaraguans that refocused their past through their
present. It also made visible the past future, the one that back in 1978–79
Nicaraguans thought they were fighting for, the unattainable future of social
justice so far removed from the future they can aspire to today.

The narrative arc of Susan Meiselas's *Reframing History* is straightforward.
The video begins by showing the photos being installed in public places—on
building facades, in the streets, along the roadside. Young men dig and climb
and stretch to position and straighten the photographs while ordinary people
move in closer, stop, watch, talk, and remember. They look at the photo and
they look again at the place the photo occupies now as if seeing it back then.
At times, they personalize this encounter with the present past. One young
man takes a snapshot of one of the photos. Two young men run their fingers
over the mesh of the iconic Molotov Man. A girl looks, trying to make sense
of what she's seeing. Three young boys mimic the three young *guerrilleros*
picking up rocks. Women group together, sorrowfully, remembering. A middle-
aged man on a bus sees the photo of people lined up, spread-eagle, outside
a bus and recalls the routine military practice of searching its citizens: "eso
es lo que tengo fijado en mi mente de esa época" ("that's what stays in my
mind from that period"). The photos, the video shows, provide an occasion

1. Marita Sturkin's observation
at the symposium "Rites of
Return: Poetics and Politics,"
Columbia University/CUNY,
April 2008, where Susan
Meiselas showed *Reframing
History*.
2. *Reframing History*, a film
by Susan Meiselas, Alfred
Guzzetti, and Richard P.
Rogers, GMR Films, 2004.
The information about the
number and placement of the
images came from a personal
communication with Susan
Meiselas, May 2, 2008.

for telling, for sharing memories of those times and the criminal practices associated with place. The video focuses on the actions prompted by the photographs, the seeing and seeing differently as people peer at their *now* through layers of mesh and political practice.

Various voiceovers interject reflections—the situation was very bad under Somoza. That's why people fought. "Our hands were tied, our mouths gagged." But it's better now, the same man concludes, "today we have liberty and we have democracy." Not everyone agrees. Some wonder if what they survived was a "war" between enemy soldiers or a "struggle" between brothers. Whatever one calls it, many young people did not survive. "I tell my daughters," we hear one woman say. Was it worth it? Did things improve? There is no work for young people today, one man complains. Globalization has not brought the promised improvement—"that's a lie; we have the same services or worse." The words do not reference a specific photo. Rather, they float, much like the images themselves, in the transitory space that the photos have opened for remembrance. One thing is sure—people remember the sadness and misery left by armed conflict. "I lived through it," says one woman referring to the sense of pain and loss, "that's what war leaves behind." The present is full of pasts, and the photographs participate in the haunting. The semitransparent mesh of the images at times allows today's bodies and landscapes to seep through, belying any comforting illusion that the past is over. Then the video shows the photos coming down, being rolled up, and taken away. Where? We do not know. Who will be their new interlocutors? Will they mean the same thing, or prompt a similar response in their next location? While the narrative arc may reveal a simple visit, the video captures the multidimensionality of what photographs *are* and, as important, what they *do*.

Meiselas's Nicaragua photographs, of course, *are* many things—they are artworks, evidentiary "proofs," historical materials, and archival remains. But they also perform. As the video shows, they provoke events in the here and now, conjure up pasts, and constitute futures. Furthermore, the video *Reframing History* is also both a thing/product (an artwork, a form of documentary evidence, and so on) that can also provoke an event (a public showing, a discussion or reaction in a community or conference). The photos, the 2004 event, and the video offer a range of visual practices that span from the archive of supposedly stable and unchanging materials (photographs *are*) to the repertoire of ever-changing embodied practices and events with various mixed modes in between.[3] While evidentiary, historical, and archival materials such as these Nicaragua photographs can be locked away for years, family members, investigators, or historians can feel relatively certain that they are accessing the "same" image even across time and distance. The photos may fade, tear, and wear but, the archive assures us, they remain essentially the "same." The staging of the photographs, however, forms part of a living and ever-shifting repertoire of cultural imaginings. Reinserting them where they were taken twenty-five years after the fact allows people to participate in the production and reproduction of knowledge of that past by "being there" now, being a part of the transmission. The video, of course, offers another form of transmission, another way of participating for those who have never been to Nicaragua.

Reframing History illuminates the complex ontological and performance nature of the images—what they are and what they do—on many levels.

3. See my book *The Archive and the Repertoire: Performing Cultural Memory in the Americas* (Durham: Duke University Press, 2003) for a discussion of archive and repertoire as different and often complementary forms of transmission.

Equally important, they show how the staging extends the questions that have traditionally been asked of photographs to the more political realm of communal reception. The Nicaragua photographs *are* signed artworks created by the internationally acclaimed photographer Susan Meiselas. But, as she acknowledges, they are more than that—for her, they function, too, as an act of witnessing, a doing, a form of participating in a power play that she could not control but of which she, as a U.S. citizen, felt a part: "Sometimes its the least you can do," she said in an interview aired in Nicaragua in 2002.[4] At the same time, she recognizes that "no image is mine alone."[5] Displaying the photos on the street rather than in a private gallery accentuates the ways in which she understands them belonging to the people whose struggle she helped record. Rather than extend the logic of the culture industries by printing up thousands of prints and giving them away to be viewed by individuals, the public exhibit opens an arena for engagement, for discussion, for remembrance. By virtue of their staging, moreover, the perennial issues of authorship and ownership spill over from a consideration of the photographs as aesthetic objects to the broader conflict and to the history/memory they make visible: Who created this crisis? Who participated? Who controls the representation of the past? Who in Nicaragua has access to the records and archives that document that history?

The public display of the images also extends their evidentiary value. Meiselas revealed the dead bodies and criminal violence that governments tried to deny. Back in June 1978, she says, "no one knew what was happening"—no one outside the immediate arena of conflict, that is—although that arena was as extensive as it was secretive, involving the U.S. government and several regional governments.[6] While many commentators have challenged the "special credibility of the photograph"[7] in an age of digital manipulation and photo-ops, passport photos and photo IDs continue to rely on the notion that the photograph provides "proof" of being, and of being *there*. The bodies were there, and so was Meiselas.

The photograph-as-evidence, as most commentators acknowledge, is never simple or straightforward; it is complicated by captions, political commitments, placement, and so forth. In 2004, however, and for those of us watching the video, the evidence provided by the photographs might be of a somewhat different order. Again, these photos *are*, but (as Edmundo Desnoes puts it) they "are in history."[8] They are not about copresence but about distance. It is impossible now to have fantasies of immediacy, of imagining that we accompany Meiselas as she looks through the lens. Rather, many lenses separate us from the Molotov Man and the three young *guerrilleros*—not just photographs and video, mesh and celluloid. Back then, their being, their ontology, were simultaneously a doing, an indictment, and a demand for justice. Now, the photographs are evidence of how quickly we've all forgotten. But the photographs remember. The history they tell now is not the same one they told during the war. In fact, part of the historical inquiry today in Nicaragua and beyond might well have to do with why no one talks about Nicaragua and Contragate any longer.

Reframing History shows photographs as "stable" historical materials and, at the same time, as radical performance actors. What photographs *do* can change dramatically over time. Back in 1978, these photographs served several functions simultaneously. Published outside the country, they helped people in

4. Susan Meiselas, "Eyes Wide Open," interview with Carlos Fernando Chamorro for Nicaraguan television, 2004, included as a "special feature" in *Pictures from a Revolution*, a film by Susan Meiselas, Richard P. Rogers, and Alfred Guzzetti, GMR Films, 2007 (my translation from the Spanish). Edmundo Desnoes, in "The Death System" (in *On Signs*, edited by Marshall Blonsky [Baltimore: Johns Hopkins University Press, 1985], pp. 39–53, reproduced in the present volume), quotes Meiselas's reflection on being "American" in the Nicaragua crisis: "I think as an American. One thing became very clear to me in Nicaragua. Coming from the States I've never had to stand on one side of the line or the other side. Even in the sixties that could be easily avoided. One participated as an activist, but that did not fundamentally affect everything about one's life. One could still masquerade, to some extent. Very, very early in Nicaragua I was confronted with the meaning of people's actions. They took certain risks, and those risks became obvious, so obvious that they could lead to: actual death, isolation, or exile. The people had a capacity to determine what was public and what was private in a way that I didn't. I realized that everything about the way I dressed, the way I walked, the way I talked to people, was indicative of my culture and my condition and my consciousness" (p. 39).
5. Meiselas, "Eyes Wide Open."
6. See Greg Grandin, *Empire's Workshop: Latin America, the United States, and the Rise of the New Imperialism* (New York: Metropolitian Books, 2006).
7. Roland Barthes, "The Photographic Message," in *The Responsibility of Forms: Critical Essays on Music, Art, and Representation* (New York: Hill & Wang, 1985), p. 10.

Diana Taylor

the so-called developed world "see" and understand the terrible conflict in Nicaragua. The politics of their reception also revealed how violence in this small Central American country was actually an extension of political and economic conflicts taking place on a much larger scale.[9] Beyond that, the photos immediately became iconic. In Latin America, at least, they spoke not only to an acute political crisis but also to the commitment to social justice and an attitude of resistance that far exceeded Nicaragua 1978–79. One of my earmarked theater-as-revolution books when I was a beginning instructor of theater and politics in the early 1980s at Mexico's National University had a pirated Meiselas Nicaragua photograph as a cover. The Sandinista fighters were photographed as pure *gestus* in the Brechtian understanding of powerful, recognizable, and quotable social gestures that performed the revolutionary hope of the 1950s, '60s, and '70s throughout Latin America.[10] Youthful Davids throughout the region fought to unseat a continent of authoritarian Goliaths backed by the U.S. military and economic forces. The photograph of three *guerrilleros* in simple wire mesh masks bending down to pick up stones transmits the unequivocal attitude and the asymmetry of the power: stones against rifles, Molotov cocktails against tanks, the improvisational tactics of the disempowered against the strategies and territorial control of the armed forces. Meiselas's photos not only captured the hope for freedom and cultural agency, they enacted it. Powerful, breakaway social actors, they came into being, inserted themselves into the sociopolitical context, and helped constitute a vision of a new, more humane, future. For those of us on the Left who grew up with these images in Latin America in the late 1970s, they served not simply as evidence of what had been but, as important, a promise of what could be. The past performed a utopian future of self-determination.

Much has changed in Latin America in the twenty-five years since Meiselas took the photographs, and yet the video shows these same images continuing to interact powerfully with the present. As I have suggested, the return of the photographs in 2004 temporarily opened a public arena for interaction and engagement. The photographs, however, perform a special kind of event that extends beyond the immediate engagement in the here and now. They also act as a memory-event between past, present, and imagined future. The photographs, these spectral visitors, reinsert themselves in their former location to make visible what was already there but bleached of its potency, its indexicality to a past practice. The past, with its violent and skewed power relations, has remained present all along, although most Nicaraguans no longer focus on it. The young know little or nothing of this history. No monuments have been erected to the dead. Schools do not teach their pupils what happened or why it's important to know. These photographs, then, memorialize a history that the country itself has not acknowledged. They perform a memory-event, not a stable "site of memory" as in state-sanctioned memorial projects, but the informal, temporary interruption of quotidian reality to refocus attention on the past. They provoke not just the evidentiary recognition that "this happened here" but the recognition of the systems of power and relations (including local and global politics) that continue into the present.

Interestingly, the memory-event not only prompts reflections on the past but also reveals the fantasies of a better future that progressive Nicaraguans in the 1970s thought they were fighting for—the freedom and egalitarianism

8. Desnoes, "The Death System," p. 41.
9. Greg Grandin argues that Latin America served as a "laboratory for counterinsurgency" for the U.S. military and became "a school where the United States studied how to execute imperial violence through proxies . . . By the end of the Cold War, Latin American security forces trained, funded, equipped, and incited by Washington had executed a reign of bloody terror—hundreds of thousands killed, an equal number tortured, millions driven into exile—from which the region has yet to fully recover" (*Empire's Workshop*, p. 4).
10. Bertolt Brecht built on Kurt Weill's concept of the *gestus* in music and on Weill's definition of the "basic *gestus*" as "forcing the action into a particular attitude that excludes all doubt and misunderstanding about the incident in question." *Brecht on Theatre*, edited by John Willett (New York: Hill & Wang, 1964), p. 42, editor's note.

promised by the Sandinistas. The return of the photographs underlines the hauntedness of Nicaraguan politics—the Sandinistas returned, Daniel Ortega returned, but not in the role many had hoped for or fought for in the 1970s. Even though the installation of Meiselas's photographs in 2004 predated Ortega's democratically elected and ultra-right-wing presidency in 2006, the writing was already on the wall. Instead of the graffiti demanding accountability, the population already knew that the economic disparities and curtailed freedoms of the past would only get worse. The future had been encumbered; maybe it already had been in 1978. The video makes evident the enormous gap between the aspirations of the past and those of the present in which, instead of freedom and equality, people will settle for food and low-paying jobs. Looking back now, the photographs haven't faded, but the hope has. The future as space of potentiality has been curtailed.

As I watch *Reframing History* again, many years after the original events took place, and years since the photographs returned to Nicaragua, I am struck at yet this other reframing of the "same" photographs for an international audience. I have seen the video screened at a scholarly conference, shown it to my students, and watched it alone on my home computer. As with the photographs, the video is the "same." It lasts twelve minutes and takes us through the arrival, display, and departure of the photographic visitors. Yet in each case, the viewing means something very different to me—it sparks a different form of interaction and reflection. With my students, I engage the subject of cultural agency—the artists (photographer and videomakers) expand our imaginations; artistic images and *gestus* such as these amplify our repertoires of individuals and social movements. Social memory is not a thing but a process. At home, however, I feel the video confronts me with my own lost hopes for a better future. Ortega's current government is just one of the many current political realities that jolts me into feeling that I may be past performing futures. The staging and the frame affect my understanding of the photographs even when they remain the "same." Maybe that's why these uncanny visitors have such a force when they reinsert themselves into the ever-changing public sphere and become part of people's embodied experience. Photographs may be archival but they function as vital "acts of transfer" that help us constitute (rather than represent) past, present, and future.[11] Looking at the video once more, I know that some of the activists, artists, and scholars I work with through the Hemispheric Institute in various parts of the Americas would very much want to see this video. Maybe the photographs, too, can make another visit at our next event in Bogotá—itself a site of ongoing conflict?[12] I take out my notebook and pencil and start imagining again.

236

Diana Taylor

11. I am indebted to Paul Connerton for this term, which he uses in his excellent book *How Societies Remember* (Cambridge: Cambridge University Press, 1989), p. 39.
12. The Hemispheric Institute of Performance and Politics is an Americas-wide consortium of artists, activists, and scholars: www.hemispheric-institute.org.

Chapter 3:

Archives: Official Images and Buried Histories

1991-2008

Archives of Abuse

Kurdistan

Encounters with the Dani

Return to Kurdistan

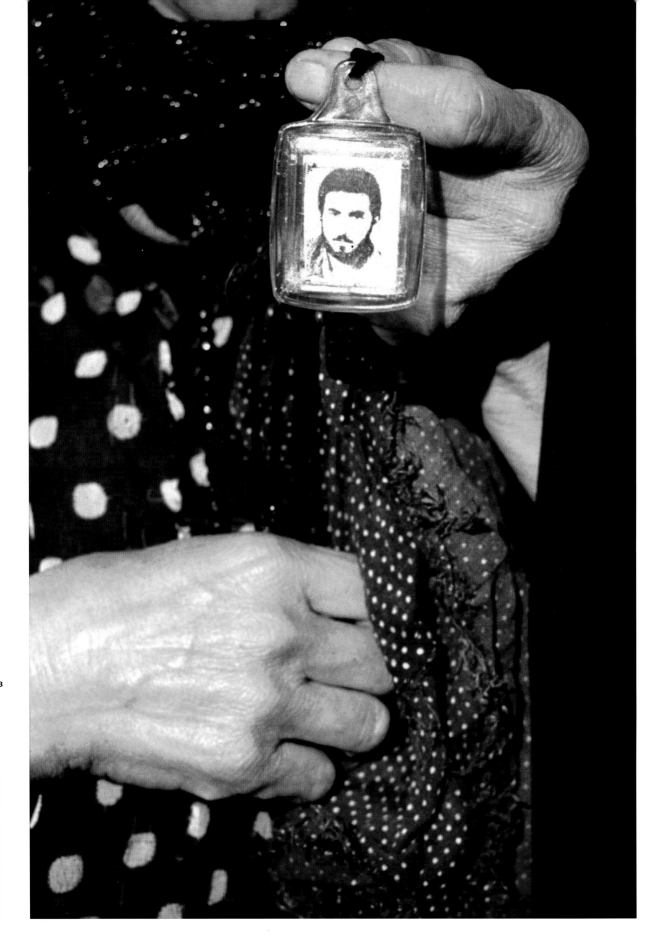

(**Meiselas interview**, continued from page 121)

Archives of Abuse

KL: As the 1980s drew to a close, you moved away from using your own photographs to tell the stories you wanted to tell. In Chile, you organized a book with work by local photographers documenting life under Pinochet. In your next projects—*Archives of Abuse*, *Kurdistan*, and *Encounters with the Dani*—you worked through found materials.

SM: The first real "archival" project was *Archives of Abuse* from 1991 to '92, right before I went to Kurdistan. This was a commission for a public art project, supported by the Liz Claiborne Foundation. Six artists were invited to do work about domestic violence, which would then be linked to a crisis line in the city. I did a huge amount of research talking to the community services that existed at that time, and was reading a lot about who it was really happening to, and visiting shelters to meet women who were victims as well as the people protecting them. I was shocked by the scale of what I learned; the statistics and demographic realities of the issue. While none of those visits led directly to photographic opportunities, they forced me to consider some fundamental questions. What are the stories that I need to tell? How am I going to tell these stories?

My first idea was to document the wounds on women's bodies and put those photographs inside the dressing rooms of department stores. I wanted to have them in those little booths that you open, so that female shoppers would confront other women's bodies that had been violated and make a very intimate connection with them. I tried to find a department store that would do it, but none would. The head of the project planned to do billboards and bus shelter posters, but I couldn't imagine putting that kind of image on the street.

At some point I went to the office of the police commissioner to ask if I could accompany the investigative unit, and they basically said, no, you can't come with us. But while they were checking to get approval from higher ups, I was sitting at a desk with piles of folders all over it. I asked if I could at least look if I was going to sit there three or four hours waiting to hear what the chief had to say, and they said sure. So I started to open up these manila folders and was completely absorbed in one novella after another, the stories of these dramatic relationships

revealed in the handwritten reports produced by the detectives. So that's part one, and then I saw a little note referring to some other part of the police archive where there were photographs, the forensic photographs that had been made on the sites.

When I saw them I just said, this is it. I don't need to make any pictures, forget about getting the police commissioner's permission, as long as they'll let me just be in their offices. I like hearing the phone calls coming in, I like being connected to their work. They're the investigative team, I can learn from them. Just let me be here as a kind of artist-in-residence with the police investigative unit. If I find a file, and can get to see the photographs, if even one of those photographs works for the project, it will be perfect.

With the police, the interesting thing is that they wouldn't let me *in*. I made some photographs, but I felt I was always in the aftermath, disconnected from the victims. Then I found that there was something they had documented already, and it was much more compelling and more important for the public to see. I'm thinking of myself again as a facilitator, as a bridge to another world.

KL: Were Donna Ferrato's pictures of domestic violence already published by this point, and did you have that work in mind at all?

SM: I was definitely aware of what Donna was doing. I'm sure I had seen her pictures. What I was doing was different than the person-to-person interactions that she was capturing, you know, the police coming in and pulling the child from the mother. The only photographs I made were forensic. They were of the blood on the wall or on the bed, and some people showing their wounds. Those were the pictures I took before I saw the police work.

KL: There's a resonance here with *Carnival Strippers*, a line of continuity between those projects in terms of marginalized women, women on the edge, in danger . . .

SM: Yes, and also my work at the New York sex club Pandora's Box (1995). You know, I think that's the difference between being a maker and being a thinker, or a curator of someone else's work. A theoretical concept comes from a different place. I tend to feel my way through things. There are patterns, of course, and I can see them, through the history projects, let's say, or projects that come from looking at women, their roles and power relations. The seminal projects we've been talking about

Photograph of Kamaran Abdullah Saber, 20 years old, held by his mother, Saiwan Hill cemetery, Arbil, Northern Iraq, December 1991, from the series Kurdistan.

are all about these relationships, right? So I can see that continuity through almost everything.

Photographing in Kurdistan (1991–92)

KL: While you are in the midst of working on the domestic violence project, you went to Kurdistan for the first time. That was in 1991, in the wake of the Gulf War.

SM: In going to Kurdistan, I was confronting something I'd heard about, read about, and knew that the human rights community had known about, but had never seen evidence of. So my first personal mission was to find out why all these people had left this place and fled into Turkey and Iran.

My initial attempt to get there began with a writer I know, Joe Conason, who wanted to do a story about the Kurds. At the time, he was working for *Details*. Joe called me, saying basically, "you're the only person I know who is crazy enough to go across the border from Syria into Northern Iraq to do a story with me about the Kurds." Now this was fall 1990, right after Saddam had invaded Kuwait, and there was a period of negotiations going on behind the scenes and nobody knew whether or not we were going to war. I was in the midst of editing *Pictures from a Revolution*, and hadn't yet determined whether I was ready to move to an entirely new part of the world to work. I was just finishing up a decade of work in Latin America, and wasn't sure I would be returning.

I discovered the Kurdish Library in Brooklyn, where I immersed myself in reading about the Kurds, and then went to Human Rights Watch to find out more about what was happening. They had reports about the chemical bombings, but no visual documentation.

Joe and I were set to go exactly when the ground war began, but *Details* balked at sending him. They didn't want to pay the insurance, they didn't want to take the risk, they didn't want him there. So I convinced Middle East Watch, a branch of Human Rights Watch, to let me join their research team that was monitoring the situation of refugees fleeing into Turkey. On my way to meet the team, I was standing in a visa line at the Iranian consul in Paris along with other media people. I overheard that Danielle Mitterrand was planning a trip to Iran and they were all going to be flown in as her media escort. I quickly decided that joining up with that trip would get me closer to what I wanted to see than the Middle East Watch team, so I ended up flying to the town of Haji Omran and following the Mitter-

rand entourage, visiting refugee camps where she was giving out food and supplies.

She had planned a meeting with the Kurdish leader Massoud Barzani, which completely freaked out the Iranian police and the military. Barzani is the leader of the KDP and the son of Mullah Mustafa Barzani, the great historical fighter for Kurdish independence for over forty years. The meeting was to be held in the demilitarized zone between Iran and Iraq, which after the Iran-Iraq War was a very sensitive area, and was still mined. But when Danielle Mitterrand, first lady of France, says I have a meeting, they respect her request, despite the dangers.

So here was the scene: Mitterrand walks across this previously mined field, the Iranian guards are in a panic that the field might not be cleared completely and she's going to blow up. She was coming down one hill, and I remember being in this mad rush of media people. At the same time, from the other side of the border, there's a surge of Peshmerga coming up over the hill with women in fabulous dresses behind them.

KL: So your first encounter with Kurds was a phalanx of armed warriors and gloriously outfitted women descending down a hill into a minefield.

SM: And I thought, where am I? What movie is this? Massoud Barzani sits down, he's magnificently dressed himself, it's a historic moment. But I can't make a photograph because it's midday light, it's absolutely bristling contrast, people are all over the place and all I'm thinking about is this is the moment and I'm missing it! It was amazing to have tea right in the middle of that minefield.

I told Mitterrand's translator, Bakhtiar Amin, that I didn't want to return with Madame Mitterrand, I wanted to go in with the Peshmerga, and asked him to help me do it. And that's how my journey began.

KL: So after the tea party, she goes back across the minefield into Iran, and you head off into Iraq with the Kurdish guerrillas.

SM: Bakhtiar introduced me to Nawshirwan, the commander of the region at that time. He asked me what I wanted to do, and I told him I'd read about the destroyed villages, I just need to see them, I need to see whatever I can see of what's happened.

KL: Who escorted you around?

SM: Nawshirwan put me in a car with four Peshmerga, in the middle of the backseat. If I hadn't gone through the fighting in Nicaragua and El Salvador, I would have been intimidated by traveling around with guys armed to the teeth with their weapons hanging out of windows.

KL: And you were the only photographer there at this point?

SM: Yes, the media were happy to photograph Danielle Mitterrand with Massoud Barzani and they left with her.

KL: The war was over by then?

SM: There had been an uprising of the Kurds, which they had hoped the U.S. would back. That didn't happen, so the Kurds felt betrayed, and the flight had occurred. The people, the civilian population, had left for the most part.

In all my work in Latin America, in all my photographing of war, I never saw destruction that was so systematic and so complete. I was trying to be thorough while document-ing the destroyed villages; the problem was there was so little left, sometimes there was nothing to photograph except piles of rubble. And no way to distinguish what had been there before.

I connected with Nawshirwan because he was a leader of the uprising and was very curious how the popular insurrection happened inside the towns of Nicaragua. He pumped me for details. I saw such a resemblance to the liberated zone of Nicaragua just after the September insurrection when the population fled to Honduras.

I never met up with the team from Middle East Watch. They actually did get to the refugee camps in Iran and they began a project of collecting testimony, about what had happened in the Anfal campaign, Saddam's attempt to annihilate the Kurds. So they were doing that while I was going in to do the visual component. My first showing of the work was actually at Middle East Watch, all the photographs that I had taken of the destroyed villages. They then committed to doing a bigger project, which became a six-month in-depth investigation of the Anfal campaign, including interviews and documentation of the mass graves. I joined them for that next trip in December.

KL: You documented the process of recovering the mass graves from the Anfal campaign in the Northern Iraqi towns of Arbil and later Koreme. And you were really part of the Middle East Watch team and linked in with their project.

SM: They were the only people who responded to the work I did when I had gone in independently on my first trip. The magazine world isn't interested in the past, they're interested in what's happening in the present. I didn't want to go to the refugee camps, I was interested in what had happened in the places the refugees came from. So the next opportunity came through Human Rights Watch, to accompany their mission. It was a very natural transition. HRW had used my work from Central America for years before that, so I knew them as an organization. If you don't have the media as the enabler, you have to find partners elsewhere.

KL: And how does the work that you did with Middle East Watch photographing the mass graves compare to your photographs of the El Mozote Massacre in El Salvador? That was another example of trying to create usable evidence of a crime. Are the two linked in your mind?

SM: At Mozote, there was the shock that the massacre had been denied officially and then we saw the evidence in front of us. Ray [reporter Ray Bonner] and I didn't know the scale of what had happened, but we saw plenty of evidence to know that something *had* happened. In Northern Iraq, I had read reports about Anfal from Middle East Watch, but because it wasn't visual evidence and because the informants were considered to be insiders, the reports weren't trusted—in the same way Radio Venceremos [Salvadoran FMLN guerrilla radio] was dis-missed when they gave the first reports of the Mozote massacre. In a similar way, being there, witnessing, documenting to the extent that we could, legitimized what in fact those insiders had reported.

KL: But in the Mozote case, you'd already had the experi-ence of seeing the evidence ignored, even when it was supplied to a congressional committee investigation. So what were your expectations for the photographic documentation of the Anfal campaign?

SM: Maybe that's part of why I felt more aligned to the mission of Middle East Watch because at least it was going to be useful to what they were doing . . .

KL: As opposed to the press?

SM: . . . versus the press. I still felt the contribution of documenting Mozote was terribly important, but how photographs operate in a political landscape is complex. They don't always perform for us quite as we might hope.

In the end, it wasn't until the bones were dug up ten years later in Mozote that there was actionable "proof" that the massacre had occurred; my photos didn't provide that.

But I was feeling aligned with the Middle East Watch approach, which was to take it slow and to look very carefully and to really try to understand something.

KL: It's an investigative process, and it allows for more depth than when you are working under deadline for a magazine. I wonder if you see that as leading into the archival work.

SM: That's exactly right, in total contrast to the urgency of news reporting. Forensics is very meticulous work. It paralleled where I was at the time. I was ready for that type of careful examination and I became absorbed in the minutiae of the process—how to track the bones, what the bones tell us. That photograph of [forensic anthropologist] Clyde Snow holding up the skull illustrates what I'm talking about: A blindfold is still attached to the skull, it survived because it's synthetic material. Snow is examining the size of the bullet hole in the back of the skull to determine the caliber of the weapon used and the distance from which the victim was shot. The process is fascinating.

KL: You were so deeply involved in Latin America, it must have been a massive shift to separate yourself from that and enter the new territory that you found in the Middle East. And yet, when you get to Kurdistan, you gravitate to precisely the same subjects. Why is that? What's the common underlying impulse?

SM: I carry these themes with me without even recognizing it, and I'm attracted like a magnet to the mass graves, destroyed villages, the missing, the themes and issues I've been involved with for the last twelve years. I had gotten to the point where there was context and continuity in my Latin American work, and I knew the history of the places I was in, and suddenly I was pulling myself out of that and landing in a place I knew absolutely nothing about, but I brought that other history with me.

I made a series of pictures with clothing on anonymous graves in the Arbil cemetery. I had never seen this in Latin America. I'd photographed anonymous graves in Argentina and Guatemala, where you see an XX or NN—*ningun nombre*—on a grave marker, so when I came to this Arbil cemetery and the gravedigger brought us to a section that he himself had dug and then I noticed the clothing, that was a completely new experience. People had already dug up the bones to try to find their loved ones as soon as the

uprising against Saddam's forces was over. They dug up the graves, found the clothing around the bones, and, if it wasn't their kin that they found, they put the clothing on the graves so the next person didn't have to dig it up.

KL: It's a gesture of community.

Collecting Photographs for *Kurdistan: In the Shadow of History*

KL: So you were taking lots of pictures and shooting video, but at a certain point that became less satisfying. When did you transition into the search for historical material, which ultimately became the focus of your work in Kurdistan?

SM: I began to notice people holding on to photographs of the disappeared. They were wearing the photographs, which for me resonated with the Plaza de Mayo in Argentina, where women publicly held up photographs of the disappeared.

KL: So your first awareness of the use of photographs to hold on to some history and some sense of lost community was through these memorial images.

SM: And by then people felt secure enough to share the history in a collective, communal way. I visited a school where they had put up photographs of the martyrs from Sulaymaniyah who had been killed at a military compound in 1963. This was the first time people in that town had seen those photographs. I met the schoolteacher who had taken the photographs, and remember how they were mounted on colored construction paper—pink, red, yellow, and green. I was very moved by that display of their history.

KL: When did you decide to do a book, and to shift the focus of your work in Kurdistan from taking pictures to just collecting?

SM: It's cumulative, you know. I remember the schoolroom exhibition. I remember the Kurdish geographer Karim Zand showing me a photograph of Margaret George, the legendary Peshmerga, that he still carried in his wallet, not because she was related to him, in the way people were carrying their missing kin on necklaces or pinned to their shirts, but for some other reason that made me curious. But when do I get the sense of a larger history to unearth,

something beyond what my photographs can do? That happened partly through conversations with people who said that there had been many more travelers in the region before me.

I experienced the photographs as a way to tell *me* the story, their stories about what has happened to them over the last hundred years. I was already focused on the past through the exhumations. And these photographs signaled the past. Why have people been killed? What's behind the ethnic cleansing, the genocide? In an attempt to understand that, I looked to what might be there as evidence through photographs of what had happened before.

KL: As you gathered the photographs, either within Kurdistan, the Kurdish diaspora, or Western archives, you brought them back to the communities from which they had come.

SM: Partly I wanted to repatriate what I found, to bring them back so people could see them, and partly because that's where the storytelling begins, around the photographs. The isolated photograph isn't interesting enough. I'm not looking at it for its aesthetic composition. I'm interested in its historical value.

KL: When you shifted away from making your own photographs into collecting, what did that do to your self-conception as a photographer?

SM: I remember somebody in the editorial department at Magnum Paris saying, you just spent six weeks in Kurdistan, you brought back nothing but pictures of other people's pictures!

I was torn, conflicted, questioning my process. I didn't want to say I was giving up photography or I was no longer making photographs, but every time I went to Kurdistan, I wasn't trying to see the kinds of things that were of interest to the media—the training of the new militia or the rebuilding of the villages. I would come back with nothing that was "newsworthy" because I kept getting drawn back into the stories.

But there was a moment at which I recognized the contours of a book that would be a timeline of image-makers, and that I had a certain place in relation to it. My role would be locating anything that referenced the Kurds in any geographic location, that visualized their history and their desire for this place—*Kurdistan*. Once that became clear to me, the project became another kind of forensic work, a kind of fanatic-obsessive work, because I was unstoppable at that point. I had discarded the preoccupa-

tion with whether or not I would be involved in making my own photographs.

And parallel to that, it's very important that at the end of 1992 I received a MacArthur Fellowship. Until then, I'd been trying to balance the Kurdistan research with my life in the media world, which was the only way I knew how to survive. I doubt that I could have continued to meet the demands of both; they are of such different natures. Once I got past that conflict, I had to retreat from the Magnum community. There was a lot of pain connected to that separation. But meanwhile, I was connecting with people in the Kurdish diaspora, and everyone I met led me on a path to someone else, which either closed a door or opened another, and that process itself was so rich and unfolded in such unpredictable ways. It was the perfect parallel to the way history, ongoing history, flows. Maybe there is a parallel between that kind of historical discovery and what can be discovered working in the field. We think of the field and the archive as so separate, but from me they ignite a similar response. The archive is a similar kind of retreat, where I can feel connected to community, where what I'm doing makes sense, in a way that the community I come from doesn't necessarily comprehend.

KL: Your deepening interest in the archival emerges in a particular cultural environment: the context of appropriation, artists using found material in their work.

SM: That aesthetic discourse, which I'm not really involved in, forms a very distant backdrop: the questioning of authorship and authenticity. I'm coming from another tradition—journalism—where there are issues of subjectivity and objectivity and crossing the line from being an outsider to an insider. These are the issues that concern me and inform my work.

KL: How did you share your work with members of Kurdish communities and gather their stories and images as you worked?

SM: After 1994, I worked primarily with the diaspora community, because I couldn't go back to Northern Iraq or the southeast of Turkey where the Kurds live. The tension in that area was too great because of the fighting between the Kurdish parties in Iraq and the strained relations in southeastern Turkey. By then, I had developed a very large network of scholars and people in the diaspora from Sweden to Germany to Holland to France to England and others dispersed in America. I carried around scrapbooks as I was assembling the book. I wandered around with a

suitcase, collecting everything I could find. I was constantly showing people the scrapbooks, trying to get more material or corrections and feedback. And in addition to the collecting and gathering, I received a lot of contesting and counterbalancing of history.

KL: So by the time the book came out, there was a community of people who felt that they had a stake in it, that it was something they had been part of.

SM: Exactly.

KL: Did the book become a reference point for the Kurds? Did they adopt it as an official history?

SM: Two things come to mind: Bakhtiar Amin (whom I had met on the Iran-Iraq border) was then in Washington, and he asked for a hundred books because he wanted to distribute them to any policy maker who had expressed an interest in the Kurds. Meanwhile, in contrast, there's the story of what happened at Human Rights Watch. Though HRW had completed six months of in-depth interviews and evidence-gathering, they couldn't bring the case to the International Criminal Court in the Hague. No government would take on the plight of the Kurds, the acknowledgment of genocide. No one was willing to challenge Saddam at that time. So that initiative ended.

As to how much the Kurds feel the book is an accurate representation of them and their history, there's the remembrance of a Kurd asking how I had gotten all of them into one book. Of course, there are missing pieces, this history and this book will never be complete. But people valued that it had been assembled. Like a rubber band holding all the little bits and pieces together. I think they valued that, principally. They don't yet have a national archive, and they are only beginning to think of building a museum to honor the victims of the Anfal campaign. I hope to aid in that effort.

Returning to Kurdistan (2007–8)

KL: You have just issued a reprint of the Kurdistan book. Does it resonate differently now, after the U.S. invasion, than when it first came out?

SM: The Kurds ordered 5,000 copies of the reprint and the question is, just what are they going to do with them? How many schools and how many libraries actually exist?

How are the books going to circulate and how many from Northern Iraq will filter over the border into Turkey and Iran and how many will be sent around the world with their ambassadors? I don't know. Making writer Martin van Bruinessen's texts available in Sorani and Turkish is the significant contribution of the reprint. The book is now more accessible to a larger part of the community that doesn't speak or read English.

When I returned to Northern Iraq in November 2007, it had been fourteen years since my last trip. I had no idea how the book had been received or how many people in Northern Iraq had even seen it. I knew the difficulty of bringing the book into Turkey, where it was banned—it was often captured at customs. And people were at risk trying to carry it across the border. So I just didn't know how much the book had penetrated into Northern Iraq.

KL: But it became clear that it had.

SM: It had. I went with a group of artists on the 2007 trip. When I was introduced to our host, Karwan Barzani, the first thing he said was, "You didn't tell the story of my great-grandfather." Karwan, a nephew of Mullah Mustafa Barzani, wanted me to meet his uncle, who is the historian of the Barzani family. I gave the senior Barzani the Kurdistan book and he immediately turned it over. I didn't know how to read that gesture. I had been told that he was a renowned historian, and also very judgmental, and his initial reaction seemed to be a way of putting me in my place. Then it occurred to me that he might not read English, so I opened the book to a photograph of his family members taken in the early 1940s. He named every person in the photograph, at which point I had a slight meltdown about what was *not* in the book—there's always more. He closed the book again, but that photograph must have sparked his curiosity, because he put it on his lap and opened it up—from the back. That's the moment in which I realized that that's the direction in which books are read in Kurdish.

So fast-forward to New York. I'm finishing up the layouts for the new edition of *Kurdistan* and trying to figure out where to put the Turkish and Kurdish sections, and suddenly it dawns on me that they have to begin at the back. Convincing the publisher to imprint "Kurdistan" in Sorani on the back cover was the ultimate touch. But none of this would have occurred to me if I hadn't been in Barzani's living room, reading his resistance and inability to penetrate what I had made. That's what I mean about experience giving direction to ideas.

KL: But what about the issue of how this book is functioning in an autonomous Kurdistan, after the changes brought about by the U.S.-Iraq war? You've mentioned that different factions with conflicting agendas have used your book for purposes you may not agree with.

SM: Throughout the making of the book, different sectors were pulling and pushing and wanting more, giving more or less. No, I think the more interesting problematic appeared earlier, when Bakhtiar handed out a hundred books in Washington in 1997 and the neo-con movement appropriated the Kurdish issue to justify the invasion of Iraq in 2003.

KL: Were you worried that your work would be used to make the case during the lead-up to war?

SM: I remember wondering, how do I make sense of this, that this book has obviously helped justify the claim that the Kurds were making under Saddam. The Kurds were firmly behind the war. Meanwhile, not only am I photographing protests but I am myself opposed to the war. Early on, I think it was late 2002, I went to Bakhtiar for help with a new film project. He was completely pro-war so we got into a huge debate about the Kurdish position, which was: we want America to intervene, we want America to bring Saddam down. So it put me into conflict with the principal community I had made this object with and for.

KL: Were they aware of that conflict? Of what your position was?

SM: Well, I was clear about my position on the war. I was clear I was antiwar, but I can see even now, five years in, how the war has benefited them. And that's the point of going back fourteen years later and seeing for myself. Where would the Kurds be today if the war hadn't occurred? How can I know? The war gave them the power to build the society that they've dreamed of all the years in diaspora and for over a century.

KL: In your initial proposal, the book is titled *The Kurds*. "Kurdistan," on the other hand, evokes an imaginary, hoped-for-place and community. Now the Kurds have a territory, but it's not "Kurdistan," it's something very different. The Kurds have moved from the mythological homeland to the reality.

SM: They would still call it Kurdistan.

KL: But it's not the borders on the map that you have in the book.

SM: No, they weren't granted the territory that's outlined on the 1945 map, and it's unlikely they ever will have that map. But they're *on* the map and they are players. They are no longer just stateless dissidents. Jalal Talabani, the head of the PUK, one of the principal organizations, is president of Iraq, and Massoud Barzani, the man from the border tea party, is the president of the regional government and head of the KDP. So those are significant positions that have been achieved in the time that we're talking about. Now what is their idea of "Kurdistan" and how does the Kurdish community both in the diaspora and beyond those borders feel about what is being created in Northern Iraq? That is what I'm trying to understand now.

Kurds in the diaspora have this idealized, nostalgic view of Kurdistan, but most of them don't want to actually go back and live there, even now, when they have all these opportunities. They just like that it's there.

KL: So the pictures that you took when you went back in 2007 were primarily of that: what does this country that has only lived in people's minds and is now getting built look like? Many of the pictures show the extremes of development, the amusement parks or malls or the massive oil infrastructure that's being built.

SM: The oil is going to change their lives, and give them the capacity to transform the physical environment with the wealth that they're sitting right on top of. Looking at the pictures so far, I'm overwhelmed by the construction campaign and in some ways a bit sad about what is being decimated in exchange. What culture is being eroded through the frantic commercial enterprise?

KL: The exhibition that we're doing is going to include your photographs of just after the revolution in Nicaragua and the beginnings of building a new society and those very optimistic but very humble pictures of guys with hammers. Laying sidewalks brick by brick, people working collectively in the aftermath of a successful revolution. What you've found in Kurdistan is also the rebuilding of a society, but on steroids. And your pictures convey a certain wariness about the culture that's being created.

SM: First of all, there were fourteen years intervening, so it's a bigger contrast for me to go back in time. But in terms of the scale of their dreams and their reference set, it's Dubai. They really have a model for where they're

going. I can relate to the necessity of twenty-four-hour electricity. They still have huge water shortages and pollution in the water. But the massive shopping mall on the ruins of a 6,000-year-old settlement in Arbil is the more disturbing part.

And some of the issues with women are growing, not receding, such as the rise in honor killings. The modernizing culture sends confusing signals to women, in a society that was traditionally deeply segregated and that is still very cautious about the roles of women in public life. As the society opens up and creates opportunities, the women are often the ones who are the risk-takers and in greatest danger of reprisals. This is what I'd like to focus on next. But finding the way to do it that feels right is very, very important, and I'm not sure I will.

Dani (1996–2003)

KL: Your book *Encounters with the Dani* uses strategies similar to the Kurdistan book, gathering archival material and embedding your own photographic work within a larger history of images, but its form and central theme are different. Where Kurdistan is a sort of compendium, a family album, the Dani book is more pointed and uses the historical material in a different way; it's about points of contact between the Dani and outsiders and how the photographic representations that come out of those encounters have impacted the Danis' attempts at self-determination and cultural preservation. Where did that project begin?

SM: I had made two trips to New Guinea, the first in 1988–89 to what was then called Irian Jaya [now West Papua]. The second trip was in 1996, just as I was finishing the Kurdistan book. Dick [Rogers] and I went with Bob Gardner, who had made the seminal ethnographic film *Dead Birds* there in 1961 [released in 1964]. During both trips, I photographed the Dani community that Gardner had described in his film, particularly the lead character, Pua, and how life had changed for the Dani in the Baliem Valley. But in 1999 or 2000, I was proposed for a commission from the Nederlands Foto Instituut in Rotterdam, and that's when the Dani project crystallized. I wanted to contextualize what I'd seen and the film that I'd known as a student, and began to wonder what kind of documentation existed. I was curious whether Bob Gardner had, in fact, been the first white man to have encountered the Dani. And I wanted to tell the story of the exposure of the Dani by the camera. I gathered the photographic and archival traces of the Dani's encounters with outsiders—ethnographers,

missionaries, Dutch colonialists—into an exhibition at the NFI. When you and I brought that material into a book to coincide with the ICP exhibition *Strangers*, my own photographs were embedded in an expanded version of that history of photographic representation and its political repercussions.

KL: In both the Kurdistan and Dani projects, there is an implied relationship between the preservation of cultural identity and the possibility of self-determination.

SM: Yes, in Kurdistan now, I'm asking some of the same questions. Will their culture survive or will the dominant Western values dictate not only the structures they're building but their future quality of life? And how will they counter it? Can people tolerate living in mud huts when they see palaces being built in the middle of nowhere with gobs of money and marble?

During the trip to West Papua in 1996, I was struck by the way the Dani were holding on to their traditions by performing them for tourists. Pua was trapped in this touristic enterprise as his only economic solution, but nonetheless he knew that this represented the demise of the culture. In Kurdistan, on the other hand, the changes are not being imposed—the Kurds are making choices about what aspects of their culture to retain or lose, to preserve in a museum or value for their own sake.

We were talking earlier about Nicaragua being crushed in the Cold War. The opposite has occurred in Kurdistan. The situation is quite different for people whose self-determination is supported rather than challenged and denied by the U.S. The Kurds are willing to play the game, and the question is, were the Sandinistas truly willing or not? I think they were, but they wanted it more their way than they could ever navigate in that construct of the Cold War. The U.S. *needs* the Kurds, which creates a different interplay. They can be power brokers in a way that the Sandinistas were not invited to be.

KL: When you entered the Kurdish story in 1991, they were a dispossessed minority. If you were just stepping into the story now, would it be as interesting to you?

SM: Certainly not in the way that it was then. What role might I take in the future is unclear, perhaps as a photographer by focusing on honor killings in some way, perhaps not. But bringing the book back is an appropriate closing of the circle, and maybe that's where my role in Kurdistan will end.

KL: One of the main themes that we've outlined in this last chapter is this idea of letting go of being the primary storyteller and creating a space for a multiplicity of stories and storytellers. Where is that leading you?

SM: I'm looking for the right metaphor to describe my role in the Dani and Kurdistan projects. I would say I am the needle threading through the stories, which is different than being the principal storyteller, but I'm still stitching them together in some fashion. A project like the web-based *akaKURDISTAN* creates a different kind of exchange that involves less control and direction on my part.

How much can I shape the space within which something else happens when I'm not part of the interaction?

If I weren't acting as witness, if I were no longer the one who threads through the stories of others, I'm not sure what my role would be. What else is there? What other kinds of dialogue can I foster or forms can I imagine? I'm certainly thinking about it.

Apart from the storytelling component of these projects, it is all about the relationships—the physicality of the process, whether in backyards in Kurdistan or over the Internet, the excitement of materials arriving in the middle of the night or living in three time frames. Being *connected* with people. That's the most compelling aspect; it's the collaborative energy that sustains me.

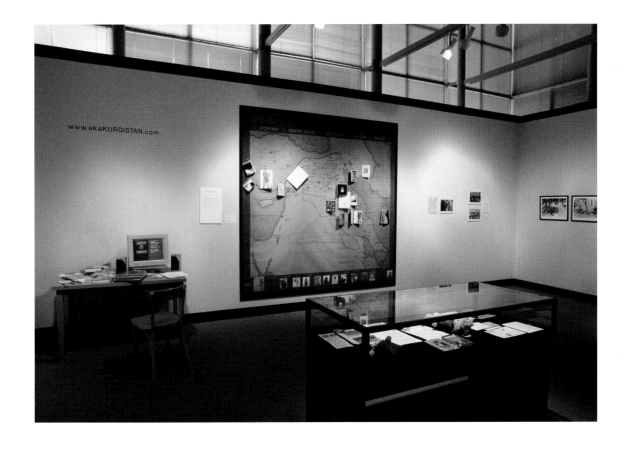

Installation view of *akaKURDISTAN* in the exhibition *Kurdistan: In the Shadow of History* at Bellevue Art Museum, Seattle, May 2000.

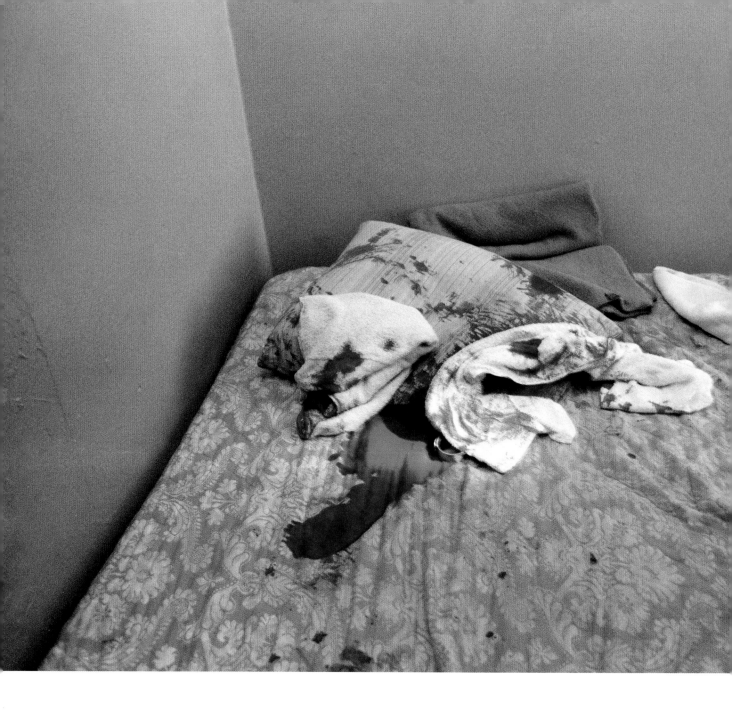

Above: *Aftermath in hotel, San Francisco*, 1991.

Right: Notes for the series *Archives of Abuse*, 1991.

Previous page: Installation view of Irma's hands for *Women's Work* poster on a bus stop, San Francisco, 1992.

36/r who knocking-pounding on doors never to have them open. no direct contact with the power str that determines whether or not I can work. nothing else seems right — hours listening to the crisis line, service workers not wanting to enter, engage w/ the lives of women in shelters knowing I will not be here long. without SFPP I have donT

That I can in fact 'document' d.v. Somewhere in the hall of justice there have to be clues — the court, the photo lab — irma's hands scarred mark my mind. I cannot forget them but I could not take any pix. the image of her hands resisting a butcher knife cutting thru to pierce her neck ...

DISTRICT ATTORNEY

ARLO SMITH
DISTRICT ATTORNEY

ROBERT M. PODESTA
CHIEF ASSISTANT
DISTRICT ATTORNEY

SAN FRANCISCO

880 BRYANT STREET, SAN FRANCISCO 94103 TEL. (415) 553-1752

April 20, 1992

Ms. Susan Meiselas
Magnum Photos
72 Spring Street
NY, NY 10012

Dear Susan,

Here are the statistics you wanted:

1. Every year it is estimated that 2.1 million married, separated, or divorced women in the U.S. are beaten by their partners. (Patrick Langar, Christopher Innes: Bureau of Justice Statistics Special Report, "Preventing Violence Against Women", Washington, D.C., U.S. D.O.J. August, 1986, p.3.).

2. F.B.I. Reports that almost 1/3 of all homicide victims in the US are killed by a husband or boyfriend (FBI, Uniform Crime Reports, 1988).

3. 22-35% of women going to hospital emergency rooms are there because of domestic violence (JAMA, August 22/29, 1990, Vol. 264, No. 8, P. 943).

4. Battering is the single most major cause of violence/injury to women, even more major than the numbers injured in muggings, rapes, or auto accidents combined (J.O'Reilly, "Wife Beating: Silent Crime" Time Magazine, September 5, 1983).

5. 95% of spouse abuse victims are women. (P. Klaus, M. Band "Family Violence" Bureau of Justice Statistics Special Reports, U.S. D.O.J., Wash. D.C., 1984, p.4).

Left: Letter from San Francisco District Attorney with domestic violence statistics, from the series *Archives of Abuse*, 1992.

Collage 1: Police report and police photograph, San Francisco, 1992, from the series *Archives of Abuse*.

INCIDENT REPORT FORM CONTINUATION SAN FRANCISCO POLICE DEPARTMENT

INCIDENT NO	REPORTING OFFICER	STAR	DATE(S) & TIME(S) OF OCCURRENCE
████████	████	██	10-21-91, 1730 - 10-22-91, 0130

NARRATIVE: SUBSEQUENT TO CLEANING UP HER RETIDENCE AFTER HER EX-HUSBAND VANDALIZED IT, ████ FOUND THE FOLLOWING WRITTEN ON HER KITCHEN FLOOR, "DON'T FUCK W/A CRAZY MAN I'LL TEACH YOU ████████████ YOU'LL BE DEAD BEFORE ANY OF THIS MATTERS. I LOVED YOU, HOW MUCH. YOU SHOULD HAVE GONE OUT W/ME BECAUSE I WANT TO DIE NOW + I'M GOING TO TAKE YOU W/ME I WON'T LET YOU BE WITH ANOTHER MAN! I'M SORRY BUT YOU HAVE TO GO TO HEAVEN W/ME."

NOTES

253

PAGE __2__ OF __2__

ICSS ENTRY BY:

SFPD 377

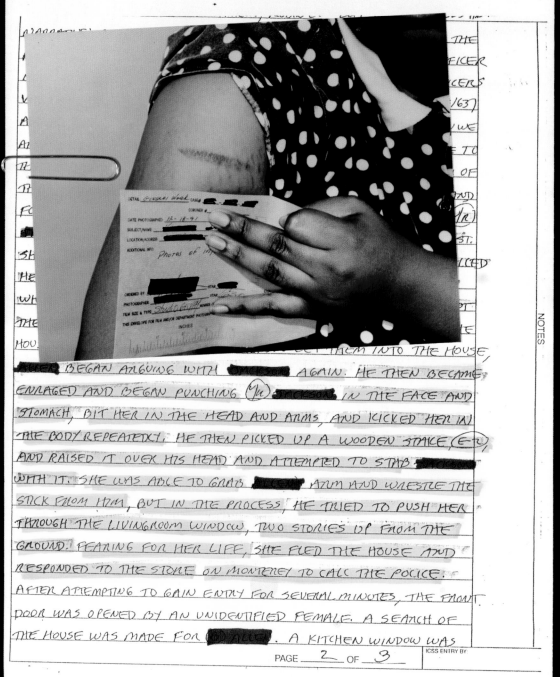

NOTES

BEGAN ARGUING WITH ████ AGAIN. HE THEN BECAME ENRAGED AND BEGAN PUNCHING (Mrs) ████ IN THE FACE AND STOMACH, BIT HER IN THE HEAD AND ARMS, AND KICKED HER IN THE BODY REPEATEDLY. HE THEN PICKED UP A WOODEN STAKE (E.V.) AND RAISED IT OVER HIS HEAD AND ATTEMPTED TO STAB ████ WITH IT. SHE WAS ABLE TO GRAB ████ ARM AND WRESTLE THE STICK FROM HIM, BUT IN THE PROCESS, HE TRIED TO PUSH HER THROUGH THE LIVINGROOM WINDOW, TWO STORIES UP FROM THE GROUND. FEARING FOR HER LIFE, SHE FLED THE HOUSE AND RESPONDED TO THE STORE ON MONTEREY TO CALL THE POLICE. AFTER ATTEMPTING TO GAIN ENTRY FOR SEVERAL MINUTES, THE FRONT DOOR WAS OPENED BY AN UNIDENTIFIED FEMALE. A SEARCH OF THE HOUSE WAS MADE FOR ████. A KITCHEN WINDOW WAS

PAGE __2__ OF __3__

ICSS ENTRY BY:

SFPD 377

Left: *Collage 2: Police report and police photograph, San Francisco,* 1992, from the series *Archives of Abuse.*

Untitled I, San Francisco, 1991.

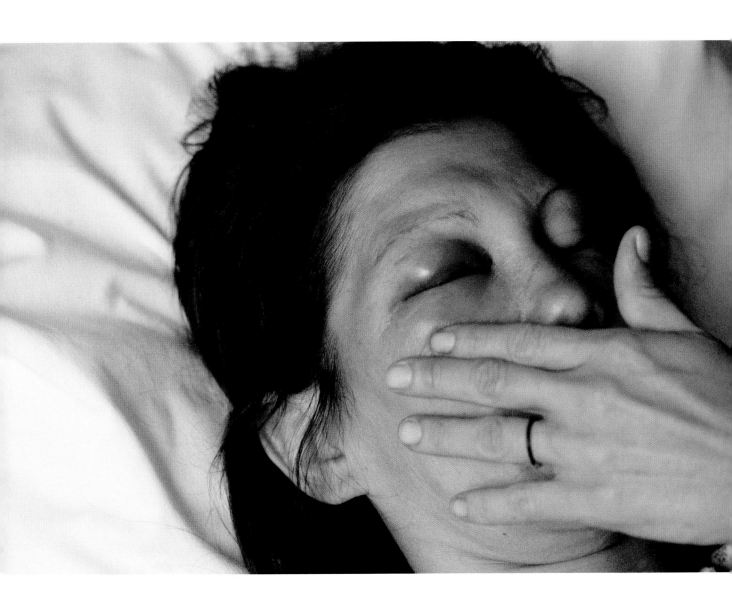

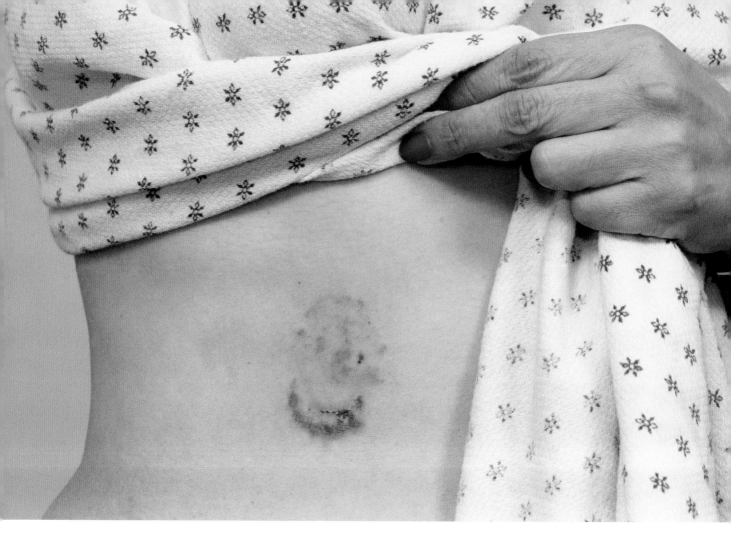

Above: *Untitled II, San Francisco*, 1991.

Right: *Collage 3: Police report and police photograph, San Francisco*, 1992, from the series *Archives of Abuse*.

INCIDENT NO	REPORTING OFFICER	STAR	DATE(S) & TIME(S) OF OCCURRENCE
███ ██ ███ ███ ███ ██	████████	███	10-30-89, 2245

███ WAS IN THE DINING AREA OF APARTMENT. █

WAS THERE ALSO. BOTH ████████ GOT INTO A

VERBAL ARGUMENT. ███ GRABBED A POT OF

BOILING WATER THAT WAS ATOP THE STOVE AND

THREW THE WATER UPON ███ CHEST. ██ THEN

LEFT THE BUILDING. ████████ HAVE BEEN

HAVING A RELATIONSHIP, BUT DO NOT LIVE TOGETHER.

██ WAS TAKEN TO ST. FRANCIS HOSPITAL BY

H 87 FOR BURNS ON THE CHEST.

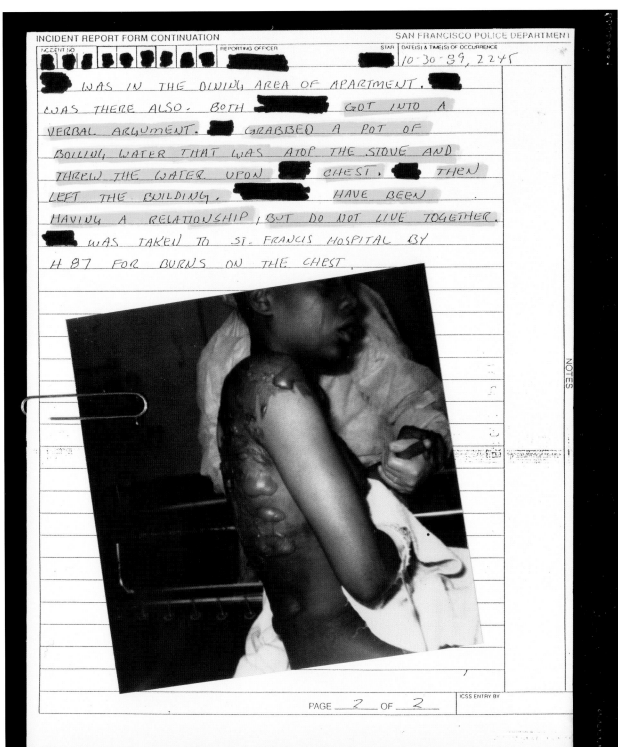

NOTES

PAGE 2 OF 2	ICSS ENTRY BY

257

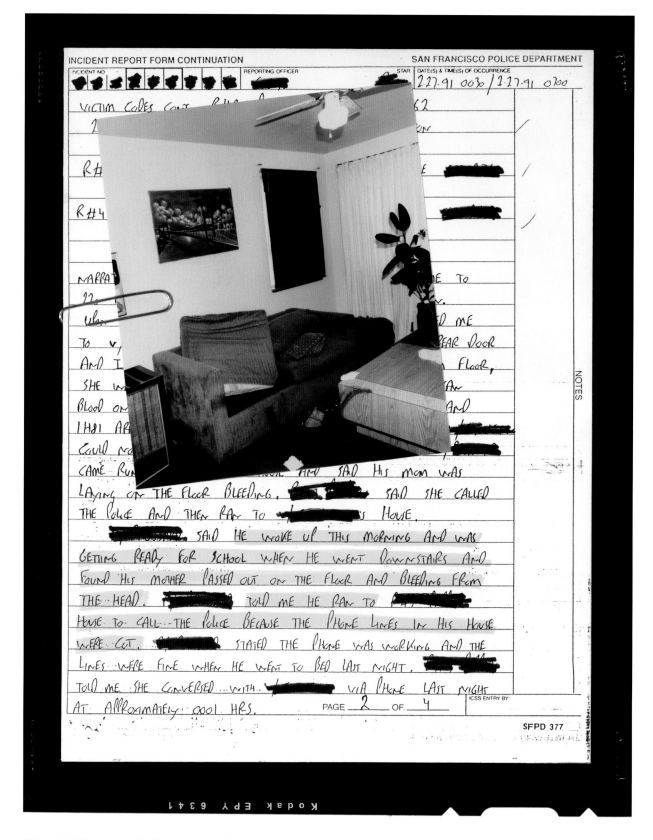

INCIDENT NO ▪▪▪▪▪▪▪▪ REPORTING OFFICER STAR DATE(S) & TIME(S) OF OCCURRENCE
 2.27.91 0030 / 2.27.91 0100

VICTIM CODES CONT ___ ___ ___ ___ 62

R# ___

R#4 ___

NARRA___

___ TO

___ ME

___ REAR DOOR

___ FLOOR,

SHE ___

BLOOD ON ___ AND

I H81 AR ___

COULD NO ___

CAME RUN ___ AND SAID HIS MOM WAS

LAYING ON THE FLOOR BLEEDING. ___ SAID SHE CALLED

THE POLICE AND THEN RAN TO ___ HOUSE.

___ SAID HE WOKE UP THIS MORNING AND WAS

GETTING READY FOR SCHOOL WHEN HE WENT DOWNSTAIRS AND

FOUND HIS MOTHER PASSED OUT ON THE FLOOR AND BLEEDING FROM

THE HEAD. ___ TOLD ME HE RAN TO ___

HOUSE TO CALL THE POLICE BECAUSE THE PHONE LINES IN HIS HOUSE

WERE CUT. ___ STATED THE PHONE WAS WORKING AND THE

LINES WERE FINE WHEN HE WENT TO BED LAST NIGHT. ___

TOLD ME SHE CONVERSED WITH ___ VIA PHONE LAST NIGHT

AT APPROXIMATELY 0001 HRS. PAGE __2__ OF __4__

NOTES

ICSS ENTRY BY:

SFPD 377

Collage 4: Police report and police photograph, San Francisco,
1992, from the series Archives of Abuse.

Right: Untitled III, San Francisco, 1991.

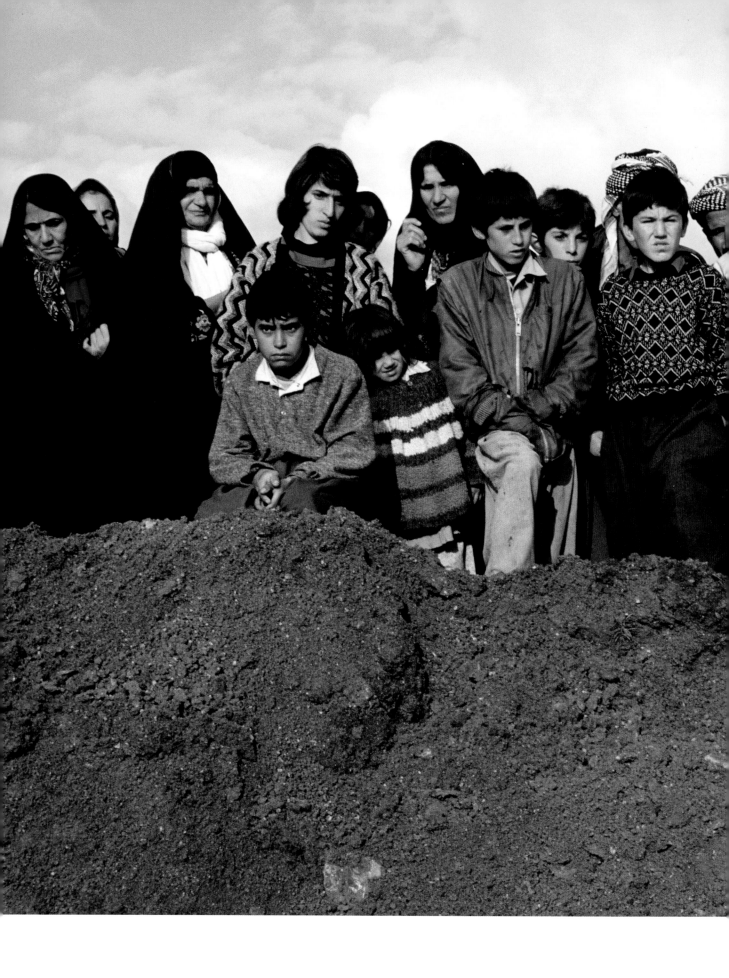

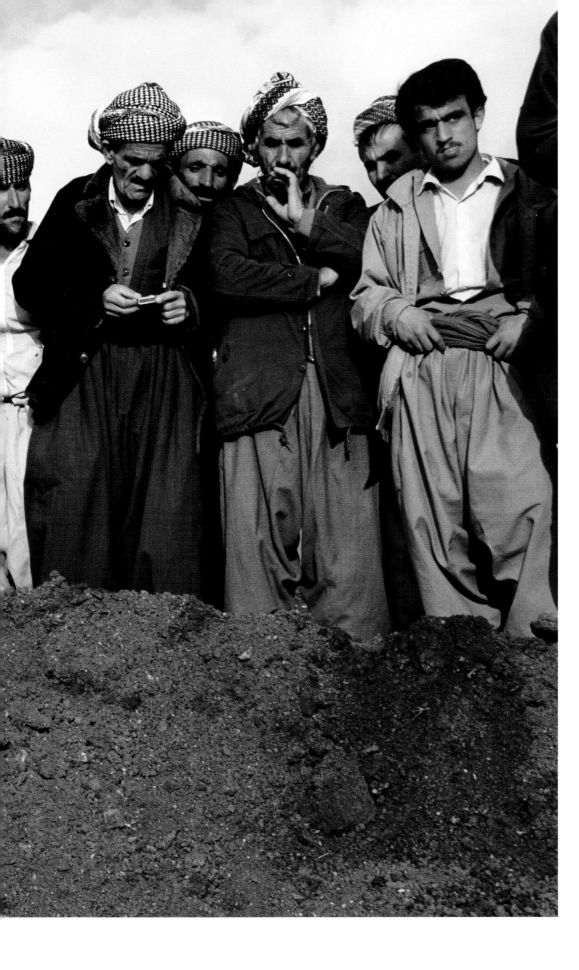

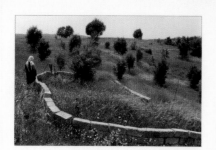

THE ANFAL CAMPAIGN IN IRAQI KURDISTAN

The Destruction of Koreme

Middle East Watch
A DIVISION OF HUMAN RIGHTS WATCH
Physicians for Human Rights

Above: *Concrete blocks mark the mass grave in Koreme, Northern Iraq, 1992, from the series* Kurdistan.

Left: Cover of *The Anfal Campaign in Iraqi Kurdistan: The Destruction of Koreme*, Middle East Watch, 1992.

Previous page: *Villagers watch exhumation at a former Iraqi military headquarters outside of Sulaymaniyah, Northern Iraq, 1991, from the series* Kurdistan.

The New York Times Magazine

JANUARY 3, 1993 / SECTION 6

IRAQ

A CASE OF GENOCIDE

ACCUSED

BY JUDITH MILLER

Cover of *New York Times Magazine*, January 3, 1993, with Meiselas's
photograph of woman with remains of her brother in Koreme mass grave.

borders uncertainty 7 mos. before Gulf War
historical ① MEW mindset secnday sorres
 ———— what we knew 88 → from afar
 Book David Korn — Zionist HR in
 Iraq

into II team A → Iran refugees
Turkey mag
Kurdish Time flight — I knew nothing, like most
infection (Iran-Iraq) destroyed village American
 war
 unable to (Mitterand) Saddam's
 held of MEW Suppression
 Uprising
 North
 &

KORDISTAN
Iran
Bastd

 collect testimony
 why had to seen
 destroyed —
 who were Kurds
 why so necessity
 to kill/exterminate

mil base
Iranian → St.
Pow's → uncertainty how long allied
 all day dig to protection last — Op Provide
 find dissappoint rely gov't — contradiction Comfort
 looking for Kurds get evidence — large claims
Tamer — buried up skeptical — doc of times
his entire village mass graves — LAm (Mn W+
survived one 1st document Kaman Mekija
mass grave KDP & PUK Peter Galbraith
+ I wied to tell contacts Aug 91
to marry

③ MEW → Clyde Snow

fall
late 91

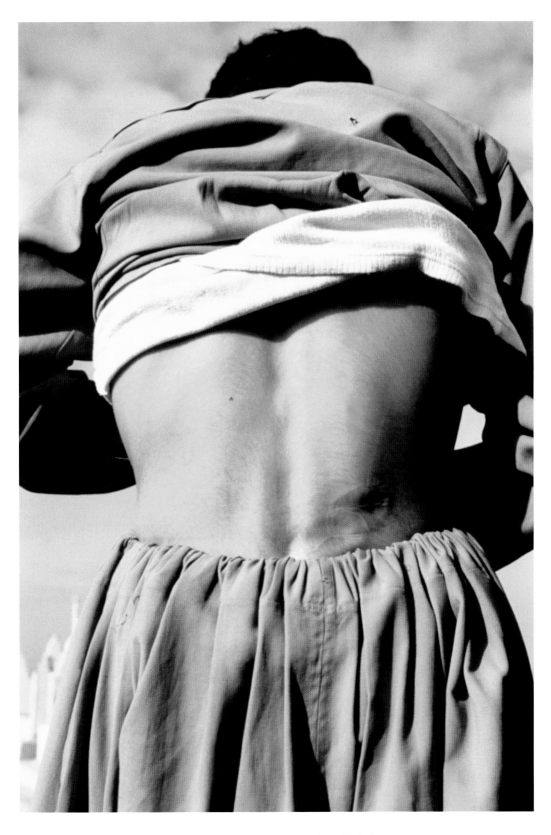

Above: *Taymour Abdullah, 15, the only survivor of village execution, shows his bullet wound, Arbil, Northern Iraq*, December 1991, from the series *Kurdistan*.

Left: Notes for the making of *Kurdistan: In the Shadow of History*, 1992.

Qala Diza, Northern Iraq, April 1991, from the series Kurdistan.

Families return to the ruins of their homes after the Iraqi army forced them to leave in 1989, Qala Diza, Northern Iraq, April 1991, from the series Kurdistan.

Kurdistan, 1991–97

Clothing unearthed in the search for identification of those buried anonymously is now left to mark the graves, Arbil cemetery, Northern Iraq, December 1991, from the series Kurdistan.

Clothing unearthed in the search for identification of those buried anonymously is now left to mark the graves, Arbil cemetery, Northern Iraq, December 1991, from the series Kurdistan.

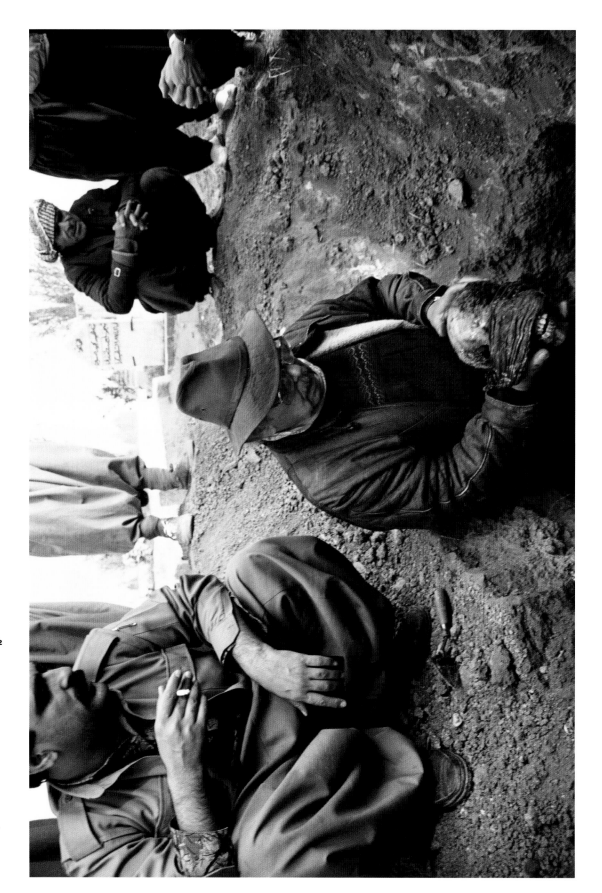

Dr. Clyde Snow, internationally known forensic anthropologist, with blindfolded skull of an executed male teenager estimated to be between 15 and 18 years old, Arbil, Northern Iraq, December 1991, from the series Kurdistan.

Widow at mass grave, Koreme, Northern Iraq, June 1992, from the series *Kurdistan.*

273

Family members wear the photographs of Peshmerga martyrs, Saiwan Hill cemetery, Arbil, Northern Iraq, December 1991, from the series Kurdistan.

Gravestone of Peshmerga martyr, Saiwan Hill cemetery, Arbil, Northern Iraq, December 1991, from the series Kurdistan.

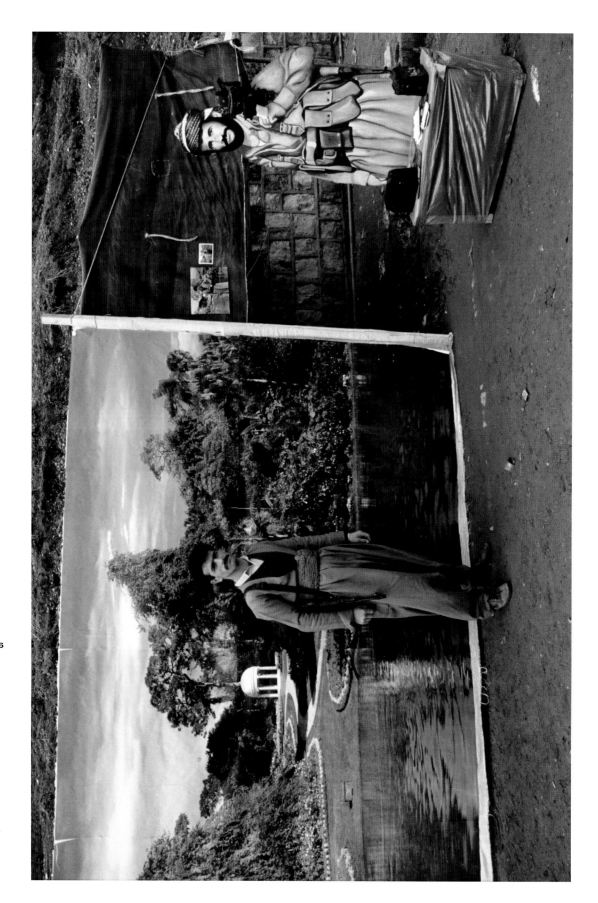

Peshmerga soldier pays to have his photograph taken on the street, Arbil, Northern Iraq, 1991, from the series Kurdistan.

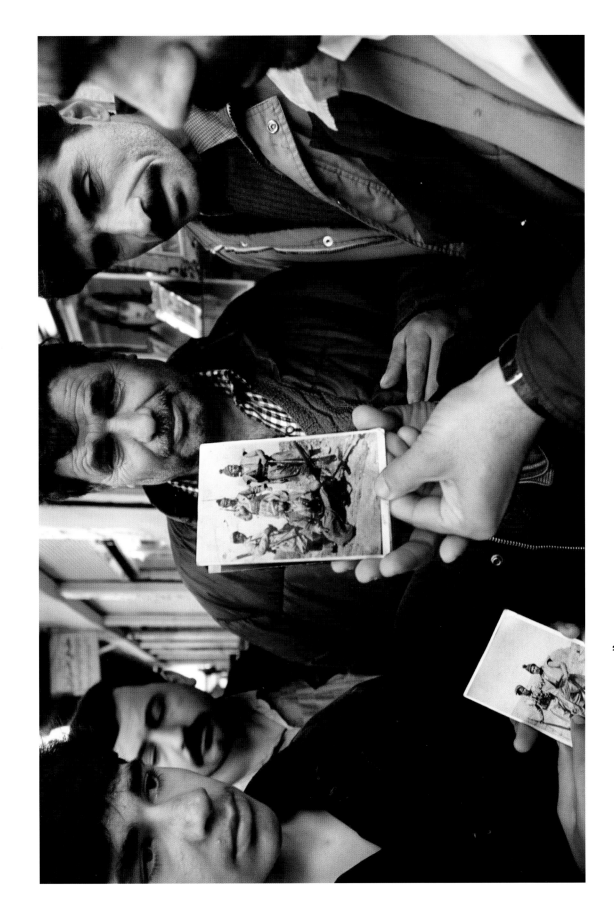

Jamal Kader Osman shows a picture he carries of himself as a Peshmerga fighter from the 1963 rebellion, Sulaymaniyah, Northern Iraq, 1991, from the series Kurdistan.

Kurdistan, 1991–97

Destroyed portrait of Saddam Hussein at military headquarters outside of Sulaymaniyah, Northern Iraq, April 1991, from the series Kurdistan.

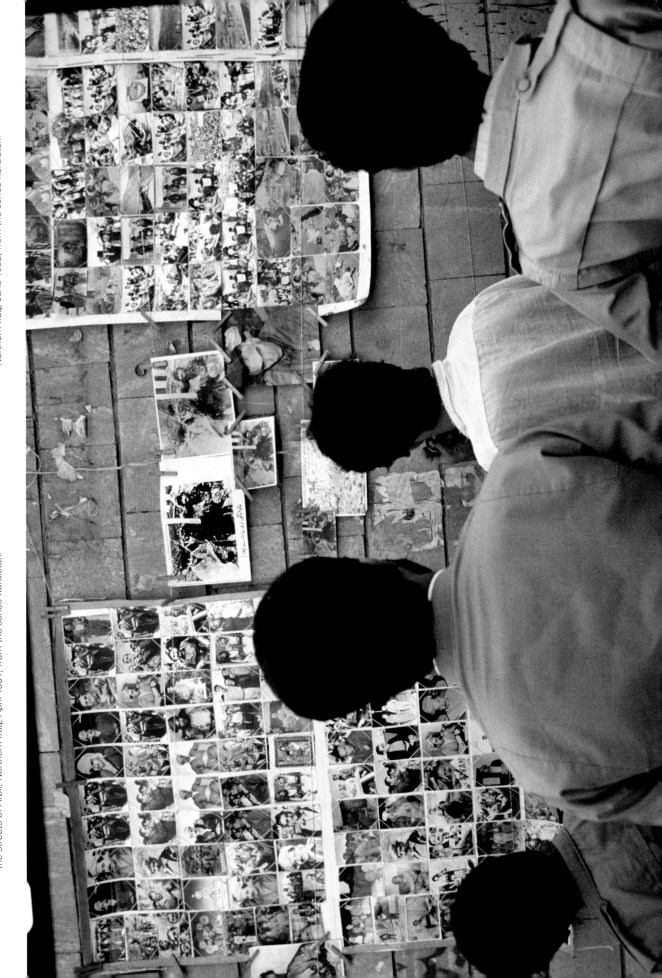

Following page: *Display window of Oskar Photo Studio, Arbil,
Northern Iraq, June 1992, from the series Kurdistan.*

*Historical photographs, including one showing the capture and execution of a Kurd, displayed on
the streets of Arbil, Northern Iraq, April 1991, from the series Kurdistan.*

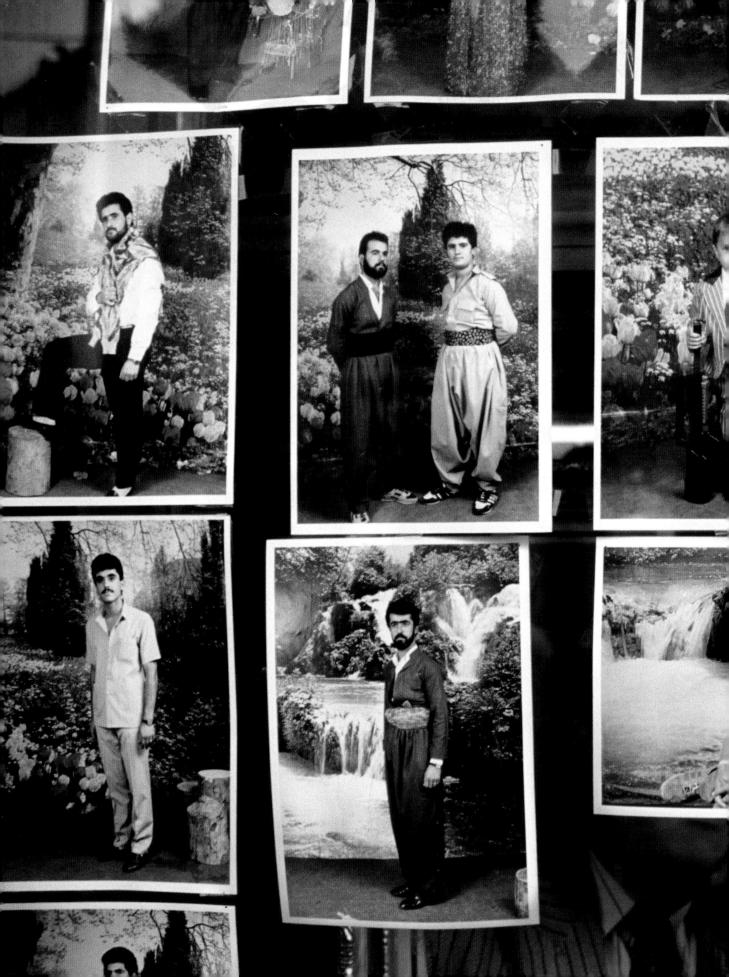

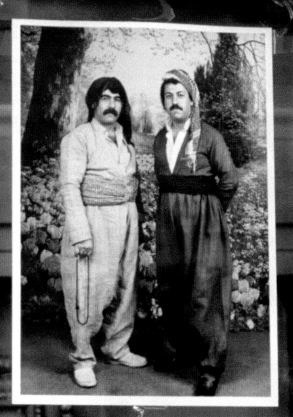

FILM

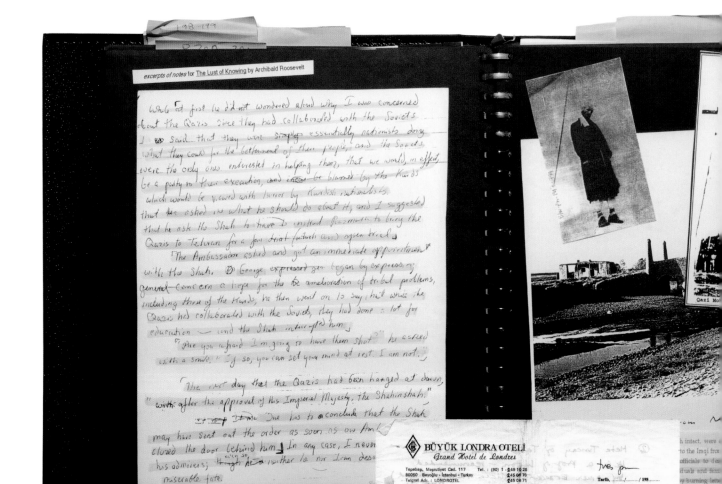

excerpts of notes for The Lust of Knowing by Archibald Roosevelt

Above: Scrapbook with preparatory research for *Kurdistan: In the Shadow of History*, 1995.

Right: Letter to Mustafa Khezry about research to be done in Turkey and Paris, ca. 1993.

Far right: Letter to assistants Meryl Levin, Laura Hubber, and Alexis Broban about the challenges facing the Kurdistan project, July 14, 1993.

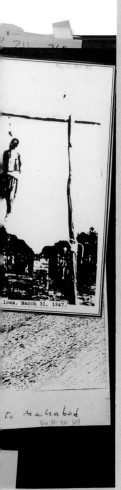

dear Meryl & Laura & Alexis

All goes well though incredibly
slowly — at times very frustrating
to work, needing a translator &
transportation & inevitably if we've
gotten a jeep there's no gasoline.
only a few hours of electricity a
day & no running water or only
some cold.

Karabagh was more fascinating
than I expected though the frontline
was very hairy — too much risk
for too little picture wise.

Meanwhile back in Yerevan
I've attempted to make progress
with Kurd research — it's not a very
popular subject here to talk about
the history of Lachin (which by the
way I did drive thru back from
Karabagh. It is completely deserted
& totally destroyed. The Armenians
do not accept that it was ever
Kurdish except when Stalin arbitrarily
gave it to them in '23.) I've
already been to the central library
& principal museum with nothing
to be found.

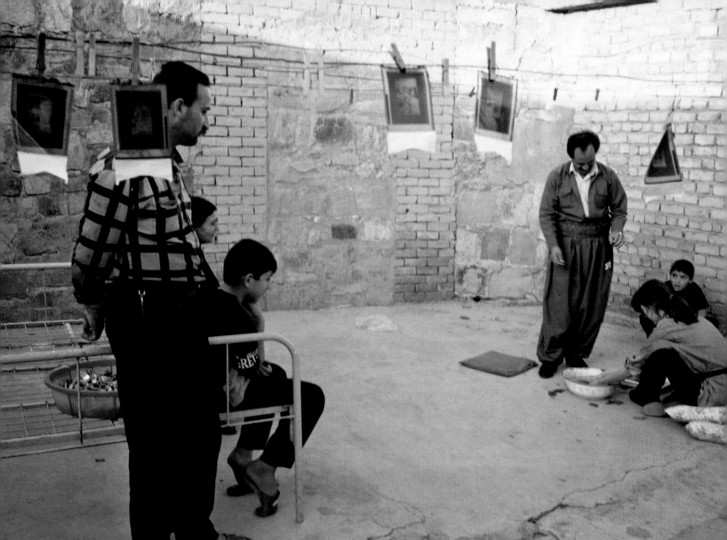

Kurdistan, 1991–97

Assistant Laura Hubber with translator As'ad Gozeh developing and processing Polaroid film, Sulaymaniyah, Northern Iraq, 1993.

Right: Meiselas researching photographs at Rafiq's studio, Sulaymaniyah, Northern Iraq, 1993. Photo: Laura Hubber.

Below: Assistant Laura Hubber developing positive/negative Polaroid film in Sulaymaniyah, Northern Iraq, 1993.

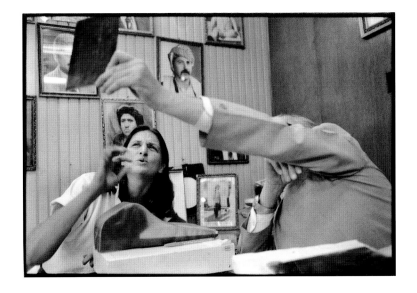

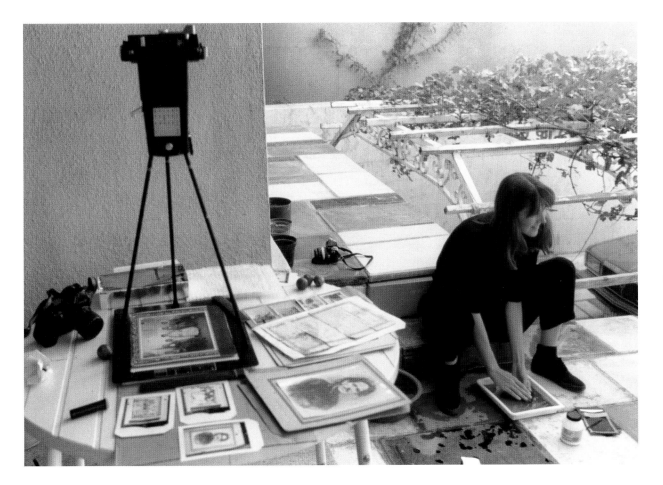

285

JONATHAN CAPE

Twenty Vauxhall Bridge Road,
London SW1V 2SA

Fax to Martin Van Bruinessem,
Holland.

31302 304235

September 24, 1996

Dear Martin,

I was in New York the week before last and was able to spend some time working with Susan on the Kurdistan book. It is making progress and there is some kind of light at the end of the tunnel. We were very pleased with the two texts you then sent to New York. They seemed to make an extremely complicated pair of historical issues seem comprehensible to the layman.

I can imagine that the nature of Susan's book is contrary to all academic practice and as such it must be strange to see it at work. Susan's role as a gatherer of evidence is even less like her role as a conventional photojournalist and much more like that of an artist. As such she is a thief. She steals these facts and reassembles them. She hopes truthfully. In fact she is making a new kind of book and in many ways it is as fragile as the objects or photographs it represents. Susan feels acute responsibility for the history she is representing but the process of assembling this history out of fragments and old images is contrary to the discipline which you have clearly practiced with such distinction. This book cannot be a history of Kurdistan, but the history it reveals should be accurate. The book hangs not on analysis but on the orchestration of the emotions as well as the mind of the reader or viewer. The book becomes visceral in its effect by the time the climax is reached. The book is important to us because it opens a door... we see the landscape and we hear the voices both of the witnessess and players as well as the victims. Your texts which we are so persistent about provide us with a grounding to steer our way though this complicated map. Like all creative products it is imprecise. Your voice cannot fill every gap in the story which Susan has missed, but it can help the reader to continue the strange fragmented narrative.

Enormous thanks for your recent texts and please can you keep going , we need the rest.

With best wishes,

Mark Holborn,

Letter from Mark Holborn, consultant to Random House, to writer
Martin van Bruinessen regarding the chapter commentaries for
Kurdistan: In the Shadow of History, September 24, 1996.

Right and following pages: Page spreads from *Kurdistan:
In the Shadow of History* (New York: Random House, 1997).

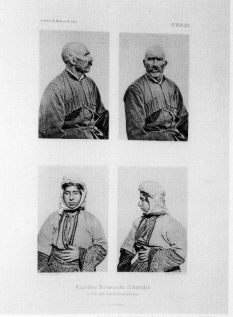

LES KURDES

Ernest Chantre
French Anthropologist
Photographs by Captain Barry,
French Photographer

The Kurdish type I established after studying 332 individuals (62 women) can be summarized as follows:

The physiognomy of the Kurds breathes savagery; their characteristics are hard, their eyes, of a fierce brightness, are small and sunken under the orb. The men are most commonly dark, tall, and lean and have uncommon strength. They wear hardly anything except for a mustache and they cover their heads with a turban that is sometimes of gigantic proportions. Their step is firm, they hold their heads up with pride, and their look has a supreme arrogance. They do not laugh or talk much.

Kurdes Bourouki d'Airidja

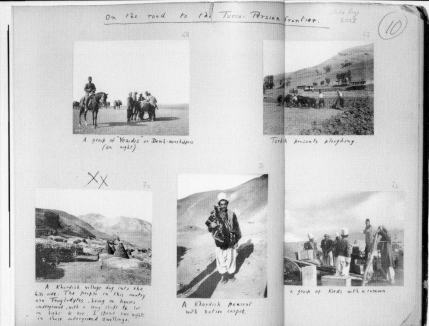

A group of Yezidis or Devil-worshippers (on right).

Turkish peasants ploughing.

A Kurdish village dug into the hill side. The people in this country are Troglodytes, living in houses underground, with a long shaft to let in light; to wit, I spent two nights in these underground dwellings.

A Kurdish peasant with native carpet

A group of Kurds with a caravan

M. Philips Price
British Journalist

After some days at Erzerum, I hired four horses with my servant and an escort of Turkish soldiers lent to me by the governor-general. I rode out of the city eastwards towards the Turco-Persian frontier.

I saw a few Khurdish nomads, the majority living in a semi-settled, semi-nomad state, indicating clearly that they were in an intermediate state preparatory to settling. All through this country the relations, not only between Mohammedan and Christian, but even between nomad and settled, were amicable. It was not till I reached the Persian frontier that the truculent attitude of the nomads became apparent. . . .

Skirting the end of the ridge which marked the frontier about nightfall, I observed an encampment of felt tents, which I knew were those of some Tartar nomads. . . At the edge of the encampment I met two Khurds who came out to see who I was. They had large black turbans, hooked noses, hanging cheeks, and an expression which suggested that they would cut anyone's throat for very little.

I explained that I was an Englishman going to Persia and that I had heard of the wonderful people called Khurds so I had come all the way to see them. This little oriental blarney worked like a charm. I was invited into the camp, and in a few minutes I was squatting cross-legged on the floor of the tent, while a few black-eyed ruffians squatted round me eyeing me like a prize bull. When once their suspicion was allayed, two of them went off to fetch a sheep to kill for me, and I settled down in comfortable quarters in the corner of this felt tent. The women, who live in a separate quarter of each tent are unveiled and have quite handsome features, brought me some of their embroidery work. Nomad shepherds of this type are chiefly monogamous. It is only the chieftains or the more wealthy flock owners who go in for polygamy. The price of a wife ranges from ten to twenty horses apiece, and appears to vary according to the price of horses. Women are not by any means oppressed however, and within the precincts of the tent their word is law. Anything to do with external policy such as the migration of the tribe, the position of the tent, the safety of the flocks is unreservedly in the men's hands. I found that the native language of these people was Khurdish, but most of them spoke Turkish which is the dialect running all through that part of the country, whether on the Turkish or the Persian side of the frontier.

During supper, I discovered that these Khurds were nothing else than professional robbers, who supplemented the produce of their flocks by occasional sheep raiding in Turkish territory, and looting caravans which entered Persia from the Black Sea. They belonged to a tribe ruled by a famous Khurdish chieftain called Simko, a notorious brigand about whom I had heard great complaints from the Turkish governors in Armenia.

The Khurdish chiefs on the Turco-Persian frontier claim the right to protect many of the Khurds now settled in the villages on the Turkish side, and also some Armenian villagers too. The consolidation of Turkish authority in the districts west of the frontier has caused these Khurdish chieftains to lose many of their retainers, and their chieftains now find amusement in distracting the Turkish authorities by periodically reviving their old claims and putting them into force by systematic raids and caravan looting. A war between nomad and settled population goes on all over the country. It is not a religious war, because the Khurds are nominally Mussulman and are more bitter against the Turkish authorities and the settled Moslem natives in Armenia than they are against the Armenians themselves.

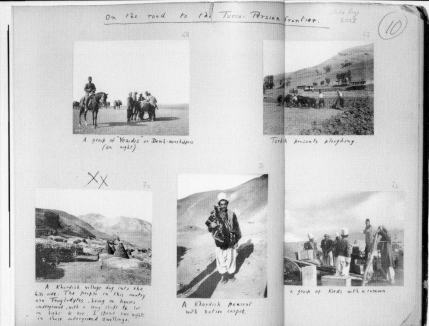

On the road to the Turco-Persian frontier.

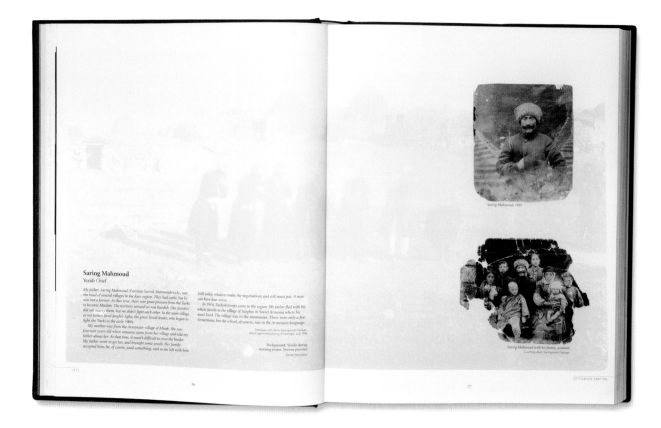

Saring Mahmoud, 1915

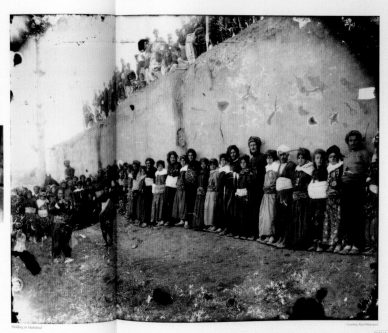

Saring Mahmoud with his family, undated
Courtesy Akim Saringovich Farizian

Saring Mahmoud
Yezidi Chief

My father, Saring Mahmoud (Farizian Sarink Mahmaudovich), was the head of several villages in the Kars region. They had cattle, but he was not a farmer. At that time, there was great pressure from the Turks to become Muslim. The territory around us was Kurdish. Our families did not marry them, but we didn't fight each other. In the same village as my father, lived Janghir Agha, the great Yezidi leader, who began to fight the Turks in the early 1900s.

My mother was from the Armenian village of Minsk. She was fourteen years old when someone came from her village and told my father about her. At that time, it wasn't difficult to cross the border. My father went to get her, and brought some jewels. Her family accepted him, he, of course, paid something, and so he left with her.

Still today, relatives make the negotiations and still must pay. A man can have four wives.

In 1914, Turkish troops came to the region. My father fled with his whole family to the village of Sarghez in Soviet Armenia where his aunt lived. The village was in the mountains. There were only a few Armenians, but the school, of course, was in the Armenian language.

Interview with Akim Saringovich Farizian,
Yezidi agronomist living in Georgia, July 1994

Background: Yezidis during
morning prayer, Yerevan province
Cerise Vannakin

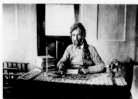

Said Husein Husni Makriyani, brother of Giw

Giw Mukriyani
Kurdish Photographer

My father worked from 1925 to 1977 as a photographer for two reasons: first, to make money to publish his newspapers—Zari Kermanji, Runaki, Hataw, etc.—and secondly, to record Kurdish cultural life and prominent Kurdish poets and writers by photographing. Most of the women in Arbil had their photographs taken in my father's shop because he was trusted. Photography was cheap, so many people visited twice a year.

In Arbil, the Revolutionary Command council decided in 1974 that all the photographs were to be gathered up and destroyed, as they were cultural products. According to this decision no cultural works were permitted in private houses. I bought an enlarger and copied all the photographs in case the originals were destroyed or decomposed when I buried them underground. Where and how I hid them is a matter I cannot tell. I beg your pardon, but it is a secret matter.

Interview with Azad Mukriyani, son of Giw Mukriyani,
living in northern Iraq, by Maslin Grahm, 1994

Sayed Husni (Husni Mukriyani) is not merely an historian, he is also the local journalist and newspaper proprietor. There is a brass notice on his door which reads, Zari Kermanji (The Cry of the Kurdish) which is the name of his paper . . . His type is set by hand. From the soft of the mountain-side he cuts small blocks of wood. He planes them smooth and true and upon them he etches the illustrations for his paper. He inks type plates, turns the primitive printing press, then sets and binds his sheets together to form the monthly magazine. A copy goes to the High Commissioner and another to the League of Nations at Geneva. The Cry of the Kurdish is called a 'monthly' magazine, but often enough the little paper is suppressed on account of its Kurdish sentiments which are not always approved of by the Government at Baghdad.

R. M. Hamilton, Road Through Kurdistan, 1937

Wedding in Mahabad

Courtesy Azad Mukriyani

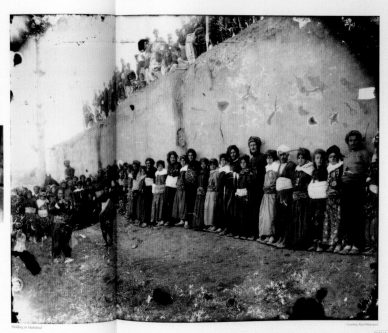

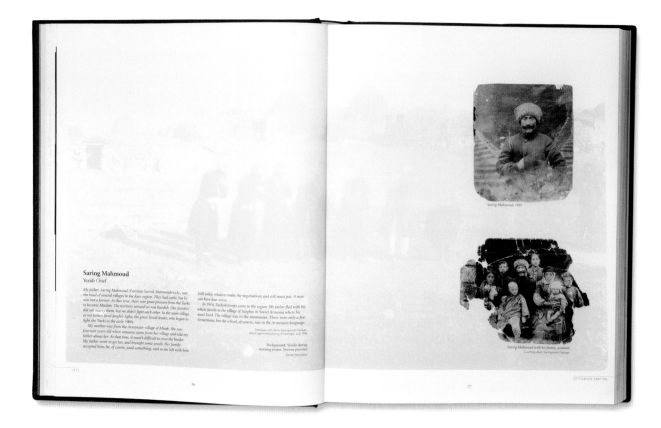

From Mr. Lindsay, British Ambassador to Turkey

Constantinople, April 22, 1925

The few remaining rebel centres appear to have been captured.

The extreme severity of the Turkish measures of repression may temporarily break the spirit of rebellion, but will probably produce a good deal of future hostility to Turkish rule on the part of the remaining Turkish Kurds, and this may eventually complicate the situation on the Irak frontier.

British Public Record Office

END OF KURDISH RISING.

SUDDEN COLLAPSE.

(FROM OUR OWN CORRESPONDENT.)

CONSTANTINOPLE, April 16.

With the capture of Sheikh Said [reported in *The Times* yesterday], together with nine other tribal chieftains and a body of 25 followers, the Kurdish rebellion is declared to have completely collapsed militarily, and no further communiqué will be issued. The Kurds, left without leaders, are submitting en masse.

Sheikh Said, who has been taken to Varto, is reported to have been found in possession of important papers referring to the revolt and of a large sum of money in gold.

Government on Sunday and a regular administration has been restored throughout the disaffected area. The reorganization of the administration was again discussed at a meeting of the Cabinet yesterday, presided over by Mustapha Kemal Pasha, and it is expected that reforms will be announced very shortly.

The sudden collapse of the rebellion is the more welcome since it was unexpected, and justifies the employment of comparatively large forces and the policy of encirclement.

The Press received this morning an order not to appear to-morrow. The reason for the suppression of the journal is unknown, and such action appears strange at this juncture, since for several weeks past nothing has been written in it of current politics.

The Times, London, April 17, 1925

From Mr. Lindsay, British Ambassador to Turkey To Mr. Austin Chamberlain, British Foreign Minister

Constantinople, June 2, 1925

I have the honour to report that the Independence Tribunals continue their activities uninterruptedly at Angora and at Diarbekir....

It is impossible to report these trials to you in any detail. Though the accounts, especially those from the Diarbekir Tribunal, take up a good deal of space in the papers, they are too obviously garbled to allow of any reliance being placed on them and too fragmentary to enable a reader to get any connected idea of what passes. Judging, however, from what is printed in the papers, one or two general impressions do stand out:

a. The papers represent Sheikh Said as an uncouth, semi-idiotic individual, worthy only of ridicule. His reported utterances are almost all those of a simple man, acting under a strong religious impulse. He had seen Islam menaced by the attitude of the Government, and, of course, it had been his duty to rise and fight.

b. The accused are brought before the court in batches, five or six at a time, even twenty or thirty. They seem almost invariably to indulge in violent recriminations against each other, each one seeking to show that he was forced to take up arms by the violence of some other, on whom alone the blame must lie. These mutual accusations must be an unedifying spectacle; they excite the hilarity of the court, and render it an easy task to find verdicts of guilty.

c. Curiously little has transpired or been allowed to transpire as to any British instigation of or participation in the Kurdish movement.... It is said that Sheikh Said hoped, after taking Diarbekir, to get into touch with the British authorities via Gezireh. This is about all the mention made of British activity reported so far in the newspaper accounts.

British Public Record Office, Kew

"The duel fist of the Republic is crushing the rebels" *Cumhuriyet, April 12, 1925*

From Strategic Services Office, Baghdad To Air Staff (Intelligence) Air Headquarters

May 22, 1925

The following report ... has been received from a well known Kurd, whose political views are decidedly patriotic and anti-Kemalist.

Causes leading up to the rebellion

The Kemalist programme ... commenced a campaign of forcibly 'tutoosing' all weaker powers within their reach and not only seizing the property of but also massacring non-moslems. Amongst those against whom this policy was directed were the Kurds.... All moral relations with the Turks having been thus utterly broken, the Kurds demanded either a national independence or special racial privileges. To secure these demands they started secretly to request the assistance of neighbouring countries through the medium of their newly formed Kurdish Society, but soon realising the hopelessness of this quest they fell back on the one hope left to them, that of revolution, which they commenced in the winter of 1924....

Turkish propaganda

In order that such Turks as were discontented with the Angora Government should not support the Kurdish movement, thousands of pamphlets and hundreds of reliable agents were despatched into the districts for the purpose of spreading the propaganda that the Kurdish insurrection was the outcome of British money, which was also being used for recruiting Armenians and Assyrians, the great enemies of Turkey, to unite with the Kurds against the Turks and so place obstacles in the way of the restoration of Mosul to its rightful owners. In addition the British with their money were aiming at creating an Assyrian and Armenian state in Eastern Anatolia in order to weaken the Turkish Republic—a fact which showed how the Kurds were being deceived by the British.

British Public Record Office, AIR 23/280/Kew

"An iron ring tightens itself around the rebels between Genç and Çapakçur" *Cumhuriyet, April 12, 1925*

Leila Bedirkhan
Kurdish Dancer

I'm not Persian ... I'm a Kurd. My grandfather was the crown prince of Kurdistan, which is on the frontier between Persia, Turkey and Syria.

But since the Turkish conquest, the independent princes in our family have become spread over a wide area. I was born in Turkey, in Constantinople. When I was very young, I left for Egypt with my mother and spent my childhood there. I only came to Europe after the war, to study in Switzerland.

I've always loved dancing. In Egypt, when I was a child, I learned it through instinct, by watching the common women dancing.

I don't learn my dances. I dance instinctively using very stylized popular themes. I also invent dances.... As you can see, they have no specific origin. I don't see my legs much when I'm dancing; I mainly see my arms and my body.

Helene Bory, "The Kurdish Princess Leila Bedirkhan Talks to Us About Her Dances and Women of the Orient," *Paris-Midi, December 18, 1932*

Dancing was just a pastime for me when I was a child, something I enjoyed doing—in the same way others learn to play the piano or to do embroidery (which I also learned to do, by the way). When, after the tragic death of my father, the Emir, I fled from my revolt-stricken country, dancing became my very reason for living, my life's aim. I traveled through Austria, Germany, and Switzerland; after some early performances in most of the large cities in these countries, I settled in Paris where, after two recitals, I decided to spend a year researching the religious rites of ancient Persia, Egyptian Mazdaism (Zoroastrism), Indian, and Oriental sacred dances.

Comœdia, December 9, 1930

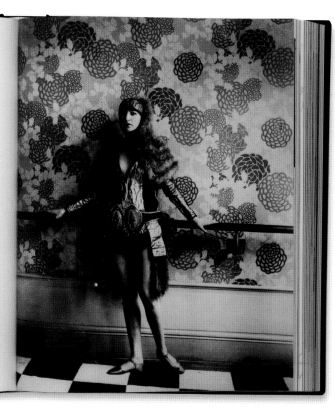

Princess Leila performing at La Scala Theater

H. Corrupt/Kurdish Institute of Paris

WATCH YOUR CREDIT...... FL 12376! "P 3 A PHOTOS" (PHOTO SHOWS PRINCESS LEILA)

KURDISTAN PRINCESS REVEALS HAREM DANCES!

PRINCESS LEILA, DAUGHTER OF THE LAST EMIR OF KURDISTAN, WHO WAS INITIATED INTO THE SACRED DANCES OF THE HAREM, IS REVEALING THEIR MYSTERIES AND IS NOW DANCING PUBLICLY IN A PARIS THEATRE. SHE RECENTLY PAID A VISIT TO LONDON. PHOTO SHOWS PRINCESS LEILA WEARING ONE OF THE DRESSES SPECIALLY MADE FOR HER BY PAUL POIRET, THE DESIGNER. (B NY 12-31-26)

1930–32

Right: "Kurdistan Princess Reveals Harem Dances"

Unknown/UPI/Corbis-Bettmann, New York

Nadir K. Nadirov
Kurdish Engineer

During the early years of Soviet rule, the state allowed the Kurdish people to experience a social, cultural, and national revival. At Lachin, the first capital of the district, the Kurdish newspaper Soviet Kurdistan appeared. In Shusha, the second capital, the district government opened a technical school, regular radio programs appeared, and children studied in their native language. Kurdish textbooks and political and artistic literature flourished as well.

Under Stalin, this progress came to a halt. In an official about-face, the very word "Kurd" was banned, a distinct Kurdish territory vanished, and the organized assimilation of Kurds accelerated. The census now listed Kurds under the category "other nationalities" as the Soviet government ceased to officially recognize this people.

Nadir K. Nadirov, "A Scattered People Seeks Its Nationhood," Cultural Survival Quarterly, Winter 1992

My father died before the [Soviet] deportation from Nakhichevan. My mother came with nine children. In 1933 they gave us a shovel and said build yourselves a home—no one even knew where we were. It was just an empty field and probably didn't have a name. There were no cars, no roads, no planes, no communication—just steppes.

One year later, they came and visited each family in the middle of the night and asked who was the head of the family. My father had already died, so my brother, Abdullah, said he was the oldest son. He was twenty-two years old and had just gotten married. I was five, and the youngest. Abdullah was taken away. My sister lived nearby and her husband was taken too. Neither of them ever returned.

Since the collapse of the Soviet Union, my sister's son has searched to find out where his father was taken. He requested information from the archive and an answer came back. He was taken to prison in 1938 and shot as an enemy of the people—an Iranian spy. He didn't even know where Iran was. He was illiterate. Though my brother disappeared that same night, my search has not turned up any information.

Interview with Nadir K. Nadirov, living in Kazakhstan, January 1996, translated by Anthony Richter

Nadirova Zarifa → директор детского сада

Nadirov Kazim доктор, декан Казахского химико технологич. инст. ←

Nadirov Azo управляющий домами ←

"*Our family still lives in the village. The special relocation caused people for decades to fight for their physical survival, so our grandfather struggled so that our family got an education. This is who we've become: (center) Karei Nadirova, grandmother and mother of the fathers of Sadik, Anvar, and Nadir Nadirov; (counterclockwise) Rashid, president 'Pharmacia,' shareholders association of northern Kazakhstan; Zarkal, teacher; Abdullah, teacher; Azim, vice president, oil shareholding company 'Shimkent Nefteorient'; Falok, mother; Nazim, head of Urological Department of Shimkent Regional Hospital; Zarifa, director of kindergarten; Kazim, Ph.D., dean of Kazakhstan's Institute of Chemistry and Technology; and Azo, housing administrator, Shimkent," 1960s.*
—Nadir K. Nadirov

Nadirov Nazim
зав. урологическим
отд. Шымкентской
областной больницы

Nadirov Falak
мама

Nadirov Azim.
вице-президент
АО „Шымкент-
нефтеоргсинтез"

Авдула
учитель
с. Заречье

Учитель
Nadirova Zarkalan

Nadirov Rashid
президент АО
Северо-казах. обл.
„Фармация"

Nadirova Kate,
бабушка, мама
их отцов Садыка и Анвара
и Надира Надиров

A Kurdish State

On August 25, 1941, the British and Russians simultaneously attacked Iran and forced Reza Shah, who had shown strong pro-German sympathies, to abdicate in favor of his son Mohammad Reza. For the rest of the war, the northern part of Iran remained occupied by Russian troops, the southern part by British, leaving a central neutral zone. Meanwhile, the Tehran government's control of this central area, which included most of Kurdistan, was considerably weakened. Tribal chieftains and big landlords, banished from the region under Reza Shah, were allowed to return to Kurdistan, where they attempted to reassert their powers. At the same time, young educated urban Kurds in Mahabad, who were in contact with Kurdish nationalists in Iraq, established an underground association, the Komalae Jiyanewey Kurd [also briefly known as Komala or JK], which was both nationalist and socially radical. The balance between the various forces was held by urban notables such as the Qazi family of Mahabad, who carefully maintained relations with both the central government and the Russians in Azerbaijan, and de facto performed many of the functions of a local government.

Developments were speeded up by the end of the war. Russia, which for some time had been reluctant to evacuate northern Iran, supported the left-wing Democratic Party of Azerbaijan when it took power in this northwestern province and established an autonomous government in December 1945. The Kurds did not need much encouragement to establish their own autonomous government. The Komala had been persuaded to accept the leadership of Qazi Mohammad, the strongest personality in Mahabad, and to merge into a broader-based mass party, the Democratic Party of Kurdistan (KDP). On January 22, 1946, Qazi Mohammad proclaimed the Republic of Kurdistan. Kurdish replaced Persian as the official language.

The Kurdish republic comprised only the northern part of Persian Kurdistan; the wider Mahabad region; the Tehran government maintained a hold on the districts further south. The army of the Republic, consisting of local tribesmen, was reinforced by several thousand

experienced fighters from Iraq, led by Mulla Mustafa Barzani and his brother Shaikh Ahmad, who took refuge in Iran in September 1945 following the suppression of their latest uprising. Mulla Mustafa had in 1943 defiantly returned to Barzan from his internal exile in Sulaimania and defeated the army sent out to capture him, until the end of the war, when a new government offensive expelled them from their strongholds. Beside the Barzanis, there were other Iraqi Kurds who crossed the border and played minor parts in the republic. These included some smaller groups of tribesmen and, more significantly, a few Kurdish officers of the Iraqi armed forces, who had earlier acted as go-betweens in negotiations between the Barzanis and the government and some of whom had been active in nationalist circles. The latter's political and military experience gave them considerable influence in Mahabad.

In April 1946, after the Soviet Union had been granted important oil concessions, Russian troops began evacuating Iran. Soviet advisors urged the Azerbaijani and Kurdish republics to negotiate a settlement with the Tehran government. While showing military muscle, Qazi Mohammad attempted to gain a degree of autonomy for the entire Kurdish region. These efforts dragged on for months but came to nothing. Meanwhile, the republic was weakened by a border conflict with Azerbaijan and by growing internal dissensions. The urban nationalists who were most strongly represented in the political leadership disliked and deeply distrusted the tribal chieftains, but the defense of the republic depended on tribal forces. Toward the end of the summer, several tribal chieftains either completely deserted or negotiated their own private settlement. When the Iranian army finally marched on Mahabad in December, it took the city without battle; Qazi Mohammad and two relatives, who had surrendered, were court-martialed and hanged. Mulla Mustafa Barzani and his forces returned to Iraq, whence they fought their way through Turkey and northern Iran to the Soviet Union, where they were to live as refugees for more than a decade. Kurdish culture, which had briefly flourished in Mahabad, was suppressed again in Iran.

— Mdl

Original photograph used for preparation of the book The Kurdish Republic of 1946, 1967
Courtesy Abbas Vali

176

PLATE XVI

4½"

26 of Azar
Dec 17, 1945
Iranian Flag replaced by Kurdish
flag at Mahabad Justice Department

The USSR has become the true fatherland of all Kurds; in the land of the Soviets, the Kurdish worker, farmer, and intellectual peacefully and joyfully accomplishes his daily task.

Basile Nikitine, quoted in Kendal Nezan, *Les Kurdes et le Kurdistan*, Paris, 1981

Yezidi dancing and singing group, District Talin, Sorik village
Unknown/Courtesy Reza Team

There were no books on the Kurds in Kurdish, but there were many in Russian. Through songs and language we knew that we were different from the Armenians. On paper there was officially no difference, but in reality there were many differences because we didn't have what the Armenians had.

With the Azerbaijanis, the Kurds were not subjected to forced assimilation. They married amongst each other, and slowly the Kurdish differences disappeared. But the Armenians were trying to assimilate us, and that pushed us to preserve our own traditions. The government saw the Kurds only as shepherds, or cleaners. The papers never made references to the intellectuals or wise Kurds. Even the Kurds were slow in doing this.

Interview with Servani Nabi, Yezidi journalist/Reza Team (December 1995)

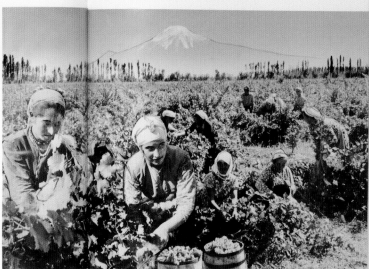

Collective farmers gather grapes. Instead of 270 tons originally planned for, they have contributed 400 tons. District Hoktemberian, Armenian village

Martin Chahbazian/Reza Team, Yerevan

One day someone called, "Come, come, come!" And we went to hear what happened. When we got there, we saw he had turned on the radio. He was listening to it very carefully. This was the first radio in the village. Many people came together. But what was happening? It was the Kurdish language on the radio! People looked at each other and said, "Oh, there is Kurdish radio! Look, they are talking Kurdish," and so on. It was Radio Yerevan.

And then people started to listen to Radio Yerevan. Because of the Turkish state's propaganda, many people didn't believe that it was possible to write and read in the Kurdish language and to use it on the radio. Even my father asked, "How is it possible to publish in Kurdish?" I showed him an article in Kurdish and read it for him. Then he believed me.

Interview with Murzad Çani, Kurdish writer living in Sweden, September 1995

225

SOVIET ARMENIA

I was born in a village called Sandur near the Turkish border. The two things that characterized this particular village were that all the people were Jewish and all of them were farmers. The thing that stood out the most was that the synagogue was in the center of the village. It was very large and built of stone, unlike the other mud-brick buildings. Most of the people were completely uneducated except those who acquired education through the synagogue itself.

The relationship between the Jews in my village and the Muslims in the neighboring villages was excellent, but there was a great change in the early 1940s. The Arabs had developed a strong relationship with the Nazis, and that had its effect on the relationship between the Jews and Muslims in Kurdistan.

Since all the people in the village were religious, when it was announced that the state of Israel was established, there was an almost spontaneous decision by all of the people in the village to leave. That's why the village was emptied of all its inhabitants.

We were taken by truck to Baghdad. Before allowing us to get on the planes, the Iraqi authorities checked our clothing on our backs. We lived in refugee camps, and as the years passed, we dispersed to different places throughout Israel.

To go from an Eastern country with a primitive society to one that was more westernized was a tremendous cultural change. We had to go through a change of a thousand years in two or three years.

Interview with Haviva Tamar, Kurdish Jew living in Israel, May 1994.

Passport of Haviva Zaken, born in 1922 in Zakho, northern Iraq. Courtesy Miri Zaken.

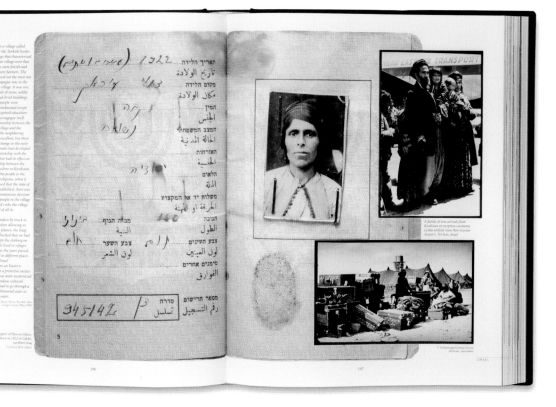

A family of new arrivals from Kurdistan at reception ceremony, Lydda airfield (now Ben-Gurion Airport), Tel Aviv, Israel.

F. Schlesinger/Central Zionist Archives, Jerusalem.

196 | 197

1951 | ISRAEL

Letter from Adela Khanum Taimur in 1920 / Lynette Soane.

Dearest,

The political officers and myself are at present living in the Khanum's house, and having a pretty good time. The Lady herself is about sixty-five years of age. But she does her hair and paints and powders her face, and on the whole, tries to play the giddy young thing. However she must be very strong willed, because her tribe (before the coming of the British) were nothing but highway robbers, and yet she had 'em in the palm of her hand to do just what she liked with—some woman!

Within a radius of say, a hundred miles each way, the political and myself are absolutely the only two Englishmen to be found. The population is Kurdish, and they have no written language, so we have to rely on what we can pick up.... We live just absolutely the same as the Kurds (they live extraordinarily well by the way) and rather like it.

The job is no sinecure as the population is almost wholly nomad (like me) and it is no easy thing to keep them in order and make them pay their taxes and things. We have a force of gendarmerie recruited from amongst the tribes to keep law and order, and very stout fellows the gendarmerie are (set a thief to catch a thief is British Policy).

Letter from Percival Richards to his wife, December 29, 1919. Courtesy Richard Hesketh.

Dear respected and faithful friend,

You left and broke both our circle and our heart. Only God knows how much sorrow has come into my heart because of the departure of you dear; especially so, because I did not know how far you've gotten. When your letter arrived from Bombay, how happy I became. May you be happy because you made our day. You had kindly asked along one. Fortunately, there is no grief except for the sorrow of you being away. I hope that soon in utmost health and joy you will return to your country, see your friends and be gratified. God willing, hasten your return so that I may once more be happy seeing you. Let me know how you are. Waiting to hear from you, dear.

Wife of Othman Pasha.

Adela Khanum (Lynette Soane is seated to her left) surrounded by her family, 1920.

Courtesy Richard Hesketh.

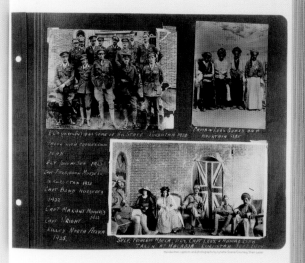

Handwritten captions and photographs by Lynette Soane. Courtesy Shari Laskin.

Major Soane came as an Oriental and stayed in the area. He had contacts with a lot of the tribal heads in the area, such as the Jaf and the Pishdar. At that time, it was not Iraq but Mesopotamia. There were three vilayets—Basra, Baghdad, and Mosul, the Kurdish vilayet. Shaikh Mahmud rose up for the rights of the Kurds, but international policy did not allow for this at the time, and the British brought Major Soane back. Major Soane was a political adviser to Shaikh Mahmud, but secretly he was contacting the heads of the tribes in Kurdistan and organizing them against him.

The day Major Soane came back, Shaikh Mahmud went to receive him. From the moment they met, Shaikh Mahmud realized, from the way Soane shook his hand, that he was coming to demolish Shaikh Mahmud's government.

The division of Kurdistan didn't start then. It started when Sykes and Picot sat at the table and divided the country in 1916. The British planned through the Orientalists how to create problems if anything endangered the decision they had decided on.

Interview with Shaikh Taha Wahbi, Shaikh Mahmud's grandson, living in Iraq, May 1993.

76 | 77

1919–23 | MESOPOTAMIA

293

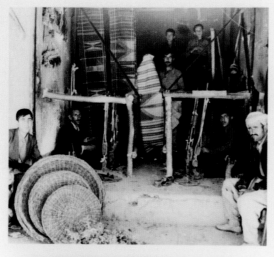

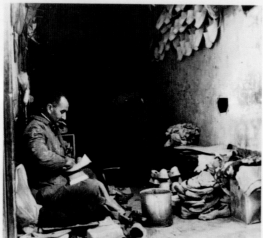

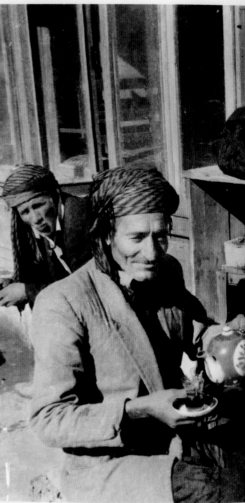

The streets of Sulaimania

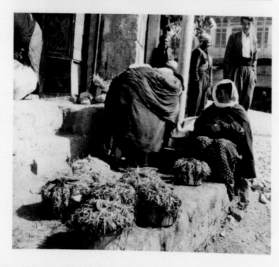

Rafiq

Each one of us [photographers] worked alone and kept our secrets to ourselves. Nobody was allowed to contact people here. I didn't meet any journalists or photographers. Maybe they came and were with the leaders, but nobody came to me to exchange ideas about photography. —*Rafiq*

Installation view of *Kurdistan: In the Shadow of History* at Bellevue
Art Museum, Seattle, May 2000 (left) and Nederlands Foto Instituut,
Rotterdam, December 1998 (right).

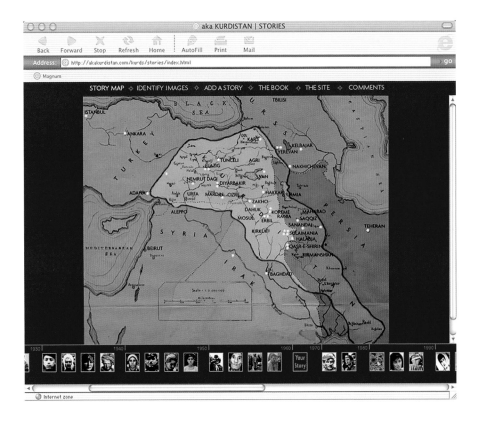

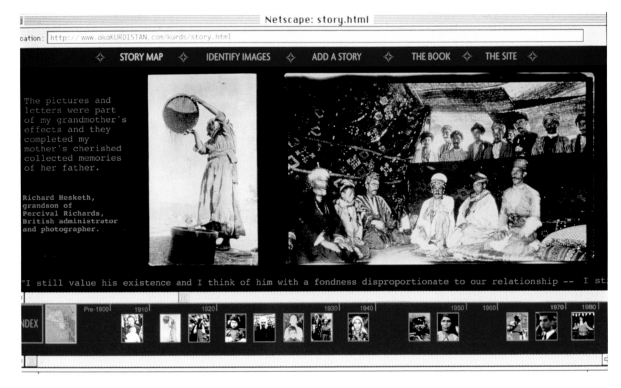

Top: Screenshot of the online project *akaKURDISTAN* showing a map of Kurdistan, 1998.
Bottom: Screenshot of contribution from Richard Hesketh, UK, on the *akaKURDISTAN* website, 1998.

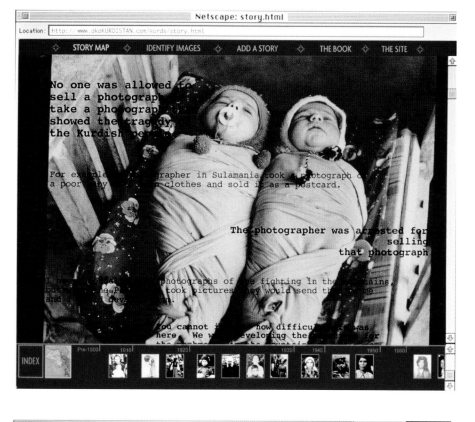

Top: Screenshot of contribution from Jabar Abdul Karim, Northern Iraq, on the *akaKURDISTAN* website, 1998.
Bottom: Screenshot of the online project *akaKURDISTAN* hacked by "Turkey Nation," November 2007.

Above: *Monument honoring Kurelu, one of the most powerful Dani tribe leaders of the Baliem Valley, Wamena, West Papua,** August 1996.

Previous page: *Members of the Dani tribe pose for a tourist during a reenactment of tribal wars, Baliem Valley, West Papua,* August 1996.

*West Papua was called Netherlands New Guinea when Robert Gardner filmed the Dani in 1961; by the time he returned in 1988–89, the name had changed to Irian Jaya. The name West Papua was officially adopted in 2007.

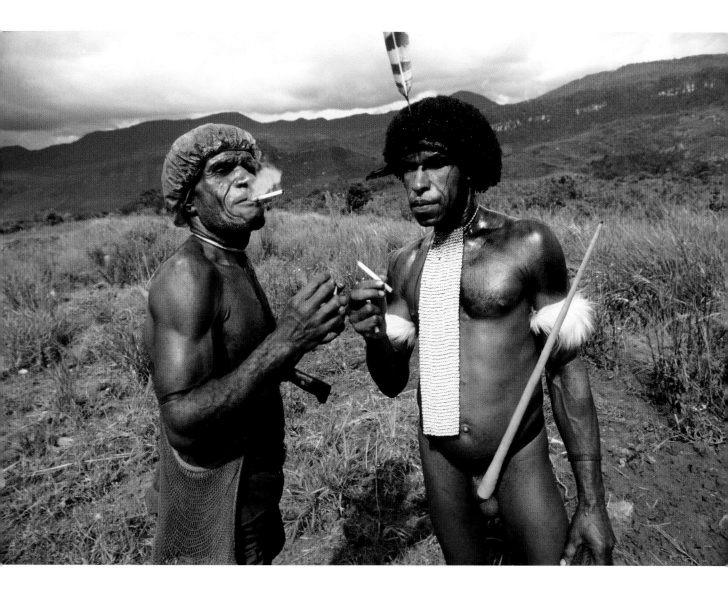

Dani tribesmen sharing a smoke near their village, Yibika, Baliem Valley, West Papua, January 1989.

BIOLOGICAL EXPLORATIONS

THE AMERICAN MUSEUM OF NATURAL HISTORY

CENTRAL PARK WEST AT 79TH STREET

NEW YORK, N.Y.

1938 NEW GUINEA EXPEDITION
RICHARD ARCHBOLD, LEADER
A. L. RAND, ORNITHOLOGIST AND ASSISTANT LEADER
WM. B. RICHARDSON, MAMMALOGIST
L. J. BRASS, BOTANIST
RUSSELL R. ROGERS, PILOT
GERALD D. BROWN, FLIGHT ENGINEER
RAYMOND E. BOOTH, RADIO OPERATOR
HAROLD G. RAMM, RADIO OPERATOR

FIELD HEADQUARTERS:
HOLLANDIA,
NETHERLANDS NEW GUINEA

August 6th 1938

Lieut Van Arcken

We delivered food to Capt Terrink today he is in the Grand Valley about half way to your meeting place. IX Please answer by signal if you want food now or on the 9th. If you wnat food on the 9th give the signal four five if not till the 12th give the signal 12 . We find the lake is to xxxl small unless trees are cut from both ends

Richard Archbold

Archbold.

SCENE OF NEW GUINEA EXPEDITION
The party led by Richard Archbold of the American Museum of Natural History plans to spend two years in a study of mammals, birds and plants in the unexplored mountainous region indicated on the map. Mr. Archbold and five companions in their seaplane alighted on and took off from Lake Habbema, 11,000 feet up in the heart of the unexplored area.

In 1938, the wealthy American explorer Richard Archbold led an expedition into the unmapped highlands of Netherlands New Guinea for the American Museum of Natural History, searching for new varieties of flora and fauna. Archbold's plane, a customized U.S. Navy model, could land on and take off from water, allowing him to explore areas earlier explorers could not reach. On June 23, 1938, while surveying the highlands from his plane, Archbold spotted the fertile, cultivated valley where the Dani live, which he called the "Grand Valley." As far as historians can tell, he was the first non-Papuan to see it; certainly he was the first to document his "discovery."

Archbold Expedition (1938)

Encounters with the Dani, 1996-2003

A porter carries 40 lbs. of food and if he goes inland
26 days he has eaten it all and arrives at his destination with
nothing. If only half of the porters carry food and the rest
equipment, the party can go only 13 days before all of the
food is gone, leaving nothing for the return trip to the coast.
Five or six days, therefore, is the limit which can be worked
without using successive relays of boys, the inland relays
being proportionately smaller as the food stores are
reduced: a costly and unsatisfactory system at its best
and the biggest factor in keeping New Guinea a primitive,
unknown land. With new methods of transport: the airplane,
parachute and radio, all the fastnesses of New Guinea will
soon be explored by white men looking for gold as well as
for birds and mammals.

—Richard Archbold, American explorer, and A.L. Rand, Canadian ornithologist, "With Plane and Radio
in Stone Age New Guinea," *Natural History*, 1937.

This and following pages: Page spreads from *Encounters with the Dani* (New York and
Göttingen: International Center of Photography and Steidl, 2003).

The Dani, the native inhabitants of the Grand Valley for at least 8,000 years, had never before encountered people from beyond the surrounding highlands. The first contact between Van Arcken's patrol and the Dani took place on August 4, 1938. This photograph accompanied an article Archbold published in National Geographic called "Unknown New Guinea." Its caption reads: "To natives [...] was a show. One proudly wore the top of a fruit can as a head ornament. The day's labor in the gardens ended, the leisure occupied by the nine visitors became the neighborhood gathering place."

Encounters with the Dani, 1996–2003

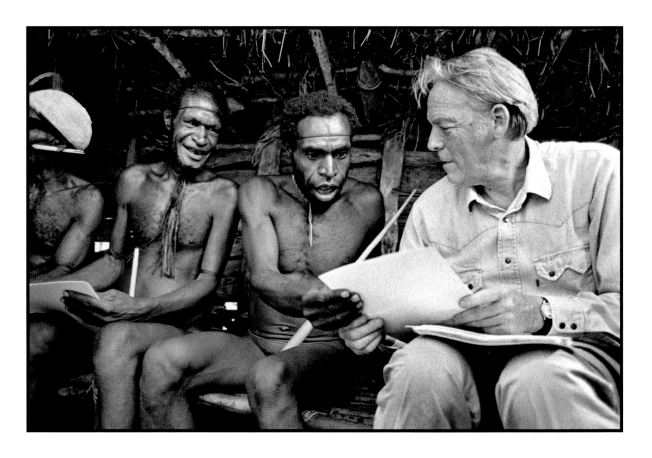

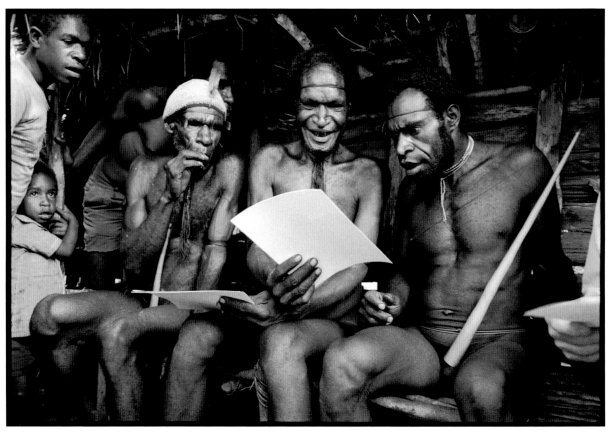

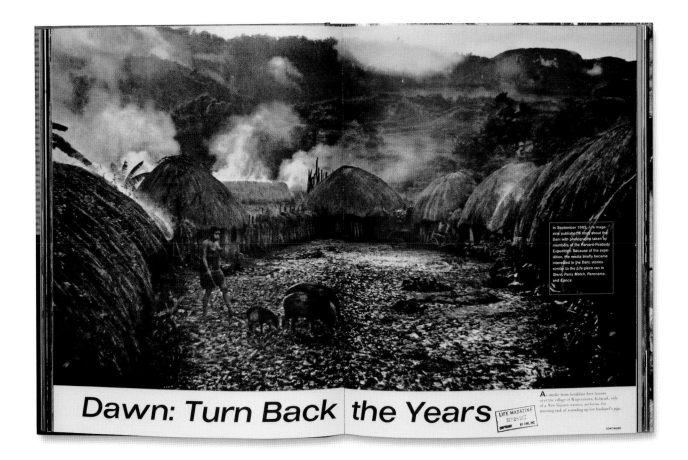

In September 1962, *Life* magazine published a story about the Dani with photographs taken by members of the Harvard-Peabody Expedition. Because of the expedition, the media briefly became interested in the Dani; stories similar to the *Life* piece ran in *Stern, Paris Match, Panorama,* and *Epoca.*

Dawn: Turn Back the Years

LIFE MAGAZINE
SEP 28 1962
COPYRIGHT BY TIME, INC.

As smoke from breakfast fires hovers over the village of Wuperainma, Kolwali, wife of a New Guinea warrior, performs the morning task of rounding up her husband's pigs.

CONTINUED

Above and following page: Page spreads from *Encounters with the Dani* (New York and Göttingen: International Center of Photography and Steidl, 2003).

Left, top: *Members of the Dani tribe with Robert Gardner, American filmmaker, director of* Dead Birds, *who returned to Irian Jaya 30 years after making his film about the Dani tribe, Baliem Valley, West Papua,* 1989.

Left, bottom: *Pua, on the right, with members of the Dani tribe, look at Robert Gardner's photographs taken of them in 1961, Baliem Valley, West Papua,* 1989.

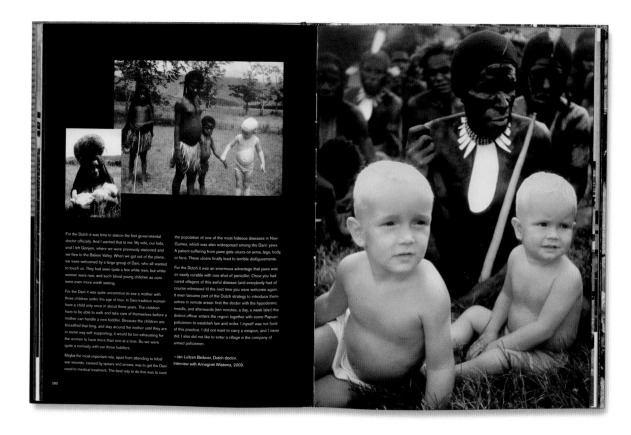

For the Dutch it was time to station the first governmental doctor officially. And I wanted that to me. My wife, our kids, and I left Genjem, where we were previously stationed and we flew to the Baliem Valley. When we got out of the plane, we were welcomed by a large group of Dani, who all wanted to touch us. They had seen quite a few white men, but white women were rare, and such blond young children as ours were even more worth seeing.

For the Dani it was quite uncommon to see a mother with three children under the age of four. In Dani tradition women have a child only once in about three years. The children have to be able to walk and take care of themselves before a mother can handle a new toddler. Because the children are breastfed that long, and stay around the mother until they are in some way self-supporting, it would be too exhausting for the women to have more than one at a time. So we were quite a curiosity with our three toddlers.

Maybe the most important role, apart from attending to tribal war wounds, caused by spears and arrows, was to get the Dani used to medical treatment. The best way to do this was to cure

the population of one of the most hideous diseases in New Guinea, which was also widespread among the Dani: yaws. A patient suffering from yaws gets ulcers on arms, legs, body, or face. These ulcers finally lead to terrible disfigurements.

For the Dutch it was an enormous advantage that yaws was so easily curable with one shot of penicillin. Once you had cured villagers of this awful disease (and everybody had of course witnessed it) the next time you were welcome again. It even became part of the Dutch strategy to introduce themselves in remote areas: first the doctor with the hypodermic needle, and afterwards (ten minutes, a day, a week later) the district officer enters the region together with some Papuan policemen to establish law and order. I myself was not fond of this practice. I did not want to carry a weapon, and I never did. I also did not like to enter a village in the company of armed policemen.

—Jan Luitzen Beiboer, Dutch doctor.
Interview with Annegriet Wietsma, 2003.

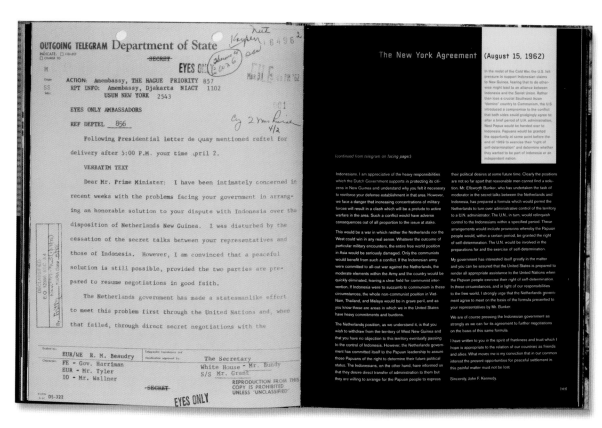

OUTGOING TELEGRAM Department of State

SECRET

EYES ONLY

ACTION: Amembassy, THE HAGUE PRIORITY 857
RPT INFO: Amembassy, Djakarta NIACT 1102
USUN NEW YORK 2543

EYES ONLY AMBASSADORS

REF DEPTEL 856

Following Presidential letter de Quay mentioned reftel for delivery after 5:00 P.M. your time April 2.

VERBATIM TEXT

Dear Mr. Prime Minister: I have been intimately concerned in recent weeks with the problems facing your government in arranging an honorable solution to your dispute with Indonesia over the disposition of Netherlands New Guinea. I was disturbed by the cessation of the secret talks between your representatives and those of Indonesia. However, I am convinced that a peaceful solution is still possible, provided the two parties are prepared to resume negotiations in good faith.

The Netherlands government has made a statesmanlike effort to meet this problem first through the United Nations and, when that failed, through direct secret negotiations with the

Drafted by: EUR/WE R. M. Beaudry
Clearances: FE - Gov. Harriman
EUR - Mr. Tyler
IO - Mr. Wallner

The Secretary
White House - Mr. Bundy
S/S Mr. Grant

SECRET

EYES ONLY

REPRODUCTION FROM THIS COPY IS PROHIBITED UNLESS "UNCLASSIFIED"

DS-322

The New York Agreement (August 15, 1962)

In the midst of the Cold War, the U.S. felt pressure to support Indonesian claims to New Guinea, fearing that to do otherwise might lead to an alliance between Indonesia and the Soviet Union. Rather than lose a crucial Southeast Asian "domino" country to Communism, the U.S. introduced a compromise to the conflict that both sides could grudgingly agree to: after a brief period of U.N. administration, West Papua would be handed over to Indonesia. Papuans would be granted the opportunity at some point before the end of 1969 to exercise their "right of self-determination" and determine whether they wanted to be part of Indonesia or an independent nation.

(continued from telegram on facing page:)

Indonesians. I am appreciative of the heavy responsibilities which the Dutch Government supports in protecting its citizens in New Guinea and understand why you felt it necessary to reinforce your defense establishment in that area. However, we face a danger that increasing concentrations of military forces will result in a clash which will be a prelude to active warfare in the area. Such a conflict would have adverse consequences out of all proportion to the issue at stake.

This would be a war in which neither the Netherlands nor the West could win in any real sense. Whatever the outcome of particular military encounters, the entire free world position in Asia would be seriously damaged. Only the communists would benefit from such a conflict. If the Indonesian army were committed to all-out war against the Netherlands, the moderate elements within the Army and the country would be quickly eliminated, leaving a clear field for communist intervention. If Indonesia were to succumb to communism in these circumstances, the whole non-communist position in Viet-Nam, Thailand, and Malaya would be in grave peril, and as you know these are areas in which we in the United States have heavy commitments and burdens.

The Netherlands position, as we understand it, is that you wish to withdraw from the territory of West New Guinea and that you have no objection to this territory eventually passing to the control of Indonesia. However, the Netherlands government has committed itself to the Papuan leadership to assure those Papuans of the right to determine their future political status. The Indonesians, on the other hand, have informed us that they desire direct transfer of administration to them but they are willing to arrange for the Papuan people to express

their political desires at some future time. Clearly the positions are not so far apart that reasonable men cannot find a solution. Mr. Ellsworth Bunker, who has undertaken the task of moderator in the secret talks between the Netherlands and Indonesia, has prepared a formula which would permit the Netherlands to turn over administrative control of the territory to a U.N. administrator. The U.N., in turn, would relinquish control to the Indonesians within a specified period. These arrangements would include provisions whereby the Papuan people would, within a certain period, be granted the right of self-determination. The U.N. would be involved in the preparations for and the exercise of self-determination.

My government has interested itself greatly in the matter and you can be assured that the United States is prepared to render all appropriate assistance to the United Nations when the Papuan people exercise their right of self-determination. In these circumstances, and in light of our responsibilities to the free world, I strongly urge that the Netherlands government agree to meet on the basis of the formula presented to your representatives by Mr. Bunker.

We are of course pressing the Indonesian government as strongly as we can for its agreement to further negotiations on the basis of this same formula.

I have written to you in the spirit of frankness and trust which I hope is appropriate to the relation of our countries as friends and allies. What moves me is my conviction that our common interest the present opportunities for peaceful settlement in this painful matter must not be lost.

Sincerely, John F. Kennedy.

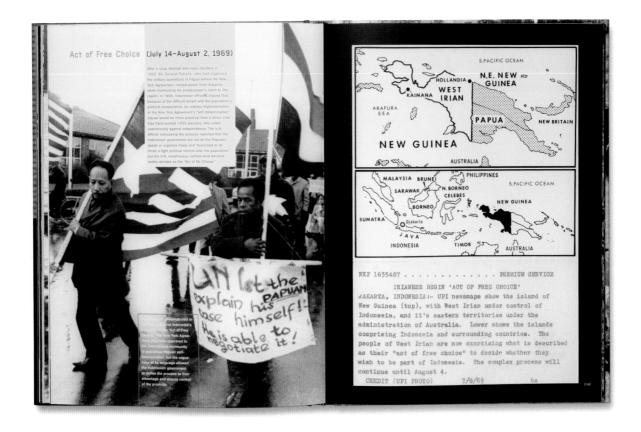

Act of Free Choice (July 14–August 2, 1969)

After a coup attempt and mass murders in 1965–66, General Suharto – who had organized the military operations in Papua before the New York Agreement—seized power from Sukarno, while maintaining his predecessor's claim to the region. In 1969, Indonesian officials argued that, because of the difficult terrain and the population's political inexperience, an indirect implementation of the New York Agreement's "self-determination" clause would be more practical than a direct vote: they hand-picked 1,025 electors, who voted unanimously against independence. The U.N. official overseeing the process reported that the Indonesian government did not let the Papuans speak or organize freely and "exercised at all times a tight political control over the population," but the U.N. nonetheless ratified what became widely derided as the "Act of No Choice."

[panel text, lower left, partly obscured]
...demonstrated in the United States against Indonesia's 'Act of Free Choice.' The New York Agreement may have appeared to the international community to guarantee Papuan self-determination, but the vagueness of its language allowed the Indonesian government to define the process to their advantage and ensure control of the province.

UN let the PAPUAN explain his case himself!! He is able to negotiate it!

NXP 1635487 PREMIUM SERVICE
 IRIANESE BEGIN 'ACT OF FREE CHOICE'
JAKARTA, INDONESIA:- UPI newsmaps show the island of
New Guinea (top), with West Irian under control of
Indonesia, and it's eastern territories under the
administration of Australia. Lower shows the islands
comprising Indonesia and surrounding countries. The
people of West Irian are now exercising what is described
as their "act of free choice" to decide whether they
wish to be part of Indonesia. The complex process will
continue until August 4.
 CREDIT (UPI PHOTO) 7/8/69 bs [mb]

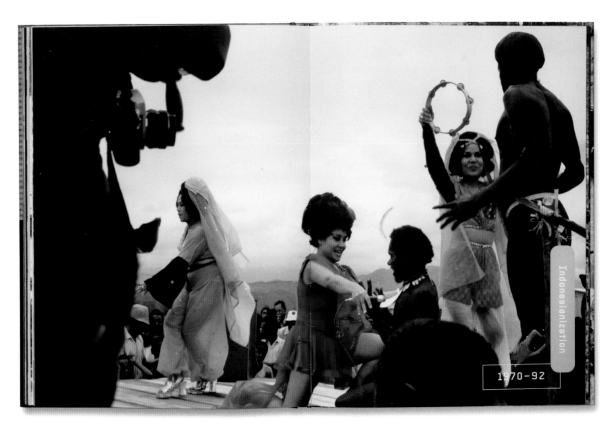

Indonesianization

1970–92

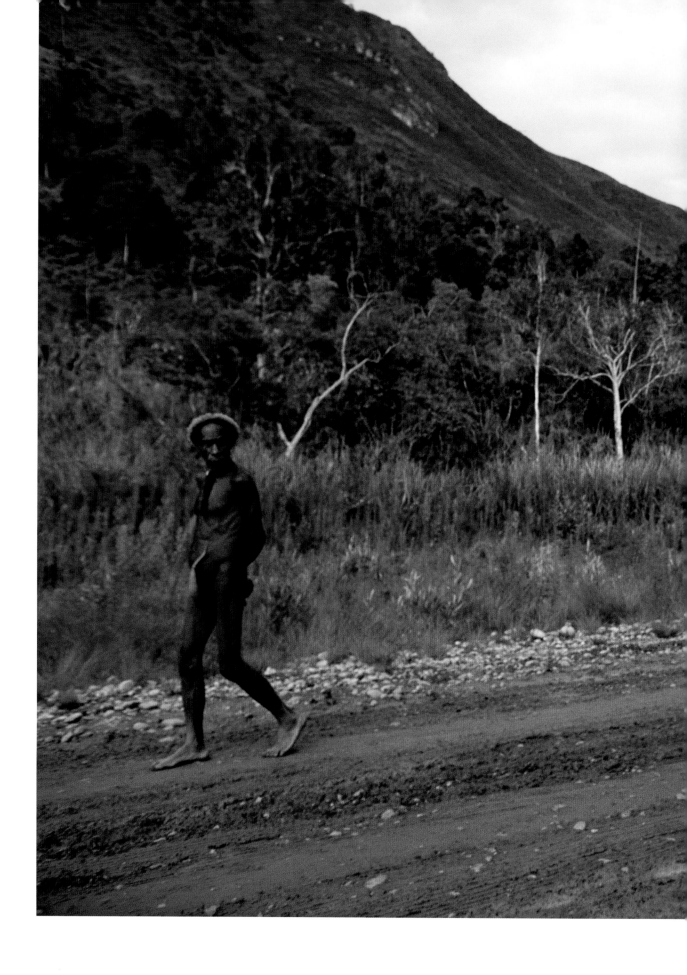

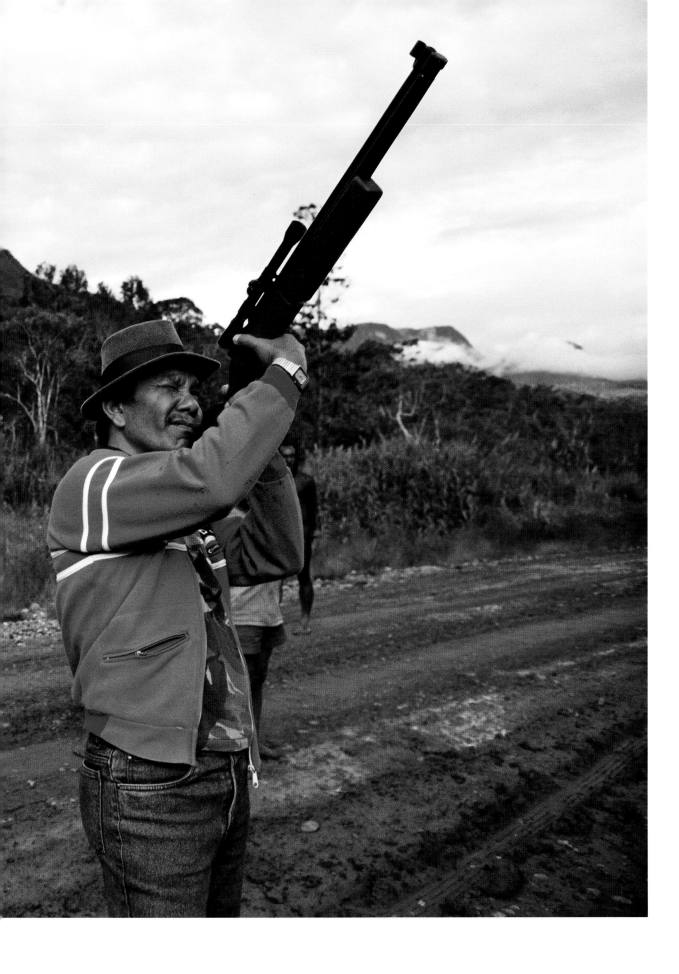

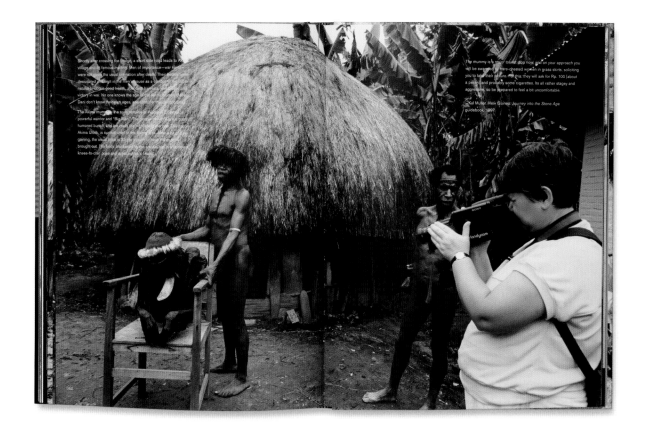

Shortly after crossing the bridge, a short side road leads to Akima village and its famous mummy. Men of importance—war killed war were not given the usual cremation after death. Their bodies were desiccated and kept in the men's house as a constant reminder... natural trophies—good health, abundant harvests and... victory in war. No one knows the age of the Akima mummy... Dani don't know their own ages, and without written...

The Akima mummy is the sole remains of the most... powerful warrior and "Big Man". The local Dani are a lively, humored bunch, and are used to the tourist trade... Akima Ukak, is current chief of the village and for his... gaining, the usual price is 25,000 rupiah when the mummy is brought out. The body, blackened by the centuries, sits in a knees-to-chin pose and stares out at...

The mummy is a major tourist stop now, and on your approach you will be swarmed by bare-chested women in grass skirts, soliciting you to take their picture. For this, they will ask for Rp. 100 [about a penny] and probably some cigarettes. It's all rather stagey and aggressive, so be prepared to feel a bit uncomfortable.

—Kal Muller, *New Guinea: Journey into the Stone Age*
guidebook, 1997.

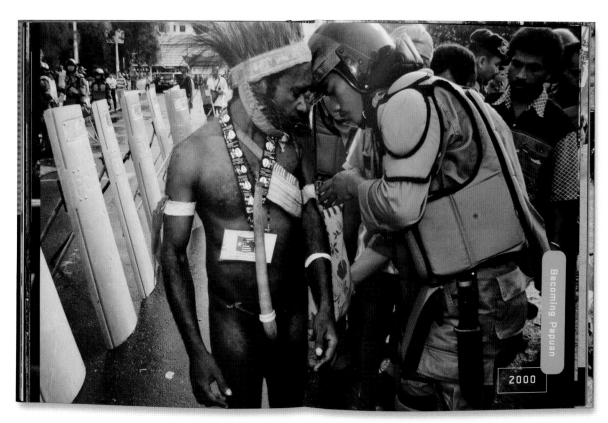

Becoming Papuan

2000

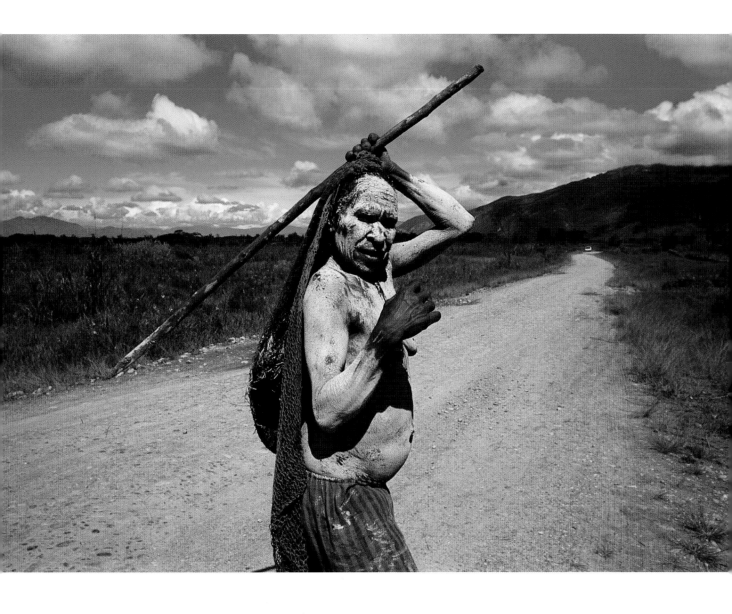

Above: *Dani tribeswoman covered in mud for traditional mourning on road through the Baliem Valley, West Papua*, 1989.

Left: Page spreads from *Encounters with the Dani* (New York and Göttingen: International Center of Photography and Steidl, 2003).

Previous page: *Indonesian hunter with Dani along the new road, Baliem Valley, West Papua*, 1989.

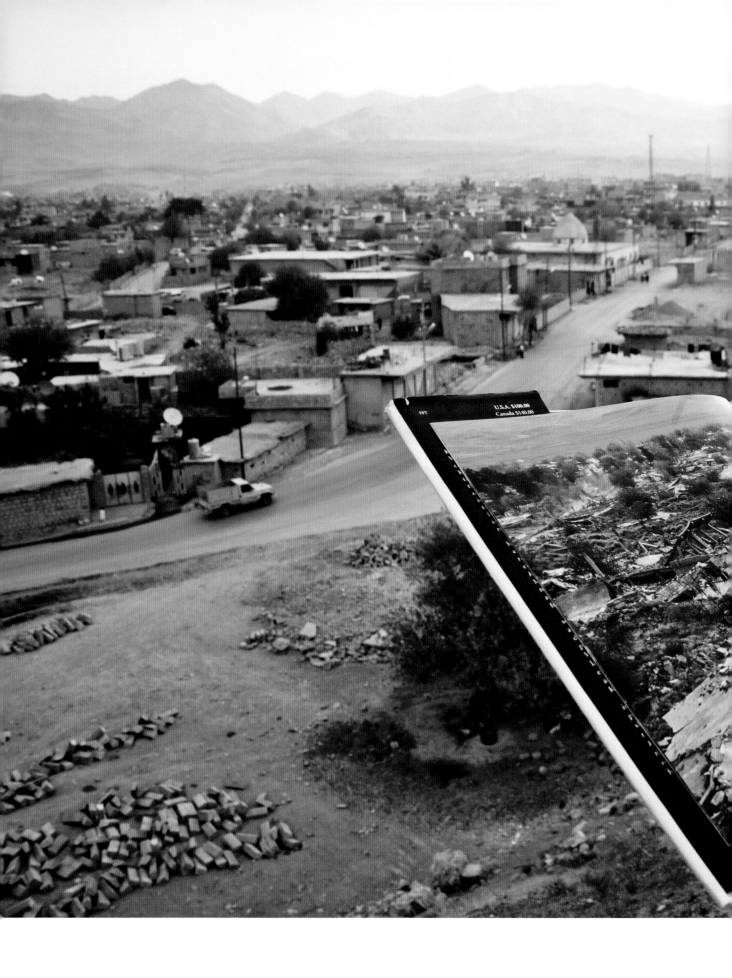

U.S.A. $100.00
Canada $140.00

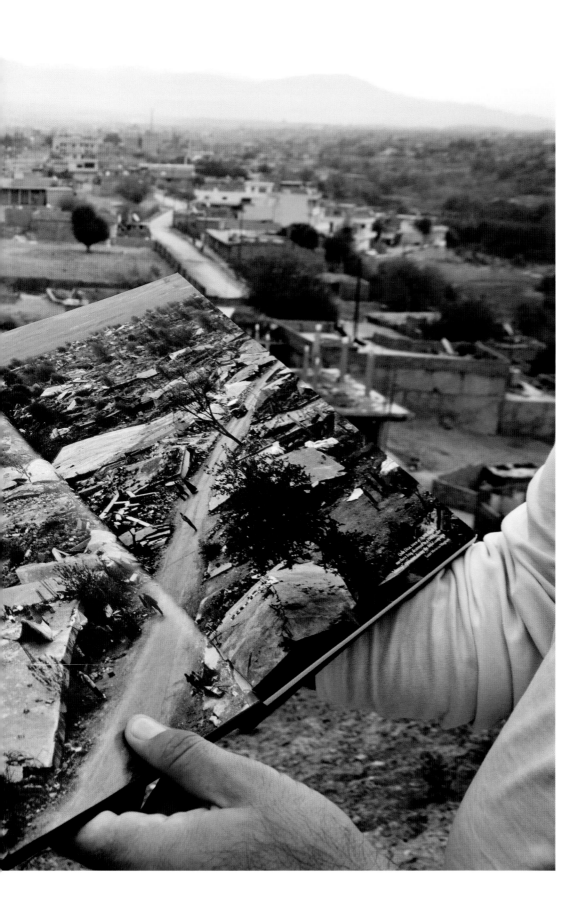

Pank amusement park recently built for domestic tourism, Rowanduz, Northern Iraq, November 2007.

Previous page: Page spread from *Kurdistan: In the Shadow of History* (1997), showing Qala Diza, 1991, in comparison to Qala Diza, 2007, Northern Iraq, November 2007.

Women wait while men look at the remnants of Saddam's tank, destroyed during Kurdish uprising in 1991, Gali Ali Beg mountain pass, Northern Iraq, 2007.

319

Lids for tanks to hold future oil production by the Kurdish Regional Government in Shwa Shok Subdistrict of Koya, Taq Taq, Northern Iraq, November 2007.

Mound that records the six meters of earth moved to prepare for the building of the new Koya refinery, Shwa Shok, Northern Iraq, November 2007.

321

Sheikh Allah cemetery in front of Neshtiman shopping center, a new mall for 6,000 shops now under construction, Arbil, Northern Iraq, November 2007.

Construction of longest airstrip in the Middle East (90 meters wide, 4.2 kilometers long), Arbil, Northern Iraq, November 2007.

323

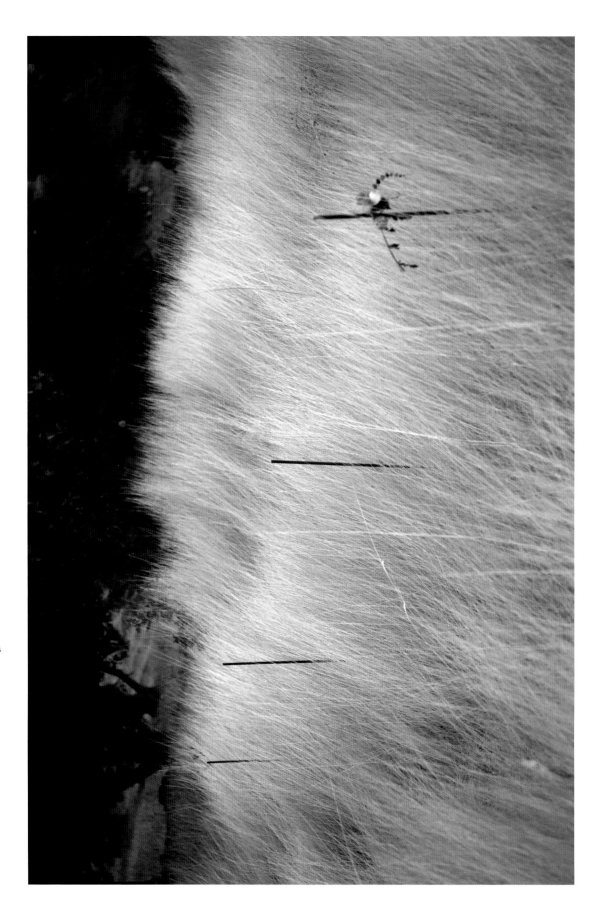

Memorial for Barzani victims of the Anfal, Bele, Northern Iraq, November. 2007.

Street seller in front of the historic Citadel, Arbil, Northern Iraq, November 2007.

Pank amusement park for domestic tourism, Rowanduz, Northern Iraq, November 2007.

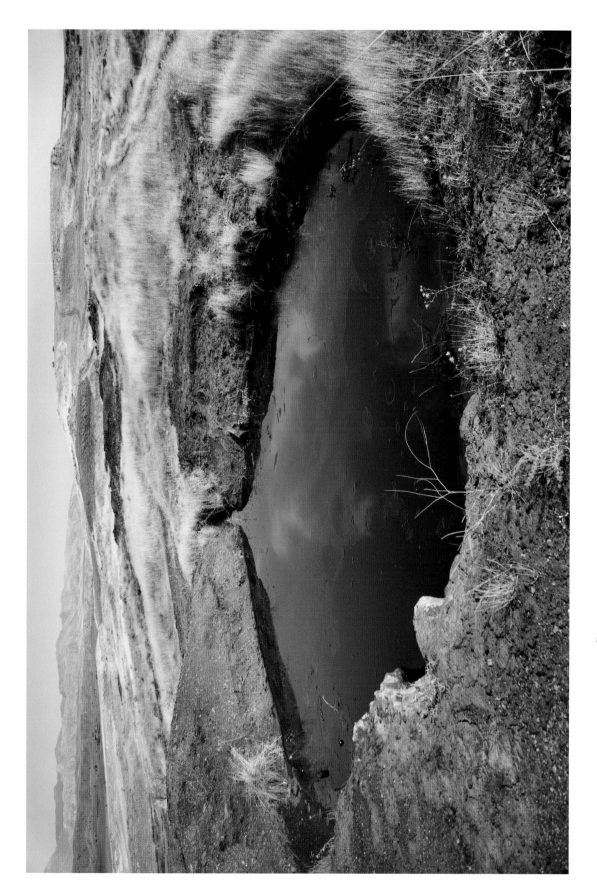

Pool of oil 40 meters deep, Tawke, Northern Iraq, November 2007.

327

Chapter 3 Essays:

Elizabeth Edwards
Entangled Documents: Visualized Histories

Allan Sekula
Photography and the Limits of National Identity

Scrapbook with preparatory research for *Kurdistan:
In the Shadow of History*, 1995.

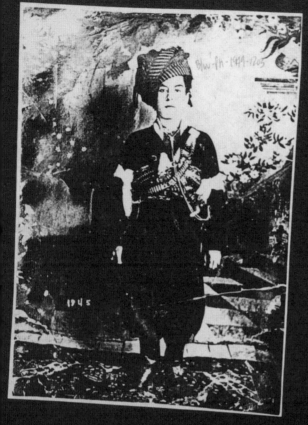

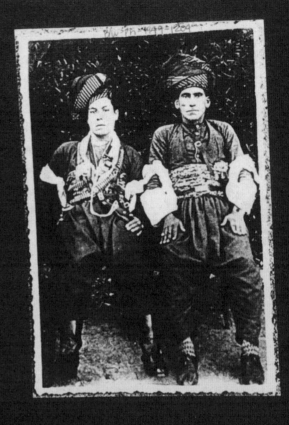

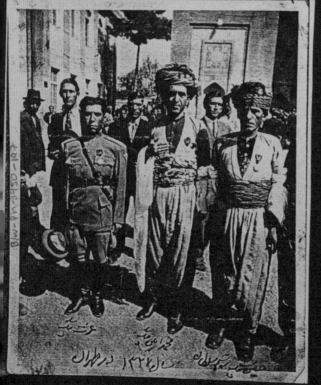

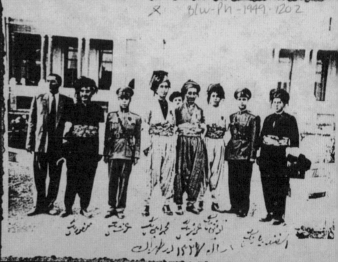

Members of the Luhoni tribe in Kurdish dress and Iranian uniform.

caption needed
bukani

missing fragment
(Mokri refers to
uniforms)

Entangled Documents: Visualized Histories

Elizabeth Edwards

Introduction

A group of Dani men stare over a palisade. The camera of Richard Archibald's Expedition stares back. There is mutual incomprehension, and perhaps mutual curiosity. Their fingers move over the palisade's wooden stakes. One man, wearing a newly acquired tin as an ornament, raises a hand to shield his eyes, to get a better view. The photograph feels slightly hurried, returning the gaze. It is August 1938. Dani men are inscribed in a photograph, which becomes part of a Dutch archive. It is the beginning of their image-lives (p. 306, top).[1]

Photographs are, with film, the major historical documents of the last century and a half. The relationship between photographing, documenting, eyewitnessing, and archiving has attracted a mass of commentary over the years, exploring them from the perspective of style and aesthetics, or critiquing the notion of "truth" and the possibility of communicating a reality of lived experience. These discussions have embraced various readings of images, including the forensic (what kinds of information do these images record?), the ideological (what are the cultural, social, and political framings that encode them and make them thinkable or desirable at a given historical moment?), and the philosophical (what constitutes a "reality" and to what extent can it be represented through photographs?).[2] While mindful of these debates, I am going to take a different approach and consider the ways in which the material forms and physical manifestations of photographs and documents are integral to their function as conduits to the past. In this, photographs are not merely images or documents, but also material objects that circulate, accrue meanings, change physical form, and carry the scars of their own historical existence in an economy of images and information. A combination of their inscribed content and their physical nature—their materiality—has the potential, I shall argue, to bring to the surface a sense of the encounters that produced them. How and why do photographs exist in certain forms? What is the weight of meaning in such forms? What work were they intended to do? A realization emerges that the visualization of history is profoundly entangled with *things*, the "little tools of knowledge"—photographs, papers, official reports, postcards, albums, telegrams—that shape lives and thus histories.[3]

My focus here is on two major archival projects undertaken by Susan Meiselas, namely: *Kurdistan: In the Shadow of History* (1997) and *Encounters with the Dani* (2003). I am not considering these volumes as histories of their regions and peoples or as geopolitical statements, although they are certainly that and powerfully so. Nor are questions of the accuracy or appropriateness of different genres of historical statement, such as family photographs, postcards, press photographs, or intelligence photographs, at issue, although they could be. Rather, I want to consider these books as a way of doing history.

The projects are of major importance as committed exercises in cultural and political recuperation. They bring together the values of culturally engaged photography, archival research, and the excavation of alternative histories as a

1. Susan Meiselas, *Encounters with the Dani* (New York and Göttingen: International Center of Photography and Steidl, 2003), pp. 10–11 (hereafter *Encounters*).

2. See, for instance, Siegfried Kracauer, *History: The Last Things Before the Last* (New York: Oxford University Press, 1969); Alan Trachtenberg, *Reading American Photographs* (New York: Hill & Wang, 1989); Robert M. Levine, *Images of History: Nineteenth and Early Twentieth Century Latin American Photographs as Documents* (Durham, N.C.: Duke University Press, 1989); Rosalind Krauss, "Photography's Discursive Spaces," *Art Journal* 42 (1982), pp. 311–19; Suren Lalvani, *Photography, Vision, and the Production of Modern Bodies* (Albany: State University of New York Press, 1996). Or in cross-cultural environments: Elizabeth Edwards, *Raw Histories* (Oxford: Berg, 2001); Christopher Pinney, *Camera Indica* (London: Reaktion, 1997); Jane Lydon, *Eye Contact: Photographing Indigenous Australians* (Durham, N.C.: Duke University Press, 2005).

3. Peter Becker and William Clark, eds., *Little Tools of Knowledge: Historical Essays on Academic and Bureaucratic Practices* (Ann Arbor: University of Michigan Press, 2001).

4. There are some 30 million Kurds stateless in territory spread over Iraq, Iran, Turkey, Syria, and parts of the former Soviet Union, with an extensive global diaspora, while there are estimated to be about 250,000 Dani in the highlands of West Papua, formerly Irian Jaya, absorbed, with other Melanesian peoples of the region, into the modern nation-state of Indonesia.

5. See, for instance, Michael E. Harkin, "Feeling and Thinking in Memory and Forgetting: Towards an Ethnohistory of the Emotions," *Ethnohistory* 50, no. 2 (2003), pp. 261–84.

6. See Susan Meiselas, *Kurdistan: In the Shadow of History* (New York: Random House, 1997), pp. xv–xvii (hereafter *Kurdistan*).

7. *Encounters*, p. 194. This expedition had itself contributed to the rich visual legacy of the region. As well as academic anthropological work, the expedition, under Robert Gardner, made an important film, *Dead Birds*, on the practice of ritual warfare of the region, and some 18,000 photographs, some of which were published under the title *Gardens of War* (New York: Random House, 1968); see *Encounters*, pp. 52–71. For a discussion of *Gardens of War*, see Elizabeth Edwards, "Gardens of War: Materiality and the Photographic Narrative," in *The Cinema of Robert Gardner*, edited by Ilisa Barbash and Lucien Taylor (Oxford: Berg, 2007).

8. Dani is used as the collective description of a group of related peoples, with closely related languages, who live in the Baliem Valley region of West Papua.

political act, making histories visible both literally and metaphorically. While the experiences of the Kurds and the Dani represent very different scales of historical entanglement,[4] what concerns me here is Meiselas's method of excavating the web of international politics and economics that has left trails of documents, impressions, images, and oral testimony spread across archives in many countries. Her books demonstrate the possibility of writing a powerful historical narrative and commentary through images, photographs of photographs, and photographs of a multitude of documents and ephemeral material.

Their emphasis is therefore on the potential of a visualized expression of history which encompasses not only the usual forms of visual culture—photographs, drawings, maps, cartoons, and so forth—but written documents and their texts as a visual and material form. Intrinsic to this approach is an understanding that such sources are not merely about information but also the affective *tone* of history, a history premised on emotions of anger, outrage, sentiment, longing, or even love, which permeate the historical record and might constitute a recognized modality in historical narrative.[5]

Through the juxtaposition of photographs and documents, these two archival excavations track the multiple, and ultimately destabilizing or destructive, experiences of entanglement with the West's dominant geopolitical and economic agendas, demonstrating the ways in which the West constructed Kurdistan or the Dani region to accord with its own concerns. Yet, as I shall discuss, the nature of photographs enables an opening up of alternative narratives that bring the Dani and Kurds to center stage, seeing through the colonialist rhetoric to refigure and reclaim.

Both projects emerged from Meiselas's long experience as a photographer. In April 1991, she went to Iraq to gather testimony and visual evidence in the aftermath of the Kurdish uprising, which had been suppressed by the Iraqi army to devastating effect. Here she photographed destroyed villages and heard stories of the traumatic flight of hundreds of thousands of refugees. She returned to Kurdistan eight months later accompanying the forensic anthropologist Clyde Snow, to search for and document mass grave sites for the organization Human Rights Watch. Returning again in May 1992, Meiselas and Snow continued documenting and photographing mass graves, scars on bodies, bullet holes in skulls, stained and discarded clothing, the visible and material evidence of the systematic massacre and destruction of people and villages (pp. 262–73). While undertaking this exploration of human conditions in the region, Meiselas encountered not only the entangled archival delineation of "the Kurdish problem," but also a rich photographic legacy within the Kurdish community itself. This legacy, in which family photographs coexisted alongside symbols of suffering and claims to identity, and which prompted return visits, appeared as a counter-narrative to the dominant imagery and history of the region.[6] It was this encounter that seeded not only the extended six-year project on Kurdistan itself, but the visual methodology of the two projects.

In Irian Jaya (now called West Papua), Meiselas made visits in 1988 and 1996 to the Baliem Valley, which had been the focus of the Harvard-Peabody New Guinea Expedition in 1961.[7] The Dani people of the region had only had contact with a wider world, beyond their immediate neighbors, since 1938.[8] Seen initially as a lost paradise, and then as a site for colonial consolidation and

missionary activity under Dutch rule, the region was absorbed at decolonization into the newly formed nation-state of Indonesia, which, in the 1970s, undertook an aggressive policy of enforced "Indonesianization." Called Operation Koteka, it emphasized state interventions in clothing, education, religion, tribal affiliation, and land management (p. 311, bottom). The Dani were, like the Kurds, a people "in the shadow of history."

The Kurdistan volume has attracted the greater attention, and the plight of the Kurds has long been more visible on the international agenda than that of the Dani people of the Baliem Valley. These are, of course, very different histories in terms of levels of political engagement and power relations, on vastly different scales and extents of violence. However, their troubled and fractured histories are not entirely dissimilar. Both faced incursion, dislocation, dispossession, and territorial domination. Both continue to face a violent and oppressive politics and military suppression, which have spawned, in their different ways, separatist movements and demands for self-determination—in the case of the Kurds, a number of sometimes violently opposed factions, notably the PKK (Kurdistan Workers' Party) and KDP (Kurdistan Democratic Party), and, in Irian Jaya, the OPM (Organisai Papua Merdeka). These histories are woven through those of Western colonization, intercolonial tensions, the politics of decolonization, and the development of postcolonial regional hegemonies.

The two regions also exhibit different visual and archival densities, reflecting not only Kurdish and Dani places in presumed global hierarchies of power and the extent and depth of their relations with the wider world, but also their different modes and technologies for the transmission of information and different forms of historical practice. Both have strong oral traditions, but their unequal historical visibility in Western terms is due to their differing levels of appropriation of other forms such as photographs, publications, and documents. Photographs imply a complex interplay of a whole range of perceptions and assumptions about how they might (or indeed might not) attach us to our pasts. This is cogently demonstrated, for instance, by a crumpled photograph returned to Dutch patrol officer and ethnographer Jan Broekhuijse in 1961 by the young Dani boy who had been carrying his rucksack: "Here's your photograph back. I don't need it any more. When I had that photo, I felt your presence. I felt your protection and now that you go, your protection won't be there. So the photo is useless to me."[9] Conversely, the Kurds had developed a substantial visual history and produced and circulated their own photographs and publications, even in the face of suppression. For instance, Said Hussain, brother of Kurdish photographer Giw Mukriyani, ran a magazine with etched illustrations in the 1930s, *The Cry of the Kurdish*, produced on primitive printing presses, while local photographers serviced the photographic requirements of the people (p. 288, bottom).

As histories, both *Kurdistan* and *Encounters* are partial in both senses of the word. First, they present a politically engaged view which attempts to open up a different side of history, to address, or even redress, injustices or asymmetries. Second, they are partial in that they engage creatively with the fragmentary deposits of intersecting histories. Meiselas presents the randomness of the raw materials from which historical accounts are constructed,

9. *Encounters*, p. 71. See also a comment on possible problems in Dani reading of missionary images, p. 139.

and does so with rhetorical force: "In the same way that a collection of unearthed bones can reveal concealed events, these photographs cannot be denied. But like scattered bones, these images would have remained disconnected from the narrative skeleton without knowledge of the people and place from which they've come." It is a self-conscious method, clearly aware of its own construction, and stated visually from the outset on the cover of *Encounters*: Meiselas's shadow—elbows out, taking the photograph—falls between the two Dani men. But this is what photographers do best, the creation of visual incisions into the experience of event and of time which both articulates their own response and at the same time addresses the issues. Meiselas's version of history is acknowledged as just one of many possible readings, foregrounding—through the process of research, presentation, and materialization—the subjective, ambiguous processes of making historical statements of this kind, visceral accounts submerged in formal historical statements.

Photographs and Doing History

Photographs draw their power and evidential force from the way in which the physical world is mechanically traced on chemical through the action of light. This is the basis of its witnessing powers, which speak to "claims of truth [resting] on protocols and hierarchies of evidence"[10] by proclaiming: "This-has-been."[11] However, the authority and sense of authenticity of the medium is grounded not only in this technical fact but in the cultural expectations of truth, directness, or actuality which are brought to it. For despite their "reality effect," there can be little claim to neutrality. Photographs are cultural objects that are made for specific purposes, to project certain meanings and elicit certain affects. In turn, these are framed by the cultural circumstances which make certain kinds of images thinkable at a given historical moment, yet at the same time they should not be reduced simply to ideological constructs, for both historical actors and photographs themselves are more complicated.

Thus photographs remain viewed with suspicion as a way of "doing history." As a form of evidence, they are always on the line—too fragmentary, too subjective, too objectifying, too raw, too lacking in the broader term, yet too randomly inclusive, carrying an excess of information which threatens to render them illegible. Not only are photographs highly selective in their making, they are infinitely recordable, their possibilities are so various that form and content cannot necessarily be conflated with meaning: "The relationship between images and imprinted meanings is fraught with uncertainties, for like opaque facts, images cannot be readily trapped within a single explanation or interpretation. They have a life of their own . . ."[12] So while content can be seen as a series of signifiers, these are by no means fixed. Photographs are fluid, performing differently in different contexts, inflected through different cultural ways of seeing. The "truth" of the photographs in these books will be very different for a Dani elder or a Kurdish activist or the visitor to an exhibition. The Kurdish man with the bandolier can be seen as a stereotypical warrior or

10. John Tagg, "The Pencil of History," in *Fugitive Images: From Photography to Video*, edited by Patrice Petro (Bloomington: Indiana University Press, 1995), p. 286.
11. Roland Barthes, *Camera Lucida* (London: Flamingo, 1984), p. 77. This is, of course, the premise of all photojournalism and documentary photography.
12. Trachtenberg, *Reading American Photographs*, p. xv.

an icon of self-determination; the Dani woman missing fingers as a sign of mourning, as a statement of tradition or of barbarous yet exotic primitive practice.[13]

Photographs also create events. By stilling a moment, extracted from the flow of human experience and contained within a frame, they create a fragment, privileging some moments over others that disappear into the mass of the unrecorded. Yet one is made conscious of the latter precisely because of the surviving photographic fragments, for these always refer to something beyond themselves. This is what makes the photographs of the Kurdish resistance at Dersim in 1938[14] or the photographs of early contact with Dani so powerful. One is aware of the wider narrative, condensed into photographs.

Thus photographs offer a close-up view capable of modifying more comprehensive views. Through their visual incisions in space and time, photographs deliver "little narratives" that both constitute and are constituted by the grander, or at least "larger," narratives. These relationships of historical scale, time, and space define Meiselas's projects, as she juxtaposes family photographs with government papers and missionaries' memoirs. What links all these elements is the "double desire for history," the assembling of detailed objective records and the "restoration of lived reality,"[15] which are so forcibly demonstrated as ways of "doing history" in these projects. What Meiselas presents, in her juxtaposition of photographs, documents, and voices, is a "visual economy," a flow of ideas, predispositions, and beliefs linked to material practices of using, reproducing, and collecting. This patterns the production, circulation, consumption, display, possession, and material forms of photographs through the political, economic, and social matrices in which they, and other related image forms, operate.[16] Thus political cartoons, travelers' snapshots, and accounts of atrocities make a collective system of shapes, forms, relations, and structures that is more than a sum of individual instances.

Related to this is the way in which photographs might be seen to have a "social biography" as they accumulate and accrue different meanings at different stages of their material existence: the official report becomes the archival document, the family photograph in the archives of the secret police becomes a source of identifying insurgents. For instance, a photograph prepared for use in *The Kurdish Republic of 1943* (1963) shows sellotape and at least four layers of markings, as the image is turned from one thing into another. These marks point to different "biographical" moments of the image and object (p. 292, top). Likewise, textual additions mark the surface of a telegram, printed on rose pink paper, sent by John F. Kennedy to the Dutch prime minister in 1962 concerning the handover of power in West New Guinea (now West Papua)—the document is stamped top and bottom with the words "Eyes Only," numbered, stamped, ticked, initialled, filed (see the punched holes), and eventually declassified (p. 310, bottom). Such examples point to the processes through which photographs and other documents come to have evidential value in a series of overlapping ambiguous, ambivalent, and unstable representational and material discourses. What Meiselas's projects reveal are the multiple strands of image making, their different objectives, modalities, and theaters of consumption, the complexity of the visual economy, and the way in which it disperses into series of microeconomies, which are at the same time integral to the collective view.

Elizabeth Edwards

13. *Kurdistan*, p. 240. Compare, for instance, *Kurdistan*, pp. 96–105, and *Encounters*, p. 163.
14. *Kurdistan*, pp. 148–49; *Encounters*, pp. 10–11.
15. *Kurdistan*, p. 290.
16. Deborah Poole, *Vision, Race, and Modernity* (Princeton: Princeton University Press, 1997), pp. 9–13.

The various sites of instability of photographs as "doing history" are, however, also the sites of their potential to offer alternative narratives: "What if pictures have a different story to tell, what if—in their luxuriant proliferation—they were able to narrate to us a different story, one told in part on their own terms?"[17] Meiselas establishes such a space through the specific but fluid economies of meaning, demonstrating how different groups of images, read in different ways and at different moments, circulate through different spaces. In juxtapositions of image, visualized text, and oral and written testimony, spread through different genres of document—government, family, ephemera, missionary, photojournalism, police reports, websites—those little close-up views are given equal historical weight. While some documents relate to recognizable seminal moments in historical relationships, most are the serendipitous or even banal deposits of multiple encounters. From such raw materials, Meiselas weaves an extraordinary alternative historical narrative in which photographs present not only access to a historical reality, but to an affective "historical poetics."

Materiality

The physical existence, or survival, of documents is central to Meiselas's approach to these histories: "I emphasize the photograph as object, as artifact, once held, now torn and stained."[18] Consequently, I shall now turn to a consideration of how the material forms of documents, their "thingness," impress themselves on our understanding of a history. For here we are thinking not simply about imprinted representation in abstract terms, but of imprinted objects that are representational. They are "made, used, kept, stored for specific reasons which do not necessarily coincide . . . they can be transported, relocated, dispersed, damaged, torn, cropped . . . because viewing implies one or several physical interactions."[19] As such, the material qualities in which the various statements circulated and survived are integral to the way in which we might understand the relations that constitute the histories of both Kurdish and Dani people.

There are two aspects to materiality. First, the material forms of the original object, including copies, duplicates, and reproductions of original forms—how they are printed, mounted, or colored. Second are the scars of history itself on the objects, which carry the marks of their own historical journey through damage, traces of administrative procedures, sellotape, the marks of rusty paper clips, tears, erasures, scribbled notes, lost corners, and fold marks obscuring text. Together these aspects materialize and reflect the function of photographs as social objects within the visual economy, the conditions and desires of both making and using: they are stuck in albums, hidden in boxes, reproduced in books (including *Kurdistan* or *Encounters*, or this one), they are written on, moved about, and "recoded" as things. Materiality also sets up the affective tone of the images and "historical poetics," as one feels the paper fiber and grain, the fragility of carbon copies, the chemical instability of a photograph.

This is not, however, a collapse into the sentimental or fetishistic, but an attempt to recognize the importance of the affective as a modality in historical narrative. The historical power of human relations with objects has long been recognized in anthropology.[20] This debate has moved the analytical focus

17. Christopher Pinney, *Photos of the Gods* (London: Reaktion, 2004), p. 8.
18. *Kurdistan*, p. xvii.
19. Nuno Porto, "Picturing the Museum: Photography and the Work of Mediation in the Portuguese Third Empire," in *Academic Anthropology and the Museum*, edited by Mary Bouquet (New York: Berghahn Books, 2001), p. 38.
20. See Elizabeth Edwards, "Photography and the Sound of History," *Visual Anthropology Review* 21 (2006), pp. 27–46; Elizabeth Edwards and Janice Hart, eds., *Photographs Objects Histories* (London: Routledge, 2004); Pinney, *Photos of the Gods*. In material culture, see Janet Hoskins, *Biographical Objects: How Things Tell the Stories of People's Lives* (New York: Routledge, 1998).

of photographs from issues of semiotics and representation alone, to the construction of the affective qualities of the material objects which perform in specific ways. In this, as Meiselas's photographic insistence makes clear, objects are not merely stage settings for human actions and meanings but integral to them.[21] Thus objects, here photographs or documents, can themselves be seen as social actors, in that it is not the meanings of things *per se* that are important, but their social effects as they construct and influence the field of social action in ways that would not have occurred if they did not exist.[22] How would an account of the Dani be understood without photographs?

Significantly, as I have suggested, Meiselas extends this thinking to other classes of document, reproducing them as material objects so as to draw attention to the power of their physical existence.[23] While the text remains resonant, it is not reduced to the distanced and over-cerebralized statement, but, rather, it reembodies the document. The way information is presented, intervened with, extended, or removed becomes highly pertinent and affective. As Brenda Danet has argued, "the physical stuff of texts—the surfaces on which they are inscribed, the materials used to do the inscribing and the aesthetic aspects of their creation and manipulation" are significant in that material forms and the formats they support can precede and shape social responses as different expectations are brought to specific objects such as the telegram, the color photograph, or the postcard.[24] Importantly, these objects suggest the mobile tentacles of power and resistance that shape experiences in precisely the way that Bruno Latour has argued: "Instead of using large scale entities to explain . . . we should start from the inscriptions and their mobilization and see how they help small entities become large ones."[25] For claims to knowledge, and thus political power, hinge on everyday practices and routines of administration and little tools such as graphs, questionnaires, reports, and dossiers.[26] Many of the documents reproduced—police files, reports by commissioners, missionaries, and government functionaries— might be seen as "conventional" historical sources. However, translated into visual objects, they are no longer just words on a page, but things that were circulated, absorbed, rejected, marked, and refigured.[27] Through careful attention to their physical existence and material forms—marks on paper, whether inscribed by light and chemical, the printing press, or pens on paper—one begins to read texts as photographs, as visual performances of relations which reach beyond the informational. Meiselas's attention to the visual and material details of this process is not merely a question of reproducing documents but rather bringing them to the same level of visual and material insistence as the reproduced photographs, thus opening them up to different kinds of interrogation. In this way, as Meiselas's juxtapositions demonstrate, short telegrams, narratives of a traveler's snapshot album, magazine illustrations of massacres, and tourist brochures of the "untrammeled primitive" can become greater than the sum of their parts, can add up to complicity in political violence and cultural appropriation.

If these documents carry the weight of eyewitness, it is not only that they claim authority, but also that they have a visceral immediacy: the stained passport of a Kurdish woman, with purple fingerprint, the faded photographs held by rusty staples which have impressed into and stained the opposite page, become affective documents of Kurdish migration (p. 293, top). But

21. Alfred Gell, *Art and Agency* (Oxford: Clarendon Press, 1998).
22. See Edwards, *Raw Histories*, p. 17.
23. Scholars of literature have also explored the substance of literary texts—their graphics, typology, layout, etc. See, for instance, E. A. Levenston, *The Stuff of Literature* (Albany: State University of New York Press, 1992). Levenston does not, however, discuss the "thingness" of texts.
24. Brenda Danet, "Books, Letters, Documents: The Changing Aesthetics of Texts in Late Print Culture," *Journal of Material Culture* 2, no. 1 (1997), pp. 5–6.
25. Bruno Latour, "Drawing Things Together," in *Representation in Scientific Practice*, edited by Michael Lynch and Steve Woolgar (Cambridge, Mass.: MIT Press, 1990), p. 57.
26. Becker and Clark, *Little Tools of Knowledge*, p. 1.
27. *Kurdistan*, p. 281.

this also raises a paradox. The hegemonic power of the document is revealed not as the bald textual statement but as constructed, fragile, and contentious, as marks are made to disguise, emphasize, interpret, or even deny meanings. While bits of paper and photographs are instruments of power,[28] they also reveal processes of refinement, erasure, even uncertainty, as documents and as evidence. For at the same time, their authority is belied by their fragility, of acidic stained paper or rusted paper clips. Rendering them visual objects makes their "biography" palpable and emphasizes the flimsiness of historical understanding based on a typed sheet of onion paper or a scarred telegram. At the same time, through the insistence of their traces, photographs give a robust sense of continuity. Despite the marks of time, if anything the survival of these objects stands for survival itself, as people stare out from the cracks, creases, and decaying emulsions (p. 288, top). As Meiselas remarks, "A photograph is a document that resists erasure."[29]

Thinking about photographs and documents *materially* reasserts a sense of people's agency in inscribing history, not only in the sense of personhood in front of the camera, be they portraits of Kurdish leaders such as Ahmed Khwaja, Yado Agha, and Ado Agha,[30] or the unnamed subjects in William Coupon's contemporary portraits from southeast Turkey,[31] but, as I have suggested, the very marks people leave on objects. Captions or marks on the surface of an image, for instance, signal how users mold photographs to their needs. A powerful example is a scarred photograph, loosely mounted on card (one can see the shadow cast by the slightly raised edge of the print), of the family of Kurdish engineer Nadir K. Nadirov. His annotations spell out the names and achievements of the family, the surface of the object becoming a kind of family archive (pp. 290–91). Here the material qualities of the mounted photograph form a series of linked surfaces for inscription, containment, and refiguration. Even the shape of the marks indicates the agency of the observer, vividly illustrated by the photograph of an annotated map of the Baliem Valley made by the Dutch lieutenant van Arcken, in which the country is fleshed out from the bare bones of a preliminary map through crayon additions—green for forest, blue for rivers, red circles for supply drops. But, importantly, one can see the different deposits of soft crayon, like artists' brushstrokes, leaving different densities on the paper, the result of different pressures, different kinds of strokes, as the hand translates observation into a series of movements, the weight of impression, and hurried scribbles (p. 306, bottom).

The two books themselves, of course, constitute further material performances. Enhanced by design and reproduction values, the book builds up the visual and material form of small entities and details into a very particular shape and form of narrative. The tone is set from the very beginning. The dust jacket of *Kurdistan* is itself like a battered file or album, creased and grubby, faded at the spine, and tied with yellow ribbon, while the opening pages of *Encounters* comprise aerial photographs looking down on an unknown region, mapping out and opening it up to no visual apprehension.

The sense of a massing of things is performed visually in the layout of the books. Her images do their work in relation to other images on the page and their positioning on that page.[32] In *Encounters*, photographs and texts are layered, often on a black background, perhaps suggesting the pages of a photograph album of the 1950s. In *Kurdistan*, images and documents are

28. Latour, "Drawing Things Together."
29. *Kurdistan*, p. xvii.
30. Ibid., pp. 82, 141.
31. Ibid., pp. 372–73.
32. Jan Baetens, "John Berger and Jean Mohr: From Photography to Photo Narrative," *History of Photography* 19, no. 4 (1995), p. 283.

again layered up both intellectually and visually. Photographs and text provide shadowy backgrounds, almost filling the page, while other images, manuscripts, and quotations, often from oral testimony collected by Meiselas, are layered over them. And yet throughout, the design enables clear strands of voices to emerge. Different kinds of typefaces are used, a clear, authoritative form of Minion Times Roman for official reports, and an italic form for the accounts of travel writers, personal diaries, and testimonies, including many Kurdish voices. So while this is a massing of raw materials, it is not a cacophony. The photographs and documents point to a confusing situation, but are not, within the strong narrative structure, confusing. Further, one can track the gradual emergence of difference voices, from being spoken about, to speaking themselves. Significantly, in *Encounters*, despite many perceptive and sympathetic assessments from missionaries and anthropologists, Dani voices do not emerge until about three-quarters of the way through the book. Rather, voices, texts, images, and the materiality of the objects, their "thingness," come together to create a unified and coherent whole.

The reader is, of course, part of all this, for the books also demand an embodied engagement and experience. One does not only look, but touch, turning the pages, just as the photographs themselves have been touched. The images are perhaps discussed, verbalized, just as photographs and documents themselves have been. The weight of the book, and perhaps history, is on one's lap. Looking at the books becomes in itself an affective and tactile experience as the minutiae of these histories are reenacted through the books. Moving through *Encounters with the Dani*, for instance, the shift from images of Dani people in their own valley to those of them in local towns and in interactions with the Indonesian authorities is as affective through the multiple layers of material performance as it is informational. The back cover shows a group of women, seated, their string bags slung over their heads, as they have always been, but facing standing rows of Indonesian troops.

Visual massing performs a visceral sense of political massing. It is precisely such points of connection that Meiselas sets up throughout both *Kurdistan* and *Encounters* and which are materially performed through the books. The attention to materiality is not, of course, to underestimate the impact of the content of the photographs. Both books are full of forceful and incisive images full of compelling detail, including those by Meiselas herself (p. 267), and these latter set the scene for her engagement with these material histories. It is the content of the photographs—of an overweight tourist videoing the Dani's Akima mummy (p. 314, top) or the Kurdish armed struggle, of executions or a protestor in the act of self-immolation[33]—which arrests or horrifies us. But thinking materially sensitizes us to the way in which image and object work together in the visual economy, for it emphasizes not merely the semiotic or linguistic, but the affective intensity of archival deposits. They can no longer be read as images alone, but must be understood as part of a matrix of representational objects that construct fluid and contested histories.

338

Elizabeth Edwards

33. *Encounters*, pp. 164–65; *Kurdistan*, pp. 170–71.

The Weight of Photographs

Both *Kurdistan* and *Encounters with the Dani* show how photographs can illuminate the contour of histories in various ways. The small acknowledgments printed with the various sources point to the dispersal of the archive, which mirrors the dislocated experiences of the people themselves. There is no national archive for Kurdistan; its records are spread across the geopolitical spectrum. Those of the Dani reflect first the structures of Dutch colonial power and administration and its satellites such as the missions, and then of the interested parties of decolonization and the expansion of Western geopolitical investment in the region. The tentacles of power are thus marked through the patterns and nature of archiving, with photographs and documents dispersed across archives and institutions in centers with the power to shape the dominant narrative. In this, these projects do not merely amass raw materials, but through the juxtapositions and a sense of voice, they constitute a new configuration of the archive itself.

What is startling throughout is the power invested and managed through these pieces of papers, and in routine administrative procedures such as filing reports, copying and circulating letters, and inscribing. It is the banality and fragility of these little tools of knowledge that is so arresting, and which belie the powerful impact they have on people's lives. They are revealing of the collective states through which Kurdistan was successively performed, suppressed, erased, and reconstituted, just as they reveal the ways in which Dani people have been entangled and commodified in world economic systems whether as touristic eternal savage or problematic and inconvenient holders of desirable natural resources.

Historical insight is contingent on the capacity of the users of documents to carry out grounded yet creative engagements and readings, allowing for the intentions of their makers as one part of the story, but also having the capacity to "read against the grain" (in Walter Benjamin's famous phrase) to allow other readings to emerge. Above all, photographs have the power to disrupt dominant and hegemonic claims to history. With their random inclusiveness in inscribing a reality of the past, recording details which eluded notice at one moment only to become key at another, photographs have the potential to elicit different readings, and to be recoded as documents, given new meanings and new work to do.

But uncontrollability is precisely why photographs are dangerous, and why oppressive regimes so assiduously attempt to control them. Photographers emerge as the secret keepers of the collective archive. As the Kurdish photographer Rafiq put it: "Each one of us worked alone and kept our secrets to ourselves. Nobody was allowed to contact people here. I didn't meet any journalists or photographers. Maybe they came and were with the leaders but nobody came to me to exchange ideas about photography."[34] Another, Jabar Abdulkarim Amin, told Meiselas in 1993:

> *Iraqi Police monitored shops selling three kinds of things: cassettes, photographs and books. No one was allowed to sell a photograph or take a photograph that showed the tragedy of the Kurdish people.*
> *For example, a photographer in Suliamania took a photograph of a poor baby with torn clothes and sold it as a postcard. The photographer was*

34. *Kurdistan*, p. 205.

arrested for selling the photograph. . . . In 1962 my cousin was impris-
oned for ten days for carrying a photograph. In 1963 . . . I gathered the
most important photographs of Kurdish leaders, about seventy of them,
and put them in a ceramic pot and hid them out side. But when they
built the road there, the photographs disappeared . . .[35]

Photographs are dangerous—dangerous because they have the potential
for incidental and uncomfortable disclosure. Meiselas uses the massing of
photographs to perform, literally make visible, entangled layers of multiple
histories: Kurdish, British, American, Iranian, Iraqi, and Turkish; Dani, Dutch,
American, Australian, and Indonesian. It is not merely a sense of the semiotic
excess of the images, or their narrative instability, but the impact of acts of
documentation in an embodied and phenomenological experienced relation
between the present and the past. Photographs, more than any other source,
carry this weight of history.

Closing Thoughts

What characterizes these two projects of archival excavation is the way in
which Meiselas shifts photographs from a social construction of the visual field
through representational practices to the visual performance of social and
political fields in ways that extend understanding of the latter. As Latour has
argued, the fragile graphic and material qualities of paper inscriptions belie the
power that they wield: "By working on papers alone, on fragile inscriptions
that are immensely less than the things from which they are extracted, it is
still possible to dominate all things and all people . . . This is the view of power
we get at by following this theme of visualization and cognition in all its conse-
quences. If you want to understand what draws *things* together, then look at
what *draws* things *together*."[36] Yet as both the Dani and Kurdistan projects
demonstrate, these traces of encounters and histories can be drawn together
in many ways, readings which both cohere and disintegrate in the face of the
document. They stand for the entanglements of both regional micropolitics and
global geopolitics.[37] But they also stand for resonant alternative histories with-
in this. Yet within those contexts, they have the ability to shift and refigure
readings. Photographs themselves provide counter-narratives to the dominant
histories of the regions. These works show how photographs can shift our
questions away from theoretical contemplations or synthesizing accounts on
the relations of the past, to explore the minutiae that suggest the experience
and feelings of those relations.

The Kurdistan project has been described as a "family album."[38] It is an
apt description because the book evinces the immediacy of such a form, but
also because of its self-conscious and unashamedly *constructed* quality. The
massing of photographs also enables one to bridge the gap between individual
and collective experience in ways that do not necessarily privilege one over the
other, for "the historian's task resembles the photographer's: how to
make the random, fragmentary, and accidental details of everyday existence
meaningful without loss of the details themselves, without sacrifice of
concrete particulars on the altar of abstraction."[39] This is the great strength

35. Ibid., p. 256.
36. Latour, "Drawing Things Together," p. 60.
37. On the visualization of geopolitics, see David Campbell, "Geopolitics and Visuality: Sighting the Darfur Conflict," *Political Geography* 26, no. 4 (2007).
38. *Kurdistan*, p. 388.
39. Trachtenberg, *Reading American Photographs*, p. xiv.

Elizabeth Edwards

of photographs: their inscriptive insistence always pulls one back to human experience, and to things collected, filed, treasured, or hidden. But in their detail they also stand not for abstraction, but for a sense of magnitude— of scale, of landscape, of human experience and endurance, of history.

At the core of these projects is the way in which photographs remain active. They have long lives, and their infinite recodability opens a multitude of readings. Making histories visible in this way enables a recoding or resignification of historical deposits which must impact on the way we think about how the past is described and knowable. Ultimately, the photographs entangle lives—those of the subjects, the users, and the viewers. Meiselas tellingly states, at the end of the Kurdistan volume: "I am not at liberty to name all those who have contributed material."[40] Photographs remain dangerous things—they are never simply archival, but active in the relations between people and people, and people and the weight of their pasts in the present.

40. *Kurdistan*, p. 194.

Photography and the Limits of National Identity

Allan Sekula

Isn't it peculiar that photographs, at once intensely private and ubiquitously social visual signs, should be believed to be capable of producing an "image of a nation"? Think of the example of the United States, a country that embraced photography perhaps more enthusiastically than any other in the mid-nineteenth century. The idea that photography could express a national character emerges in projects such as Mathew Brady's *Gallery of Illustrious Americans* (1850). But it takes the construction of a scholarly discipline of "American Studies" to make the photographic component of national identity a "topic" to be studied. Thus F. O. Matthiessen's book *American Renaissance* (1941) begins with a frontispiece reproduction of a daguerreotype portrait by Southworth and Hawes of the clipper-ship builder McKay, linking the photographic representation of this enterprising Yankee physiognomy ("the common man in his heroic stature," as Matthiessen put it) to the literary generation of the 1850s: Emerson, Hawthorne, Melville, Thoreau, Whitman.

Richard Rudisill's *Mirror Image* (1971) pushes this insight further, asserting an autonomous "national" photographic culture, arguing that the proliferation of daguerreotype portraits in the 1840s actually produced a coherent image of national identity. Alan Trachtenberg's *Reading American Photographs* (1989) develops a high modernist variant of the same argument, tracing a trajectory from Brady to Walker Evans.

The notion of a close link between photography and nation has been most thoroughly argued for American society, the society that has perhaps the most developed and pervasive photographic culture, and at least since the end of the Civil War, a secure national "identity." The game is governed by a certain expansive confidence, even if that confidence is subject to underlying anxieties about racial difference. In this sense, the confident global familialism of Edward Steichen's 1955 *Family of Man* was a projection of a mythic and deracinated idea of American national unity.

Perhaps it goes without saying that Kurdistan represents the opposite extreme. If the United States is one limit case, Kurdistan may well be the other. Susan Meiselas and her colleagues seem to me to be developing the case for a highly cautious, even suspicious view of photographs representing "the Kurds." Here are a people defined from without by multiple oppressors and scientists and adventurers: Ottoman Turks and Persians and Europeans in the nineteenth century, Turks, Iraqis, and Iranians in the present period, with periodic bursts of "Western" journalistic intervention. The "archive" itself is dispersed, must be constructed from discontinuous and even mutually antagonistic sources. Everything is shadowed by fakery (or at the very least, circumspection and doubt) and fear.

This brings us to an ominous and even morbid question. What is the relation between national identity, extermination, and forensics? Under genocidal siege conditions, the road to national identity may well be forced to find its first signposts in the forensic retrieval of individual identities.

The Kurds have been photographed repeatedly by the police and military forces of their oppressors. The aim of this surveillance and cataloguing is both modern and premodern in its display of power: modern in the sense attributed by Michel Foucault to Jeremy Bentham's "Panopticon" prison, initiating the tactics of today's Western police agencies; premodern in the sense of the ritualistic and medieval display of the decapitated bodies of Kurdish chiefs, a premodern way for putatively modern states

(Kurdistan, pp. 260–299)

to communicate terror to a premodern tribal people. In this case, as with all contemporary uses of torture and extermination as instruments of state policy, we must recognize the limits of Foucault's notion of the triumph of panoptic techniques. The old and the new methods coexist.

Forensic methods (detective methods focusing on evidence and the body) offer a tool for oppressive states, but forensic methods have also become tools of opposition. Here we might consider the following sequence of actions:

Identification–Annihilation–Identification

The oppressor state catalogues its victims as precisely as possible, typing them as a group, but seeking to register and track individual members. The key to ideological power over the "other" lies in typing; the key to functional power lies in individuation. In other words, stereotypes are ideologically useful and necessary, but in the end it is individuals who must be reduced to ashes. The further aim is to annihilate the group, and thus its memory, and to annihilate further memory of the group. As Camus spoke of the Nazi obliteration of the town of Lidice: "to make assurance doubly sure, the cemetery was emptied of its dead, who might have been a perpetual reminder that something once existed in this place."

Counter-forensics, the exhumation and identification of the anonymized ("disappeared") bodies of the oppressor state's victims, becomes the key to a process of political resistance and mourning. The work of the American forensic anthropologist Clyde Snow, first in Argentina, with the victims and survivors of the "dirty war," then in El Salvador, at the massacre site of El Mozote, and then again with the remains of the Iraqi campaign of extermination of the Kurds, has provided the technical basis for this project. In Argentina, this work combines with that of psychoanalysts in the study and therapy of the interrupted work of mourning in the psyches of those who suffer from the indeterminacy of the "disappearance" of their loved ones. These are dismal sciences, but fundamental in their basic humanism, a humanism of mournful reindividuation, laying the groundwork for a collective memory of suffering.

It is here, at the "individual" and forensic level, that the project of building a usable archive of the Kurdish "nation" begins. Without a recognition of this level, all assertions of national identity are just that, mere assertions, liable to become dangerous fictions. The individual and mass graves and intimate griefs must never become sepulchral excuses for abstract monuments. And it is precisely in this sense that photography's incapacity for abstraction is valuable.

343

Afterword (Atlas and Archive) 2008

I recall visiting Susan Meiselas in New York while she was working on her Kurdistan book. At that moment, she felt that nothing could be left out, that each and every image she had unearthed had unfathomed meaning for someone, and thus demanded to be included in her archive of a stateless people. Her radical nominalism, that is, her reluctance to allow any one image to stand as a type for other images that were excluded was worthy of the utmost philosophical respect. The Kurds had been typed enough as a people. And her interest in building a provisional national archive from what were often literally buried fragments was itself the outcome of a continuing dialogic

desire. She wanted to produce a book that would continue and broaden the conversation she had heard in blasted villages and refugee tents. In theory, no potential story should be thwarted by editorial selection or publisher's page counts. So we can think of this sequence:

Stories–Photographs–Stories

The idea of dialogue sounds both hopeful and rather innocent. It is not always easy to convey how dangerous it has sometimes been to propose such a thing.

Later, in 1998, at the Rotterdam opening of Meiselas's "completed" Kurdistan project at what is now the Nederlands Foto Museum, an exiled Kurdish activist tells me that had he made a few more phone calls he could have had "10,000 people here for the show, in buses from Germany." Having already checked the galleries for bombs, the Dutch police are nervous about this promised opening-night blockbuster. In one vitrine we see a charred copy of Meiselas's book, retrieved from the ruins of a Kurdish cultural center in London, torched by arsonists from the Turkish fascist Grey Wolves or else working with the Turkish secret police.

Pragmatically, Meiselas knew the project would die unborn if it aimed for the inclusivity of a telephone directory. We reached an impasse as we talked about and around this problem that afternoon in New York. Finally, I suggested we take the subway uptown and walk over to see Gerhard Richter's *Atlas* at the Dia Foundation: "It won't provide any answers, but it will pose a few questions about inclusion and exclusion and the sheer mass of images in the world." And, of course, nothing could have been much further from Meiselas's own engagement with photojournalism, with history in the phenomenological intensity of its unpredictable unfolding.

Later, while she was still working on the book, she made an interesting comment, defending the specificity of documentary photography: "When you are working with evidence—say, when you're digging up grave sites—you don't want people to think that it is conceptual art, an installation, or that it's just invented."

Richter and Meiselas: The painter's studio, on the one hand, as a philosophical ground from which to collect and view images of the world, of one's own work and one's own life in the provisionality of its remaking. And on the other hand, the photographer with a five-day visa, gazing down—not for the first time—into a mass grave and realizing that history has offered no clue for what she is seeing. Thus she begins, not with the images that already exist, that overwhelm us with familiarity and ennui, and can only be made strange by relentless categorization and repetition and the judicious suspension of normative sharpness, but with the sense that where bodies are buried in secret there must also be a buried archive, limited in scope but immense nonetheless, waiting for resurrection. An archive, but not an atlas: the point here is not to take the world upon one's shoulders, but to crouch down to the earth, and dig.

An earlier version of this text was published in *Culture Front: A Magazine of the Humanities* (New York) 2, no. 3 (Fall 1993). A revised version, reprinted here by permission of the author, was originally published in *Camera Austria International*, no. 95 (2006).

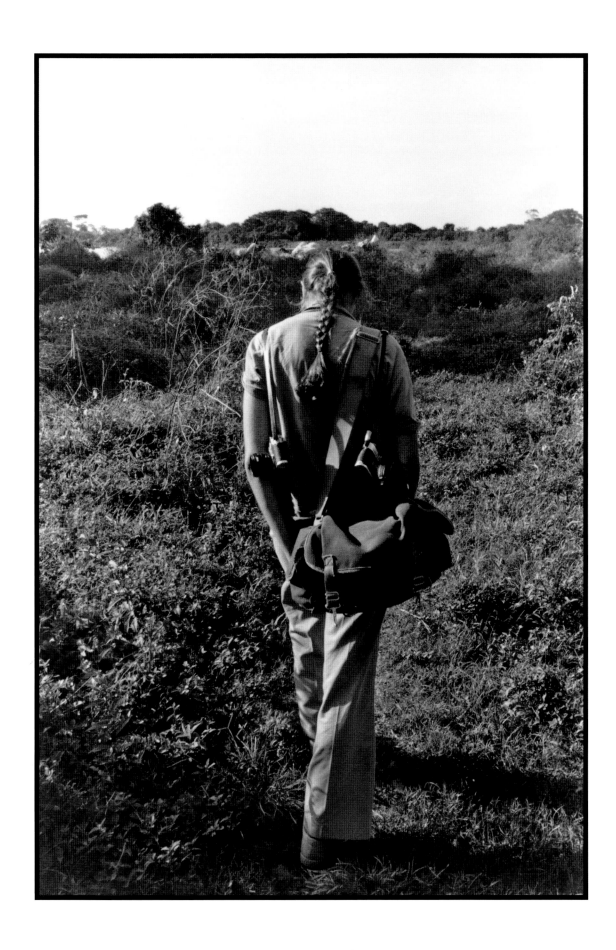

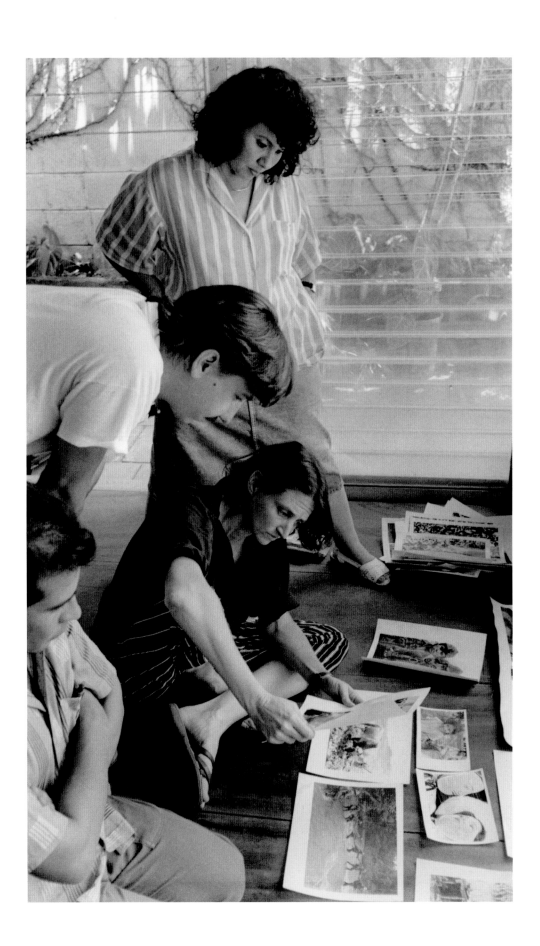

1948

Born June 21 in Baltimore, Maryland.

1970

Receives a BA from Sarah Lawrence College, Bronxville, New York.

1971

Receives a master's degree in visual education from Harvard Graduate School of Education. While living at 44 Irving Street, a boarding house in Cambridge, Meiselas takes 4 x 5 portraits of fellow residents. Each portrait is accompanied by a text in which the subjects comment on how they see themselves represented in the photograph. Simultaneously she works as an assistant editor to filmmaker Frederick Wiseman on *Basic Training*.

1972

Becomes a Photographic Consultant at the Community Resources Institute, where she develops a curriculum for teachers in New York City public schools using visual materials. During the summer, while following state fairs, she encounters the itinerant girl shows, which she then follows for the next three years.

1973

Travels to South Carolina and Mississippi as an artist-in-residence with the South Carolina Arts Commission and Mississippi Arts Commission. While teaching photography and animation in rural communities, she begins a series called *Porch Portraits* that depicts encounters with strangers in the South.

1974

Continues to work in South Carolina, where she develops a Bicentennial project with teenagers. They collect photographic and oral histories for the exhibition *A Photographic Genealogy—The History of Lando*, a company-owned mill town in South Carolina. Participates in her first group exhibition, *Daredevils & Showgirls*, at the Brockton Art Center in Brockton, Massachusetts, where she shows work focusing on the life of one stripper, Lena.

1975

Appointed to the faculty of the Center for Understanding Media, New School for Social Research, New York, and works with media studies educators in local public schools. As a consultant for the Polaroid Foundation, she conceives of and edits *Learn to See*, a compilation of the work of teachers using Polaroid materials in the classroom. Her first solo show, *Carnival Strippers*, opens at the CEPA Gallery in Buffalo, New York; accompanying the photographs are audio recordings made with the strippers, their managers, and spectators.

1976

Joins Magnum Photos. *Carnival Strippers* is published by Farrar, Straus & Giroux in the United States and Éditions du Chêne in France. She begins a project called *Prince Street Girls*, in which she photographs girls living in her neighborhood in Little Italy. In the winter, she begins to photograph homeless men living on the Bowery in New York City. These men take temporary jobs as Santa Claus with the Volunteers of America. The *Volunteers of America* series continues though 1978.

1977

Travels to Latin America for the first time. She visits Cuba with seven other American photographers through the Center for Cuban Studies; Parsons Gallery in New York organizes an exhibition of their work. In May, the Everyman Company of Brooklyn, directed by Ricardo E. Velez, produces a play called *Strippers* based on the interviews used in the book. She travels to Chad in the fall with French filmmaker Raymond Depardon to cover the civil war and resulting refugee crisis. They follow Bernard Kouchner, cofounder of Doctors Without Borders/Médecins Sans Frontières, on one of their first missions.

1978

Travels to Nicaragua for the first time in June, staying six weeks. Her photographs are published in the *New York Times Magazine* under the headline "National Mutiny in Nicaragua" (July 30, 1978). She returns to Nicaragua in August just after the National Palace in Managua is captured and before the first insurrections begin in Masaya, Estelí, and Matagalpa.

1979

Makes her first trip to El Salvador with Alan Riding for the *New York Times* to cover the assassinations of local

Left: Meiselas looking at work by Nicaraguan photographers, Managua, 1989 (left to right): Guillermo Flores, Leonardo Barreto, Meiselas, Margarita Montealegre. Photo: Claudia Gordilllo.

Previous page: Susan Meiselas, Morazán Province, El Salvador, 1980. Photo: Peter Howe

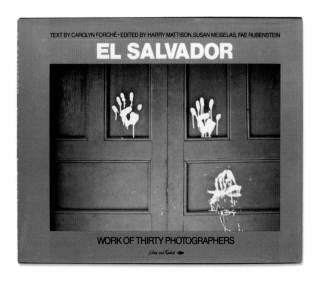

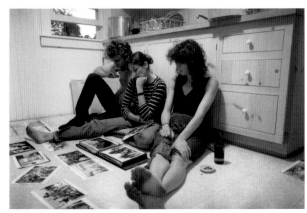

priests. She returns after the October military coup and covers the civil war for the next four years, including the popular resistance and the Frente Farabundo Martí para la Liberación Nacional (FMLN). During this period, she also continues to photograph the conflict in Nicaragua, covering Sandinista training camps in Costa Rica and the northern mountains of Nicaragua, the last offensive in Masaya and Managua, and the beginning of reconstruction following the overthrow of Somoza on July 19. For her photographs of Nicaragua, she receives the Robert Capa Gold Medal from the Overseas Press Club. She will continue to photograph in Nicaragua over the next twenty-five years.

1980
Continues to live and work in Central America. Documents the discovery and exhumation of the American Maryknoll sisters, killed by death squads in El Salvador, December 4, 1980.

1981
In January, Meiselas is wounded in a land-mine explosion near Suchitoto, El Salvador, while on assignment for *Time* covering the "Last Offensive" of the FMLN. With her is photographer John Hoagland, who is also wounded, and cameraman Ian Mates, who is killed. She travels to Argentina to photograph the Mothers of the Plaza de Mayo

and the "disappeared"; the photographs are published in the September issue of *Life*. *Nicaragua, June 1978–July 1979* is published by Pantheon, with editions in Spanish and French. In December, she photographs the aftermath of the El Mozote Massacre with *New York Times* reporter Raymond Bonner. The *Times* publishes the photographs on February 21, 1982, and the work is later used as evidence in the congressional debates to halt U.S. military aid to El Salvador.

1982
Presents *Mediations*, an exhibition deconstructing the way the international media presented her photographs from Nicaragua, first at Side Gallery, Newcastle-on-Tyne, and later at Camerawork, London.

1983
Documents the destruction of infrastructure and villages in northern Nicaragua by the contras during the U.S.-backed "counter-revolution" and continues to photograph extensively in El Salvador. With Harry Mattison and Fae Rubenstein, she edits *El Salvador: Work of Thirty Photographers*, published by Writers & Readers.

1984
Curates the exhibition *From Central America*, held at

Above right: Harry Mattison, Susan Meiselas, and Fae Rubenstein editing the book *El Salvador: Work of Thirty Photographers*, in Wainscott, Long Island, 1983. Above left: Cover of *El Salvador: Work of Thirty Photographers* (New York: Writers & Readers, 1983).

Right: Funeral procession for John Hoagland, who was killed in crossfire while working in El Salvador, March 17, 1984. Left to right: Marcello Zannini, Godefredo Goedes, Meiselas, Ivan Montecinos, and Bob Nickelsberg. Photo: Luis Romero/AP.

Central Hall in New York, in conjunction with Artists Call Against U.S. Intervention in Central America. In collaboration with Visual Studies Workshop, she organizes the touring exhibition *Inside El Salvador*. The show opens at the Museum of Photographic Arts, San Diego, and the International Center of Photography, New York, traveling to colleges, public libraries, and museums over the next two years. *Mediations* is presented again at the Museum Folkwang in Essen, Germany.

1985

Directs and produces, with Alfred Guzzetti and Richard Rogers, the film *Living at Risk: The Story of a Nicaraguan Family*. For the experimental documentary *Voyages*, produced in collaboration with director Marc Karlin for Channel 4 (UK), she cowrites a narration reflecting on her work in Nicaragua. In the winter, she travels with Ray Bonner to the Philippines to cover the 1986 reelection of Ferdinand Marcos for the *New York Times*.

1986

Stays in the Philippines for six months to follow the People Power Revolution and the election of Corazón Aquino; her

work there includes a photo-essay on "Mail-Order Brides" for the *New York Times Magazine*. Her color work from Nicaragua is included in *On the Line*, an exhibition at the Walker Art Center in Minneapolis.

1987

Continues to work in Nicaragua, covering the impact of the contra war and the beginnings of the peace process.

1988

Travels to Colombia to document the escalating political violence against human rights monitors, and to Chile to cover the Pinochet referendum. Collaborates with anthropologist and filmmaker Robert Gardner on his return to the Baliem Valley in Irian Jaya (now West Papua), Indonesia. They travel to the highlands to reconnect with the indigenous Dani tribe whom Gardner had first filmed in 1961 for his documentary *Dead Birds*.

1989

Continues work in Argentina and Chile. In July, she returns to Nicaragua with filmmakers Richard Rogers and Alfred Guzzetti for the tenth anniversary of the overthrow of

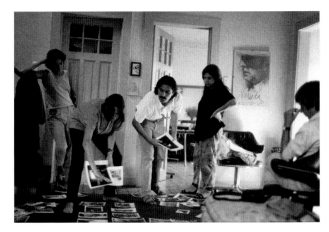

Somoza. She begins the process of locating the subjects of her photographs from the insurrection of 1978–79 to make the film *Pictures from a Revolution*. In the fall, she photographs undocumented workers attempting to cross the U.S.-Mexico border, a project that continues through 1990. The photographs are exhibited in *Los Vecinos* at the Museum of Photographic Arts, San Diego; the exhibition includes the work of three Mexican and four American photographers.

1990

Collaborates with Chilean photographers on editing the book *Chile from Within*, which includes the work of sixteen Chilean photographers (published by W. W. Norton). Photographs from her border project are integrated with photographs from her Latin American work in the exhibition *Crossings* at the Art Institute of Chicago.

1991

Becomes a Gahan Fellow at the Carpenter Center, Harvard University, where she teaches photography and coedits *Pictures from a Revolution*. In April, she photographs the meeting between Danielle Mitterrand and Massoud Barzani on the Iran-Iraq border and then enters Northern Iraq for the first time to document the destroyed villages

Above right: Meiselas working with Chilean photographers on *Chile from Within*, 1990 (left to right): Helen Hughes, Meiselas, Alvaro Hoppe, Paz Errázuriz, and Marcelo Montecinos. Photo: Claudio Perez. Above left: Cover of *Chile from Within* (New York: W. W. Norton, 1990).

of Saddam Hussein's 1988 Anfal campaign. In October, *Pictures from a Revolution* opens at the New York Film Festival. That same month, Meiselas joins the project *Women's Work*, commissioned by the Liz Claiborne Foundation, along with five other photographers; she works with the San Francisco Police Department and District Attorney's Office to investigate domestic violence. The resulting photo-collages are installed in bus shelters around the city in 1992, and later published in *Grand Street* as *Archives of Abuse*. She returns to Iraq in December with the forensic anthropologist Clyde Snow and Physicians for Human Rights to record the exhumation of mass graves from the Anfal campaign. During this trip, she begins to collect a visual history of the Kurdish people; the project continues through 1997.

1992

With the support of a MacArthur Fellowship, she continues work on the Kurdistan project, organizing a network of researchers, including exiled Kurdish scholars, to gather photographs and other documents of Kurdish history in Western archives and from members of the Kurdish diaspora throughout Europe. Becomes a graduate seminar instructor at Cal Arts in Los Angeles.

1993

Returns to El Salvador in February with Ray Bonner and *60 Minutes* during the exhumation of the El Mozote Massacre site. Later that year, she and Bonner report on the Nagorno-Karabakh War in Armenia and the Republic of Azerbaijan while she continues collecting Kurdish archival documents in Yerevan, Armenia.

1994

Receives the Hasselblad Foundation Prize; her photographs are exhibited at the Hasselblad Center in Göteborg, Sweden, including some materials gathered from Kurdistan. She receives the Maria Moors Cabot prize from Columbia University Graduate School of Journalism for her decade of work in Latin America.

1995

Photographs the clientele of a New York City S&M club Pandora's Box. She receives a Rockefeller Foundation Multi-Media Fellowship to develop the website akaKURDISTAN.com as a site of collective memory and exchange with Picture Projects.

1996

Photographs in Tajikistan and Northern Afghanistan for the Open Society Institute, which allows her to continue gathering visual materials from Kurds in Kazakhstan. She creates a collage, *Evidence/Identity*, for the *Facing History* show at the Centre Georges Pompidou, Paris, and all the collected objects are brought together in *Kurdistan: In the Shadow of History* at the Menil Collection in Houston as part of FotoFest. The latter exhibition tours Europe for eight years with the addition of site-specific materials collected from each exiled Kurdish community. During this time, she returns to Colombia to photograph "teenage assassins" and also accompanies Robert Gardner, for the second time, to the Baliem Valley to photograph the Dani.

1997

Life in the E.R.: Loss of Innocence, her first video shoot, made with producer Pamela Yates for Skylight Pictures, focuses on the emergency room of New Orleans' Charity Hospital. The program, aired on the Learning Channel, receives a National Emmy for cinematography. Random House publishes *Kurdistan: In the Shadow of History*.

1998

Returns to Mexico to report on the missing women of Ciudad Juarez, then accepts a visiting lectureship at Carpenter Center, Harvard University. She begins curating *Moving Walls*, rotating installations of work by documentary photographers sponsored by the Open Society Institute in New York.

Mistress Catherine after the Whipping I, The Versailles Room, New York, 1995, from the series *Pandora's Box*.

1999

Continues her work on domestic violence with the Chicago District Attorney's office while a Globalization Fellow in Human Rights at the University of Chicago. She contributes a series of panoramic photographs focused on women and urban street life to the National Millennium Survey organized by James Enyeart.

2000

Carnival Strippers is exhibited at the Whitney Museum of American Art, New York. Meiselas returns to Nicaragua to photograph land-mine victims from the contra war in collaboration with Handicap International.

2001

Organizes the exhibition *From the Stone Age to the Digital Age: The Dani of the Baliem Valley*, a visual history documenting the "discovery" of the Dani and their exposure through photography as related to Dutch colonialism. Held at the Nederlands Foto Instituut in Rotterdam as part of a Photoworks in Progress Commission, the exhibition later travels to the Mois de la Photo in Montréal. *Pandora's Box* is published by Magnum Editions. She photographs the collapse of the World Trade Center on September 11 and later contributes to *Here Is New York*, as well as to *New York September 11*, a Magnum publication. In late September, she participates in the first Festival of Photography in Pingyao, China, with a reinstallation of the exhibition *Crossings*. In December, she returns to El Salvador to photograph the reburials in El Mozote on the twentieth anniversary of the massacre.

351

2002

Becomes a Visiting Fellow at the Graduate School of Journalism, University of California, Berkeley, where she teaches multimedia storytelling until 2007. The exhibition *Intimate Strangers*, consisting of selections from *Carnival Strippers* and *Pandora's Box*, opens at Canal de Isabel II in Madrid and later travels to FOAM in Amsterdam.

2003

An installation of her work from the Baliem Valley called *Encounters with the Dani* is included in *Strangers: The First ICP Triennial of Photography and Video* at the International Center of Photography, New York. Two books of her work are published: *Encounters with the Dani* (ICP/Steidl) and a second edition of *Carnival Strippers* (Steidl/Whitney) which includes a CD of the original sound recordings.

2004

On the twenty-fifth anniversary of the overthrow of Somoza, she returns to Nicaragua with murals of her 1978–79 photographs, which she reinstalls in the landscape. With Alfred Guzzetti, she coproduces the video *Reframing History*, documenting public response to the project. She works with the Acumen Fund, a nonprofit global venture fund, to document their health and water projects in Africa and India.

2005

Travels to Portugal to photograph the neighborhood of Cova da Moura, creating a community installation, parallel to an exhibition, called *Mirror, Mirror* at the Centro Cultural de Belém in Lisbon. An installation of *Reframing History* is included in *After the Fact: The First Festival of Photography* in Berlin. She receives the Cornell Capa Infinity Award from the International Center of Photography.

352

2006

Works with Human Rights Watch to document the migration of Indonesian domestic workers to Singapore, part of a Magnum project on contemporary slavery to be exhibited at the Haywood Gallery, London, in fall 2008. The Comunidad de Madrid commissions her to photograph Ecuadorian immigrants. She is invited to join the faculty of the Masters of Photographic Studies at Leiden University, the Netherlands. An excerpt of her Kurdistan exhibition is shown at the Gwangju Biennale.

2007

The Orange Foundation commissions her to document girls' education in Mali. An exhibition of the work is shown at the Bibliothèque Nationale in Paris. *Madrid Inmigrante*, an exhibition at the Canal de Isabel II, Madrid, includes her images of the working lives of The Masters, an Ecuadorian women's soccer team. She also photographs in the Democratic Republic of Congo for a film produced by Skylight Pictures about the International Criminal Court. In association with the Asia Society, New York, she begins curating the work of Chinese photographers who document the impact of coal mining on the environment. In November, she returns to Northern Iraq to photograph for the first time since *Kurdistan* was published.

2008

In conjunction with FotoFest, she installs a multimedia installation of the coal project, titled *Mined in China*, at the Houston Center of Photography. She becomes a Professor "Extraordinaire" at the Masters of Photographic Studies, Leiden University. Aperture and ICP republish *Nicaragua* in an edition that includes a DVD of both *Pictures from a Revolution* and *Reframing History*. *Kurdistan: In the Shadow of History* is updated and reprinted by the University of Chicago and distributed in Northern Iraq for the first time.

Mural of Polaroid portrait installed as part of a community project with
Cape Verdians in Cova da Moura, outskirts of Lisbon, Portugal, 2005.

Contributors

Caroline Brothers is the author of *War and Photography: A Cultural History* (1996). A graduate of the University of Melbourne, Australia, she obtained her doctorate from University College London before joining Reuters as a correspondent. She reported from London, Brussels, Belfast, Mexico, Central America, and Paris, before joining the *International Herald Tribune*, where she writes about immigration.

Edmundo Desnoes is one of Cuba's best known writers. His novel *Memories of Underdevelopment* (1965) has been translated into French, Italian, and German; the English edition, published by New American Library, is his own translation. The novel was adapted into a seminal Latin American film by Desnoes and director Tomás Gutiérrez Alea in 1968. His defection from Cuba in 1979, during the Venice Biennale, marked the end of his commitment to any form of ideology. He has taught at Dartmouth, Stanford, and Smith College. His essay "The Photographic Image of Underdevelopment" is a classic on the visual interpretation of Latin America. He has contributed to *Aperture* and other international reviews and is currently working on another novel, *Memories of Overdevelopment*.

Elizabeth Edwards is professor and senior research fellow at the University of the Arts London (LCC) and was previously curator of photographs at Pitt Rivers Museum and lecturer in visual anthropology, University of Oxford. She has written extensively on the relationship between photography, anthropology, cross-cultural histories, and material culture.

Marc Karlin was a central figure in the Berwick Street Collective (London), which made the groundbreaking documentary *The Nightcleaners* in 1975. Throughout the 1980s and 1990s, he continued to explore the possibilities of experimental documentary, producing and directing a series of films on the aftermath of revolution in Nicaragua and on different visions of socialism. He made a major contribution to the shaping of Channel 4 and founded the influential film journal *Vertigo*. He died in 1999.

David Levi Strauss is the author of *Between Dog & Wolf: Essays on Art & Politics* (1999), *Between the Eyes: Essays on Photography & Politics*, with an introduction by John Berger (2003), and *From Head to Hand* (forthcoming from Oxford University Press).

Lucy R. Lippard is a writer and activist. She is the author of twenty books on contemporary art and cultural criticism, including one novel, and has curated some fifty exhibitions in the U.S., Europe, and Latin America. For thirty years, she has worked with artists' groups such as the Artworkers' Coalition, Ad Hoc Women Artists, Artists Meeting for Cultural Change, the Alliance for Cultural Democracy, and WAC (Women's Action Coalition). She was a cofounder of Printed Matter, the Heresies Collective and journal, PADD (Political Art Documentation/Distribution) and its journal *Upfront*, and Artists Call Against U.S. Intervention in Central America. She continues to write and lecture frequently at museums and universities.

Allan Sekula is a photographer, filmmaker, writer, and critic. His published books are *Photography Against the Grain* (1984), *Geography Lesson: Canadian Notes* (1997), *Dismal Science* (1999), *Fish Story* (2002), *TITANIC's Wake* (2003), and *The Traffic in Photographs* (forthcoming from MIT Press). His films include *Lottery of the Sea* and *A Short Film for Laos*. His work has been shown in solo exhibitions throughout the world.

Abigail Solomon-Godeau is professor of art history at the University of California, Santa Barbara. She is the author of *Male Trouble: A Crisis in Representation* (1997) and *The Face of Difference* (forthcoming from Duke University Press). Her essays have appeared in such journals as *Art in America*, *Artforum*, *The Art Journal*, *Afterimage*, *Camera Obscura*, *October*, and *Screen*, and have been widely anthologized and translated into various languages.

Diana Taylor is University Professor and professor of performance studies and Spanish at New York University. She is the author of numerous books, including, most recently, the award-winning *The Archive and the Repertoire: Performing Cultural Memory in the Americas* (2003). She is founding director of the Hemispheric Institute of Performance and Politics.

International Center of Photography

Published in conjunction with the exhibition
Susan Meiselas: In History organized by Kristen Lubben
for the International Center of Photography, New York

Exhibition Dates: September 19, 2008–January 4, 2009

This exhibition is made possible by Shell.

Copublished by the International Center of Photography, New York,
and Steidl Publishers, Göttingen, Germany

Cover: *Family members wear the photographs of Peshmerga
martyrs, Saiwan Hill cemetery, Arbil, Northern Iraq*, 1991, from the
series *Kurdistan*; facing contents page: Susan Meiselas, *Self-Portrait*,
from the series *44 Irving Street*, 1971.

Director of Publications: Philomena Mariani
Managing Editor: Eli Spindel
Design: Bethany Johns
Separations: Steidl's Digital Darkroom/Reiner Motz,
Inès Schumann
Production: Julia Braun, Bernard Fischer,
Katharina Staal, Gerhard Steidl
Printing: Steidl, Göttingen

International Center of Photography
1114 Avenue of the Americas
New York, NY 10036
www.icp.org

STEIDL
Düstere Str. 4 / D-37073 Göttingen
Phone +49 551-49 60 60 / Fax +49 551-49 60 649
www.steidlville.com

ISBN 978-3-86521-685-4
Printed in Germany